GALEN ROWELL'S

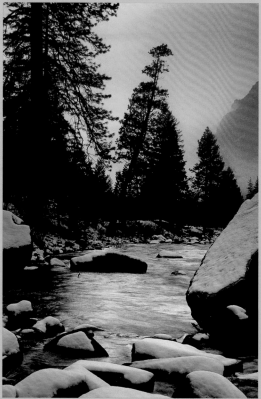

INNER GAME OF
OUTDOOR PHOTOGRAPHY

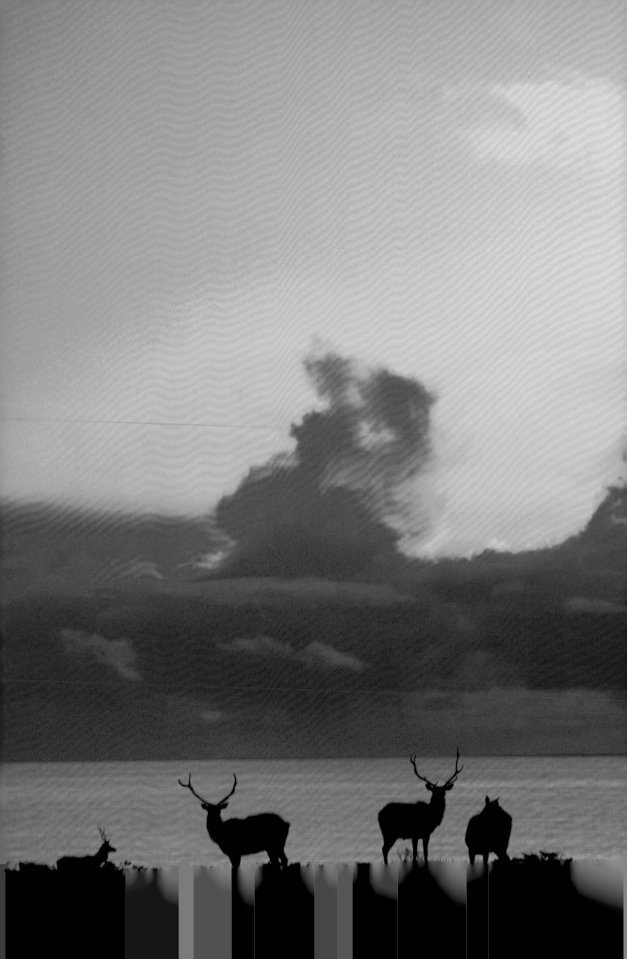

GALEN ROWELL'S
INNER GAME OF
OUTDOOR PHOTOGRAPHY

GALEN ROWELL

W. W. NORTON & COMPANY
NEW YORK · LONDON

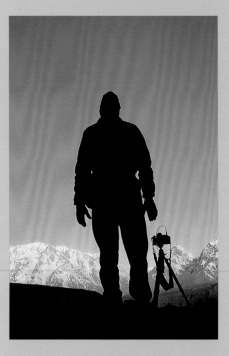

Composition by Kristen Wurz. Book design by Jennifer Barry Design, Sausalito, CA
Manufacturing by Friesens

Library of Congress Cataloging-in-Publication Data
Rowell, Galen A.
Galen Rowell's inner game of outdoor photography / Galen Rowell.
p. cm.
Includes index.
ISBN 0-393-04985-X
1. Outdoor photography. I. Title: Inner game of outdoor photography. II. Title.
TR659.5.R677 2000
778.7'1—dc21 00-041881

ISBN 978-0-393-33808-9 pbk.

W. W. Norton & Company, Inc., 500 Fifth Avenue, New York, N. Y. 10110
www.wwnorton.com

W. W. Norton & Company Ltd., Castle House, 75/76 Wells Street, London W1T 3QT

3 4 5 6 7 8 9 0

Photo page 1: *Essay pages 41–43, 51–53, 90–91,* Mist over the Merced River in Yosemite Valley glows red in last light as snowy boulders reflect the blue sky overhead. **Photo pages 2–3:** *Essay pages 46–47, 269–275, 276–279,* Tule elk profiled against the Pacific Ocean at Point Reyes near San Francisco would not appear to the eye as black silhouettes.
Photo page 6: *Essay pages 36–37, 98–102, 186–188,* With a manual exposure set for the sky, fill flash lights the walls of an ice tower of frozen steam on the crater of Mt. Erebus in Antarctica (see page 165). **Above:** *Essay pages 31–33, 34–35, 36–37, 46–47, 84–85, 151–152, 228–229,* A photographer contemplates the infinite creative possibilities of a Himalayan sunrise in the Mustang district of Nepal. **Right:** *Essay pages 38–40, 54–56, 135–137,* To expose for the vivid sunset and the deeply shadowed ruins of Machu Picchu required 5 stops of graduated neutral-density filters.

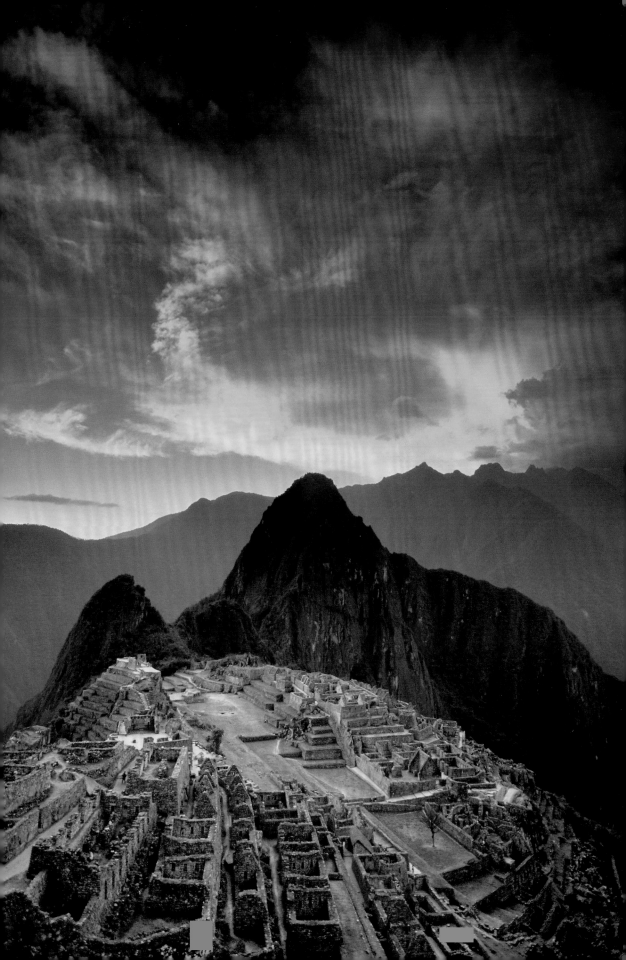

CONTENTS

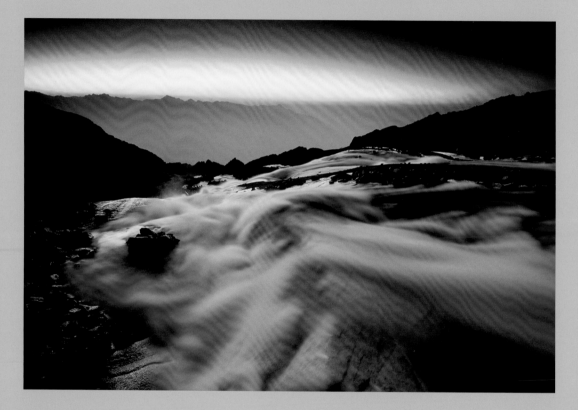

Above:
Essay pages 54–56, 57–60
A 10-second exposure turns
a river in the Cordillera
Blanca of Peru into silky mist
beneath a sunset held back
with 5 stops of graduated
neutral-density filters.

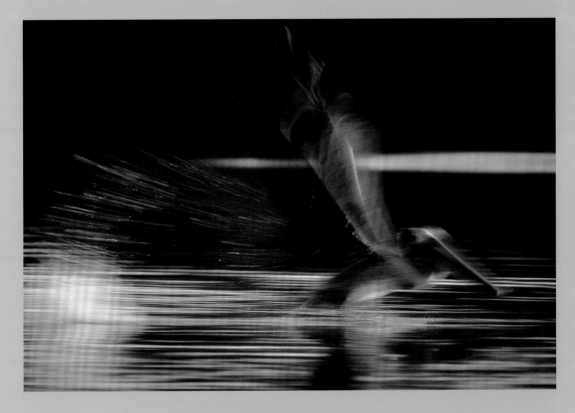

Above:

Essay pages 57–60, 276–279
A brown pelican touches
down at sunset in Berkeley's
Aquatic Park, panned with a
$1/2$-second exposure through
a 600mm lens.

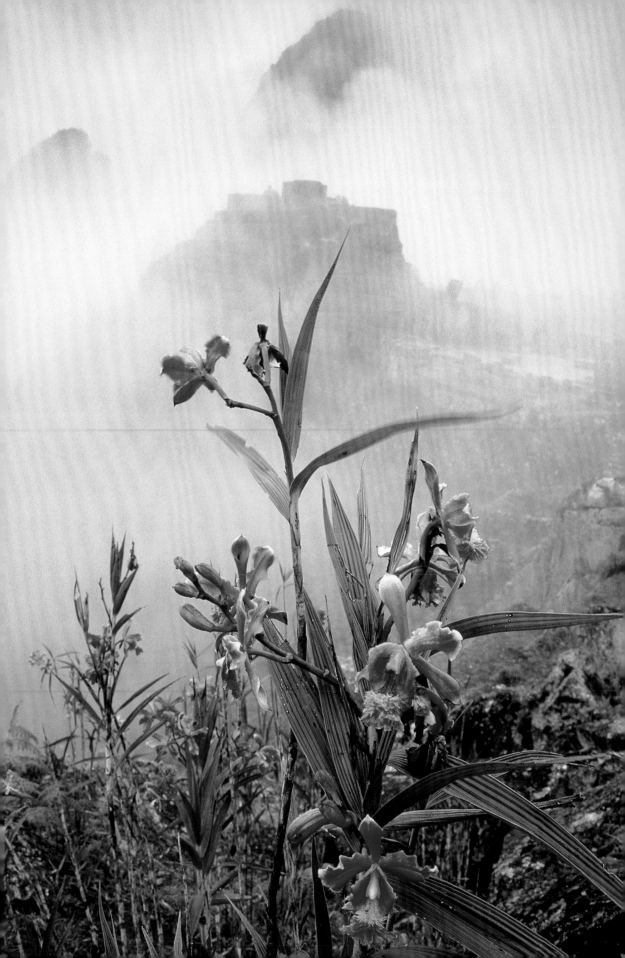

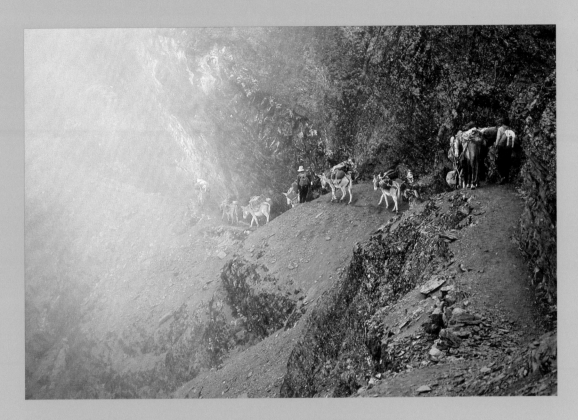

Left: *Essay pages 38–40, 82–83, 135–137*
Focusing closely on wild orchids with the ruins of Machu Picchu veiled in mist creates impressions of both sharpness and mystery.

Above: *Essay pages 82–83, 84–85*
Rising mists also add a sense of mystery to a pack train crossing a 16,000-foot pass in the Cordillera Blanca of Peru.

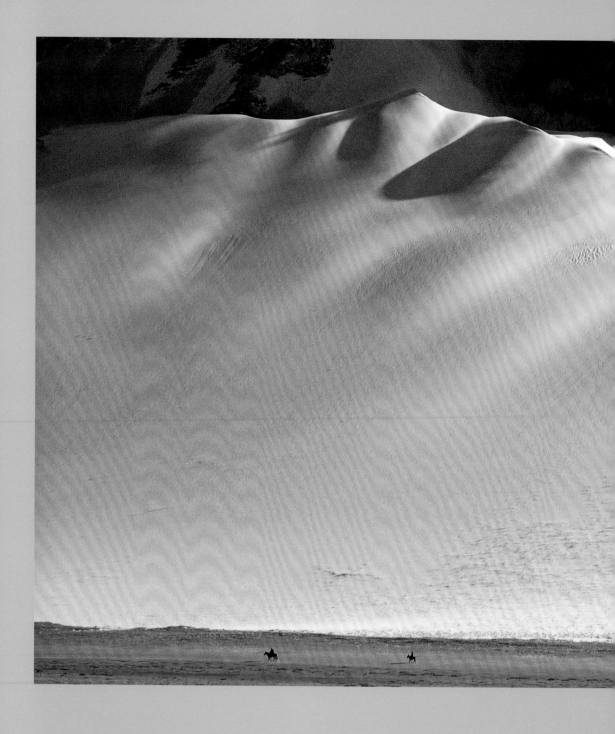

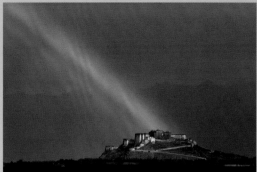

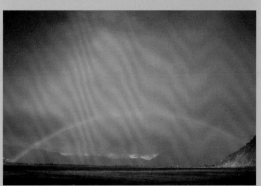

Left: *Essay pages 44–45, 57–60, 82–83*
Riders give a sense of scale to a 180mm telephoto of a giant sand dune along the ancient Silk Road in the Pamirs of Chinese Turkestan.

Above, bottom:
Essay pages 41–43
When a weak rainbow appeared over a field outside Lhasa, Tibet, I snapped this record shot before running a mile with camera and lens in hand and a vision in my mind's eye of the rainbow emanating from the golden roofs of the Dalai Lama's Potala Palace.

Above, top:
Essay pages 38–40, 41–43, 57–60, 61–62
My vision came true as the sunlit curtain of falling rain stayed in place while the rainbow moved with me in relation to the sun. I used a telephoto lens to magnify part of the bow as a spot of light came through the clouds onto the palace.

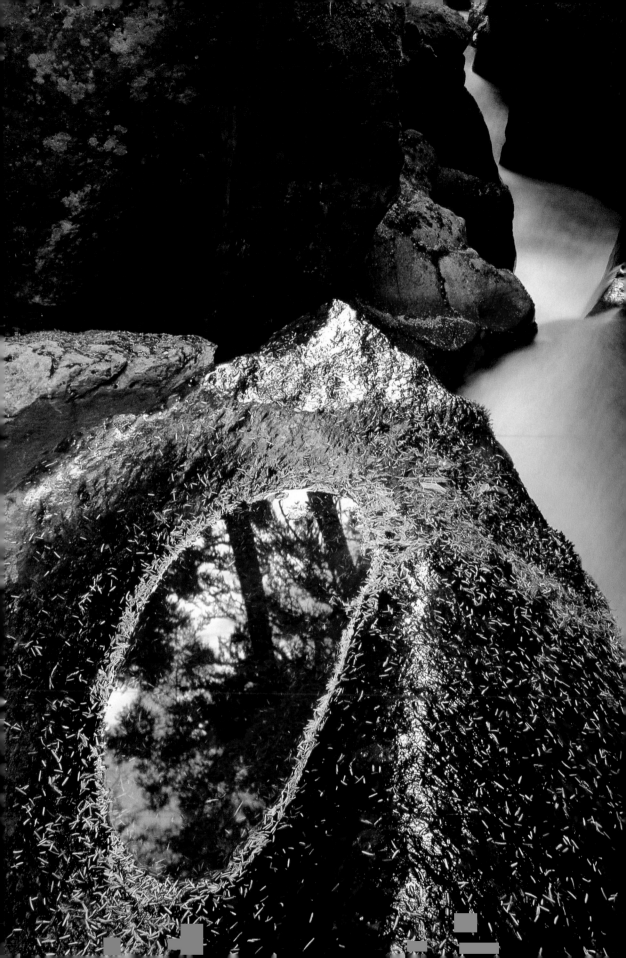

Left:
Essay pages 54–56, 82–83
A reflection in a pool filled by
spray from the cascades of
Avalanche Creek mirrors a
hemlock forest in Montana's
Glacier National Park.

Right: *Essay pages 22–24*
A chaotic spiral of floating
pollen forms in an eddy
of the Tuolumne River near
Glen Aulin in Yosemite
National Park.

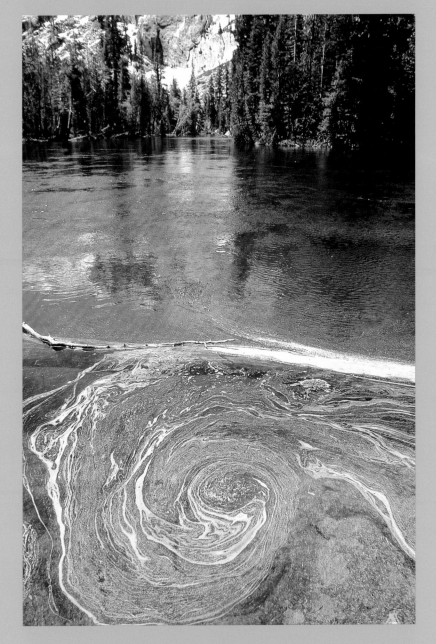

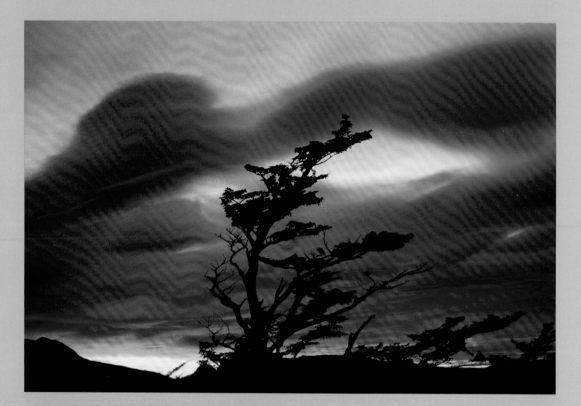

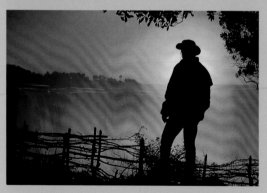

Above: *Essay pages 38–40, 57–60, 61–62, 228–229* Edges of light and form flow together in the wilds of Patagonia below Fitz Roy, but not by coincidence. Extreme westerly winds shaped both tree and cloud.

Left: *Essay pages 29–30, 48–50, 61–62, 149–150* At Victoria Falls in Zimbabwe I stepped into the scene to put my silhouette against a corona formed in the rising mists, as well as to block the sun from causing lens flares.

Preface

If photography was limited to what Daguerre described when he introduced it to the world in 1839—"a process that gives Nature the ability to reproduce herself that enables anyone to take the most detailed views in a few minutes"—this book would never have been written. A technical instruction manual for your camera would be all you'd need to replicate the world before your eyes. But photographic images don't do that. They are visual illusions that trick our senses into believing that the images represent the way the eye would see a real scene.

In the rush of modern life, few images hold our attention long enough to contemplate their making. Most of these eye-stoppers seem to have been taken by someone just outside the scene who had no effect on it whatsoever, yet just happened to be in the right place at the right time with the right equipment. Visionary imaging doesn't happen that way.

Cameras capable of making great photographs have become commonplace these days, but photographers have not. While technical innovations have made photography ever easier in recent decades, the art of producing images that other people will care about has become ever more formidable. This apparent paradox is due to rising expectations in a culture where we are surrounded by a growing number of sophisticated images every day of our lives.

Most of the fifty billion photographs taken each year "don't come out." Just a few billion are chosen to show friends and family. Far fewer, mere tens of millions, are commissioned or selected for use in publications and advertisements that influence how we think about nature, sports, politics, cars, travel, entertainment, and just about everything else in the universe. What most of us believe we know about the modern world has more to do with these carefully selected

artificial visual inputs than with our direct visual experience. This was not true for our forefathers.

As the ancient Greeks realized long ago, true knowledge begins only when people take the time to wonder about things that previously seemed self-evident. Those who try to understand what makes images tick are far less prone to being emotionally manipulated by clever imagery than those who claim no interest in photography or how images are made.

Vision is not self-evident, especially where imagery—rather than direct observation—is involved. Visionary imaging relates to a previsualization in the mind's eye of the photographer more than to the apparent subject before the lens. A properly conceived visionary image becomes a phenomenally powerful means of communicating emotional and aesthetic information that can transcend what at first glance appears to be a simple subject. For example, where a small child sees only a mother with another child in a famous Dorothea Lange photograph of a migrant mother, most adults sense a deep spiritual connection with a tragic era. In a similar way, classic nature photographs lead our minds beyond the apparent simple subject matter into spiritual appreciation of a world not visible before our eyes.

Every life science student learns that the eye takes in information about the world from light focused through the lens onto the retina. In the recent past, the retina was often compared to a piece of film. We now know that the retina is actually an externally placed chunk of brain tissue, similar to that beneath the skull in the visual cortex. Rather than being a passive image receiver like film, the retina actually has more computational ability than today's most sophisticated supercomputers, which can only crudely simulate interpretive pattern recognition. Intelligent, highly constructive retinal processes occur well before the information is passed through the optic nerve into the brain for further image processing.

Knowing that nearly half of the human cortex

deals with vision makes it not so surprising that cognitive scientists now conclude that our general thought processes parallel the way our brains process imagery. Brain is not mind, but brain structure does limit how the mind operates. Vision scientist Donald Hoffman asserts, "Your visual prowess is nowhere more impressive than when you view a natural scene." This is true because our visual system has evolved to interpret just these kinds of scenes. Photographs of natural scenes, as opposed to the scenes themselves, hold a greatly impoverished range of visual cues. What's more impressive to me is that we can look at a strange, two-dimensional pattern of inks or dyes on paper and reconstruct a meaningful image that triggers emotions similar to those we feel when we directly observe a natural scene.

Early outdoor photographers followed Daguerre's promise of direct representation, concentrating on technically accurate renditions of the world around them in the largest possible format. The nineteenth-century masters of wilderness photography—William Henry Jackson, Eadweard Muybridge, and Timothy O'Sullivan—spent years becoming proficient in the technical side of their craft before lugging huge view cameras and portable darkrooms for processing glass plates into the wilds on the backs of pack animals.

Today, a smart novice with instruction manual in hand can master autofocus, auto-exposure, and film loading in less than an hour. Yet regardless of how technically sharp and well composed the resulting photographs may be, literal images of nature no longer wow the public as those of the first master landscape photographers once did. In every field, there comes a time when we stop paying attention to examples of technical success. With the first telephones, televisions, and personal computers, people passed through an early stage of fascination with the medium itself, rather than with the information being communicated. Every budding photographer passes through this stage anew. Many never move

beyond it. They use their images to validate their experience, rather than the other way around. Simply defined, a visionary image communicates the intentionality of the artist's experience.

Today's visionary outdoor photographers are members of a small fraternity of artists, scientists, and philosophers who have lost the certitude of every other creature on the planet that what is sensed in the shape the eye beholds is actually there in that way. Their best pictures show us a world different from the one we directly observe, a world that bears an uncanny resemblance to the one held in the mind's eye of our memory.

The golden sieve of memory simplifies visual information down to bare essentials and records it by association. In effect, it becomes the currency of our minds. Minute by minute, year by year, details fall away as our mental imagery becomes more iconographic. That's how we see; that's how we think.

Beginning with a very incomplete visual recording of a landscape, our minds reduce it ever further, until, as Robert Pirsig wrote in *Zen and the Art of Motorcycle Maintenance,* "We take a handful of sand from the endless landscape of awareness around us and call that handful of sand the world."

A great landscape photograph of a national park radically simplifies that park in the same way that Pirsig's handful of sand looks like the world. It doesn't attempt to replicate as many features as possible in a single panorama, nor does it attempt to record every pine needle a mile away on a 20-by-24-inch sheet of film. Instead, it evokes the essence of parkness through the photographer's intentional choice of subject matter and how it is arranged, much as a single great quotation without one word too many is far more memorable than an entire book of accurate explanation.

As with a memorable quotation, a great photograph of the natural world sums up our own feelings in a way that we instantly recognize and accept. We have the sense that we, too, could have uttered those words or taken that photograph of what we would have seen with our eyes if we had been there at the time, but such is not the case.

In the real world of direct observation, we are rarely aware of the aesthetic relationships of different natural objects in our visual field. If we walk through a meadow, we may respond to the pretty wildflowers and that neat cloud up in the sky, but unless we use visionary imaging to actively search out a composition to render as secondary visual input, we are most unlikely to move our head down and right to a point 14 inches off the ground so that the pattern we perceive in the flowers leads our eye up to a matching one in the cloud. When the average person takes a photograph of the same meadow at eye level without having gone through a similar process, the resulting image of the clouds well separated from the flowers is unlikely to be compelling.

We all take pictures to communicate what's important in our lives. Most of us carry around images of our spouses and children, our vacations, and the unusual scenes we've witnessed because pictures speak louder than words. We sense their symbolic power to communicate what's meaningful in our lives and to validate the imagery in our memory bank of life, as if the image on paper is somehow a part of us.

In the era before photography and electronic media, I would have passed my life several states away without ever seeing an image of the tornado that hit Oklahoma in 1999. As I sat glued to live television coverage in California, the imagery from an eye in the sky swooping past ruined homes seemed to have little relevance for me. I tried to imagine what it would be like to be one of those heroic figures rushing down the streets to save trapped children, neighbors, and pets. Then the scene switched to ground level on an especially ravaged street where a distraught woman was trying to convince a policeman to let her pass through a barricade. She was saying, "My pictures, my pictures. Let me through. I must have my pictures!"

To her at that moment, those pictures must have held the key to the meaning of her life. Whether or not she should have been looking for survivors is another story. Suffice it to say that she didn't appear on any of the later TV news replays. Yet in one way or another, we all collect life's most special moments in hopes of replaying them. The novelist Pam Houston has redefined her idea of personal success as no longer being about getting a Ph.D. or publishing a bestseller, but rather as "the accumulation of moments." She's realized that "creating a successful life might be as simple as determining which moments are the most valuable, and seeing how many of those I can string together in a line."

Humanity is all the better for it when creative individuals succeed in communicating their life's most important visions into the minds of others. Elie Wiesel survived the Holocaust and felt that, for his life to gain deeper meaning, he needed to share with others what he had directly observed. Decades later, after winning the Nobel Peace Prize, he said, "Not to transmit an experience is to betray it."

Visionary images have always ruled our lives. Though our ancestors mainly relied on direct, real-time observations of the world, they still took the time to create imagery in the minds of others to be passed down for generations. Images scratched onto the walls of cliffs and painted inside caves have transmitted powerful visual memories across generations with an archival stability far exceeding that of any film.

Today, leisure-time, secondary images of someone else's experiences form a major part of our collective worldview via books, magazines, newspapers, television, and the internet. What the observer sees as basic documentary photojournalism has often involved visionary imaging for the photographer, even when it seems to be entirely about someone else and their experiences. I've done that for *Life* and *National Geographic,* but I've made a conscious effort to focus the great majority of my life's work toward my own brand of participatory photography, in which I actively create images to reflect my own direct experience with nature or with chosen partners on my own adventures.

Thus my most memorable pictures are not about being a spectator. Like Pam Houston's mental images, they succeed in stringing together life's most valuable moments in both a personal and a commercial sense. To make these two worlds coincide, so that work becomes inseparable from play, is as gratifying a lifestyle as I can imagine. I wouldn't trade places with any politician, movie star, or Fortune 500 CEO.

No single image of mine or anyone else's will ever answer that eternal question: What is the meaning of life? But a series of images that match a person's ultimate experiences can indeed provide multiple answers to that more pragmatic question: Which life experiences are the most worth living?

The sixty-five essays in this book explore the inner game of creating images in the natural world that go beyond documentation to communicate at a visionary level. The essays first appeared in slightly different form and very different sequence in *Outdoor Photographer* magazine between 1993 and 1999. I wrote them with the full intention of later merging them to make a book that would have a broader meaning than the sum of its parts. Though they were originally published separated in time and pages, they are now combined into a narrative that follows my personal sequence of visionary imaging, beginning well before an image is made.

The introduction compares the emotional repertoire of fine photography to visual music. Visionary imaging can take us as far beyond documentation as a Beethoven symphony lifts us beyond the song of a mockingbird. Both are valid and pleasing, but in the symphony something emergent forms in the mind of another through human intention.

Part I, called *Visions*, explores mysteries of the creative and cognitive processes. The ways that

photographers consciously and subconsciously pre-visualize images are described, as well as how viewers who were never at the scene transform the impoverished visual information on a sheet of paper into an illusion that fools their mind into believing that they are glimpsing a different reality. Understanding the cognitive processes unlocks the door to visionary thinking about how to trigger someone else's visual system in a positive, predictable, artistic manner.

Part II, *Preparations*, explores the current limits of equipment, film, and technique for outdoor photography. Instead of reviewing the greatest stuff, these essays describe how to get the most out of a personal experience in the natural world with the least stuff. Less is more when you have to carry it yourself, or even monitor its whereabouts. It's all too easy to let photography overwhelm the very wild experience that you hoped to have for yourself and record for others.

Part III, *Journeys*, describes how visions can be merged with realities. These inner experiences of photographing the Earth's wild places range from Africa to Australia, Glacier Park to Greenland, Nepal to Nunavut, and Peru to the Pribilof Islands, to name a few. Bringing them together emphasizes their similarities as well as imaging techniques, instead of focusing on the exotic differences, as in normal travel writing.

Part IV, *Realizations*, explores ways to communicate your personal worldview after the images have been created. The essence of a definitive style is that part of visual communication beyond the subject itself which consistently displays the intentions of the artist. It must be clear without becoming obtrusive. Some realizations have to do with the limits of the current publishing marketplace, including virtual censorship of certain subjects. Others touch on more mundane issues like editing, filing, and storing of images, plus making the best possible color prints. State-of-the-art digital enlarging, several years ahead of the consumer curve, is described as the way of the future to create the finest-ever true photographic prints without a darkroom or optical enlarger. Initially labor intensive, the process allows future identical-appearing prints of almost any size to be made from digital files that hold all the photographer's aesthetic decisions of color and tonality.

In sum, these essays chronicle a journey, but not an outward exploration of the Earth, as has been the subject of so many of my past books and magazine features. This journey is an inner one that has paralleled my physical journeys for more than thirty years and propelled me toward a greater understanding of the role of imagery in the modern world.

Introduction

Visual Music

"When I started taking awful pictures that failed to reflect the inner intentions of my adventures and my response to natural landscapes, I didn't quit. I intuitively believed there must be a way to bring out those intentions from within."

On a clear spring morning a few years ago, I opened a letter urging me to quit the guru stuff and just write about the nuts and bolts of what makes for better pictures in my magazine column. My mother, Margaret Avery Rowell, had died the previous day at ninety-four. Her philosophy could hardly have been at greater odds with my reader's advice. My phone was ringing off the hook with calls from my mother's former cello students and from concert musicians around the world. At quite a young age, she stepped beyond being a successful performing artist in order to communicate her methods to others. Her teaching techniques for music—not found in standard manuals of instruction—strongly influenced and paralleled my development as a photographer.

The feedback I've received from musicians since my mother's passing strongly reinforces the connection between photography and music that I previously described in my book, *Mountain Light:* "Ordering a performance of light waves for the public eye is much like ordering a performance of sound waves for the public ear. Many photographers of the natural world, including such greats as Ansel Adams and Ernst Haas, emerged from strong musical backgrounds."

Musical analogies as to what makes for better pictures stood out even more clearly in my mind as friends, relatives, and former students shared memories in the Berkeley Hills garden of the home where my mother had lived her last sixty years. One

ex-student and renowned teacher related how my mother used to say, "I don't teach the cello. The cello can't learn. I teach the human being." She described my mother's interest as less in prize protégés than in the development of human potential through unconventional approaches that allow people, "whether they are aged seven or seventy, amateur or professional, farmer or nun," to cross personal hurdles toward satisfaction when practicing their chosen art. I remember coming home from school to find her crawling on the floor with a middle-aged Nobel laureate to demonstrate how his hands could carry lots of weight while his fingers could still move freely. She never confused physical tightness, or mental uptightness, with lack of innate ability.

Although I soon quit every musical instrument I tried in my youth, I emerged conditioned to hearing "average" people make wonderful, or sometimes not quite so wonderful, music in my house under my mother's instruction. I had no doubt that music and other fine arts could be appreciated, understood, and performed by anyone who took the time to approach them with the proper attitude. Technique and knowledge go only so far. What makes for better music—or better pictures—is simply a better human being who either naturally forms a more complete worldview from life experience, or gains it through understanding.

My mother passed on to me not only her passion for communicating human emotion through the arts, but also her love of the wilderness. When she graduated from the University of California in 1923, she immediately set off during a snowy June to trek the as-yet-unfinished John Muir Trail across 200 miles of the California High Sierra with her sister and a few friends. It took them three summers to complete.

As I set off to both hike the trail in summer and ski it in winter for a 1989 *National Geographic* story, she emphasized that her months on the trail "mean more to me than anything in my whole lifetime." Tears flowed when she opened the April 1989 issue to see a full-page, sixty-five-year-old picture of herself reaching the top of an unclimbed peak. It had been taken by my late aunt, who introduced me to photography.

While still in her teens, my mother became a concert cellist with a women's chamber music trio that played the world's first regularly scheduled live classical music broadcasts on the NBC radio network. When she was twenty-eight, a three-year bout with tuberculosis before the days of antibiotics stopped her career in its tracks. She became so ill and weak that she was physically unable to play. As she recovered in a sanatorium, she retaught herself the motions she knew must have been within her by focusing on her own previous methodology, thus forming the basis for a "whole body" teaching technique she went on to practice for the next fifty years. She recognized the powerful connection between mind, body, and instrument as all-important.

Although my mother returned to performing, she gave it up and put her heart into teaching a few years before I came along in 1940. I grew up watching and hearing individual students as they were taught to express themselves from within, rather than to only perfect outward technique by repetitive practice. On Sundays, my mother began a wonderful experiment with the powerful sounds of many cellos playing together in an ensemble that filled living room, dining room, halls, and kitchen with wall-to-wall cellists playing in unison. These informal sessions led to the founding of the first cello club in

the nation. Great performers, such as Pablo Casals and Mstislav Rostropovich, began showing up at our home and teaching local master classes.

With hindsight, I see that these lessons were virtual blueprints for the small interactive photo workshop groups that I and many other photo teachers have more recently come to favor as far better learning situations than large, passive seminars. Even my rejection of the tradition of reviewing portfolios of past work in the brief days students have together, in favor of only critiquing work made at the workshop, is due to my mother's influence. I recall listening, per her instruction, to two cello recordings and describing the difference. One touched me deeply, yet had definite imperfections, while the other was flawless, but not particularly inspired. I strongly preferred the first, but I couldn't guess the difference. She told me the first was a live recording of a Casals concert in the thirties, while the second was pieced together in a sound studio by a well-known contemporary cellist after many attempts to master each section without a flaw.

Thus when I started taking awful pictures that failed to reflect the inner intentions of my adventures and my response to natural landscapes, I didn't quit. I intuitively believed there must be a way to bring out those intentions from within—if only I could understand the nature of the human process beyond the technical nuts and bolts that photo manuals emphasize.

My learning process was ever so similar to that described in a contemporary San Francisco Symphony program by a former student of my mother's. Peter Shelton was quoted as saying that my mother opened up "a sense of infinite possibilities" to him when he was fifteen. "She taught me that, to be a complete musician, you must be able to draw on all elements of life. If we studied a Bach suite, she would show me pictures of baroque architecture, of paintings from the period. She would talk about the literature of the time. She was able to go to any discipline and relate it to the task at hand. She helped me feel my connection, as a musician, to the rest of the world." Before an early concert, she counseled, "The most important thing you can do in performance is to show the audience how much you love what you're doing."

When I read these words aloud to my mother at home shortly before her final illness, she smiled with pleasure and asked, "Now who said this about me? I don't remember him."

Her memory had been ebbing, first of the recent past, then of all but the immediate present and her early life. As I described what I knew of Peter, she perked up and said, "How do you know all that?"

I answered, "I got it from you. You told me all about him."

"Well that explains it! That's why I don't have it anymore. I gave it all to you!"

For me, this anecdote sums up a lifetime attitude of giving energy and communicating methods to others with good humor. Her dimming mind remained attuned to sharing the wordless dignity and joy that makes for great music or nature photography. I feel it is my duty to pass it on.

PART I: VISIONS

Mysteries of the creative and cognitive processes

The Most Powerful Nature Photograph Ever Made

"Our belief in Anders' earthrise image—and all other meaningful photographs of the natural world—implies a sacred trust between photographer and audience that, like an endangered species, is highly threatened but very much alive."

Behind every successful photograph of the past lies its power to endure. The most memorable, mind-changing photograph of all time—a color landscape shot taken without a tripod by an amateur—appears in many books and on critics' lists of great photographs that have changed our worldview, yet the source of its power is almost universally misunderstood.

In this digital age, photographers are often tempted to take shortcuts to visual power by creating altered images of nature that never were before their eyes. As this straight-image success story unfolds, it shows us that the power of a nature photograph is irrevocably connected to our human belief system, rather than wholly rooted in the image itself as so many photographers, publishers, and members of the public wrongly assume. The tremendous public response to this photograph is inextricably tied to the belief that it truthfully represents a "real" event witnessed by another human being.

This single photograph that has most changed our worldview is, of course, a view of Earth from space, but not just any view. Several authors attribute the birth of the global ecology movement to a particular photograph of earthrise over the moon taken in December 1968 by Colonel William Anders on the first manned mission to escape Earth's gravity. As Apollo 8 orbited the moon without landing, Anders held a Hasselblad up to the window and clicked away. On live TV and in other media around the world, he mused about the fragile nature of the little ball he saw and photographed.

When I sat on the board of an environmental organization beside Bill Anders in the seventies, I asked him for an autographed photograph to inspire my young son. He sent his standard NASA portrait in a space suit, but also included a print of his earthrise photo signed: "Dear Tony, I hope you can see this someday," with a cover note, "Here's a photograph I took on my last vacation." The image suddenly took on additional power for me as the shared experience of a fellow adventurer.

Years later, I began putting together an environmental slide show in which I wanted to show an image of Tony's earthrise print while reading the most powerful description I could find of that new vision of our planet. I recalled a perfect quote often used by my famous Berkeley neighbor, David Brower, who had jump-started the global ecology movement in 1960 by creating the Sierra Club "Exhibit Format Series"—the first "coffee-table" books of beautifully reproduced environmental photographs and words. Pleased to oblige, Brower wrote down from memory the final words of Adlai Stevenson's last speech as ambassador to the United Nations:

"We travel together, passengers on a little spaceship, dependent upon its vulnerable reserves of air and soil, all committed for our safety to its security and place, preserved from annihilation only by the care, the work, and I will say, the love we give our fragile craft. We cannot maintain it half fortunate and half miserable, half confident, half despairing, half slave to the ancient enemies of mankind and half free in a liberation of resources undreamed of until this day. No craft, no crew, can travel safely with such vast contradictions. On their resolution depends the security of us all."

As I asked Brower more about it, the neat chronology I had envisioned for my slide lecture came

apart. Stevenson gave his speech in July 1965; Anders made the photograph that was said to have changed our worldview in December 1968. Further research revealed that certain visionaries had anticipated the power of Anders' photograph long before he made it. As early as 1948, British author Fred Hoyle had written in *The Nature of the Universe*: "Once a photograph of the Earth, taken from outside is available, we shall, in an emotional sense, acquire another dimension . . . a new idea as powerful as any in history will be let loose."

Adlai Stevenson had used his imagination to create the most eloquent and concise message about global ecology ever spoken—an image for humanity that did not yet exist in a single photograph witnessed by a human being. He had seen only black-and-white composite photographs of the Earth assembled from images made by remote, unmanned cameras, plus other partial images from low orbit made in the early sixties after the first space flights of Yuri Gagarin and John Glenn.

To further complicate the matter, a young man named Stewart Brand took one hundred micrograms of LSD in San Francisco a few months after Stevenson's speech and wondered why the United States had spent billions sending unmanned hardware into space that sent back photographs of the moon, but none looking the other way at Earth. Brand began a campaign with the slogan, "Why haven't we seen an image of the Whole Earth yet?" Buttons and posters were sent to NASA, members of Congress, and VIPs like Buckminster Fuller, who wrote back to say that it would be impossible to see more than half of the face of the Earth at any one time.

After Lunar Orbiter 5, an unmanned 1967 mission, produced an image of a nearly full Earth, Fuller pleaded with Brand never to disclose his letter. Instead, Brand coerced Fuller into adopting the Whole Earth concept for his public lectures, while Brand himself published the first Whole Earth catalog—just before Anders' photograph was made—with a composite black-and-white on the cover. The counterculture instantly embraced the "Whole Earth" paradigm, but the public had yet to be convinced by an unmanipulated photograph made by a human being.

Thus the world was as primed for the appearance of Anders' eyewitness photo as for the much earlier revelation by Copernicus that the Earth was not the center of the universe. Why Anders' photo continues to receive critical acclaim long after tighter NASA shots are more frequently published is explained in the proceedings of a most unusual 1987 conference of scientists and Buddhists discussing the nature of the mind.

As a number of eminent cognitive scientists were discussing how Western minds verify what they appear to see, the Dalai Lama of Tibet mentioned a level of perception that Buddhists call "extremely hidden phenomena." He gave this example: "I know the Earth to be a round bluish globe, although I have never seen it and have not done any conclusive reasoning about it." The assembled group of neuroscientists, experimental psychologists, and artificial intelligence experts were most curious as to how Buddhists validate their perceptions and if they accept the existence of external phenomena apart from concepts already in place in their minds. The Dalai Lama continued to explain, "I know the Earth is round by relying on the words of someone who has seen it and proven it with photographs. First you must prove that the person is reliable by various reasonings, that there is no reason he should tell lies with false photos. . . .

After this, you understand that the earth is round, although you haven't seen it. This is called inference based upon belief. . . . you have to rely on a person who has already had this kind of experience and has no reason to tell lies."

The Dalai Lama reaffirms what astronaut Rusty Schweickart said after seeing Earth from space a few months after Anders did: "You are the sensing element for humanity . . . and that becomes a rather special responsibility." All nature photographers share that special responsibility to humanity to bring back images of the truths they witness, or to disclose how they altered images in pursuit of less-enduring agendas that could betray that assumption of truth. In the final analysis, our belief in Anders' earthrise image—and all other meaningful photographs of the natural world—implies a sacred trust between photographer and audience that, like an endangered species, is highly threatened but very much alive.

Learning to See

"Lastingly successful art triggers audience responses that are ready to happen in the culture as a whole. Regardless of how perfectly a photographer's work renders a subject, it is bound to fail unless it strikes that chord that elicits a common emotional and visual response."

By far the hardest part of photography is learning how to see. Contrary to popular opinion, we humans are not born with the ability to recognize objects in front of our eyes. Babies slowly and selectively evolve pattern recognitions only after myriad memories of sensory experience are stored. These visual memories quite literally enable us to "make sense" of a world that we have come to believe we directly observe. Without stored memories we are unable to "see" a perceptual world, although we may indeed "look" at it with a thousand-yard stare.

What does this have to do with taking pictures? Plenty. The visual clutter that ruins most nature photographs is usually not perceived until the image is processed and judged apart from the "real" experience. Those who weren't there at the time, a category that includes 99.44 percent of all editors and photo buyers, have even more trouble perceiving the image, because they don't hold sensory memories of the scene to help decode the photographer's intentions.

Frogs that starve to death with dead flies in front of them are an extreme case of the selective seeing that is an inescapable evolutionary heritage of the human visual system. A frog's vision is hardwired to detect moving flies. Its visual system lacks the ability to store and recall the kind of conceptual memories that would identify dead flies as food. Despite our human ability to exceed such limited perception, we are bound by similar, vestigial limitations of our ability to perceive what is right in front of the lenses of both our eyes and our cameras.

Any human who isn't visually defective learns effortlessly to tell his mother from a mannequin or a rock from a tree. However, this type of basic perception is much too crude to empower a person to visually judge, in advance, the essential nature of what makes a fine photograph. The same brain link-up that enables us to perceive a broader world than a frog does sets up a catch-22 for our photographs to have the same meaning for others who were not there.

Scientific evidence strongly suggests that all memories—whether visual or not—are associative. In other words, we never remember anything by itself (for example, the single image in an isolated photograph). Because vision is so dominant in the way that we perceive the world, we tend to ignore the powerful associative connections that code mental imagery in our minds. Certain scents and sounds, however, are so associative that we can't re-experience them without having images from the past cascade to the front of our consciousness. Our visual experience of photographs depends on very similar, but less conscious, links with past experience. When we look at an exhibit print or a picture in a magazine, the nature of the physical object before our eyes—the chemistry of a real photograph or the colored inks on a page—recedes in the face of visual memories that subconsciously download to help create a realistic mental image from the graphic pattern before us.

Neither frogs nor dogs nor hogs nor hawks can share in the absent vision of something else that we see in patterns on the seemingly unrelated physical objects that we call photographs. Our sophisticated

visual system goes so far as to trigger an emotional response toward a loved one by looking at a 2-by-3-inch piece of paper in a wallet. This happens because in our minds we are producing the same sort of imagery of a real person from the past that we would download if that person were right there before our eyes. Other stored sensory associations also surface as we view the image.

This is why photography holds such power for humans and why technically perfect photographs that do not evoke strong memories seem boring to us. Simple and conceptually well-executed photographs are seen by most people in such a similar way that there is very little difference of opinion about them. Editors generally favor using carefully selected simplistic images to illustrate far more complex subjects. Robert Capa's slightly out-of-focus D-Day photograph of a swimming soldier is on many lists of the ten greatest photos of the century, not because of its technical excellence, but because it serves as a master key to open the door into a vast storehouse of imagery and emotion about a great event of the century. While its content remains the same, each individual re-creates a different visual symphony about it.

The average person is a capable judge of a finished photograph on a gallery wall, yet if put in the field at the same place at the same time with a camera, that person would have only a slim chance of "seeing" the same scene as the one in the gallery—much less producing a similar photograph. Many would-be photographers, reacting to their stored mental imagery, come away from the gallery with the feeling that they have seen and taken virtually the "same" great picture, even though they have experienced something quite different and made a less effective photograph.

I've almost never had a truly accomplished photographer say, "I've got a shot just like that." What evokes a comment like that is raw associative memory dominating visual perception without emphasis on the conceptual thought that makes for meaningful photography. An unconscious mental process says, "been there/shot that/here it is." Seeing an image by someone else of a place that the viewer associates with his own photographs evokes real memories.

I state this in strong terms because over the years I've received hundreds of unsolicited photographs from photographers who inform me that they've got a shot just like mine. Virtually 100 percent of the time their composition is compromised by distracting subject matter, such as tree limbs seemingly from outer space, neon dead grass in the foreground, or burned-out highlights rudely cropped at the edge of the frame, that draws my eye once and for all out of the picture.

An intriguing method for creating awareness of how much normal perception is oversimplified has been used to jump-start advanced art students into an understanding of fine art photography. A telltale exercise asks them to walk around, discover a photograph they would like to make, and draw a sketch of their vision before taking out their cameras. Invariably, the sketches these students create are clean, simple, bold, pleasing, and easily comprehensible compared to the cluttered photographs that later result from their failure to comprehend the unconscious inferences their brains have made in interpreting and simplifying the scene. They learn that the images they hold in their minds—both from direct observation and their imagination—need translation to come across in photographs.

In summary, the elements that make a great photograph go far beyond the absence of technical flaws and the use of pleasing compositional devices. Most images made at photo workshops are somewhat like musical scales—exercises of tones and interpretation that prepare the would-be artist for future performances. Images with universal appeal always relate to a common thread in our collective worldview that pops into our minds as we view them.

You can't force photography to be something it isn't. Lastingly successful art triggers audience responses that are ready to happen in the culture as a whole. Regardless of how perfectly a photographer's work renders a subject, it is bound to fail unless it strikes that chord that elicits a common emotional and visual response. We photographers need to constantly remind ourselves that we can't escape human nature.

The Photographer as a Blind Monkey

"It is this very assumption—that seeing is a singular truth—that gets us into trouble. We learn lots of ways to adjust our cameras without giving much attention to how to adjust the way we see."

At the end of a one-day seminar for hundreds of photographers, a few participants invited me out for a beer. As we sat down, several people thanked me profusely for the visionary philosophy I had expressed, while one fellow seemed clearly unenthusiastic. Had I offended him? Perhaps he was an engineer who took personally my comment that members of his profession are more likely to make technically perfect but uninspired photographs because they've been taught to present facts without emotion. When I tried to bring him out by asking about his photography, his answers were lackluster.

After a couple of beers, he let it out: "All that visionary crap about Einstein and Van Gogh won't do us any good. You take your kind of pictures; we take ours. You see the world differently because you always have. You gave us a few technical tips, but that visionary stuff went right over my head. I'm going to go out and shoot the same kind of pictures I've always shot."

Later that evening, I lay awake in my Holiday Inn room wondering if this doubter or any of the other participants would really improve the way they saw the world through the lens after passively ingesting my seminar.

My wife, Barbara, voiced the same kind of doubt about a future book project that I am still working on. By both natural gift and osmosis, she has become a visionary photographer in her own right, but she questions whether the cognitive science information I have been researching will have much relevance for the average photographer.

That future title, *The Visionary Wilderness*, will explore the same cognitive chasm between what the eye and the camera see in more depth than this one does. At first I shared Barbara's doubts that mere knowledge about the differences between how we create imagery in our minds and on film could empower photographers, especially because our perception is so seemingly automatic. But I kept coming back to the fact that it is this very assumption—that seeing is a singular truth—that gets us into trouble. We learn lots of ways to adjust our cameras without giving much attention to how to adjust the way we see. Visionary seeing goes a big step beyond simply sensing and unconsciously accepting what is before our eyes.

Before I dozed off, I thought of a provocative statement that really would have raised the neck hairs of the doubter at my seminar: I've heard about a blind monkey who would make a better photographer than a similarly blind human who remains in denial about a truly visionary aspect of sight. I'd have to add that I'm not talking about just any blind monkey here, nor would I be saying that blind monkeys take better photographs than your average engineer. My comparison is more specific between one blind monkey and those few human beings who suffer from the same rare kind of cortical blindness. Their eyes are functional, but because of a brain defect they have no awareness of what is happening in a large part of their visual field.

To further a Cambridge study begun in the sixties by neurophysiologist Lawrence Weiskrantz, a rhesus monkey named Helen had her entire striate cortex surgically removed. Weiskrantz was studying a fascinating syndrome called "blindsight," in which certain humans who have no conscious awareness of

"seeing" objects before their eyes have unexplained sensory awareness of them, as if by ESP. Some human subjects, when coerced to reach for something unseen, unconsciously extend their hands in the proper direction and open them the proper amount to grasp differing "unseen" objects, such as pens or cantaloupes. Even after hundreds of successful trials, these subjects insist nothing was "there" for them to see.

The point here is that humans with blindsight remain consistently passive about their ability to sense objects they cannot consciously see in parts of their visual field (just as those photographers who cannot "see" pictures are consistently passive about imagining how their results on film compare to what they saw before their eyes). Blindsight does not make a human unable to act, but most of those afflicted with it choose not to make unreasonable gestures toward unseen things not validated by conscious awareness. Monkeys have fewer inhibitions because they are less self-conscious.

We might expect Helen to have lived out her days huddling in fear in a tiny cage, maimed in the interest of science, but she performed far better than her more comfortable blindsighted human counterparts. Nicholas Humphrey, a graduate student of Weiskrantz' in the sixties, describes how he "worked with her for seven years . . . coaxed her and encouraged her . . . played with her and took her for walks in the fields near the laboratory. I tried in every way to persuade her she was not blind. . . . Eventually she could move deftly through a room full of obstacles and pick up tiny currants from the floor. She could even reach out and catch a passing fly. Her 3-D spatial vision and her ability to discriminate between objects that differed in size or brightness became almost perfect. . . . When she was running around a room she generally seemed as confident as any normal monkey. But the least upset and she would go to pieces: an unexpected noise or even the presence of an unfamiliar person in the room was enough to reduce her to a state of blind confusion. It was as though, even after all those years, she was still uncertain of her own capacity—and could only see provided she did not try too hard to see."

For Humphrey, Helen was a link in a life-long study he chronicled in his 1992 book, *A History of the Mind: Evolution and the Birth of Consciousness*. He speculates that one reason why no human has ever approached Helen's ability to function with blindsight is that humans are so self-consciously aware that they don't want to appear foolish by reaching out for things they can't see or by trying to move quickly among them. As Humphrey quips, "Foolishness is probably not an emotion that monkeys feel." Anyone who has been to the zoo knows monkeys act out in all sorts of ways that human beings would never think of doing in public.

Monkeys easily learn tricks because they act more on impulse than on consciously recalled procedures. Thus the tale of a blind monkey and a blind man, both receiving visual information without conscious awareness, is a parable for the difference between photographers who act on impulse to emotionally express scenes on film and those who never progress beyond trying to replicate what they believe is before their eyes. Great photographs normally combine a degree of unexplainable "bottom-up" visual intuition with a firm base of "top-down" direct symbolism of what is indeed there to be seen.

Common wisdom has it that only human beings are capable of symbolism, language, and making sense of patterns on flat paper representing something else, as in photographs and paintings. It is hardly

coincidence that two of the only apes known to have created representational drawings, Moja the chimpanzee and Koko the gorilla, were trained in sign language and thus had an organized form of symbolism wired into their minds at an early age. Koko, in fact, went on to stunning success as a photographer with a self-portrait that became a *National Geographic* cover.

I chuckle imagining what that doubter in my seminar might have said to me had I brought up Koko's success: "The photograph really isn't that good. It's just like affirmative action: They chose it 'cause a monkey did it. If it was me that took it, they never would have used it."

Paintings made by a child, a chimpanzee, and two art students were presented to subjects in an art psychology experiment in the sixties. No information about the artists was given. Chimpanzee paintings were clearly preferred over those done by the adult artists. However funny this seems, it indicates that chimpanzees are capable of producing primal art that evokes a common response in human experience. Human art begins to fail when it pursues not this central emotional response, but the barren polar opposites of a pure mental exercise or a found object with minimal interpretation, as in most outdoor photography that gives us the feeling, "That doesn't do anything for me."

As Helen the monkey benefitted from exploring an intuitive world she could not see, so do photographers who seek results beyond what they can directly observe. The bottom line is that consistently creative photography requires learning to bridge the chasm between an engineer's technical mastery and a blind monkey's unselfconscious intuition.

Cameras and the Man

"The basic nature of a photograph remains unchanged from the day of its invention. If computerized cameras really could deliver photographs of what we see with such precision, wouldn't their instruction manuals use such enlightened imagery instead of hand-drawn sketches to show us how to use them?"

The great playwright George Bernard Shaw tried very hard to become a respected photographer. Yet this creative genius failed to make more than a few ripples in the domain he so desperately sought to influence, until *Bernard Shaw on Photography* was published in 1989.

The foreword calls him "as good a photographer as he was a motorist, and considerably less dangerous." A feisty and contrary egotist with an opinion on everything, Shaw believed that photographs should replicate the world exactly as we see it and that a photographer could accomplish this goal by choice. By sheer force of fame and obsession, his predictably mediocre results were exhibited, published, and placed into permanent collections.

As I thumbed the pages of *Bernard Shaw on Photography* in a bookstore, his images took the first step toward success by creating an emotional response in me: I thought about the paper on which they were printed and how much better off it had been as part of a forest. Minutes later, however, I bought the book. My change of heart came when I realized its value as a document of the futility of trying to make photographs exactly resemble reality. Others who have pursued photography to this extreme simply have not had their fruitless efforts published.

Shaw said a "photographer is like the cod, which produces a million eggs in order that one may reach maturity." With this attitude it is hardly surprising that he grew frustrated by his own lack of results. He began lavishing praise on the work of his personal heroes, especially that of Frederick Evans, who had a dramatic method for preserving the integrity of nature photography. Shaw described with delight "how if the negative does not give him what he saw when he set up the camera, he smashes it."

At a major gallery opening in London in 1900, Evans told the Royal Photographic Society: "Realism in the sense of true atmosphere, a feeling of space, truth of lighting, solidity and perfection of perspective in the eye's habit of seeing it, has been my ambitious aim; and to say that I have not achieved it, but only hinted at it, would be praise enough, considering the really great difficulties in the way of a full achievement."

It would be easy to criticize both Shaw and Evans for failing to follow their own proclaimed ethic. Evans publicly hyped the pursuit of a perfect reality, yet privately told his peers that he never achieved it. Shaw could be pegged as either a loud-mouthed huckster or someone so visually challenged that he failed to notice the lack of realism that Evans acknowledged. Before passing hasty judgment, however, consider that all the efforts of camera designers during the intervening century have yet to solve the problems Evans noted. Contemporary photography still fails to replicate what Evans called "the eye's habit of seeing," yet the public continues to believe that an image on a flat sheet of film directly copies reality unless the photographer has manipulated it to deceive us.

A more likely interpretation that may exonerate both Shaw and Evans comes from the cognitive sciences. The quirks that may have honestly led Shaw and Evans astray are still with us today because they

34

are part of the biology rather than the technology of photography. Despite recent ads for a camera with a computer that "analyzes every subtlety of motion, light and distance . . . instantaneously to record precisely what you see," the basic nature of a photograph remains unchanged from the day of its invention. If computerized cameras really could deliver photographs of what we see with such precision, wouldn't their instruction manuals use such enlightened imagery instead of hand-drawn sketches to show us how to use them? The fact remains that we are biologically incapable of interpreting a photograph in the same way that we see the real world. In many situations, simple drawings are less ambiguous and paradoxical. Sir Richard Gregory, knighted for his life's work on perception, has said, "Pictures are such artificial visual inputs that the surprising thing is . . . that we make anything of them at all."

Each of us builds a different visual construct in our brain as we view the same photograph. Our brains, unlike computers, thrive on incomplete information to shape the cognitive maps by which we interpret the world. Many cognitive scientists now believe that memory and consciousness originally evolved as tools to make the visual system perform better. The basis of intelligence is the ability to interpret sensory perceptions, past and present. Because photographs have been around for less than a hundredth of one percent of human evolution, it is hardly surprising that our visual system has not adapted to accurately perceive the altered and diminished information recorded in a photograph.

The unconscious inferences we make about the contents of a photograph are based on a myriad of stored assumptions in our minds. To make sense of an image, we subconsciously match "bottom-up" information that begins directly with the lines, colors, and forms before our eyes with "top-down" information stored in our brains.

When we watch an artist draw a pencil sketch, we experience a moment of recognition when the addition of a particular line makes the hidden likeness of a face pop out at us, no matter how incomplete the sketch may be. For the artist, that likeness was present in the very first mark. A similar thing happens when two people view a landscape photograph. If one person has been to the actual place, his brain interprets the photograph with more top-down information. If the other has never been to the location, he builds up a less accurate mental image based solely on the visual information in the photograph and without top-down information from the actual scene. Thus our first view of a place we have seen only in photos is often somewhat jarring until we reorient our visual inferences. "The pictures don't do it justice" is a common cliche among world travelers, even if those images have been made by some of the world's best photographers. This is to be expected when a real scene doesn't match the imaginary scene we have shaped in our mind.

When George Bernard Shaw looked at Frederick Evans' photographs, he built up unquestioned constructs of reality based on his trust in his friend's work. When he looked at his own results with a carefully honed ability for self-criticism, he came to the unmistakable conclusion that his photographs missed the mark. Evans, on the other hand, achieved a better balance between pursuit of an honest impression of reality and pursuit of his own personal vision. Remember that it was Shaw, not Evans, who unequivocally stated that Evans destroyed negatives that weren't perfect representations. Evans more likely destroyed only those that were obvious failures and did his best to make fine prints from the rest.

The real question is what Evans had that Shaw lacked. The thought process of photography is neither obvious nor wholly intuitive. Over and over again, many of the best and the brightest minds of each generation have floundered in the simple act of taking a meaningful photograph. There's a reason why advertising agencies continue to pay high day rates to those people who know how to operate these over-the-counter devices that are promoted to do everything for us. It's all in our heads, but not in *all* of our heads.

The Size of the Rat

"The phrase was coined by working-class British climbers to account for why some of them became so much more successful than others. The public believes that climbers who scale remote mountains, like published photographers, must have greater innate talent and skill than their less successful companions."

What does it take to become a successful outdoor photographer? Talent and technical knowledge are the answers we hear again and again, but rarely from those who have actually made it on their own. Most of us are at a loss for words. That's why we take pictures. When journalists ask what it takes to do our job, they write down their own best guess as we either sit there speechless or mumble on at great length about things that seem to have little to do with photography.

Freelancers who shoot for *National Geographic* got together and described their work as: "creator, researcher, field producer, logistics expert, diplomat, equipment bearer, image maker, and field editor." These aren't exactly what the winner of last month's "Best Scenic" award at the local camera club would list in response to a question about what it took to get that great shot.

I have yet to observe a correlation between superior talent or knowledge about photography and being a pro. Lots of people with precisely these attributes fail as working pros, while others with skills not so finely honed make the grade. I've watched a number of people go the full distance from humble photographs that showed little promise to satisfying careers in outdoor photography. After two decades of giving seminars for groups of enthusiastic amateurs as well as for members of prestigious professional photographic societies, I would go so far as to say that I haven't observed a substantive difference in talent or knowledge between committed individuals on either side of the divide. But there *are* differences.

Photography does not conform to the pattern of "normal" professions that require years of academic training followed by certification. We expect a doctor or an attorney to have been taught much more about medicine or law than the rest of us, including specialized procedural knowledge that laymen rarely seek. There isn't much common ground between careers based on years of training to deal with other people's problems in a professional way and those based upon personal creative output. Those who have the psychological breadth to succeed at both are rare enough to have their backgrounds conspicuously singled out by the media.

I'm always amused to read about my own lesser, but instant ascension from the lowly doorway of a small automotive shop onto the cover of *National Geographic*. The process actually took at least seven years. Once my background became widely published, I began to receive hundreds of letters from well-meaning doctors, lawyers, scientists, and engineers asking for advice on how to change careers so they can do what I do, or something very similar. I've given my answer—that no such blueprint exists—so many times that I've begun to wonder if the very act of asking for one could have a higher correlation to not having what it takes than lack of photographic talent or knowledge.

When I have had a chance to sit down casually and compare beginnings with other top outdoor pros, they usually describe discovering an inner path broadly similar to my own, rather than following a course of study and apprenticeship. The pattern is consistent even for those who switched over from highly structured careers.

The initial act of visualizing a meaningful photograph has more in common with meditation than with professional skill. Strong personal vision is what *National Geographic* photographers and camera club winners have in common. The deliberate physical actions necessary to transform a previsualized image onto film to achieve success are apart from this critical inner path and quite straightforward to learn.

One of the few areas of agreement among all the diverse disciplines of meditation is the belief that a person who sets out with the goal of becoming a spiritual leader by achieving the technical skills needed to gain personal enlightenment is inevitably led down the opposite path by self-delusion. The best photographers know better than to try to lead others all the way down their inner path, because the act of following someone else's, instead of discovering your own, will eventually be self-defeating. They also know that staying on the chosen path of your personal vision, once you have found it, is the key to doing photography for a living, day after day, year after year.

Photographers, like other mortals, are judged by their great potential only if they die young. Otherwise, we are judged only by what we have already accomplished. Unless we have a portfolio of published work or great work in an agency's files, it's hard to gain entrance to the marketplace. To aspiring photographers, this need to have already been published before you can get hired to be published or even sell your existing work is the ultimate catch-22. Yet newcomers are always breaking through. How do they do it?

Now I've asked the same question I first posed in a different way after describing one trait—commitment to the inner path—that the best outdoor pros seem to share. Without an energy source for empowerment, the most perfect inner path is as useless as a Ferrari out of gas. You can talk and dream about its future all you want, but it's not going anywhere until you fuel it and start moving.

An equally important trait is the size of the rat. The phrase was coined by working-class British climbers to account for why some of them became so much more successful than others. The public believes that climbers who scale remote mountains, like published photographers, must have greater innate talent and skill than their less successful companions, but this is not the case. The rat refers to the voracious creature gnawing at a person's stomach from the inside that drives him or her to repeatedly leave the comforts and security of civilized life to challenge him or herself in the natural world. Without a big rat, a person stays at home with the family and is content to be a shopkeeper.

This same factor was eloquently described in another way by the British Antarctic explorer Apsley Cherry-Gerrard in the last paragraph of his book about Captain Robert Falcon Scott's tragic 1910 expedition to the South Pole, *The Worst Journey in the World*. After a long overland trip in the dead of winter in total darkness and −70°F temperatures to visit an emperor penguin colony, he wrote: "The desire . . . for its own sake is the one which really counts Some will tell you that you are mad, and nearly all will say, 'What is the use?' for we are a nation of shopkeepers, and no shopkeeper will look at a research which does not promise him a financial return within a year. And so you will sledge nearly alone, but those with whom you sledge will not be shopkeepers: this is worth a great deal. If you march your Winter Journeys you will have your reward, so long as all you want is a penguin's egg."

Top photography of the natural world, like that penguin's egg, is the result of unique personal commitment. A surprising number of mountaineers and adventurers from countries all over the world have evolved into professional photographers. Their big rats and proven ability to follow an inner-directed path predisposes them toward what psychoanalyst Rollo May has called "the courage to create." Since this courage is a quality that exists quite apart from physical prowess or personal vision, it is hardly surprising that the world of professional outdoor photography favors so many unlikely successes from so many previous walks of life, while closing the gates on some promising souls who appear to be brimming over with talent and photographic knowledge.

Decoding the Creative Process

"One of the greatest satisfactions of nature photography as a career is having public perception of the meaning of your art coincide with your own images of your most important life experiences."

What makes a successful photographer? How much is nature, and how much is nurture? Do visionary images reveal hidden talent that only some of us possess? Or are they simply the result of practice and passion, and thus within the capabilities of any normal person?

It is human nature to attribute your successes to your unique abilities, yet view your failures as caused by others. We tend to direct our life's efforts in line with our perceived "talents," where things come relatively easily for us, and avoid spending much time on things that don't come out so well. True masters of a subject pay at least as much attention to what goes wrong for them.

Some of the mystery surrounding the creative process has begun to recede of late. The common wisdom that every Nobel laureate must be a genius has shifted toward a vision of a highly creative person possessing a reasonably normal, but finely tuned mind. The tuning appears to have far more to do with passionate life experience than extraordinary genetics. Most everyone knows at least one apparent genius who hasn't made meaningful accomplishments, and one professed photographer who knows everything about cameras, but can't take meaningful pictures.

After my friend Reinhold Messner made the first ascent of Mount Everest without supplementary oxygen and became the first to climb all the world's 8000-meter peaks, the media singled him out as some sort of genetic superman. He continues to have trouble convincing people otherwise. In lectures, he now uses a slide of himself that shows him looking like a pin cushion with scientific probes all over his head and body. After performing grueling batteries of tests, the retreating physiologists said he was disappointingly normal.

If Messner has an unusual natural gift, it's his ability to focus on a goal. He stretches the limits of the possible by reassembling visualizations of what he already knows he can do into bold new configurations.

I once heard a National Public Radio interviewer refer to the enormous talent of a preteen dance virtuoso that begged to be expressed to the world. The young girl shot back a harsh retort. She said she was sick and tired of people talking about her luck to have been born with such talent, while in reality she was devoting the majority of her waking hours to practice. She was very aware of missing out on much of the fun that normal kids have, but willing to do it because she knew in her bones that what made the difference was hard work. Whenever she slacked off her regimen, her performances suffered.

When I don't take pictures for a while, my percentage of keepers in my first rolls goes down until I get the feel of it again. Early in my career, I saw this as a personal failing. Then I attended a *National Geographic* photographer's seminar and learned that such performance swings are universal. Editors and photographers alike acknowledged that early rolls shot on assignment by people not recently in the field were usually inferior. Unfamiliarity with the location could not account for these fluctuations, because work in new places in the midst of an assignment looked much better.

Visionary photography is not a basic skill, like riding a bicycle, that comes back instantly without practice. The simplicity of riding down the street can't be equated to the complexity of photographing for

Time or *National Geographic*. An average photographer would be happy as a pig in mud to get back one of those "inferior" rolls of film shot by a seasoned pro on the first day of a long assignment. Similarly, my confidence about hopping on a bike any time would more than falter if I tried to follow a world-class mountain biker down a steep obstacle course.

To capture a fleeting moment when light and landscape and the living things upon it come together into a perceived whole, and instantly translate that reality into the visual "foreign language" of film, is at least as hard as not falling off a bicycle pushed near its limits. If your reactions are late, it's all over. As Lucretius recognized long ago, "When something has changed, it will never again be what it was before."

Most of my favorite photographs capture fleeting juxtapositions that will never exactly repeat themselves. Of course there are exceptions, and these "timeless landscapes" that stay static before the lens for relatively long periods tend to become the stylistic hallmarks of nature photographers who work slowly. Those who make a full-time living out of creating only static, evenly lit landscapes are as seldom seen as lone wolves or mountain lions.

Successful nature photographs visually excite the buyers who select them for publication or for the walls of homes and offices. So it is with the primary, wild experience. When I've spent time with some of the very best outdoor pros, I've never come away feeling that they are driven by the lure of money or prestige. What matters most is capturing a significant witnessed moment in a way that its essence is communicated to others. Knowing that something wondrous happened before our eyes and that we responded to it successfully seems far more important to us than having a collection of images to sell (though of course we treasure their ability to make us a living as well as for what they represent to us).

The difference between basic collectors of objects, whether the objects be slides or fossils, and creative artists or scientists for whom these same objects become part of a visionary worldview, is essential to understanding the heart of the creative process. One of the greatest satisfactions of nature photography as a career is having public perception of the meaning of your art coincide with your own images of your most important life experiences.

It is no coincidence that the most creative people in both the arts and the sciences have followed a comparable three-step process of understanding that links together their internal and external worlds. Creativity researchers have noticed an unusually high number of obsessive childhood collectors among those who later perform at high levels. This first step of making assemblages of stamps, flowers, rocks, or beer cans often bears no relation to the eventual creative endeavor. Like a scrapbook of random snapshots, it represents unstructured visual curiosity.

Serious collectors take the second step of organizing their assemblage beyond mere numbers. Plants, animals, and minerals fall into well-defined categories that are the result of centuries of such organization. Photographs of many things a person happens to like often defy clear organization, so slide shows by collectors of images who have not yet mastered stage two are likely to have the same effect on audiences as Valium.

High-level creativity begins at stage three, when a person intimately familiar with the known organizational relationships in stage two uses his mind's eye to visualize a previously unseen pattern in the sciences or the arts. Fine photography blends aspects of both science and art to produce an image first crafted by the human mind.

Despite any genetic predisposition, true innovators in fields as diverse as modern art, particle physics, and wildlife photography have all worked their way through these three stages. Breaking down the

structure of creative efforts into three evolving stages makes us realize that any normal person is easily capable of becoming a collector or organizer. Ansel Adams' good friend and fellow nature photographer, Cedric Wright, poetically described this process half a century ago as a "saturation of awareness" that grows out of "a quality of emotional knowing."

We produce our best pictures when we feel them oozing out of every pore of our bodies. Time seems to stand still and the world is more beautiful than we have ever seen it. Somebody else photographing a few feet away is usually having quite a different experience and taking a very different picture. And that difference is less in their genes than in their mind's eye: Each time we create a new sense of order out of chaos as we visualize a fresh image of the natural world, we intuitively rely on a lifetime storehouse of memories and associations. Each successful new photograph we add to our collection adds a measure of meaning to our life.

The Power of Participatory Photography

"Without a guiding visualization, two camera positions only a step apart might as well be on different planets. The odds of winning the state lottery are better than those of randomly walking up to the optimum position for a photograph."

While sailing the Galápagos Islands with a group of photographers, my wife, Barbara, thought up a parlor game to help us get to know one another. First, she asked us to write answers to a few questions. Then we split into teams of men versus women for a contest. As answers from the opposite sex were read aloud, the teams tried to match them with the right person.

One intriguing question asked your wildest wish if you were certain it would be granted, and if you could back out at will with no consequences. Answers were split almost evenly between known realities and imaginary visions. Although none of our wishes was specific to the Galápagos, they were unquestionably influenced by our wild surroundings where every day we visited new islands in a primeval chain that teemed with wildlife as unafraid of humans as they were in Darwin's time.

Our answers were quite different than they would have been if the same question had been posed over a power lunch on Wall Street. In the wilds of the Galápagos, where a young Darwin's imagination led him to one of the most tremendous insights in history, none of us visualized typical American dreams of becoming a billionaire or a movie star. While surrounded by the natural world, experiences meant more to us than money or power.

Our ship's naturalist wanted to experience death and come back to life again. The women wrongly guessed that I was the man who wanted to climb a high mountain and ski down into the arms of a beautiful woman at sunset. Instead, I asked to see the world for a day through my dog's brain—a wish that brought laughter, even though it was no joke. How my golden retriever perceived things so intrigued me that I had opened a chapter of *Mountain Light* with an anecdote about his disinterest in my life's work. Khumbu loved water, but showed no response whatsoever to an exhibit print of a landscape with a pond that would have made him quiver with excitement in reality. Photographs failed to represent reality for him. Yet whenever we took him up in our small plane, he would announce his recognition of ponds and streams with quivers and tail wags so long as we flew low enough. Because all wild smells and sounds are absent in the plane, Khumbu's identification of water must have been wholly visual. When the plane climbed above a few hundred feet, Khumbu stopped responding and curled up on the floor.

Through my veil of human perception, Khumbu alternated between acting very smart or very dumb. His trail memory out in the wilds was often so uncanny as to seem photographic. I especially remember his behavior running an intricate ten-mile trail loop. Although he had only been on it twice by two different variations a year before going the opposite direction, he confidently ran past every trail junction except for two, where he stopped at crossings of our previous routes to await my decision.

With or without a map, a human would be hard-pressed to remember such a route after a similar time gap, especially if someone else had led the way. Yet in human surroundings, Khumbu's navigational skills were often inadequate. The same dog with the photographic trail brain repeatedly tried to pull his favorite toy through the rungs of a chair in our living room.

41

All he had to do was walk around to the other side. After we led him around the chair repeatedly until he performed the steps like a trick, he repeated his dumb-dog act a week later when the chair was in a different spot with the toy just as visible from the back.

Khumbu's actions parallel the way many people approach photography. Our human ability for conceptual thought is greater than Khumbu's only if we choose to use it. Of key importance to the creative process are imagined rotations of scenes before our eyes and in our mind's eye. I've often watched a photographer pull up to a scenic viewpoint, get thousands of dollars' worth of camera gear out of the trunk, walk straight ahead toward a chosen subject, and snap a picture without imagining other options. Almost invariably, the foreground of the photograph isn't composed to merge with the background. The lure of the main subject, like that of Khumbu's toy, has triggered "mindless" line-of-sight action.

In these situations, both dog and human act oblivious to potentials that require visualizing something not yet perceived—the unseen angle of the other side of the chair or the unseen point of view that could turn a mediocre landscape photograph into a great one. Without a guiding visualization, two camera positions only a step apart might as well be on different planets. The odds of winning the state lottery are better than those of randomly walking up to the optimum position for a photograph.

During scores of field workshops, I've had the chance to observe how photographers shoot, followed soon afterwards by how their photographs appear in group projection sessions. I have yet to witness a person casually walk up and produce a great photo-graph of the natural world. Whenever I have watched a person producing what later turned out be a truly

inspired image, they appeared to be deep into their own world.

The workings of this creative process became very apparent in a situation where a group missed seeing a once-in-a-lifetime event that I captured in a photo-graph. In hindsight several members believed they saw it. On my first visit to Tibet in 1981 I spotted a rainbow in a field, looked around, and visualized it coming out of the roofs of the Dalai Lama's Potala Palace. With me were fifteen other members of a trekking group. We had just been called to dinner.

When I shared my idea for a photo and asked if anyone wanted to join me and run across the fields to line the rainbow up with the palace, no one else came. They didn't see what I envisioned from past experi-ence with outdoor optical phenomena. After running to where a different rainbow (refracted from a differ-ent set of water droplets) matched my imagined image, I made one of the great photos of my life.

The next year, I described in a book how "I set off into the fields while the group went to dinner" and made a photo in which "the rainbow rose magically from the golden rooftops of this summit of Buddhism as if some power in the palace were its source." To my surprise, several members of the trip felt slighted. They assured me that they had also seen the rainbow over the Potala, and sent photos to prove it. Their images showed their own personal rainbows with the palace in the shadows far off in the distance to the side of the arc, as we had first seen it. While many of the group had indeed delayed going to dinner, they had not perceived the creative potential of the situation or photographed it, although they certainly believed they had shared in my vision *after* they saw my results.

Jacob Bronowski describes a similar sequence as a familiar pattern in the history of scientific creativity:

"The mind is roving in a highly charged active way and is looking for connections, for unseen likenesses. . . . It is the highly inquiring mind which at that moment seizes the chance. . . . The world is full of people who are always claiming that they really made the discovery, only they missed it."

The key catalyst for all forms of creativity is to visualize oneself as an active participant rather than a passive observer. The jargon may sound modern, but the same idea is in an Old Testament proverb that warns, "Where there is no vision, the people perish." Today, people without vision live longer, but not necessarily happier, lives.

Our education system favors those who passively swallow presented material and regurgitate it on demand. Those who ask questions and seek answers are likely to fall off the fast track. When a passively educated person picks up a camera, he naturally expects it to respond to the same set of rules he lives by. Creativity doesn't work that way. At the most basic level, neither civilization nor photography is able to progress through passivity.

Grand Illusions

"Only by consciously switching gears back to my intuitive emotional response can I begin to visualize the illusory power an image could have in the 'foreign language' of film."

No photograph truly succeeds unless it triggers strong emotion. To make this happen, the audience's attention must focus on the photographer's intended subject. And yet that subject isn't really there. All photographs are illusions. You're not actually looking at riders beneath a giant sand dune on pages 12–13. Like this page, it's only paper and ink.

One of the more famous visual illusions shown in psychology books (page 45) appears to be either a vase or a pair of faces in profile. A person not familiar with the illusion sees only one aspect at first. When the other aspect is seen, the first one disappears. Though it becomes ever easier to go back and forth between the two apparent realities, no amount of familiarity will allow both subjects to be seen at the same time.

Neuroscientists have proven that the different aspects are processed by different regions of the brain. The vase and the faces are created in our imagination, based on the limited information on the paper in front of us matched to stored memories of similar real objects. As with all perceptions, we see only what we are prepared to see. If we had been looking at a still-life photograph of a vase, we would be far more likely to see a vase first. If we had been thumbing through a book of portraits, we might be more likely to see the faces first.

A photograph that conveys the beauty of a vase should be composed so the viewer will not imagine faces, and thus lose the emotional power of the shape of the vase. However, if the intention of a photograph is a sense of mystery, the more illusions, the better.

The same holds true for all visual arts. Illusions are created in the mind of each human as the result of viewing an object of art first imagined in the mind of another human being. Some may love what they see in a particular photograph, while others loathe the same image because it elicits negative perceptions from their life experience. Still others may withhold emotional involvement and say, "That doesn't do anything for me!"

All of these responses relate to the unconscious assumption we make that a photograph represents more than a straight depiction of the world. Photographs that we find most meaningful are those that ooze human endeavor and symbolize the meaning of our world and our lives. Images that hold the most power for us tend to focus on loved ones, leaders, tragedy, or beauty.

This illusory emotional content depends on us not interrupting the process to question a photograph's technical quality or validity. When our attention is drawn to technical aspects, we disconnect from emotional content as surely as we stop seeing the vase just as we see the faces. As we begin to see a nature photograph as unsharp or manipulated, our brains shift gears. Loss of emotional power is also related to the viewer's life experience and the context in which the photograph is presented. Imagine the difference in your emotional response to the same image appearing in *National Geographic* or in *The National Enquirer* captioned "Bigfoot in the wilds of British Columbia."

Photographers see images differently than everyone else because we tend to view all photographs with a more technical eye that reduces our emotional connection. More of our experiences have been devoted to looking critically at photographs.

This suggests why books and magazines with images chosen by editorial committees evoke a flatter emotional response than ones where selections are made by a single, involved eye. Images that pass muster through a group of viewers with differing emotional and technical perceptions are either so astounding that they hold universal appeal, or so banal that they offend no one.

We cannot escape seeing illusions because perception is not a democratic process. Rather than comparing alternative percepts, we jump to unconscious conclusions based on autocratic assumptions imbedded in our minds. Even after illusions are explained to us, our understanding doesn't erase them. Were it otherwise, we would be unable to enjoy photographs. The more we understood them, the less illusory reality they would hold.

The illusion that a wild animal inhabits an image before our eyes is not destroyed by knowing that the photograph is an illusion, or briefly noting that it is slightly off-color or unsharp. That understanding allows creative photographers to keep from getting stuck on the technical side of viewing or making images by consciously tuning in to the emotional and illusory potential. When I'm in the field and something stirs within me, I'm aware of the need to assess the technical side before pushing the shutter release, but if I simply take a photograph at this stage, it is rarely inspired. Only by consciously switching gears back to my intuitive emotional response can I begin to visualize the illusory power an image could have in the "foreign language" of film.

Where a photo opportunity allows me the luxury of time, I begin by asking myself what drew me to want to take a photograph in the first place. Almost always, the answers are a lesser part of the scene before my eyes. When I stood before a great sand dune on the ancient Silk Road in western China in 1980, I was unaware of the central fovea of my eyes darting back and forth between a sand dune and a meadow. Yet I clearly sensed my emotional attraction to these subjects and realized that they would lose context and scale in a photograph that included extraneous subject matter. I decided to focus tightly on the dune with only a narrow strip of meadow to hint at its contrasting presence. Even a moderate amount of meadow in the foreground would have taken on added importance in two dimensions and overwhelmed the giant dune.

About 50 percent of the time, a first concept such as this produces my best photograph. When conditions allow, I patiently shoot many more concepts of a subject that has potential. Though the majority of these later compositions do not work as well, one of them often turns out to be far more evocative. So it was when I waited to see if two riders in the distance would come close enough to the dune to give it scale.

Many people who saw this photograph in a 1981 *National Geographic* told me that at first glance it created a whole different scene in their minds. It seemed to be a snowfield or a small bluff of sand until spotting the tiny riders created a jump in their perception. Only then did they feel an emotional response to a new and different illusion.

The lesson of multiple illusions is that emotional content is not inherent in a photograph. Like Narcissus, each of us imparts the illusory power of our own being onto the inanimate surface before our eyes.

The Art of Fixing A Shadow

"The 'art of fixing a shadow' is exactly what an-cient eyes evolved to do. Only after creatures gained the ability to sense a moving illumina-tion edge between light and dark passing over them did vision begin to evolve toward sensing reflectance edges of still objects."

We may never know what William Henry Fox Talbot was really thinking in 1839 when he announced his invention of photography as "the art of fixing a shadow." The poetic meaning of those words has come to obscure the inability of photography to render a shadow properly except in highly selective lighting situations. Talbot must have sensed that if he could make a shadow look right, other light values would automatically fall into place. He never succeeded. Nor has anyone else.

One hundred sixty years later, nature photogra-phers still cater to this basic failure of our medium when we seek out cloudy, bright skies with no shadows for our most accurate renderings of flowers, trees, and animals. Most of us don't give a second thought to why this is so. We simply obey little rules that we learned or discovered for ourselves and often avoid trying to make certain kinds of photographs in normal daylight. We learn that photography within a forest in direct light will result in hideous shadow-ing, yet in broad, open landscapes, shadows can become wonderful compositional elements.

Shadows present such visual surprises in our photographs because our eyes never see them the same way at the real scene. Something more than the narrow exposure latitude of film is at work here. Our perception attempts to give us the enduring nature of an object, even if it is half in shadow, but a shadow in a photograph takes on a genuine, solid appearance

similar to the edge of a real object. A shadow across a silhouetted person can appear to cut the figure in half. A shadow across the sharp boundary between two colors can render a clearly painted sign unreadable in a properly exposed photograph. What is happening is that a photograph, by its nature, fails to give us the visual input necessary to distinguish between a reflectance edge and an illumination edge.

A reflectance edge involves a difference in the quantity or quality of light that bounces off an object, regardless of the illumination. We perceive the real world mainly through these reflectance edges that show us everything from the changing colors in a peacock to whether our white car needs to be washed. An illumination edge is caused by a difference in the quantity of light *before* it reaches an object. An illumi-nation edge is commonly known as a shadow.

In a classic medical case history, a middle-aged blind man who, after an operation, gained the ability to see for the first time, found himself unable to dis-tinguish reflectance edges from illumination edges. Shadows of ladders and posts stopped him on the street as if they were solid objects. Perceptual scientists theorize that discrimination between reflectance and illumination edges may not take place in the eye, but rather in the central nervous system, where genetics and experience, beginning in infancy, come together to deliver functional, unconscious inference.

We learn quite a bit more about why shadows look so different in real life than in photographs when we consider our perception of a white object. In real-life situations we can almost always ascertain the relative lightness of an object in shadow. White paper looks white, never black. A black rock stays black, whether in sunlight or shadow. In photographs, how-ever, white objects often appear dark gray or black.

The cover of my book, *Mountain Light*, shows a jet-black split rock in shadow that appeared white to my eyes. I previsualized that the granite would go black on film. Snow in shadow looks normal to our eyes, but on film it can appear blue, gray, or sometimes even black. If we render it true white, our photograph will look burned out.

The strange appearance of a shadow in a photograph is not a failure of our visual system. Our perception is doing exactly what it is supposed to do. It has evolved over millions of years to recognize the most constant visual properties of what we are seeing. A piece of paper in the real world appears white, no matter if it is in sunlight or shadow. A photograph of a piece of paper, however, has the stable, constant nature of the color in the photograph rather than the color of the original object. Our perception is telling us that we are indeed looking at something that is not white. The only way to have the paper in the photograph appear white is to make it white or close to white in the photograph. The bottom line is that photographs convert all illumination edges into reflectance edges.

If we want white blossoms in shadow to appear white, we have to make them white or very light gray by overexposure or use of supplementary fill lighting. What we are doing here is not making the shadows look right, but "murdering the messenger" by getting rid of all or part of them. These solutions help, but they never quite deliver the quality of shadows that we directly perceive. If we open up an exposure in the shadows to lighten an object the way we see it, objects in the highlights become drastically overexposed. If we use a film that has extremely wide latitude to see into the shadows, we end up with a curiously flat appearance. If we use fill-flash, only certain things at certain distances will be rendered with the proper reflectivity and perceived lightness.

Photography's inability to render the stable nature of an object in shadows is similar to the operation of crude visual systems in primitive creatures. The "art of fixing a shadow" is exactly what ancient eyes evolved to do. Only after creatures gained the ability to sense a moving illumination edge between light and dark passing over them did vision begin to evolve toward sensing reflectance edges of still objects. Recognition of something in widely varying environmental conditions by means of separate reflectance and illumination edges is a relatively recent degree of visual sophistication.

Thus when a compelling landscape photograph with impenetrably black shadows evokes a sense of mystery, it is entirely possible that we are responding to more than bold graphics. Primal emotions buried in our central nervous systems might be triggered, as happens when the shadow of a big bird or a low-flying plane comes over us from behind and causes a burst of adrenaline to shoot through our body before we have time to think.

When we "like" black-and-white or color photographs with powerful shadows, we may be reacting to a sensory echo of our collective past. We are triggered to stop and look, or to quit turning pages in that magazine, or to buy that print on that gallery wall. And if photography ever does succeed in the art of fixing a shadow, the resulting images could end up being more accurate, but less visually compelling.

The Doors Of Perception

"Most conventionally educated cognitive scientists can't properly explain why we can see correct flesh tones under a broad range of lighting conditions, yet are unable to correct them in the same way when we look at photographs."

Galen would have had some big problems as a color photographer. His outdated ideas about color are incompatible with modern cameras and film. For more than a thousand years the second-century physician for whom I was named was considered one of the trio of master Greek scholars who brought about scientific enlightenment. Then he was toppled from his pedestal when his theories about how the human body worked were disproved by Renaissance scientists. History dealt more kindly with the two remaining scholars; Aristotle and Ptolemy still hold their ground long after blows from a legion of heavyweights, including Copernicus, Galileo, and Einstein, knocked many of their favorite theories down for the count. We humans are much more tolerant of bad information about the Earth and the sky than about the workings of our own bodies.

Galen believed that vision and color were produced by rays powered by body heat that came out of a magical fluid in the eye. He claimed to have confirmed this notion by direct observation as chief doctor to the gladiators. He sounded so convincing that were he alive today, he would probably be on daytime television.

It would be fun to see how Galen might respond to using a Polaroid camera that delivers a color image even when his eyes are closed as he pushes the shutter. Would the result pique his scientific curiosity? Or would he modify his theory to explain how that camera was just like the eye after all, and continue to blithely take photographs that he thought were images of what he saw?

Photographic history has followed the latter course, which explains why we are stuck with devices that have modern bells and whistles but hide antiquated functions based on nineteenth-century ideas about color and vision.

As with the rest of us, poor Galen's initial thrill with photography would give way to disappointment that his pictures bore too little resemblance to the colors he believed he had seen in the real world. He would eventually become conditioned to throwing out 90 percent of his photographs to keep only the ones that looked right. After a while, his keepers would begin to appear so convincingly real, even though they were not quite what he had seen, that instead of questioning the basic truth of the photographic process, he would question his own ability as a photographer.

Most photographers behave in a similar way. They scratch their heads when their photos don't resemble what they think they saw, but congratulate themselves on the few that "come out" and try to find the same types of situations to shoot again. When they discover a "personal style" by default, they stick within its confines more out of fear of failure with other subject matter than out of choice.

Failure to pleasingly render colors in natural light is one of the greatest stumbling blocks to a career in outdoor photography. That color is a property of light itself, rather than of objects or the mind, is an idea that took the world by storm in the seventeenth century. A twenty-three-year-old whiz kid named Isaac Newton—the guy who brought us gravity and calculus during the same year when he was hiding out from

the plague—proved to most everyone's satisfaction but his own that light and color had a fixed relationship wholly separate from the human body. He did this by simply focusing the colored light that came out of one prism into another. It came out white again.

Newton's cautious statement that the concept of color should properly be applied to perception and not to light itself was not taken seriously enough by later researchers. When the race was on at the turn of the century to invent a practical color film, trial emulsions were solidly based on the part of Newton's theory that separated white light into specific colors by wavelength. Early films didn't work nearly as well as expected. The best results came from a sleight of hand beginning with black-and-white emulsions and adding color later in the process. Colors could be assigned to particular wavelengths of light only so long as lighting conditions were rigidly standardized, which is almost never the case in outdoor photography.

Today, good color is almost a given in controlled studio situations, but when a whole outdoor shoot rather than just the rare successful image is analyzed, perfectly colored photographs are rare exceptions rather than the rule. Modern science textbooks continue to explain color vision by Newton's three-color theory, with some fine tuning by later scientists such as Young and Helmholtz. We are taught that the cones of our retinas respond to the color of objects, while the rods that work in low light see only black and white. Only a few texts mention in passing an alternative theory advanced by another young genius who also made major discoveries in his twenties.

Edwin Land's retinex theory of color vision has remained out of mainstream thought both because it challenges basic assumptions about color and because

it never directly resulted in a marketable product, as did his inventions of the polarizing filter and the first instant film. Retinex is a contraction of retina plus cortex. Ansel Adams, a close friend of Land's, found the theory of "immense importance." It not only answered some of his questions about reflectance, but firmed his resolve to stick to black and white and drop further experiments with color except for some demonstration Polaroids for his friend's company.

Newtonian color theory simply falls on its face in outdoor situations. Most conventionally educated cognitive scientists can't properly explain why we can see correct flesh tones under a broad range of lighting conditions, yet are unable to correct them in the same way when we look at photographs. When I've posed the question in interviews and letters, the top experts either don't answer or attribute it to our visual color correction for the wavelength of the dominant light source. This explanation fails to account for why our vision will adjust to see the proper color of a face under the strong amber bias of tungsten light, but won't adjust to see that face's same color in a photograph made on daylight film, no matter what light source is used to view it.

Land's radical answer is that our eyes don't respond to color at all. Quite literally, color is a figment of our imagination. Gordon Rattray Taylor, chief science advisor for the BBC, states in his book, *The Natural History of the Mind,* that because of Land, classic color theory "lies in ruins." Back in the fifties, Taylor watched Land project two special black-and-white negatives through two different yellow light sources to form a scene that displayed a full range of colors.

In another experiment that I have replicated for advanced workshops, two black-and-white slides

projected on top of one another take on a full range of colors when only a red filter is added to one side. Take away the other black-and-white, shot with different filtration to have different gray values, and the screen shifts to the expected shades of red. Land conclusively demonstrated in several other ways that the eye senses only black and white and that our experience of color is entirely a construct of our minds that varies tremendously.

Although texts continue to say that the cones in our eyes see color, while the rods see only black and white, Land has turned the tables to make subjects sense color strictly with their rods in extremely low light. He has also demonstrated how almost all common colors can be made to appear from information delivered by a triplet of cones that are not responsive to individual "colors." In a process somewhat like merging black-and-white negatives made with different filters, the three types of cones deliver colorless responses to broad, overlapping bands of wavelengths, together with all-important lightness information about reflectivity derived by comparison of the triplet of responses. The color is in our heads. This explains why I often wake up in a dark room shortly before dawn and can't tell if the sky is clear enough to go out and take sunrise photos. Even though the sky is bright enough to trigger my cones instead of my rods, it looks gray through the window so long as I have no reference to reflective lightness information. The color is not "there" on its own. I am unable to tell if the sky is blue or gray until I step outside or to the window.

The triplet comparison system gives our vision a reality detector that served us well in the days before photography. Our color and lightness sensations are fine tuned to ascertain the stable properties of objects rather than the wavelength of light reflected from them, but our film is designed for a lockstep color response that does not fairly represent the real world. We can't see that proper flesh tone in a photograph made on daylight film at sunset because our retinex reality detector is telling us the truth: We're seeing orange hues on paper rather than a real face.

For this same reason, a landscape photographed at sunset looks more vivid on film than it does to the eye. The difference is usually less striking than when the same daylight film is used with a similar orange wavelength of artificial light to photograph a face. This is partly due to the way our visual system more easily adjusts to known subjects seen in person, but also to the fact that when we are outdoors we take a portion of our lightness cues from objects in the shadows that reflect parts of the sky that we perceive as blue. Thus we really do "see" more of the red in the sky at sunset than red in a face indoors, but in both cases we see far less than our daylight film will record.

What all this means is that outdoor photographers who shoot color film can't consistently make good photographs by trusting their eyes alone. Proper knowledge of color vision won't solve the technical problems, but it can help guide a person to be in the right place at the right time to record great natural events in the different visual language of film. After spending years trying to learn how to read the subtle clues of color perception, I may, like my namesake, have some ideas that are later proved to be wrong, but I have two distinct advantages. The first is my ability to directly judge the effectiveness of my mental experiments by my photographic results. The second is living after Edwin Land.

Eye of the Beholder

"Language reinforces the idea that color is a real phenomenon, and it would be incredibly awkward for me to always refer to 'the stimulus that evoked the sensation of red in my visual system' instead of 'seeing red.'"

A number of photographers told me that I'd finally gone off the deep end after reading the preceding essay, "The Doors of Perception." They remain unconvinced that color is created in their minds. Some take special issue with my statement that color is a figment of our imagination, a description that paraphrases the results of experiments done by the late, great Edwin Land. A few have even said they could care less if color is only in the mind so long as they can see it in their pictures and others see it, too.

I care because I'm convinced that knowing more about the biological mechanism of color perception has made me a better color photographer and that sharing my knowledge helps others. Not so many years ago, if I had read a brief story about color existing only in the mind, I might not have believed it either. Depending on my trust in the publication or the writer, I would have passed it over or checked out other sources.

Edwin Land was far too cautious a scientist to use the word "imagination." I've used it for shock value, to challenge the dominant visual paradigm of our time. Most of us believe that we initially see an accurate representation of the world with our eyes, and only then begin to consciously interpret that image with our brain. Current research indicates that the images we first see are already highly interpretive. Mental assumptions beyond our control explain why we can't undo a true optical illusion even after we're told about it. They also explain why we are able to

51

relate to the illusory content of a photograph without getting stuck on the fact that we're really looking at a piece of film or paper. Of equal importance to the creative photographer is the fact that a photograph can never exactly replicate the already interpretive image "right there before our eyes" that we assume represents an objective reality.

As I've explained in the preceding essay, color isn't really "out there" as a fixed property of light or objects. We create it "in here," in our minds, by highly interpretive processes involving selective light-and-dark luminance information. Since photographs do not deliver all the visual constructs we observe in the real world, we interpret their color quite differently. To further complicate things, color photography is based on the disproven Newtonian concept of fixed color response to specific wavelengths of light. Land has shown that we can see the same set of wavelengths of reflected light as red, green, or yellow depending on surrounding visual constructs of shadows and reflectance, which cannot be replicated separately in a photograph. Illumination edges, or shadows, are converted into reflectance edges in photographs. In the real world, illumination edges allow us to ascertain whites and blacks in shadows, where wholly reflective photography fails. This helps explain my long-standing question of why I automatically adjust a flesh tone I see in person to be reasonably accurate in almost any light, but cannot do so with an altered flesh tone in a photograph, regardless of the light source used for viewing.

Before I used the word "imagination," I carefully checked its meaning and chuckled to myself that it seemed almost too perfect. My *New Lexicon Webster's Dictionary* defines it as "the power to form mental images . . . not wholly perceived by the senses." Even my old college *Dictionary of Modern English Usage* from the sixties separates the meanings of "imaginary" and "imaginative" as quite distinct and never interchangeable. The former can mean unreal, but the latter refers to the ability to form mental pictures.

In a September 1992 special issue of *Scientific American* devoted to mind and brain, Semir Zeki shed some light, so to speak, on the mental nature of color imagery. He related that a lesion in area V4 of the visual cortex causes achromatopsia and described how "this syndrome is different from simple color blindness: not only do such patients fail to see or know the world in color, they cannot even recall colors from a time before the lesion formed." Here is a clue, strongly supported by other research, that we use much of the same imaging system to create images of scenes before our eyes as we do to visualize with our imagination—fittingly called our mind's eye.

When the preceding essay first appeared in *Outdoor Photographer*, suggesting that color is a figment of our imagination, I was counting on visual support from an accompanying photograph, but it was inadvertently reproduced with a radical color shift to correct perceived objectionable flesh tones set against a pleasing landscape in evening light (page 207). Catch-22. I had chosen the image to illustrate how the same altered recording of warmer colors that we enjoy and search out for landscape photographs looks inescapably awful in the way film renders a face. After color correction, the face looked passable, but the crimson glow in my original took on the hue of a faded orange peel.

Wait a minute! Haven't I just contradicted my premise? I just referred to "a crimson glow" as if it were really out there for each of us to see. Language

reinforces the idea that color is a real phenomenon, and it would be incredibly awkward for me to always refer to "the stimulus that evoked the sensation of red in my visual system" instead of "seeing red." Perhaps a future generation will redefine colors in a more scientifically accurate way; the process has already begun.

The 1941 dictionary my father gave me gives the first meaning of color as: "A quality of visible phenomena, distinct from form and from light and shade." *Webster's New Lexicon* now gives the first meaning as: "A sensation experienced usually as a result of light of varying wavelengths reaching the eye." We have good reason to think that color is related to the wavelengths of light that enter our eyes, and to some degree it is, but the relationship is quite subjective. Color film, on the other hand, is designed with a direct relationship between wavelengths of light and the color response of dyes that are triggered in the resulting image. That is why photographs can never reproduce the colors that we think we saw at a real scene. We may be able to get one or two hues to match, but the overall palette will never look the same. Our color vision has evolved not to give us a direct readout of particular wavelengths of light, but to give us consistent information about the enduring, stable nature of objects in the world in which we live. Colors stay relatively the same in extremely varying types of light because there was a distinct survival value in our ancestors being able to identify objects in the shortest time possible, rather than in a critically precise way.

The photograph of the Merced River that appears on page 1 shows the fixed-wavelength response of my film producing distinctly blue snow on foreground rocks set against crimson twilight mist. I understood that my film would record this, even though I did not see the colors this way at the scene. The mist had a rich, warm glow, but the snow on the foreground rocks looked white. I knew that if I could find snow that was aimed to reflect the blue sky away from the setting sun, it would be rendered rich blue on film. I found inclined boulders in the river that were perfectly positioned to do that.

Many of my favorite landscape photographs feature similar junctures of warm and cool colors that I do not clearly see at the scene with my eyes. In my mind's eye, I know they will be there on my film. Whoops! There I go again! Those colors are in my head, not on my film. It's time for new definitions.

Visual Reality

"It took me more than a decade to understand that it's often what I'm not seeing through the lens that's most important. Today's young photographers can use knowledge from the cognitive sciences to shortcut my learning process."

Despite all of the advances in photo technology, the human factor still reigns supreme. More than 99 percent of the world's cameras are capable of taking publishable pictures, yet most of the world's photographs aren't of publishable quality. At least half of the problem is due to basic human error, the kind of "little" mistakes that cause pilots to crash jumbo jets and photographers to shoot unrepeatable moments without film in their cameras.

I learned the hard way that I have to work around these little mistakes to make my workshop critique sessions come off smoothly. I can't count on any group of enthusiastic photographers to correctly load their slides into a tray by themselves. I begin by giving and repeating clear instructions to select ten slides for projection, to orient them as they should appear on the screen, to initial the upper right of each mount, and to stack them on a table with the first slide at the bottom. If my staff loads the trays without checking each slide, it becomes apparent during the projection session that a few people have put their slides last one first or sporadically sideways or flopped. That I find a strong correlation between those who make these "little mistakes" and those whose otherwise artful pictures are most often ruined by "little problems" should come as no surprise.

But lack of attention to detail fails to explain why a 1999 camera in the hands of a meticulous Ph.D. who studies the instruction manual won't produce as many publishable images as a 1939 camera in the hands of a person with a refined "photographic eye."

Top photographers learn to "see" pictures by trial and error after years of field experience. Certain situations work while others fail to "come out." One's quantity of experience seems somehow related to the quality and consistency of one's ability to produce meaningful, artistic images. Before autofocus, top photojournalists peaked in their late thirties or forties, just as their ability to focus on the ground glass was starting to wane. Despite countless child prodigies in music, chess, skating, and ballet, there have been few in photography. The early work of talented young photographers remains conspicuously absent from top selections of images with enduring meaning.

It took me more than a decade to understand that it's often what I'm *not* seeing through the lens that's most important. Today's young photographers can use knowledge from the cognitive sciences to shortcut my learning process and thus elevate their photographs to greater visual power than what they see directly through the lens. But there's a catch: The process can't be directly illustrated in photographs, which show us what we *don't* see. Nor can it be fully described in words.

At the heart of the problem of seeing photographs before they're made are *constancy* phenomena. Our visual system unconsciously infers and corrects "little mistakes" in scenes before our eyes that might otherwise confuse our drastically simplified conscious perception of the world. Thus, we don't directly observe all of what we are about to photograph. Nor is our vision truly accurate in any sense of the word. The image in our brain is altered and idealized to help us make clear, fast decisions.

Taking photographs with hopes of looking at them as representations of the world we see clashes

with the way our visual system has evolved to edit out distractions from the subjects of our attention. Constancy phenomena delete information on changing perspective and light, which are the very things most essential to fine-tuning great photographs. Yet in photographs, changing perspective and light render colors, shadows, contrasts, shapes, foregrounds, and relative sizes without the constancy corrections we think we see "in reality."

This isn't all bad news. If our visual systems responded to every difference they are capable of detecting, we would go through life terribly confused. As with a computer search using an overly precise keyword, our brains would fail to consistently find and compare images held in memory that allow us to identify familiar people or objects before our eyes.

But photographs record much of this unwanted information. They can ruin our best intentions by producing confusing visual clutter and dreadful lighting that the photographer simply didn't see.

An obvious question arises. Why doesn't the same eye-brain system also simplify photographs by constancy phenomena? The answer is that photographs fail to record the broad range of visual cues that trigger constancy. In fact, our visual system does a great job of unconsciously responding to the essential nature of the object before us, recognizing that we are seeing a magazine page, rather than the absent forms that we consciously think we're seeing on that page, such as the Grand Canyon at sunset or the president stepping off an airplane. Understanding these processes gives clues as to how and when a photograph can show us an apparent heightened reality, often a more complete visual truth than what was actually seen before the lens.

My own attempts to describe some of the physiology behind the act and art of seeing in articles generated boxes of critical letters. Some readers especially took me to task for saying that color isn't a real property of the world "out there," but rather something created in our mind's eye. One published review accused me of "New Age hype." Hadn't I heard about Sir Isaac Newton proving that color was a property of light by splitting the colors of a white ray with one prism and bringing them back into white again with a reversed prism?

Newton himself had grave doubts about his need to assume a constant relationship between color and wavelength. He mused that he had no way of explaining how "light produceth in our minds the *phantasms* of colors." Experts now regard color perception as a biologically introduced mechanism for helping us identify the essential nature of objects in *changing* illumination. We see leaves as green in any color of natural light, yet our color films, designed by folks taught to take Newton literally, absolutely lock color to wavelength.

When I received letters asking for clear, simple sources to read about all this, I pointed readers toward cognitive psychologist Sir Richard Gregory's many books that describe visual constancy, as well as scientific papers on the retinex theory of color vision discovered by Edwin Land, the inventor of the polarizing filter and instant film. I've also cited the bestseller by Nobel laureate Francis Crick, *The Astonishing Hypothesis*. None of these make for easy bedtime reading.

One of the best popularly written insights into the creation of color in the mind, and how perceptual constancies affect our vision, is so readable that it appeared as a Book-of-the-Month Club selection. *An Anthropologist on Mars* (Knopf: New York) by Oliver Sacks chronicles seven case histories of neurological

patients with strange perceptual disabilities, including an accomplished painter who totally lost his color vision due to a head injury. The consequences of his injury proved much more serious than congenital red/green color blindness.

When Mr. I. lost his color vision, his perceptual world changed in unpredicted ways. Instead of clearly seeing nature in black and white like an Ansel Adams print, his disturbed ability to unconsciously compare luminance and reflective values caused him to see dirty, off-color whites and disturbingly harsh contrasts. His visual system so seriously confused shadows with real objects that he swerved to avoid shadows when he tried to drive his car. He learned to seek out soft, low light where he didn't make mistakes in perception because of his lack of visual constancy information.

The world of reduced visual constancies Sacks describes is hauntingly close to that photographed by someone who has not learned "to see" pictures. Similarly, our pictures "come out" by accident, resembling what we think we saw, only in fortuitous situations where the need for visual constancy adaptations of the image in our brain is largely cancelled out by even lighting, shooting parallel to the horizon, or ideal subject orientation.

Sacks brings Crick into the investigation, describes Land's work in layman's terms, and consults Gregory on a later perceptual case. Thus, great minds come together to assess abnormal perceptual worlds that help us understand why our seemingly normal one doesn't photograph that way.

The Art and Science of Photography

"Great photographers always know, either intuitively or scientifically, many subtle nuances of how humans perceive visual information. Photographers who lack this knowledge go through life virtually shooting blind."

As you've doubtless figured out by now, I'm a believer in the ability of cognitive science to jump-start photographic creativity. Great photographers always know, either intuitively or scientifically, many subtle nuances of how humans perceive visual information. Photographers who lack this knowledge go through life virtually shooting blind. By not knowing how to anticipate emotionally compelling compositions, they at best end up with a handful of good images from accidents they are unable to explain or repeat.

Though I'm often asked to recommend a single book that ties together photography and the cognitive sciences, I have yet to find just one. Many touch on the important differences between the way we perceive the real world and photographs. My search for answers now fills a wall of the new library we had to add to our house. Some are "sleepers" with improbable titles, such as *Clouds in a Glass of Beer* or *The Embodied Mind*. Others are thick and academic. Before reading the capsule reviews of some favorites, let me caution you that some of these titles may not be in print or easily found. In that case, consult a good library or internet book source.

Arnheim, Rudolph. *Art and Visual Perception: A Psychology of the Creative Eye*. Berkeley and Los Angeles: University of California Press, 1954.

This classic asserts that all discussion of creating or experiencing art is essentially psychological. While one of the best early works that links art and percep-

tion in a broad-based way, it conspicuously lacks mention of more recent discoveries about the neural correlates of the visual process. It remains a great place to start.

Lynch, David K. and William Livingston. *Color and Light in Nature*. Cambridge: Cambridge University Press, 1995.

A superb compendium of outdoor optical phenomena with revealing photographs and diagrams. Emphasis is on explaining all the varieties of light effects we see in nature, without direct descriptions of how to photograph them. The camera is mentioned as an "observing tool," not a creative instrument. Nevertheless, the plethora of information on shadows, halos, glories, rainbows, sun dogs, twilight, northern lights, green flashes, polarization, and the night sky is more than enough to keep a nature photographer's creative juices flowing for decades.

Williamson, Samuel J. and Herman Z. Cummins. *Light and Color in Nature and Art*. New York: John Wiley and Sons, 1983.

Though similar in title to the above, this in-depth textbook is less user-friendly. Phenomena are explained in great detail with math, formulas, and graphs. Forty pages on still photography, optics, and films are nicely positioned before sections on the visual system, pigments, dyes, paints, holography, and color broadcasting.

Cronly-Dillon, John R. and Richard L. Gregory, eds. *Evolution of the Eye and Visual System (Vision and Visual Dysfunction Series, Volume 2)*. Boca Raton: CRC Press, 1991.

This advanced, esoteric work is a collection of scientific papers that traces the evolution of the

vertebrate eye from photosensitive algae through sea snails to humans. It provides a deep understanding of how eyes have evolved to match the physical constraints of biological systems and the nature of light. Darwin wondered how something so complex that could not function without many fine parts in harmony could have evolved through natural selection, but this book displays the almost infinite stages in the process, beginning with photoreceptors in the skin that gradually recessed into depressions to increase shadow contrast—nature's own lens hoods.

Varela, Francisco J., Evan Thompson, and Eleanor Rosch. *The Embodied Mind: Cognitive Science and Human Experience*. Cambridge: M.I.T. Press, 1991.

These eminent cognitive scientists challenge the traditional view that our minds simply represent what is out there before our eyes. They convincingly argue that the embodiment of information in our minds cannot be separated from human experience. Color vision is presented as an example of the concept that what we see is really an emergent pattern of neuronal activity. Color does not exist in the physical world as a property of light or surface reflectance, but is embodied experientially within us as an emergent qualia. We have no way of knowing if others see "our" blue; all we can know is our own mental reality. Differences between what we directly observe and what we see in photographs become far more understandable as the authors link perception to tenets of Buddhist thought and modern science.

Frisby, John P. *Seeing: Illusion, Brain and Mind*. Oxford: Oxford University Press, 1979.

The author set out to explain illusions, but realized that he could not do so without educating his audience about the operation of the basic neural machinery of the visual system. His precise explanations allow photographers to gain a deep understanding of how and when certain visual illusions will appear on film. Seeing is "an explicit symbolic description of the scene observed," and illusions happen when visual cues are too sparse to deliver full information about a subject. Photographs radically reduce the number of visual cues present in direct observation, and all photographs are, in fact, illusions.

Bohren, Craig F. *Clouds in a Glass of Beer: Simple Experiments in Atmospheric Physics*. New York: John Wiley and Sons, 1987.

This delightful book by an atmospheric physicist explains dew, frost, rainbows, whiteouts, polarization, clouds, and the significance of nucleation bubbles in a glass of beer—all in laymen's terms. Though photography is not a direct subject, the ability to anticipate changing situations in the natural world can have profound effects on the outcome of photographs.

Boyer, Carl B. *The Rainbow: From Myth to Mathematics*. Princeton: Princeton University Press, 1959.

More than you ever wanted to know about rainbows from ancient myth through modern science, art, and photography. Related sky phenomena are also explained, such as moonbows and solar halos caused by refraction from ice crystals instead of rain drops.

Gardner, Howard. *Art, Mind & Brain: A Cognitive Approach to Creativity*. New York: Basic Books, 1982.

A prolific creativity researcher explores the artistic creativity of masters, children, and normal adults. Teaching, television, and the transmission of knowledge are well covered, but relevance to photography must be induced by comparison. He admits that the comprehensive aspects of artistic production "remain

a complete mystery for the student of neuropsychology." His descriptions of underlying order emerging from mental ideas stumbling all over one another in a chaotic fashion rings true to dedicated photographers seeking artistically pleasing compositions.

Gregory, Richard L. *Eye and Brain: The Psychology of Seeing*. Princeton: Princeton University Press, 1966.

An old classic that remains among the best popular books on how human perception works. Sir Richard, a knighted professor of neuropsychology, gives concise explanations of scientific concepts in simple language. He goes beyond known facts to speculate about the meaning of conscious experience. He hopes for a conceptual breakthrough that "may truly link science and art and tell us what it is to be alive and to perceive with wonder the world around us."

Gregory, Richard L, ed. *The Artful Eye*. Oxford/New York/Tokyo: Oxford University Press, 1995.

Here, at last, is a major work that merges artistic and scientific conceptions of visual perception. It describes all artistic images as attempts "to bridge the gap from mind to mind, via the eye." Many illusions fool us every time, even when we recognize and understand them. The author asks, "Does this mean art is neurologically beyond reason? If so, this is no essential criticism of art."

Since every photograph is an illusion, subsequent chapters should have special meaning for photographers. They begin to explain the power of an artistic substitute for a real object in terms of neural transformations, such as lateral inhibition and orientation detectors. Just a few years ago, the points of view of neurobiologists studying at the cellular level and psychologists studying the behavior of whole beings were compared to two teams digging a tunnel by hand from opposite sides of a huge mountain. The chance that they would ever meet in the middle was considered remote and distant in time. Here we have contact.

For example, scientists wired and isolated thirty cells in the temporal cortex of a rhesus macaque that were found to be responsive in the monkey's identification of a real face, something that scientists know includes an environmental "nurture" factor of experience as well as the innate "nature" factor of inherited brain structure. So far, so good. The surprise came when a line drawing of the same face was substituted. Three cells responded, but when the same line orientations were disorganized into a configuration no longer recognizable as a face, none of those three cells responded.

This research strongly suggests that artistic representations, including photographs, trigger impoverished reactions in some of the same neurons that react to direct experience. The authors speculate that such low responses may trigger a greater amount of top-down processing (from stored mental imagery) to try to perceive what is before the eyes. Thus we see faces in clouds and stumps in a field as wild animals. The authors conclude, "It may well be that one reason humans enjoy art is precisely because it requires this extra interpretive effort. Natural images, with all the rich sources of information which make the perception of object structure unambiguous, are just too easy." Maybe that's why technically perfect large-format color landscapes made on absolutely clear days are usually boring.

Sir Richard Gregory has the final word: "Art thrives on illusions, while science does its best to avoid illusions. . . . The fact that we accept pictures as surrogates of very different realities is the key to visual art. It is not obvious why marks on a cave wall are accepted as animals—they are very different!"

Barlow, Horace, Colin Blakemore, and Miranda Weston-Smith. *Images and Understanding.* Cambridge: Cambridge University Press, 1990.

This collection of broad-ranging essays comes from an international symposium on how we see images. Nobel laureate Francis Crick lays the groundwork in the preface, saying, "We do not see things in the way common sense says we should." He further explains how the work of visual artists often draws our attention to the higher levels of visual processing that are the subject of the essays. Sections cover the essence of images (photograph? Picasso? shadow? reflection?); image creation by artists, other animals, and computers; motion; visual thought; and meaning. A final chapter by an old-school psychologist takes the opposite position from *The Embodied Mind* by calling into question the very existence of mental imagery. I think I can come up with a mental image of the kind of dispassionate nature photograph such a mindset might generate.

Pinker, Steven. *How the Mind Works.* New York/London: W. W. Norton, 1997.

Despite its 660 pages, this is by far the most readable and comprehensive popular book on what modern science knows about the workings of the brain and visual system. Pinker is as great a writer as he is a director of the Center for Cognitive Neuroscience at M.I.T. He is at once bold ("Human evolution is the original revenge of the nerds") and humble ("Every idea in the book may turn out to be wrong, but that would be progress, because our old ideas were too vapid to be wrong.").

According to Pinker, the eye is an instrument of information processing, and "before there was photography, it was adaptive to receive visual images of attractive members of the opposite sex, because those images arose only from light reflecting off fertile bodies." Lest you think Pinker is sexist, he quotes Gloria Steinem saying, "There are really not many jobs that actually require a penis or a vagina, and all the other occupations should be open to everyone."

With similar wit, Pinker tells us, "The camera does not lie; left to its own devices it renders outdoor scenes as milk and indoor scenes as mud." Then, he edges into scientific explanation: "The harmony between how the world *looks* and how the world *is* must be an achievement of our neural wizardry, because black and white don't simply announce themselves on our retina."

After some insight into how our brains make some rather rash assumptions about surfaces being evenly illuminated, Pinker suggests that we should easily be seduced into hallucinating objects that aren't really there. "Could that really happen? It happens every day. We call these hallucinations slide shows and movies."

Solso, Robert L. *Cognition and the Visual Arts.* Cambridge: M.I.T. Press, 1994.

A splendid cognitive-science slant on how we visually experience art, despite conspicuously avoiding any explanation of how we create artistic imagery. Photography is not even mentioned in the index, but the author does espouse a wonderfully broad reverse view of artistic cognition, saying, "We do not 'see' art, we see the mind. . . . When we create or experience art, in a very real sense we have the clearest view of the mind."

Seeing from the Heart

"Creative photographs don't originate in the human organ that pumps blood any more than small, wild canines tell space aliens the meaning of life. Yet we can't deny that the metaphorical heart that we associate with love and compassion must be intrinsically connected to original photographic seeing."

In Antoine de Saint-Exupery's fable, *The Little Prince*, a child of the royal family of a tiny planet visits Earth to seek the meaning of life. He fails to find it with his eyes, so he takes to asking others where to pursue his vision. No one has an answer until a wise fox tells him: "It is only with the heart that one can see rightly. What is essential is invisible to the eye."

So it is for nature photographers. Those who seek a special place where their photography will come alive are always disappointed unless they already know how to see from the heart.

But what does this really mean? Can the process be explained without getting mired in mushy jargon? Creative photographs don't originate in the human organ that pumps blood any more than small, wild canines tell space aliens the meaning of life. Yet we can't deny that the metaphorical heart that we associate with love and compassion must be intrinsically connected to original photographic seeing as well as to all-important secondary appreciation, without which photographs would lack the common meaning needed to communicate.

As viewers of nature photographs, we tend to pass by images that fail to deliver a genuine emotional response. Images that pull on our heartstrings remind us of beauty we've really seen or perhaps surprise us with an "aha" that echoes what the photographer felt discovering something unusual. I have yet to make an image that has sold more than once as an exhibit print without an indelible memory of my heart pounding wildly as the beauty of light and form came together before my eyes.

Unlike the Little Prince, I have not wandered Planet Earth waiting for images filled with meaning to appear before my eyes. Being in the right place at the right time is not chance (as so many novice photographers and art critics assume), but rather the result of following intuitive clues. What critics call style reflects the individuality of each photographer's search from the heart.

All photographers, consciously or not, use the same basic process of previsualization to guide themselves toward events they have yet to witness. If this verges on sounding New Agey, consider that every Stone Age hunter had to previsualize, not only where prey might appear, but where to place himself to make the most of an as-yet-unseen situation. Even a pack of wolves knows better than to just sit down and wait for prey to appear.

The intuitive ability of some people to pick up a camera and make evocative images is related to frequent honing of these ancestral survival skills. The inability of more people to do the same is related to a life history of shutting down their intuitive, emotional side. Before they were old enough to ask the right questions, parents and teachers convinced them not to let their emotions get in the way of doing good work. They expect a camera to be no more than a clever tool designed to reproduce an exact image of what they see, with no more artistry than a pocket computer that always says 12 times 12 is 144. Occasionally, their camera produces a better image than they saw through the viewfinder; these rarities are selected to show family and friends as evidence of

61

their talent (just as gamblers and investors tend to only show off their winnings). Yet situations where the same factors (such as strong light and shadows or heavy emphasis on foreground) "didn't come out" are rejected as some sort of camera problem that more technical knowledge could have solved.

In photo workshops I've noticed some patterns in the types of people who most easily make the leap to seeing intuitively from the heart. It is the wife of that executive with a gigabyte of camera gadgets who wanders off from her husband with a single body and lens to produce the best image of the day. It is the ex-hunter who easily makes the transition from pre-visualizing a close approach to unseen wildlife with a rifle to using those same faculties to be in the right place with a camera.

And then there are the exceptions: men and women who discover, each in his or her own time, what it means to photograph nature from the heart. For some, it lifts off the pages of a book or magazine as if they were there in the field, peering through their own viewfinder. For others, it happens only when they observe someone else—friend, spouse, or instructor—having an "aha" experience with a camera that translates into a far more haunting image than what they thought they saw with their own eyes. For still others, the full process must unfold from written words such as these, to observations of others' successes, to their own realization of the power of heartfelt imagery.

Fittingly, Saint-Exupery never tells us what the Little Prince did with his new vision of the meaning of life when he returned to his little home planet. If he had brought a camera, he would have first confined himself to a familiar room with indirect light to spend hours or days editing the slides of his journey. He would select the visions that best communicated his vision of the meaning of life down on that larger planet, but with odds longer than those of any lottery ticket that no single slide would be a winner.

We locals who live down here on this planet take over fifty billion photographs a year. No single image has yet been made that communicates the meaning of life to others. Like us, the Little Prince would probably need to assemble an extended personal statement with a series of images—as in a slide show or coffee-table book. Only then could he begin to share the richness and diversity of life, invisible to his eyes, that he had experienced from the heart on Planet Earth.

In Search of a Mentor

"Only after I came to know the limits of the possible as expressed by these other visual artists, and had tested them by my own experimentation, was I able to evoke the style of photography that had been inside of me all along."

I used to answer no when asked if I had a mentor. No single person either directly taught me or created photographs that I tried to emulate. My Aunt Marion came the closest. An avid naturalist who made thousands of images of flowers, plants, and trees, she also chronicled remote hikes and foreign travels in slide shows that put me to sleep. None of her photographs filled my heart with awe like Ansel Adams' images of Yosemite in her collection of his signed books.

Aunt Marion did not consider Ansel her mentor, though she had been on long Sierra Club pack trips with him and they both had homes in Carmel. One Christmas she gave me a Yosemite paperback, inscribed to me by Adams, filled with technical information about each photograph. That convinced me that I never wanted to be a photographer. I didn't like the idea of having my love of the natural world compromised by carrying heavy equipment and spending days in a darkroom.

I felt similarly about technical rock climbing. I learned how at one of those Sierra Club camps and did moderate Yosemite climbs at sixteen, but got turned off to ever trying the bigger walls that would burden me with ropes and hardware. Six more years of cameraless peak and crag bagging passed before I, too, pounded hundreds of pitons to ascend the sheer face of Half Dome in 1962.

On that climb, I took one unsatisfactory roll of snapshots with the mind-set of using as little equipment and time as possible. I naively hoped for pictures that recorded what was important to me, like Aunt Marion's, but with the added emotional response of Adams' work. To get that result, I realized I would need to compromise my ideals, as I had done on Half Dome. I wondered if it was possible to combine direct records of my experience with far more elusive visual metaphors of my inner responses while I hiked or climbed in the wilderness.

I began struggling (and still do today) to figure out how to communicate my most powerful visual experiences without diminishing them in advance because of an excess of photographic impedimenta. I was all too familiar with how a heavy pack for a three-week journey or a three-day climb muted the joy of walking through a flowered wilderness. And yet the outcome often seemed worth the price. Accomplishing a big-wall climb or executing a photograph that took tremendous forethought added deep meaning to my life, so long as I didn't take it to excess and lose sight of what fueled my passion for nature. It became ever clearer to me that my best work mirrored my own simple joy and certitude rather than the size of my accomplishment or film format. I reasoned that if the goal of nature photography was to record as much as possible of a scene with the finest resolution, publications would be filled with 360-degree panoramas shot on 24-inch roll film.

Early on, I was intrigued by the work of Henri Cartier-Bresson, who captured "the decisive moment" in common scenes that would never repeat themselves from France to India. Though he carried only a single Leica, often with only a 50mm lens, his black-and-white images held a sense of clarity and immediacy at least equal to that of the large-format work of Ansel Adams.

Back then, black and white reigned supreme in both fine-art and nature photography. I saw color as all too important a part of my perceptual experience to deny, but only a few nature photographers seemed to use color in a natural and creative way. The first color nature photography that really impressed me was in a lavishly reproduced Sierra Club Exhibit Format book by Eliot Porter in which color whispered extra meaning without dulling dramatic appeal.

When I was twenty-four, Aunt Marion gave me a Christmas present of a later, very different book in the Exhibit Format series. It had the same lavish reproduction that had been used for the works of Ansel Adams and Eliot Porter, but *Everest: The West Ridge* featured compelling color images by amateur 35mm photographers of the entire spectrum of experience of a Mount Everest expedition. Native people, natural scenes, camps, climbs, and comrades were all eloquently rendered.

I soon bought a tiny Kodak Instamatic 500 camera with a Schneider lens. This 1965 forerunner of the APS system rendered tack-sharp Kodachrome slides slightly smaller than 35mm. Making a living as a photographer barely crossed my mind as I set about recording what the natural world meant to me, like those members of the Everest expedition. Even they had day jobs.

When the fixed lens and film size compromises of the Kodak became too much for me to bear, I bought a Nikon, published some work, and began to visualize a future as a career photographer. When I saw Ernst Haas' 1971 book, *The Creation*, it firmed up my resolve to become a full-time free-lancer the following year. Like Ansel Adams, Ernst Haas had a musical background that had set him on a course of orchestrating great performances of ordered perceptions on film. Haas, however, had mastered the art of using unfiltered colors to create a sense of visual power in common scenes that often exceeded that in the Everest images I so admired. He, too, used 35mm instead of large-format cameras.

Only after I came to know the limits of the possible as expressed by these other visual artists, and had tested them by my own experimentation, was I able to evoke the style of photography that had been inside of me all along. I could see my way clear toward a career in which making money from commercial assignments was a less important goal than living a life in which the wholeness of knowing and communicating about the earth's wild places reigned supreme. I judged that Ansel Adams' emerging immortal greatness was at least as much due to his breadth as a human being—teacher, technician, innovator, environmentalist—as to his images themselves.

Ever since my 89-year-old mother broke into tears upon opening an issue of the *National Geographic* with my story about the John Muir Trail, I've answered yes, I do have mentors—phantom mentors who made a difference. The 1989 article included a spread of 1924 photographs of my mother's journey along the trail with her late older sister. I had inherited Aunt Marion's photo collection and sent some of her pictures, with a mention in my text, on a whim. My mother looked up and said, "She got you started, Galen, didn't she?"

The two images of Evolution Lake beside the John Muir Trail that appear with this story link seventy-three years of outdoor photography, from hand-tinted monochrome to Fujichrome. I went back yet again in the summer of 1997 because my mentor made me do it. During ten days camped beside the lake, I made one of the most memorable photographs of my life. Her spirit is part of that image on the facing page.

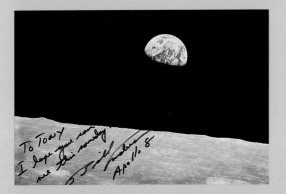

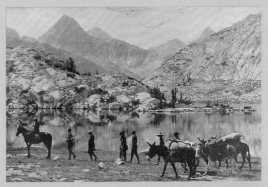

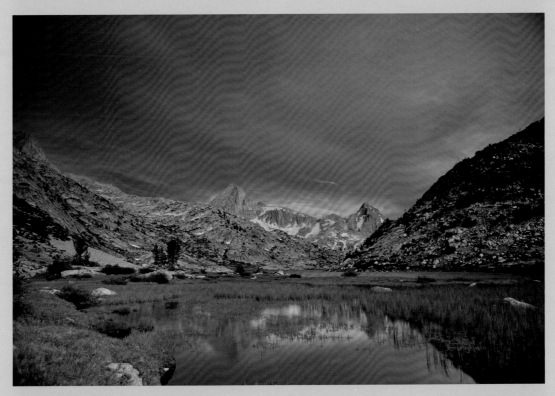

Above, bottom: *Essay pages 63–64, 90–91, 189–190*
A stormy sunset over Evolution Lake along the John Muir Trail shows the wild beauty of the High Sierra. The colors are wholly natural, with a graduated neutral-density filter holding back the intense crimson glow to allow an exposure for the shadowed grasses.

Top, right:
Essay pages 63–64
My aunt, Marion Avery, took this hand-tinted photograph showing my mother and friends at Evolution Lake in 1924 during a traverse of the 211-mile John Muir Trail before it was completed. With grazing of horses and sheep now prohibited, the area is in better shape today.

Top, left: *Essay pages 26–28*
The single photograph that has most changed our world-view was snapped by Bill Anders as Apollo 8 first orbited the moon in 1968. When we later served together on an environmental board, he signed a print to my son Tony with a cover note that said "Here's a photo I took on my last vacation."

Following pages:
Essay pages 90–91
Having failed numerous times to render the random forms of these glacial erratic boulders amidst a stunted juniper and Jeffrey pine in the Yosemite high country, I fulfilled my vision as the first fall snowstorm veiled away background distractions.

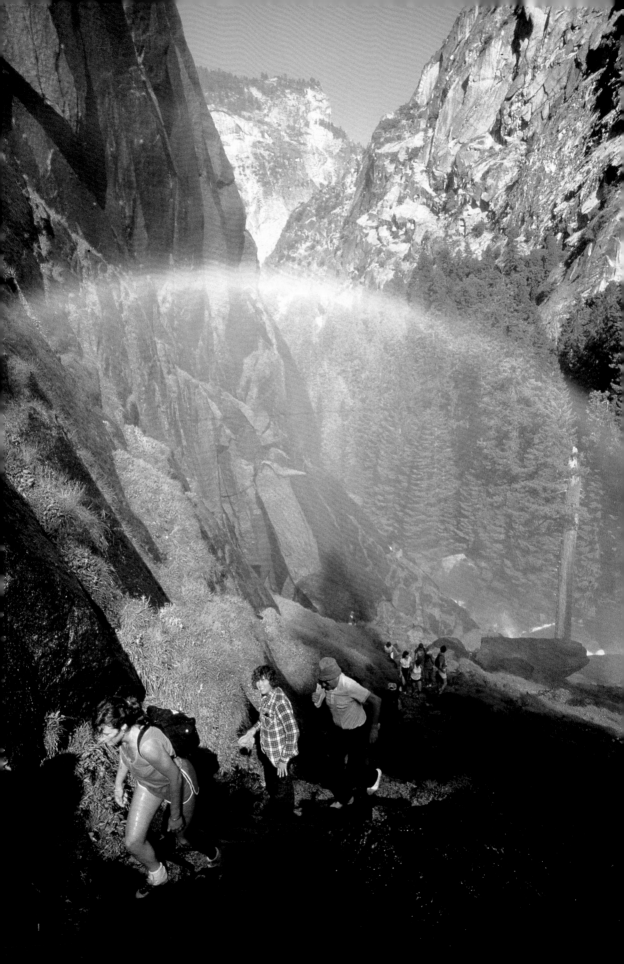

Left, right, and far right:

Essay pages 109–110 The same scene photographed minutes apart beneath a rainbow in the mist from Yosemite's Vernal Falls produced images that have been published to depict overcrowding of national parks (left), rugged backpacking on the remote John Muir Trail (right), and casual day-hiking (far right).

Right, bottom:

Essay pages 105–106 A climber on Yosemite's El Capitan is partly lost in dark shadows in this snapshot with a Canon Rebel and 20–35mm zoom lens.

Far right, bottom:

Essay pages 105–106 The Rebel's pop-up flash fills the shadow on the climber, but casts a new one from the large 20–35mm *f*3.5 lens. Solution: rotate the camera 180 degrees to put the open side of the flash toward the nearest subject.

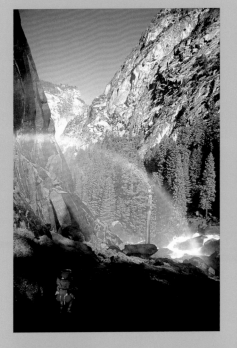

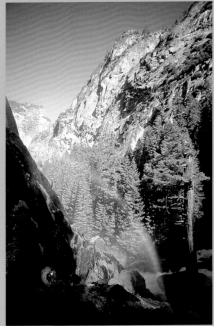

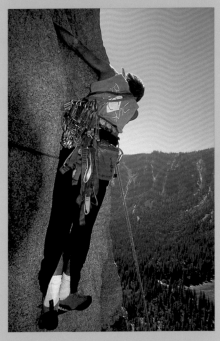

Above: *Essay pages 88–89*
Maples beneath an old-growth
forest near Oregon's Mount
Hood glow crimson in a drizzle
using a polarizer with Fuji Velvia
film. I made the photo with a
Nikon F100, 24mm ƒ 2.8 lens,
and Gitzo 026 tripod: total
weight less than five pounds.

Right, top, center, and bottom: *Essay pages 92–93* Three films render Canadian Arctic fall colors differently. Though printing may not reproduce the same way, Kodak Ektachrome E100VS (top) has the richest reds and yellows, but with more grain and less shadow detail than Fuji Velvia (bottom), which has slightly richer greens and less harsh contrast in direct sun. Fuji Provia (center), has less saturation but more accurate flesh tones and the finest grain of any color film in the latest 100F emulsion.

Above: *Essay pages
107–108*
My wife, Barbara Cushman
Rowell, made this aerial
of virgin rainforest on the
Península de Osa while
flying an environmental
mission in Costa Rica and
following a few simple rules
of "aerial wisdom."

Above: *Essay pages 107–108, 276–279* Though most visitors think of Costa Rica as unspoiled paradise, Barbara's photos reveal forests highly impacted by slash-and-burn agriculture where nature preserves are the exception. When she later saw more contiguous forest in Marin County near San Francisco, she conceived the idea for my 1997 book, *Bay Area Wild.*

Above, top left and center:
Essay pages 96–97, 98–102, 223–225, 276–279
Though my closer, fill-flashed bobcat photo at left is more likely to be published than my son Tony's wild photo (center), mine is a captive cat at a wildlife education facility. His is the more worthy image, made on his 23rd attempt in the hills of Marin County, California. Captive animal photos should be disclosed for editorial uses.

Above, bottom left and center: *Essay pages 96–97, 223–225, 276–279*
Continuing his stalking of bobcats around Marin County, Tony caught one pouncing on a pocket gopher and carrying it away in low light. He stopped the action at $^1/_{125}$th, metered the scene, and push-processed ISO 100 Ektachrome to 1200.

Right: *Essay pages 98–102, 103–104, 276–279*
A northern spotted owl, famous as a threatened species that only nests in old-growth forests, is lit by a remote flash angled from the side so as not to create eye glow from the bird's huge retinas. This wild bird at Point Reyes is near the southern limit of its range.

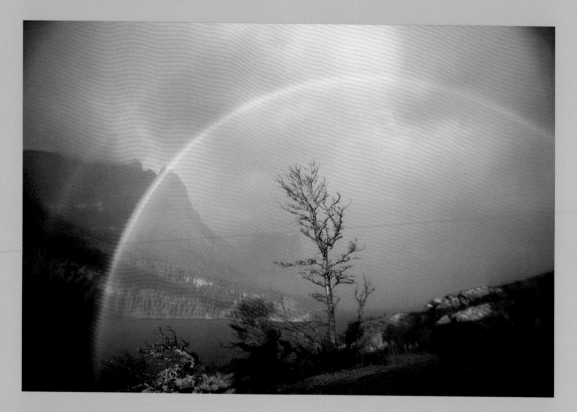

Above, center, and right: *Essay pages 36–37, 130–131* A rainbow appears over St. Mary's Lake in Glacier National Park during a blowing rainstorm that required holding a chamois cloth over the lens until a moment before clicking the shutter.

A Nikon 20mm wide-angle lens recorded the broad scene (left), while an 80–200mm telephoto zoomed in on the double rainbow around a peak (center) and a classic scene of lake, forest, mountain, and rainbow (right), all within a few minutes.

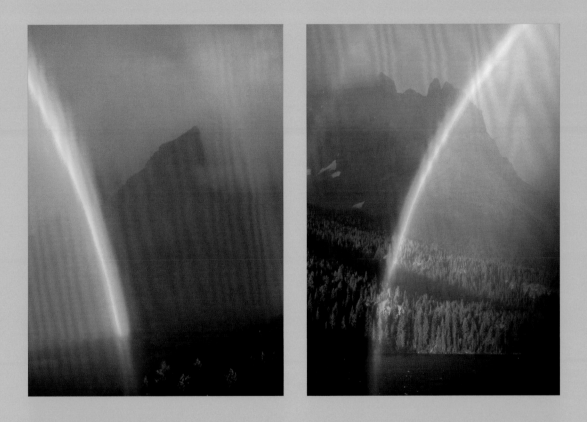

Left:
Essay pages 276–279
As a full moon set before sunrise over San Francisco Bay, I framed it through a dead snag atop the Berkeley Hills, using a 2-stop graduated neutral-density filter.

Above:
Essay pages 94–95
Twilight comes to the edge of the Patriarch Grove of ancient bristlecone pines at over 11,000 feet in the White Mountains of California.

Right:
Essay pages 94–95
Sports Illustrated chose this image of tents beneath Mt. Everest lit by flash during a six-minute exposure to run as a double spread. It involved zero creativity on location, as I knocked off a concept I'd used before.

Following page:
Essay pages 82–83, 98–102
Fill-flash set at the magic compensation ratio of –1.7 brightens stalks of beargrass at Logan Pass in Glacier National Park. Bright contrast and long, thin edges create a "whisker-sharp" impression of sharpness.

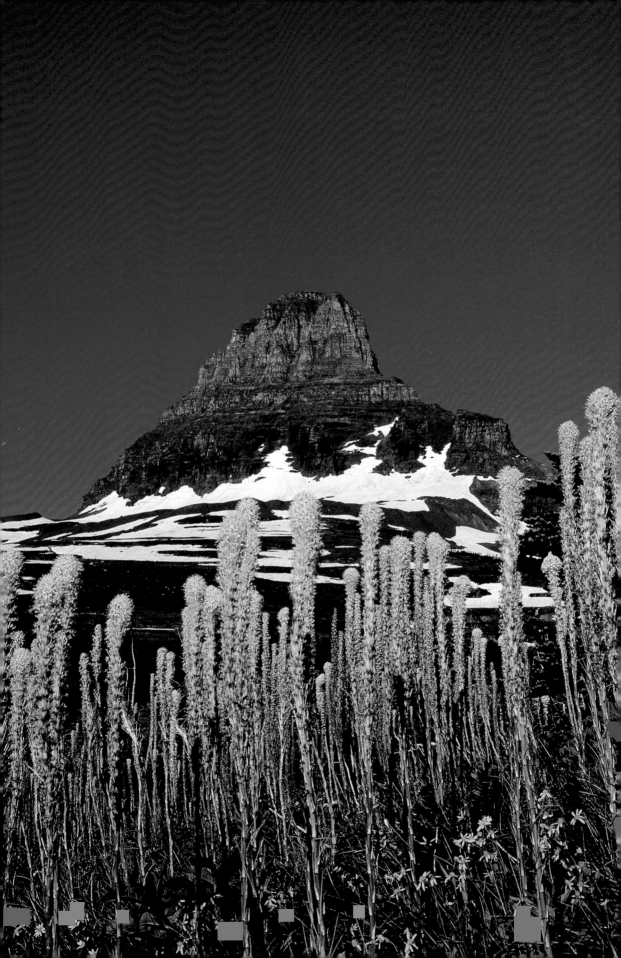

PART II: PREPARATIONS

Pushing the limits of equipment, film, and technique

Sharpness on the Mind

"What appears to be sharpness on a projection screen or a magazine page is a complex holistic quality that goes far beyond the measured resolving power of fine lenses and films. It depends on a combination of factors that aspiring photographers must learn to control."

After a joint projection session during the planning stages of an expedition, a seasoned Arctic explorer asked me, "Why are your pictures so much sharper than mine?" He explained that he owned a top-of-the-line camera and shot only the finest-grained films, but from the look of my pictures, I must be using special cameras and films not available to the general public.

He so earnestly believed the differences he saw were due to equipment that I doubted he would hear the most basic truth: His original Kodachromes were actually "sharper" than the duplicate slides I had shown. I began by saying that what appears to be sharpness on a projection screen or a magazine page is a complex holistic quality that goes far beyond the measured resolving power of fine lenses and films. It depends on a combination of factors that aspiring photographers must learn to control.

Top outdoor photographers aren't born with special vision or given special goodies that others can't buy. They simply learn more tricks of the trade and religiously apply them even when a landscape subject seems absurdly obvious or when the action seems too fast-paced for anything more than a grab shot. On the other hand, when a situation seems clearly beyond the range of all known tricks, the best photographers don't try to force rigid, preconceived ideas. They assess what kind of photographs they *can* make in the particular conditions they've been handed.

For example, a photographer who arrives in the Grand Tetons during a long storm with a firm goal of shooting broad landscapes over the classic bend of the Snake River has four choices:

(1) Shoot a lousy, unpublishable landscape.

(2) Sit in a hotel and wait for the rain to stop.

(3) Go home.

(4) Creatively modify the original goal.

Number four is the only option that can produce viable results in the existing weather. In heavy falling rain, it makes no difference if you shoot 35mm or use an 8-by-10 view camera; distant landscapes are going to turn out distinctly unsharp.

Yet a person who tries lots of experiments under such conditions may well return with a few images that evoke more visual attention and sense of mystery than any shot of the classic view on a clear day. A typical success might be a tight shot of wet flowers or leaves with the peaks barely visible in the mist. Images like this do not "come out" by chance. Any distant subject will appear murky through the rain, but focusing on close objects with strong edge definition will create a distinct impression of sharpness.

Imagine a fall rainstorm with a foreground of green, yellow, and red aspen leaves in front of the Tetons. Although the green leaves do appear far sharper than the murky Tetons, one's attention is most powerfully drawn to the even sharper-looking edges of the yellow and red leaves. These are not only more attractive colors, but also edges that have technically sharper resolution in the context of how we view the world. We have a distinctly higher visual acuity for red and yellow edges because the cones on our retinas are more sensitive to these wavelengths than to those at the blue end of the spectrum. Even where the measured resolution of a film image may be identical, yellow or red

edges will always appear sharper than blue or green edges. Similarly, high saturation films that produce stronger warm tones in poor lighting look sharper.

Just as a camera's autofocus system searches for edges and fails without them, the human visual system thrives on clear edges to make sense of the world. Any photograph appears somewhat muddy when subjects are distant in bluish light due to overcast or midday light, such as the Glacier Park scene rescued with a fill-flashed foreground (page 15). An equally important factor is having a broad range of edges in focus. When foreground edges are blurred, we are likely to see the entire image as somewhat unsharp (except if a prominent subject stands out in one plane of focus elsewhere). When great depth of field is achieved at apertures of $f16$ or $f22$, a 35mm image takes on the look of large-format photography. Doing this naturally forces you to slow down, put the camera on a tripod, and carefully frame and focus, just like the guys with those big cameras. They retain the advantage only in tighter film grain, while 35mm offers far greater creative choices of ultrawide to extreme telephoto lenses with other options, such as balanced fill-flash. Some of these choices, however, are guaranteed to create atmospheric problems similar to those of pictures shot in bad weather.

Extreme telephoto lenses magnify hazy air in the shade as assuredly as they enlarge chosen subjects. In the resulting cooler, softer light, even the highest resolution photograph of a wild animal made with a 600mm lens may be too dull and blue to catch an editor's eye. In these situations, push-processing ISO 100 Fuji Provia or Kodak Ektachrome 100VS slide films a full stop to ISO 200 will produce much sharper-appearing photographs than using an actual 200 ISO film. By altering development for a higher speed, push-processing of these two films induces added contrast and warmer colors that might appear garish in close portraits shot with full sunlight, yet are ideal compensating factors in flat light when shooting with long telephotos or with normal lenses thousands of feet above the landscape, as in aerial photography.

I equip all my lenses longer than 200mm with 81A warming filters, which are double the strength of the standard skylight filters that I use on shorter focal lengths. This tends to give my telephoto shots a more natural balance of warm and cool tones without adding visible red to what should be bluish shadows.

Owning a fast $f1.4$ lens that a photojournalist would covet is another potential 35mm trap that tempts some to hand-hold substandard nature images that contain only one narrow range of focus. A photographer using a far slower, cheaper, and lighter lens is more likely to make captivating images in the same situations by being forced to use a tripod.

When I choose to travel light without a tripod, I often improvise. On wilderness trail runs I've sometimes found great landscapes in low light that I've been able to render tack-sharp from two feet to infinity with my camera and wide-angle lens propped on rocks or logs. On urban walks I've even resorted to stacking my camera on a couple of empty beer cans to get perfect long exposures.

Although I could fill a book with many more common-sense solutions to sharper-appearing images, my overall message should be clearly in focus by now: Sharpness is as much a quality of mind as of film or optics.

When You Can't Take it with You

**"When the going gets tough in the wilds, light-
ness and simplicity far outweigh all the
bells and whistles on a battery-hungry pro
SLR with a chip that knows more ways not
to take a picture than I can remember. Mean-
while, something fleeting and wonderful is
unfolding before my eyes."**

In 1957, I spent three weeks in the wilderness with
sixty pounds in a frame pack wearing clunky Vibram-
soled boots and itchy army-surplus woolens. I had no
room to add something as frivolous as a camera. Since
then, outdoor equipment has become far lighter and
more functional.

That first trans-Sierra backpack trip changed my
life. I met a loose-knit group of scruffy climbers
who had anticipated the sixties by dropping out to
live in a Yosemite campground. Doing my first roped
climbs with them unwittingly set me on the inside
track of the coming outdoor movement. We had
no inkling that anything we were doing might ever
become mainstream.

A former cross-country runner scoffed at my
boots and convinced me to live in running shoes for
everything but technical climbing. City folk would
stop me on the street, point at my weird Adidas, and
ask what sport I played. Another climber who sold
pitons of his own design out of the back of his old
station wagon later gave me prototypes of packs
without frames and jackets without wool to test. He
soon founded a little company named for the loca-
tion of his wildest climb: Patagonia.

I used my small auto repair business both to
fund my outdoor addiction and to create personal
prototypes of modern sport-utility vehicles. Well-
worn Chevy station wagons were refitted with tall

suspensions, fat tires, low gears, positraction, over-
drive, and big motors to survive both marathon
highway drives and wild dirt roads. When one body
fell apart, I simply switched the special parts onto
the next one.

Soon after I began outdoor photography, Nikons
became my Chevrolets. Durable, interchangeable parts
that fit different bodies allowed me to rig both a light
combo for rugged adventures and a heavier kit for
more exacting work with easier access. This dual path
led me to give up fixing Chevies and become a profes-
sional photographer in 1972.

My philosophy hasn't changed. I have no simple
answer to that common query, "What camera do I
use?" What I use when photography is my primary
goal remains different from what I use on a self-
propelled adventure. The occasional overlap can
surprise those who expect me to sport all the latest
toys. An art director on a recent ad shoot looked
askance at my Nikon F5 fitted with a battle-scarred
1970s manual-focus 20mm lens instead of the
20–35mm ƒ2.8 zoom he owned, which has right-
fully become the rage for photojournalism. Beyond
my tiny fixed lens being lighter, sharper, and less
prone to vignetting corners with graduated filters, it
serves double duty on a lighter camera for adventure
runs, climbs, and ski tours.

For personal shooting with easy access or on
assignments with fixed locations, there's no question
that my sophisticated Nikon F5 with a heavy AF pro
lens (such as the latest 80–200mm ƒ2.8D) gives me
more keepers per roll and more rolls per subject than
the far lighter gear I carry where I would rather not
have a camera at all than be burdened by a big one.
But when the going gets tough in the wilds, lightness
and simplicity far outweigh all the bells and whistles

on a battery-hungry pro SLR with a chip that knows more ways not to take a picture than I can remember. Meanwhile, something fleeting and wonderful is unfolding before my eyes.

Even when the living is easy, a featherweight body with an inexpensive lens stopped down from wide open gives me landscape slides that look just as good with a 10X loupe as ones made with state-of-the art equipment. Ninety percent of my best life's work could have been made with a manual body, a 24mm lens, and a telephoto zoom in the 80–200mm range.

Though I have an F5, an F4, an F100, an N90S, and a featherweight FE-10, I rarely take more than two bodies anywhere. If we cross paths on a mountain pass, I'll likely have my 14-ounce FE-10 or 18-ounce N80 with a 7-ounce 28–80mm $f3.5$–5.6D zoom in a Photoflex Galen Rowell Chest Pouch. A zipper pocket holds a couple of graduated filters, a polarizer, and film. An attached lens pouch holds an 11-ounce 80–200mm $f4.5$–5.6D zoom and my trusty 20mm $f4$. Built-in Velcro tighteners stop them from rattling around. Total weight: three pounds.

If I have a tripod, it's a 2-pound Gitzo 001 or slightly heavier 026. If I need AF or better metering, switching to the F100 adds another pound. Taking the new, tack-sharp 18-ounce ED 70–300mm $f4$–5.6 instead of the 80–200mm $f4.5$–5.6D adds less than a half-pound where there's interesting wildlife or distant scenics.

If we cross paths at a roadside overlook, I'll have fourteen pounds in a Photoflex Modular Waist Pack and five more of Gitzo Mountaineer carbon-fiber tripod with a Kirk ballhead. The pack with a shoulder strap easily holds a primary camera with six lenses, a flash, and lots of gadgets. If I need a second body, it's in a chest pouch.

The body in my waist pack is either an F100 or F4 (with four lithium AA batteries in the optional MB-20 module). Lenses (all Nikon) include a 20mm $f4$ (lightweight, 52mm threads), 24mm $f2.8$ (lighter with less flare than the 24mm $f2$), 35mm $f2$ (fast wide-angle, great for aerials and night landscapes), 55mm $f2.8$ Micro-Nikkor (works well as a normal lens), and an 80–200mm $f2.8$ (very fast and sharp). For moving subjects (rather than landscapes, where fixed lenses maximize sharpness) I leave behind the 35mm and 55mm in favor of a 35–70mm AF $f2.8$ zoom.

The main compartment also houses my Nikon SB-28 flash. Its SC-17 remote cord and Rosco gels fit in a side pocket, along with tiny Photoflex soft gold and white reflectors and a Litelink slave unit for remote TTL wireless flash. Other pockets hold five Singh-Ray Galen Rowell graduated filters with a Cokin P holder and adapter rings, three screw-in 81A filters (2X skylights to correct deep shadow or overcast), two Singh-Ray circular polarizers (rotate in a Cokin holder—one standard, one with 81A), one Nikon 52mm polarizer (solves 20mm vignetting), four lithium AA batteries, four AA rechargeable Supercells (for flash), a cable release, a chamois cloth (to wipe off water), and a tiny lens cloth.

I bring along a larger bag only where I need special-purpose lenses, such as my rectilinear 15mm $f3.5$ (renders straight lines), my 16mm $f2.8$ (slightly fish-eyed), my 28mm $f2.8$ PC (corrects parallax), or my fast 35mm $f1.4$ and 85mm $f1.4$ lenses (great for aerial photography in low light). For wildlife or sports, I add a 300mm $f2.8$ or 500mm F4 with TC-14B (1.4X) and TC-301 (2X) teleconverters. For commercial work, I add assorted flashes, reflectors, and soft boxes.

Only where my gear can be carried by vehicle, pack animal, porter, or assistant do I ever consider taking all of it. Otherwise, you'll find me as I started out—carrying one simple camera or none at all.

Packing for Chaos

"I will probably never know why Delta wreaked more havoc on my luggage than a wild burro in Peru, but both experiences confirm that my packing system works so well that I see no need to change it in the future."

For years I've prided myself on my system of packing camera equipment for travel. Unlike most working pros, I don't use hard cases and don't waste any unnecessary pounds in camera protection that doesn't have other uses in my travels. For example, instead of hauling expensive lenses over 400mm in their monumental cases or in other dedicated packing, I simply roll my big lens of choice into my deflated Thermarest sleeping pad, stuff it into a nylon sack, and blow up the pad as tightly as possible to create a firm cushion of air several inches thick around the lens. Smaller lenses fit perfectly into those foam coffee-cup insulators sold at truck stops and souvenir stores, which, in turn, fit inside Photoflex lens cases with Velcro tighteners before being wrapped inside a sleeping bag or jacket. My large Gitzo carbon-fiber tripod goes into a Cordura bag before being wrapped in tee shirts, while my small #001 Gitzo gets a glove over each end. Extra filters get wrapped in socks and stuffed in shoes. All this, plus the rest of my clothes and personal effects, goes into off-the-shelf North Face travel duffel bags, size XL.

Because I utilize only packing materials that are already being taken on my trip, I can't remember the last time I had to pay excess baggage charges for commercial air travel. I normally walk away from the baggage claim carrying everything myself—at least as far as a taxi or rental car. My system doesn't change when I get farther into the field. Over the years, my duffels have successfully traveled on the backs of porters, mules, and yaks as well as in every type of motorized land, sea, and air vehicle imaginable.

Besides the duffels that may not travel with me, I keep a standard camera bag on my person with the gear I most often use. A Photoflex Modular Waist Pack (no longer available) becomes the bottom compartment of a prototype modular backpack (also not currently available) that holds all my film and normal equipment for airplane carry-on as well as other motor or foot travel. It separates into two parts to fit through X-ray security. I almost never change the position of gear in this bag so that I know I can find anything I need at any time.

Suddenly one summer, however, my venerable packing system for checked baggage was subjected to the two most extreme incidents of my career within a single month. In both cases, major equipment survived unscathed, but with considerable peripheral chaos. One incident happened when the burro toting all my equipment (except the camera and two lenses I was carrying) rolled over in the rocks near the crest of a 16,000-foot pass in the Peruvian Andes. The other had a far more benign beginning. I simply checked my bags on my first commercial flight into the newly completed Denver Airport.

Comparing the results of the incidents leaves no doubt that the burro was the kinder, gentler baggage handler. Delta Airlines must have routed my bags through a war zone to have them look as they delivered them to me, a mere seventeen hours after my flight landed in Denver. The bags arrived with holes in my clothes around my small tripod, a shattered "unbreakable" drinking mug, cracked lens filters in cases wrapped inside socks in my running shoes, a punctured Thermarest pad around a lens, plus a broken razor, toothbrush, toothpaste, sun

cream, and shampoo, yet not one bit of noticeable harm to any of my deeply packed camera gear. Although I was horrified by the condition of the contents of the bag, my packing system had worked well enough that within minutes after it arrived, at 4:30 A.M. the day after my flight, I was off to do a successful national advertising shoot at the break of dawn at 12,000 feet in the Rockies. My equipment had somehow survived an epic journey that I can only imagine.

On the day of the burro incident, I had decided to walk light over the pass with just a camera and a couple of lenses in a chest pouch. In the morning I had wrapped the Photoflex Modular Waist Pack, which I usually carry inside my duffel, rolled in the middle of an inflated Thermarest pad after stuffing socks and tee shirts inside to pad everything. Not one item in the camera bag was damaged.

To condemn the Denver Airport after an isolated bad experience would not be justified, were it not for mounds of supporting evidence that mine was not a once-in-a-lifetime experience. The facility gets many an experienced traveler's vote as the most ineptly managed modern airport in the world. Pilots tell me it often takes them a full hour from entry by vehicle to reach the cockpit, a journey that takes only minutes elsewhere. A Denver newspaper story that ran the day I arrived cited predictions that the new airport would lose over half a million passengers a year because of its problems.

When I arrived in Denver, Delta was using the same baggage carousel for four simultaneously arriving flights, thus overwhelming baggage service and all phone lines for the remainder of the day and night. As I waited for almost two hours, empty-handed, with many other frustrated travelers, an airport worker confided to us that our experience could have been worse. During ski season, an elderly gentleman had a true once-in-a-lifetime experience, his last one. The worker pointed across the room to a brand-new automated machine designed to bring out odd-sized luggage, such as skis. After a long wait for his bags in the chairless room, the old man had sat down in one of the knee-high chambers of the device. When someone in a back room turned on the machine, he was rotated through a slot in the wall and killed.

Perhaps something similar happened to my oversized duffel. It could have jammed somewhere during a test of prototype automated machinery, but the airline offered no explanation, despite the many questions I asked.

I will probably never know why Delta wreaked more havoc on my luggage than a wild burro in Peru, but both experiences confirm that my packing system works so well that I see no need to change it in the future. It certainly beats other methods I've seen used, such as large, hard cases that require hiring assistants to lug them around, or trying to protect yellow pelican cases from theft with labels like "Sam's Septic Service" or "Contents: Human Fecal Specimens. Do Not Contaminate!"

My formula for success in getting through airports and cities into the right places for the best photographs of the Earth's wild places is to look like an ordinary traveler and act like one. Being treated like one, however, is even more of a problem these days.

Knowing When Less is More

"When an artist is actively involved in an interpretive experience, whether it be climbing Everest or walking through a field, too much equipment interrupts the flow of emotional response that is the essential human element communicated in the best nature photography."

How much equipment do you really need to take great outdoor photographs? I've seen several talented photographers, who followed their obsession to own all the latest stuff and take it to every location, burn out after a few years. Much of my genuine excitement every time I'm out in the natural world with a camera is due to carefully moderating my gear for each situation, even if it sometimes costs me an image I dearly want.

I packed just five pounds of camera gear in my carry-on luggage for flights to major cities on a book promotion tour. On a free morning in Portland, I drove into the country and shot several rolls of wet maple leaves oozing saturation amidst old-growth evergreens. As I jumped back into my rental car, I congratulated myself for making images every bit as fine as I could have shot with the five cases of gear that some pros always take on location.

Around the next bend my smug satisfaction vanished. An even better foliage situation across a brushy roadside ditch cried for either a much longer lens than my trusty 24mm *f*2.8, or a much taller tripod than my 026 Gitzo that extends less than waist high with good stability.

As I lamented my laziness in not checking at least one bag with a bigger tripod and personal effects, which would have freed me to carry on my normal bag with six lenses plus accessories, I realized that all my problems could have been solved by an item light enough to carry in one hand onto the plane or down a trail. Out of habit, I had brought my short Gitzo aluminum tripod instead of my Gitzo 1228 Mountaineer. Made out of ultralight carbon fiber, the four-pound wonder extends to eye level with the stability of a metal ten-pounder. I left it home because I had pigeonholed it in my mind as a lighter *big* tripod, rather than a taller and more stable *light* tripod. The difference is significant.

For nearly a year after its introduction, I resisted spending over $500 just to get a set of lighter legs without a ballhead. I stuck with my metal two-pounder for casual use and the seven-pounder for more serious work. I have yet to see a metal unit between these weights that extends near eye level with sufficient stability to consistently make sharp images with heavy zooms or big telephoto lenses in low light.

The decisive moment came as my wife, Barbara, began packing for a long trek through the Peruvian Andes. She wondered whether she should take her light tripod or her heavy one. She thought about taking both, because she wanted a light one for the trail and a more stable one for important shots close to camp or a vehicle. Then she remembered seeing the Mountaineer at a photo show. She had been impressed by its light weight, sturdy legs that flexed much less than equal-sized aluminum ones, and improved collars for easier operation. When I confided that I was thinking of bringing two or three Gitzos for similar reasons, we decided to make our biggest photo equipment expenditure of the year: two Mountaineers at once.

At first, I kept my old-standby Arca-Swiss ballhead. I switched only after I shot critical comparisons against Barbara's lighter and more compact Kaiser ballhead specially modified with an Arca-style quick-

release that we bought from Kirk Enterprises (800-626-5074). I found no sharpness difference, because the Kaiser has an equally thick support shaft, with only slightly reduced smoothness of motion due to its smaller ball. For the majority of my shooting, I now use a newer Kirk ballhead, designed as an improvement on the Arca-Swiss. Only when weight is critical do I switch to the Kaiser.

The $2000 worth of tripods, ballheads, and lens tripod mounts we acquired before our long trip to Peru more than paid for themselves within weeks after our return, in cash stock sales from results far beyond our expectations. Not only did we significantly up the number of critically sharp "keepers" per roll, but also we found ourselves venturing further afield to make creative images that we might not otherwise have bothered to try.

One unexpected benefit came in subfreezing weather. My hand carrying the bare tripod actually stayed warmer than my empty hand—quite the opposite of holding an aluminum leg that sucks away heat like ice. In the final analysis, the weight savings of the more rigid carbon-fiber legs should be compared, not only to similar-sized metal legs, but also to the two or more tripods I often brought along on longer trips in the past.

This latter point helps answer an oft-asked question. If weight is so important to me in the wilds, why do I carry a Nikon F100 or F4 instead of a featherweight Canon Rebel X or Olympus OM-4? Because to have confidence that I can bring back the goods for myself or on a professional assignment, I don't need to bring two of them. Of course I take an extra camera body on any long overseas trip, but on shorter, participatory adventures where weight really counts—day trips near home or side excursions during exotic journeys—I want to carry just one camera I can trust.

After more than fifty expeditions to the world's most remote regions, I have yet to have a problem significant enough to stop a Nikon N90, F100, or F4 from giving me well-exposed pictures, while I have yet to lead a foreign photo trek where some other type of SLR didn't expire in the hands of a grief-stricken participant. I've seen many Olympus obituaries, a smattering of lower-end Nikon and Canon casualties, but virtually no full mortalities in top-end pro cameras. There must be exceptions, but not enough to disprove the general rule that pro cameras give pros the dependability they pay for.

To accomplish this, top-of-the-line Nikon and Canon units forsake light weight for sturdy reliability. I'm not holding my breath for the SLR equivalent of my carbon-fiber tripod to appear any time soon.

Expensive 35mm point-and-shoots that combine light weight with reliability severely limit creative options, such as lens choices and positioning of graduated filters. I've made some technically perfect photographs with point-and-shoots, but as a whole my best results clearly lack the creative breadth and consistency of top SLR images seen and composed through the lens.

Knowing when less is more—and when it is not—is more important for consistent success in *participatory* outdoor photography than in traditional journalistic or documentary coverage. When an artist is actively involved in an interpretive experience, whether it be climbing Everest or walking through a field, too much equipment interrupts the flow of emotional response that is the essential human element communicated in the best nature photography. Yes, little things *do* mean a lot.

Landscape as Human Intention

"Photographs that we call powerful or dramatic communicate the photographer's passion as surely as they represent natural features. A photographer who is able to communicate intention consistently is said to have a creative style."

Why do some images of natural landscapes captivate us, while most pass us by? What is it that we photographers try so hard, usually without success, to communicate? The answers are deeply buried within us, not our camera's instruction manuals. Einstein could have been talking about photography when he said, "Perfection of means and confusion of goals seem to characterize our age."

Perfecting the means—autofocus, multi-segment TTL metering, ever more color saturation—has not brought most photographers closer to the goal of composing a photograph that represents what they see and feel. This sense of "aboutness" goes beyond a photograph's grains of silver emulsion, or the pattern of that animal or tree we see in it, to hold a sense of intentionality that wasn't there in the natural scene.

Photography is a visual language. When someone writes or speaks the word "life," it's about more than the letters l, i, f, and e. Completing the word is only the first step toward expressing a concept, as are the technical considerations of completing an image. It helps to know from a technical side that landscapes *always* appear differently on film than to the eye. Foregrounds *always* become radically emphasized against backgrounds that tend to all but disappear in size or soft focus. Highlights burn out, shadows drop to black, and colors go weird in light that isn't white.

But beyond these discrepancies—which can be minimized by intelligent use of filters, films, and lighting—is an unseen realm in which we perceive the arrangement of a landscape's features as created by human intention. Photographs that we call powerful or dramatic communicate the photographer's passion as surely as they represent natural features. A photographer who is able to communicate intention consistently is said to have a creative style.

As intention becomes more artful, subjects lose their relative importance. Irving Penn's intriguing landscapes created out of close-ups of cigarette butts were exhibited at the Museum of Modern Art. Even where intention may appear to be direct representation of a landscape, as in a picture of a lake in a travel brochure, the intentional communication of the photographer's passion is what makes the photograph get chosen and tourists want to go there. A casual snapshot wouldn't do the job.

Had photography begun as a recognized art form, our culture would be more keenly aware of the role of intentionality. The famous art psychologist Rudolph Arnheim has denied it by expressing the common, wrongheaded view that photographs only capture what was already there in nature: "passive recordings" that "register all detail with equal faithfulness." To the contrary, neither photographs nor direct observations fully represent reality. When I was old enough to ask my father why he became a professor of philosophy, he told me that nothing in life can be held separate from a philosophy about it. Every science begins as philosophy and becomes art. Knowledge starts out as mental contemplation, moves through modern scientific experimentation, then escapes into celebrations of form and beauty. The exceptions are reverse cases where the art precedes the science.

Photography as we know it began as a science, even though some artists had used a camera obscura without a photosensitive emulsion to trace an image

in perspective as the basis for their paintings. Photography's inventor, Nicephore Niepce, devised producing direct images by photochemistry to make up for his utter lack of artistic skill before teaming up with Daguerre. Their process was marketed as scientific visual truth apart from artistic fancy. When ensuing landscape photographs failed to resemble the real world closely enough, the technical solution was to make them much bigger and sharper. In the 1870s, William Henry Jackson photographed the West with a 20-by-24 view camera (Some of today's photographers, disappointed by their efforts in 35mm, switch to 4-by-5 in the hope of better communicating their intentions.)

Landscape photography as art only arrived after photographers understood that the inherent failures of photographs to correspond with the world could be previsualized and composed as artistic intention. Alfred Stieglitz founded the legendary Photo-Secession movement early in the twentiety century to liberate American pictorial photography from the stranglehold of academics and critics. Few of the great landscape photographers who followed had formal training in photography. Ansel Adams was a musician, Eliot Porter a physician.

Since the sixties, successful scenic photographers have been less likely to emerge from such singular urban professions and more likely to surface from unstructured, spontaneous involvement with the arts, the sciences, and the natural world to compose images that communicate how they feel about a scene. As audiences for all the arts now respond to ever less formal compositions, successful painters, sculptors, musicians, and photographers have become true sensory sages who evoke, without words, emotional responses in vast numbers of people.

In the classic sense, art has been regarded as being in opposition to nature. Art is the modification of things by human skill and intention, and thus an *artifact* is no longer considered *natural*. A landscape photograph, however, asks to be accepted as both artifact and natural. This helps explain why we do not look at a photograph the same way we look at a natural scene. When we walk through nature, we are rarely aware of the aesthetic relationships between objects in our visual field. At a classic turnout in Grand Teton National Park, most tourists are content to see the mountains over an S-curve of the Snake River from anywhere along a 300-foot paved clearing. Photographers cluster within a step or two of where Ansel Adams took a famous photograph, not because they are seeking to copy his vision, but because they, too, are searching out a place where the elegant pattern of the river leads the eye into the mountains. Photographed from ten feet to the side, the composition would appear skewed and unbalanced, but from that same point, most spectators would believe they were seeing just what the photographers in the right place were photographing.

Our best pictures show a less "busy" world than we experienced, a world that bears an uncanny resemblance to the sentimental one held in the mind's eye that was first simplified through normal visual processing and further idealized through the golden sieve of memory. Minute by minute, year by year, details fall away and our mental imagery becomes more iconographic and personal. As Robert Pirsig wrote in *Zen and the Art of Motorcycle Maintenance,* "We take a handful of sand from the endless landscape of awareness around us and call that handful of sand the world."

When Being First Doesn't Win

"In 1977, a nice man asked me to try out the camera strap he had designed. When a joint parted, my Nikon FM departed—at 32 feet per second toward terminal velocity from 20,000 feet on the unclimbed Great Trango Tower."

Back in the seventies, I waited a long and stormy week on a Denali glacier to be picked up by Doug Geeting, the bush pilot who had flown me in to climb the Alaskan giant. As the clouds began to lift, two bold pilots dropped through and picked up full loads of climbers hours before Doug arrived in much better visibility. When I mentioned that I was probably going to miss my high school reunion, Doug smiled and said, "How do you tell a climber who's been sitting on the ice for days that the first pilot who lands may not be the one he wants to be flying with?"

Of those three pilots, Doug is the only one still flying Denali. His logic also applies to remote-area photography: How do you tell photographers heading off on once-in-a-lifetime journeys that the latest innovations may not be what they want to take? Using unproven gear or film on a remote journey is akin to flying into a cloud. Most of the time you come out the other side, but is that good enough?

As the proverb goes, good judgment comes from experience and experience comes from bad judgment. Being an outdoor pro and magazine columnist at the front of the line to try new products is not always an advantage. I've learned to be conservative about any changes to what's inside the basic fourteen-pound Modular Waist Pack that I carry onto flights to remote locations around the world. I spent more than eight months away from home in 1998 on climbing expeditions, taking photographs for the 1999 book, *The Living Planet,* which included images by Frans Lanting, David Doubilet, and myself. Deep in the Arctic, I met a Swedish pro who wasn't taking any photos, even in the finest light, of splendid landscapes and wildlife. Her two identical camera bodies with the newest high-tech wizardry had both failed.

Only once have I had a product failure deprive me of a working camera at a critical time. In 1977, a nice man asked me to try out the camera strap he had designed. When a joint parted, my Nikon FM departed—at 32 feet per second toward terminal velocity from 20,000 feet on the unclimbed Great Trango Tower. On top, I saved a small part of the day by asking one of my partners if I could run a roll of my film through his Pentax.

Had that happened at a major sporting event, I could have run over to the Nikon booth and borrowed another body. Most of the advice in photo magazines is written by folks who are able to take the darn thing back on the spot or to grab another body from their car or their assistant's hand. *Not* carrying extra gear is my key to staying light enough to get into the most exotic photo locations.

In line with Doug's bush-pilot logic, I've had thirty years of success with Nikon—a company that gives us well-tested camera body innovations. They're likely to be first with breakthroughs in lenses and accessories, such as the smart flash capabilities of their Speedlights. In the sixties and seventies, using one or two basic bodies in the field with the certitude that they were free from design flaws produced some of my life's best photos. Today, based on that history, I am willing to wait for Nikon to add proven increments of technology to something as essential as a camera body.

Now I know there are the cynical types who figure anyone who gives a testimonial must have

some ulterior motive. I've never accepted payment to use or endorse a photo product. However, I have given free testimonials about products that I really use and have been paid normal fees for any photos published with them.

Film is another product that we all must depend on. As a pro, I need to have film that I understand and can depend on to deliver the results I need. So film is the item I'm most reluctant to change, but after back-to-back assignments in the summer of 1999, I came to regret *not* having tested a new Kodak film in the development stage. When I finally brought the plain yellow boxes to the Canadian Arctic in September, tests against both Fuji Velvia and Provia knocked my socks off. Yellows and reds jumped off the light box in situations where I was used to subdued saturation through magnified haze or blue shadow. I wished that I had taken it earlier to shoot wildlife in the Pacific Northwest, Alaska, and Nepal.

Released as Ektachrome E100VS (very saturated), the film's richer reds with clean neutral tones may not reproduce quite the same in the comparisons on page 71. Also note that because our eyes respond more to the red end of the spectrum, it is easy to overlook the richer Velvia greens. With a granularity rating of 9 compared to the 11 of E100VS, Velvia also reigns supreme for better resolution and detail in both shadows and highlights, plus more believable saturation of close, rich colors in direct light. E100VS holds a big edge in speed at ISO 125 for those, like me, who shoot Velvia at ISO 50 to hold brighter highlights in typical outdoor scenes, or at an honest ISO 100 for those who rate their Velvia at 40. In really flat light or for wildlife with long lenses, E100VS makes all six films I've now compared it with except Velvia look dead in the water, especially both Kodak's

and Fuji's recent multispeed films beside E100VS push-processed to ISO 200 in soft light.

Much of what people were saying when Velvia first came out applies to E100VS today. Sometimes it looks garish, sometimes it looks great, and much of the time it will produce the image that editors will choose. E100VS often produces bright colors closer to what you believe you saw in flat light or at a distance, but if you use it all the time, you risk having the sum total of your style appear garish and suspect. In direct light this film doesn't just come near the edge of the color saturation envelope; it moves beyond into a realm that requires the same sort of restraint as the use of color-enhancing filters does.

So E100VS will never be the only film in my camera bag—as has sometimes been the case with Velvia in the past—but it's a great new tool I can't do without. Only time will tell whether its expanded color gamut will gain the general acceptance that Velvia has against those Paleolithic Kodachromes and Ektachromes of the eighties.

Photographs: Pages 79, 195, 245

Relying On Faulty Faculties

"Above 20,000 feet on Mount Everest the critical faculties I needed to do creative photography were reduced to a childlike level. An early symptom of oxygen deprivation is a strong sense of well-being and sound judgment."

Before he disappeared in 1924 near the summit of Mount Everest, George Leigh Mallory described how he and his companions felt "like sick men walking in a dream." I never had that feeling when I spent two months on the mountain without oxygen in 1983 at lower altitudes between 20,000 and 25,000 feet. As climbing leader of a team held up by severe storms and avalanches on a new route from Tibet, I felt disappointed not to summit, but good about our group decision to quit and all return home alive. I was especially pleased at how well I acclimatized and how sound my judgment seemed up there.

I wouldn't have questioned my perceived clarity of mind except for a nagging concern. My photographs didn't turn out as well as I'd hoped. The 7,000 transparencies I shot on assignment for *Sports Illustrated* rank well below other work I did that year at lower altitudes in both creative inspiration and technical quality. Even though the editors found enough selects to run a twelve-page spread, my shooting ratio was well below normal. My few successes were knock-offs of concepts that had worked for me before rather than freshly conceived images.

What's missing from my high-altitude photography is a clue to the difference between inspired and uninspired photographs people take at normal altitudes. I've always felt a connection I can't define in words between my dreams, fantasies, and photographic style. Such a nebulous affinity makes for better New Age party chatter than photographs unless it can be translated into conscious actions. Otherwise, why bother? Let it "do its thing" naturally without conscious interference. That's exactly the approach many photographers follow with mixed results.

Some people simply "take" photographs of objects they perceive before their eyes: mountains, sunsets, wildlife, or family. Others try to "make" photographs that communicate their emotional response to similar landscapes, natural events, wild creatures, or people. This latter approach accounts for the great majority of fine outdoor photographs, yet it is filled with pitfalls. The main catch-22 is that the act of tuning into our deep emotions and allowing mental imagery to flow freely in a dream-like way shuts off the higher mental processes we must use to critically assess photographs as we make them.

We cannot hold the two concepts simultaneously in our minds because the former is not yet a concept. The nature of the intuitive emotional response we are after is preconceptual and usually nonverbal. We must tune into it, like a dream or daydream, and let it flow before awakening conscious control to create a photographic metaphor capable of evoking a similar response in others.

One process without the other invariably fails to produce a creative photograph. There's good reason why people who go through life trying to stay entirely in concept mode are called two-dimensional. At the other extreme, those who stay tuned only to the soap operas of their dreams and fantasies tend toward bizarre originality rather than true creative synthesis. Originality does not pass for creativity except in kindergarten and art galleries that sell chimpanzee finger-paintings as limited editions.

During my first years of amateur photography, I would walk through the wilds, feel emotional

about a scene, lift my camera, and take a picture that almost never recreated my original feeling to share with others. When once out of a thousand times it did, I was ecstatic. Most of my failures presented subject matter I had seen minus my emotional response. I couldn't figure out for the life of me why I had taken a particular shot that did nothing for me. It was as if I had made it in a dream.

By the time I became a pro, I had discovered by trial and error a procedure I describe in my book, *Mountain Light*: "Before I press the shutter release, I think about the validity of my subject. . . . making a photograph implies that the photographer understands what his photograph says."

I tend to follow one of two basic procedures. Either I preconceptualize a photo and then let my flow of mental imagery guide me to a visual metaphor, or I begin with the flow alone and conceptualize images into my consciousness for critical review only after I feel the urge to take a photograph. Examples of both appear on page 79. The night scene below Mount Everest was used by *Sports Illustrated* as their opening spread. It's a preconceptualized image that's a knock-off of a concept I'd used many times before. It involves walking around during an exposure long enough not to record my moving presence in the dark while I set off flashes by hand in each tent. The image of the edge of the bristlecone pine forest in California began without a concept. It evolved from a dreamy state of flow as I slowly sensed the burnished earth with its few dead trees frozen in time and space as having qualities similar to a surreal Salvador Dali painting.

The key to both procedures is asking yourself before you click the shutter, "What am I responding to here? What are the essential values I need to include to communicate this concept or feeling in the visual for-

eign language of film?" Everything extraneous to that message must be deleted or de-emphasized to create a photograph others will appreciate in the same way.

Above 20,000 feet on Mount Everest the critical faculties I needed to do creative photography were reduced to a childlike level. An early symptom of oxygen deprivation is a strong sense of well-being and sound judgment. In 1999, my California climbing partner, Conrad Anker, found Mallory's body at 27,500 feet on Everest, and I once again wondered what mistake led to Mallory's demise. Dr. Charles Houston, another friend who specializes in high-altitude medicine, reports: "In general terms, the highest or most developed brain functions are the first affected—judgment, difficult decision making, or appreciation of one's condition."

These higher mental faculties are what we lose control over when we dream. Houston's medical description almost exactly parallels Mallory's dream comparison. Our dreams defy normal laws of reality and keep right on rolling in wild metaphorical progressions because our higher brain functions are turned off in full sleep. At high altitudes, consciousness approaches a dream state not unlike that pleasing mental flow I use elsewhere at will to connect emotionally with the natural world. Down low, I can wake myself to form a concept and capably execute it. Up high, I'm stuck in a dream without knowing it, and perhaps I am lucky to have returned alive. Whenever I've been at extreme altitudes, I've always believed that I've taken great pictures until I see them much later.

If you commonly have this experience without going over 20,000 feet, wake up and click your brain to full conceptual power before you click your shutter!

Pushing Film to Extremes

"Though situations like this aren't exactly common in nature, they do coincide with most of the times a wildlife photographer feels the need to use very high film speeds with long lenses in low light."

After I published one of my son Tony's wild bobcat photos beside a captive shot of my own, he continued his quest to observe and photograph predators in wild areas near his home. His first publishable bobcat photo was the result of twenty-three attempts in the hills of Marin County, but his latest bobcat images have eclipsed not only both of our previous efforts but also the well-meant advice of film manufacturers and photographers, including his father. Beforehand, I would have sternly advised him never, under any circumstances, to push ISO 100 color film 3.5 stops to ISO 1200. Even with newer Ektachromes re-designed for better push-processing, I push at most two stops to ISO 200 or 400, but no further.

Real life does not always follow armchair logic. When Tony spotted a wild cat stalking a pocket gopher in very low light, he was riding his mountain bike with a 500mm $f5.6$ lens in his pack and a roll of old Kodak Lumiere 100 in his camera. He had no better option than to shoot at a high enough speed to stop the action and have the film push-processed accordingly. He kept his shutter speed at 1/125th even though he was a full 3.5 stops underexposed. Thus, the photographs on page 74 were taken at ISO 1200 on ISO 100 film. Had Tony not pushed the film so far, he would have failed to capture the cat in the act of pouncing and carrying the pocket gopher away. His results would have been too dark at a lower film speed or too blurry at a lower shutter speed.

On the same day that Tony photographed the bobcat and called to ask for processing advice, I had already been talking about push-processing with Sam Hoffman, owner of The New Lab in San Francisco. I told Sam that many photographers had been contacting me to ask if I exposed ISO 100 film to be pushed one stop to ISO 160, as George Lepp had reported doing in *Outdoor Photographer*. My experience had been that one- and two-stop push-processes by The New Lab had produced very accurate exposures at the expected EI ratings. For a one-stop push of ISO 100 film, I had set my ISO at 200; if the lighting or the subject were contrasty, I sometimes set my ISO at 240 to hold detail in the highlights, which burn out more quickly with push-processing. Similarly, when I shoot ISO 100 Kodak films without push-processing, I also prefer to set my camera at ISO 125 if the lighting or the subject is contrasty, as in most sunlit outdoor scenes.

Sam described how his professional lab uses a densitometer to create logarithmic increases in development to precisely achieve the indicated push. Using another lab, George Lepp might indeed need to use ISO 160 to get the same results The New Lab produces when I use ISO 200 or even 240. One lab isn't right and the other wrong; it's a matter of personal choice and preference. It's the middle tones that are controlled to have the one-stop push. Shadows will always appear darker with push-processing due to contrast build-up.

When Tony told me that the cat was in an even darker spot than he had metered as being three full stops underexposed, I gave him fatherly advice not to try four stops and to go no further than a three-stop push. He'd have to accept a slightly dark slide, which could then be lightened in duplication if necessary.

After talking it over with the lab, he decided to try a 3.5-stop push to ISO 1200.

The results have surprisingly little grain for ISO 1200 as well as perfect exposure. The grain appears considerably tighter than that of a straight ISO 800 color slide film and about the same as a straight ISO 400 slide film. By following and exceeding my advice to push ISO 100 film in low light rather than use a faster film, Tony's results benefitted from the contrast build-up and warm color shift associated with push-processing. Using a film not designed by the manufacturer to be regularly pushed can often improve a telephoto taken in flat light. I regularly push ISO 50 Fuji Velvia one stop for aerials and flat lighting to get snappier images. Had Tony been shooting in direct sun or mottled light, his results at ISO 1200 would have been ghastly. Shadows would have blocked up into a murky brown with no true blacks, while highlights would have completely burned out.

Tony's bobcat images succeeded at ISO 1200 because there were no distinct shadows and no highlights much brighter than the cat. Though situations like this aren't exactly common in nature, they do coincide with most of the times a wildlife photographer feels the need to use very high film speeds with long lenses in low light.

Much of the credit for the proper exposure and the clarity of these images pushed 3.5 stops is due to fine processing by The New Lab (800-526-3165). When I've had film push-processed elsewhere while on the road, I've all too often had objectionable color shifts and dark slides due to variations in procedures and chemistry. It pays off in the long run to shoot test rolls and stick with a lab that gives you consistently fine results.

After Tony pushed his film to ISO 1200, Kodak asked me to do extensive tests on a new Ektachrome 200 designed to be pushed to ISO 800 or more. The film indeed performs as well as Kodak describes it, except for being about a half-stop dark with push of two stops, which is not unusual. Although E200 has significantly more grain than 100-speed Ektachromes to begin with, it pushes with less color shift, less contrast build-up, and less visible grain increase at ISO 800 and ISO 1600 than Fuji's multispeed MS 100/1000 slide film, which looks better at film speeds of ISO 400 and below. At these lower speeds, my favorite film for push-processing one or two stops is Fuji's new Provia 100F, the finest-grained color slide film ever made.

For extremely high-speed shooting with normal lenses in average lighting, I would definitely choose the new Ektachrome 200 over far more grainy ISO 800 films or over having to push a 100-speed film a full stop further. But for the rare situation in very low, soft light that Tony caught with this bobcat, I wouldn't change a thing, except to use 20/20 hindsight to bring a faster lens.

Photographs: Pages 6, 74–75, 80, 116, 124, 161, 199, 206–207, 246–247

Getting the Most out of On-Camera Fill-Flash

"Why is a manual override for the fill ratio so important? Because nature pictures look wrong when flash obviously overpowers natural light. Whenever you flash the same intensity of light into shadows that you have in naturally lit highlights, your picture will look unnatural."

I can't imagine how I made it through twenty years of professional photography hardly ever using fill-flash for scenics or wildlife. The Stone Age technology of the sixties and seventies was designed for static shooting. My attempts at using fill-flash in real time, as events unfolded before me, produced results that ranged from haphazard to downright awful. I quit to honor a self-imposed commitment to tune my pictures toward what my eyes or film naturally see.

For the same reason that I chose 35mm over larger format cameras, I was unwilling to lug a heavy studio flash with big batteries or a generator into the field to put enough fill into a sunlit scene: Outdoor photography is an extension of my outdoor experience and psyche; I want to avoid getting bogged down with gear. I dutifully took a lightweight off-camera flash with me on assignments to photograph exotic cultures or models on location. I brought it out only where it would easily overpower low natural light and where I had extra time or assistants to set up soft boxes and check exposures with a flash meter.

The miracle of "smart flash" arrived in 1988 in the form of a Nikon SB-24 Speedlight that could properly balance flash to daylight during auto-exposures. Unfortunately, many of its possibilities were obfuscated by a complex 99-page instruction manual. Only through trial and error did the magic contained in this small package slowly reveal itself. In a fraction of the pages I'll share the simple techniques that I now use to get the most out of the original Nikon SB-24 smart flash, the upgraded SB-25 model that sports a 143-page manual, and the newer SB-26 and SB-28 models.

Following a few basic procedures permits me to point and shoot in automatic exposure modes and get great fill-flash photos the majority of the time. I also have the option to manually fine-tune most every aspect of my unit's artificial beam to be soft or hard, warm or cool, wide or narrow, or to flash near the start of the ambient exposure or at the end.

Most of my techniques can also be applied to Canon, Minolta, and other true smart flashes now on the market (units that allow simultaneous automatic metering of ambient and strobe illumination to be controlled by a manual balance setting). In my experience, Nikon's Speedlights remain the most versatile and user-friendly, once you get beyond that instruction manual.

I shoot away at will in most situations by simply presetting a fixed −1.7 compensation for the fill ratio. Before I explain how to do this, take my word for it that the amount of compensation delivered by computerized autobalancing systems on smart flashes is insufficient for nature photography. It may produce a brightly lit publicity portrait of Hillary and Bill standing in front of the White House, or a paparazzi shot of someone else coming out of the back of that house, but it will just as assuredly over-light that wonderful dead tree at a similar distance from the camera in front of a mountain. I backed up my strong opinion by using extra manual compensation beyond Nikon's Matrix Balanced Fill-Flash system to shoot two national Nikon ads of natural scenes. Their editors chose the shots I had manually compensated over others I took using the autobalance settings.

Why is a manual override for the fill ratio so important? Because nature pictures look wrong when flash obviously overpowers natural light. Whenever you flash the same intensity of light into shadows that you have in naturally lit highlights, your picture will look unnatural.

But isn't this just what Nikon Speedlights are designed to do in their fully automatic "Matrix Balanced Fill-Flash" mode? Don't they have a computer-controlled system for balancing flash to daylight based on preprogrammed algorithms of possible lighting situations? Doesn't the flash already supply up to one stop less light than the ambient exposure, depending on the relative contrasts of the situation? Yes on all counts, but however great the system sounds on paper, it does not produce enough compensation to give scenics a natural appearance. These computer programs, like those that control automated one-hour color prints, have been devised to favor bright, clean flesh tones on portraits. Scenic values will lose both saturation and subtleties on slide film.

The slow, fine-grained slide films that most nature photographers use, such as Ektachrome and Velvia, have about a two-stop range from a middle exposure into shadows before they become extremely dark and lose all detail. This brightness ratio of 4 to 1 into the shadows sounds okay until we compare it to the minimum of 128 to 1, or seven stops, in which our eyes see good enough detail to read a newspaper in shadowed daylight. What this means is that a −1.3 to −1.7 exposure compensation fills the shadows just enough to appear very natural in the visual "foreign language" of film. The bright highlights still come from the sun. People, wild animals, or aspects of the landscape can thus be rendered well within the film's normal latitude without blowing out the shadows.

To plug in a fixed −1.7 flash compensation value on an SB-24, SB-25, SB-26, or SB-28, first turn off the fancy automatic compensation by pushing the "M" button and then use the "select" button (with the unit on the camera and both camera and flash turned on) to make the exposure compensation scale appear in the upper right corner of the display. (The percentage of Nikon owners who don't know how to do this at least equals that of VCR owners who don't have a clue how to program the features they paid dearly for.) On older flashes, the balanced flash icon will blink when the M button deactivates it, while on the SB-26 and newer, it will disappear.

About 80 percent of my exposures are right on with a −1.7 setting on my SB-24. When I need a bit more flash to single out a subject or brighten it, I choose a −1.3 setting. If in doubt, I bracket both. When I think I need more than a −1.7 setting, I don't try a −2.0 or a −2.3 right off. Instead, I set the compensation at −1.3 and reactivate the Automatic Balanced Fill-Flash mode, thus letting the camera choose a degree of compensation up to one stop *plus* the −1.3. Thus the −1.3 is *in addition* to the lesser compensation, probably −.3 or −.7, chosen by the auto flash metering for a total of around −1.7 or −2.0. I find this works especially well with an N90 or newer body and the newer Speedlights, which monitor exposure with a series of unseen preflashes. The F100/SB-28 metering combo is so good at analyzing tricky lighting that when I'm dealing with changeable human interest situations, such as walking through a village or shooting an event, I almost always leave the Matrix Balanced Fill-Flash mode on (together with the −1.3 setting), but turn it off and use straight −1.7 for more predictable nature subjects, such as a meadow or a wild animal of neutral color.

Creatively fine-tuning fill-flash begins with options for bracketing exposures. You can independently vary either the flash or the ambient exposure. I find it best to use manual exposure mode to vary only ambient lighting. For example, I might emphasize foreground wildflowers by setting the background a full stop darker than my meter reading or further bracketing the background −.7, −.3, and right on the

meter, but never overexposed. Exposing for the brightest background is all-important. If you move in tight on dark subject matter, your meter will favor it and overexpose your ambient setting. If the lighting is contrasty, use a manual ambient setting.

In the situation just described, I could also bracket the fill on the flower while holding the same background by using flash compensations of −1.0, −1.3, −1.7, and −2.0. Or if I'm really serious about the photo, I could bracket all sixteen possible flash and ambient light variations. I'd only be able to shoot two different scenes on a roll, but I'd be pretty darn sure to nab the optimum balance, so long as I had carefully selected and metered my subjects.

But even with smart flash, exposures can get tricky. When you choose subject matter that isn't conducive to autobalanced fill-flash, you'll get lousy results, just as you do when you shoot away without flash in lousy light with a $2,000 SLR in "program" mode. Experienced photographers know that they can't use the total range of detail that their eyes see into shadow and highlights to fairly judge the way their pictures will come out. Exposure values have to be quite close—not farther than two or three stops apart—to hold detail important to the subject. Matrix Balanced Fill-Flash is a license to disobey this traditional way of thinking only in certain situations. Fill-flash is subject to limitations at least as severe—and predictable—as those awful results we get in harsh ambient light that looks okay to non-photographers.

The harsh-lighting analogy for fill-flash is a disparity of subject distances or reflectivity. These situations directly correspond to too much variation in the intensities of natural light because they cause variations in artificial light intensities that create a similar harsh look. Here is the single largest cause of failure of otherwise properly exposed fill-flash photographs.

Imagine, for example, that a crimson glow at sunrise strikes a mountain and a cloud as you discover a red Indian paintbrush blossom sticking out of a clump of sagebrush in the shadows. You eagerly choose an aperture on your 24mm wide-angle lens that will hold both peak and flower in focus, plug in that perfect −1.7 fill-flash setting, and get back a bitter disappointment from your photo lab. Instead of a red flower popping out of a dark foreground in counterpoint to the crimson peak, it pales beside a sickly white stick and some blades of grass a foot closer to the camera that are about two stops brighter than flower or peak.

What happened? Light falls off in proportion to the square of the distance from its source. A subject lit by flash from two feet away is more than a stop brighter than a subject three feet away. This doesn't happen with natural light because the square of 93 million miles and 2 feet is not appreciably different from the square of 93 million miles and 3 feet. The lighter colored grass and stick also pick up an extra stop or two of light compared to the dark red flower, thus burning them out even farther beyond the latitude of the film, despite the fact that the red flower and the bulk of the fill-flashed area were properly exposed. No camera settings or bracketings will cure this problem.

The bottom line is to be very careful about how you frame any foreground that falls away from the camera. Compose dark subject matter to be near the camera and lighter subject matter to be well behind. Finding just the right spot in a meadow to accommodate the fickle nature of your flash may prove more challenging than any other aspect of making a balanced fill-flashed scenic.

Using fill on people standing still at an equal distance from the camera is an ideal situation, so long as they aren't wearing white or one of those reflective jogging jackets that photographs like a laser beam. If your subjects are sitting down, lying down, or using hand gestures, you'll have to be very careful about over-lighting their closer limbs in relation to their more distant faces.

A clever way to prevent these hot foreground

exposures is to "tunnel" the flash. You can fool a smart flash into thinking that it's matched to a narrower focal length than you're actually using. To evenly fill that person lying down in the flowers, I would manually set my flash's zoom control to 50mm even though I was using a 24mm lens. The internal fresnel lens will then focus the light to cover the narrower area of a 50mm lens with soft-edged fall-off all around.

The same technique works wonders in many conditions where flash is not the total foreground light source. For example, imagine a lightly shadowed foreground only two stops darker than a sunlit landscape. Even with a −1.7 compensation, light flowers in a meadow that are closest to the lens might be over-lit, but with the proper composition the light fall-off from a 50mm setting could be perfectly matched to the brightness fall-off of the flash from the near edge. In other words, you can make a visual miracle happen if the light of your tunneled flash falls off from the closer foreground at exactly the same rate that it would otherwise brighten the closer subject matter. For even more precise control, you can rotate the flash head to aim the narrowed beam wherever you'd like, or take it off camera with a special SC-17 synch cord.

When I photographed my partner rappelling into a steaming ice tower atop Mount Erebus in Antarctica, (page 6), I utilized a 24mm lens with the flash tunneled to 50mm. This not only avoided harsh lighting on the nearer walls, but also projected the flash beam much further than on a wide-angle setting. With ISO 50 Fuji Velvia, I first set a manual exposure of $f5.6$ and 1/250th for the blue sky, then adjusted the flash to fill the foreground.

Surprisingly, you get no more distance with fill-flash by using faster film when shooting at the maximum synch speed of your camera in bright daylight. I'll repeat that: *You gain absolutely nothing in terms of distance by using a faster film.* Imagine a portrait with a wide-angle lens using fill-flash of a man at eight feet against a light sunlit background. You would have to shoot at $f8$ at 1/250th with ISO 50 film to hold the background exposure (assuming 1/250th is the camera's maximum synch speed). From experience you've learned that you get bright enough fill-flash exposures at $f8$ only up to about ten feet. Now let's say that you switch to ISO 200 film. Do you gain a brighter image or a greater distance? No, because you're limited by that 1/250th synch speed which now requires $f16$ for the same ambient exposure, thus giving you exactly the same fill distance you had with ISO 50 at $f8$. It takes two stops more flash to fill an aperture that's two stops smaller. The slower film remains the best choice because of its finer grain and wider exposure latitude.

When I've used a 300mm $f2.8$ lens with on-camera flash in weak daylight to shoot a wild animal at sixty feet, I've heard some disparaging remarks about that guy over there trying to take a flash picture of a distant animal from too far away. I'm not trying to fill the whole creature, only to get a "catch light" eye reflection that may make or break an image for publication. I often get catch lights at up to sixty feet with my flash tunneled to its 85mm maximum on much longer lenses, or even further with an added Fresnel lens to focus the beam narrowly.

Two other key factors of natural-appearing fill-flash are color balance and harshness. Most flashes are balanced to 5500°K or higher, the cool blue light of high noon. This cold light calls attention to itself as unnatural when it strikes the foreground of an image made at sunset with a color temperature around 2500°K. A gelatin filter over the flash head to match the color of the natural light solves the problem.

I keep a gel equivalent to an 81A fixed onto both my Nikon Speedlights. Unfortunately, Nikon does not market filters or filter holders for their Speedlights. I attach it by a method that could violate the manufacturer's warranty, so suffice it to say that the fragile gel does not end up exposed on the surface of the unit. Have a qualified camera repairman insert

the gel internally if you have the least bit of doubt about doing it yourself, but a gel can also be temporarily attached with Scotch Tape, Velcro, or a Photoflex On-Camera XTC inflatable soft box that conveniently doubles as a gel holder. Its transparent back fits tight against the flash head, allowing a gel to be slipped in between.

Since the majority of my landscape photographs are made early or late in the day, I prefer to err on the side of my flash being slightly too warm rather than too cool. When I need even more warmth to match a sunset, I use an 85 series amber gel folded at the edge and tucked into the diffuser on the flash head so as to cover most of the face. One benefit of using a strong gel is that you can easily slide just part of the gel across the flash head. A gel that would overly warm your image can be used to bracket the warmth of the light by decreasing the percentage of the flash head covered in successive exposures, from full gel, to two-thirds gel, to one-third gel. You've gotten the same effect as carrying three filters of different strengths.

My inflatable XTC On-Camera soft box comes into its own when shooting subjects at close range, especially where the ambient light is soft and the harsh shadows of direct flash would stand out. It is also important for even flesh tones with tight portraits. At a distance of more than six feet, such a small soft box has little effect. The closer the flash, the more the light is softened by a wider angle of view. To further enhance the softening effect of a small soft box and make the light directional, move it off-camera but leave it attached to the flash with a Nikon SC-17 cord that enables TTL flash metering to continue. The SC-17 has a tripod socket on the bottom of the flash mount that allows you to set the device on a tripod much closer to your subject to soften the light. With the flash aimed in a fixed position, you can move around with the camera on the synch cord to make the optimal composition of your subject. When your shutter speed is fast enough for the ambient light, you don't even need a second tripod.

All the lighting tools I have described thus far fit into a side pocket of my camera bag: a flash unit, a synch cord, a few gels that take up no more space than a credit card, and a soft box that folds up like a road map. They have produced countless times in situations where I would have lost the photo opportunity without instant access to lightweight lighting.

Once you get the hang of it, you'll know exactly when the soft light of a cloudy day calls for use of a soft box so that a close subject doesn't draw attention to some strange harsh light source. Or when, as just before sunset in the strong, direct light of a clear day, the hard-edged light of a bare flash with a warming gel will blend almost unnoticed.

To hold all these options in mind, I've devised a checklist keyed to an acronym. My goal is to BESTOW a perfect balance with natural light. B is for my option to *bracket* ambient lighting with manual exposures. E is for my option to choose different flash *exposure* compensation values. S is for my option to *soften* the light by using a soft box or bouncing it off a wall or some other kind of reflector. T is for my option to *tunnel* the flash to a narrower beam in order to avoid over-lit foreground objects and to gain more distance if necessary. O is for my option to take the flash *off-camera* for brighter or more directional lighting. W is for my option to use *warming* gels to match the warmer light at the beginning and at the end of the day.

The best way to learn about fill-flash is to go beyond rigidly following the guidelines I've outlined here. Shoot around them and see not only what looks best for you, but also what happens when you violate them. Until fill-flash is absolutely second nature, it's a good idea to study every reject slide and figure out what went wrong. If your middle brackets are *not* your selects, figure out what's leading you astray and try again.

Remote Smart Flash Outdoors

"The miracle is ready to happen. Through a stroke of genius, your wireless, off-camera unit has been elegantly transformed into a perfect clone of the master unit on your camera."

The basic contents of my fourteen-pound standard camera bag rarely change. In recent years, I've added only one wholly new item. It's an innocuous-looking black box about the size of a cigarette pack called a LiteLink and described by the manufacturer—Ikelite Underwater Systems—as a "wireless TTL slave sensor."

Attach this electronic Cinderella to any flash unit with a normal hot shoe, from an old manual Vivitar 283 to the latest dedicated "smart flash," and the miracle is ready to happen. Through a stroke of genius, your wireless, off-camera unit has been elegantly transformed into a perfect clone of the master unit on your camera.

If you have a sophisticated on-camera smart flash with programmable exposure compensation settings that deliver seamless fill lighting in balance with natural daylight, your wireless remote is ready to dance to the same tune, even from 200 feet away. For example, I can even trigger perfect fill on a distant subject from a remote flash with the programmable pop-up flash on a Nikon N70. The unique solution is one that escaped camera manufacturers trying to solve the same problem for many years.

Simplifying multiple flash has been a major bugaboo of the "smart flash" systems that were introduced in 1988 with Nikon's SB-24 Speedlight. Like programming your VCR, making multiple flashes work in unison used to require a precise procedure of manual settings that were beyond the gumption factor of most photographers. Multiple wireless flash usually involved pretesting with a flash meter after calculations of subject distance, film speed, aperture, and flash guide number.

Nikon attempted to solve this problem by putting a built-in slave unit in its SB-26 Speedlight. Although this feature sometimes comes in handy, it isn't workable in most nature photography situations. Nikon's approach appears to have been: "Let's build a studio slave unit into a flash and add whatever controls and instructions we need to allow the consumer to operate it in the field."

In the past, landscape photographers had good reason not to use flash at all. They not only lacked the time to mess with manual settings as the sun was rapidly setting during magic hour, but also saw that the majority of flash photographs in open landscapes called attention to themselves because of light fall-off that looked obviously unnatural. Only in situations where a foreground subject could be rendered at an even distance did on-camera or near-camera flash look credible. Warm fill light on a tree trunk four feet away might look great, but the same light source on a meadow spread from two feet to infinity would look ghastly.

Multiple remote flash won't solve the big meadow problem, but it can put believable accents of light exactly where you need them to call attention to plants, animals, or people in darker parts of your image. Forests regularly deliver nightmare exposure problems, but also offer plenty of high positions out of the frame of an image in which to position a remote flash equipped with a wireless slave unit.

When the Nikon SB-26 first came out, I had great expectations that its integral slave unit would solve many of the hassles I had experienced in the past with remote flash. Although this unit or the newer

103

SB-28 remain my choice of an on-camera smart flash, I initially gave up trying to use its remote wireless function after spending hours in the field with the instruction manual. When I called Nikon for technical help, their answers confirmed my suspicions that the SB-26 as an internally slaved wireless remote for outdoor use became like Cinderella after midnight. All the fancy trappings suddenly disappeared.

The unit would deliver proper auto-flash exposures, just in non-TTL mode, only when three conditions were met. First, the auto-flash sensor on the front of the unit had to be aimed directly at the subject. Second, the slave unit mounted on the same side had to be aimed toward the camera so that the on-camera flash would trigger it. Third, the unit had to be placed outside the framing of the image in order not to show up in the photograph. The odds of having these three conditions coincide with the pictures I want to take in the natural world are no better than those of getting three bars to line up on a slot machine.

To further complicate things, delay switches must be set so that the two flashes will not go off at the same time and confound the TTL exposure of the on-camera unit. This causes maximum flash synch speed to drop from 1/250th to 1/125th on my top-of-the-line Nikons, a very real problem in bright daylight where loss of a stop of shutter speed means having to set a higher aperture that may reduce working distance to arm's length.

I devised a very successful remote-flash photograph in bright natural light for a Nikon N70 ad by aiming a manually adjusted SB-26 in one hand while shooting a shadowed bristlecone pine limb within touching distance with the other. The weaker built-in flash on the N70 indeed triggered the fill light exactly where I wanted it, but if I had used a LiteLink, I wouldn't have had to figure out all the settings and I could have worked from a greater distance.

Now imagine trying to photograph a spotted owl in mottled forest light. It's a calm bird that can be photographed at about thirty feet on a limb, and it will usually stay put for a brief closer approach to position a remote flash. However, at the moment you near the flight distance of the owl, trying to manually set the power output of an SB-24 for the subject distance would be a hassle that could lose the shot.

With Ikelite's LiteLink, you quickly set down the flash on a small tripod and back up to shoot from forty feet with a 500mm lens without flushing the bird. Each frame has perfect fill without ever thinking about power settings.

LiteLink synchronizes the output of a remote flash by a brilliantly simple technique. Ikelite created two separate slave channels, one to turn on the remote flash by light from the mother flash, and the other to turn it off when that light stops. Since the mother flash stops when the right amount of light has been metered through the lens, the cumulative amount of light put out by more than one unit is simultaneously metered and controlled. The light on the subject can come entirely from one unit or the other, from both or from any number of units with separate LiteLinks.

My exposures have been as good as on-camera smart flash, and I've only had problems where I've gone beyond the capability of the system. For example, I've occasionally exceeded the power of my remote flash by placing it too far away; or I've had the metering system fail to render exposure properly when I aimed the remote flash at a small part of the image area. You can easily learn to predict how your particular metering system responds to these situations and to bracket flash exposures accordingly.

LiteLink can be ordered directly from Ikelite Underwater Systems (317-923-4523) or from Kirk Enterprises (800-626-5074). Remember that you might not need to purchase a new flash for your remote unit. Many old automatic flash units with hot-shoe mounts will synchronize with your state-of-the-art mother flash.

Smart Flash for Dumb Cameras

"Without a smart flash, the desired –1.7 compensation ratio can be attained in a number of ways. A dedicated flash unit that ties the amount of light to the film speed setting on the camera can be fooled into doing the right thing for the wrong reason."

Back in 1988, a few months after I got hooked on smart flash for landscape and adventure photography, I used the same technique for casual shooting at an afternoon party. Every slide came out with a perfect balance of fill and natural light. I had put my Nikon 8008 in Program mode with my SB-24 flash set at a –1.7 compensation ratio; by trial and error I had found that it gave me natural-looking fill in landscape photographs.

When I had tried such casual shooting with either flash-equipped point-and-shoot cameras or more sophisticated SLRs with pop-up flashes, I had found I could get acceptable one-hour prints for family use, but not well-exposed slides for publication. What caught my fancy, however, was that an occasional frame would come out just right. Was there a way to make that happen every time, just like my smart flash?

I began experimenting with point-and-shoots and light SLRs for outdoor adventures after Nikon introduced the N70 with the first programmable built-in smart flash. I tried "top-down" tests with the "smart" N70 and then began to see if I could simulate those results with "bottom-up" tests using an old favorite Olympus XA and a super-light Canon Rebel-X SLR.

If you want to set your camera on autopilot and never worry about computing for flash, there's no substitute for smart flash. If you regularly exert finer control over your images, however, balanced fill-flash with an unsmart camera is possible.

Without a smart flash, the desired –1.7 compensation ratio can be attained in a number of ways. A dedicated flash unit that ties the amount of light to the film speed setting on the camera can be fooled into doing the right thing for the wrong reason. First, set shutter speed and aperture for a manual exposure of the naturally lit background. Second, set the exposure compensation for –1.7 stops (or 1.5 if there is no 1.7 setting). For cameras without this adjustment, set the film speed 1.7 stops higher than normal; for example, ISO 320 instead of 100. Now you'll have a correct background exposure combined with flash that won't blow out natural shadows with overly bright fill. Remember to set your film speed back to the original ISO or you might end up with whole rolls of seriously underexposed pictures.

Things get more complicated when built-in flash units are relatively weak or not dedicated. Beginning from square one, you need to determine at what distance and apertures your unit will give you perfect-looking flash fill. Don't trust the listed guide number for your flash unit. Logically, it should be too low; you need 1.7 stops less light for fill than for full-power flash in totally dark situations. Practically, guide numbers tend to be exaggerated, unless, that is, you're shooting in a narrow white hallway in a Hobbit house with five-foot ceilings, where lots of light is reflected. In the open outdoors, effective guide numbers are reduced by at least half.

The concept of a guide number is far more simple than its relationship to light falling off in inverse proportion to the square of the distance makes it sound. Because the f-stops on your lens are also based on squares relating to the size of the lens opening, a flash guide number for a particular film speed remains constant as simply aperture times distance.

A guide number of 64 means that at f8 a subject can be properly lit up to eight feet; at f16, four feet.

When I tested a Nikon N70 for outdoor fill with ISO 100 film, I began by setting the lens at f8 using the pop-up flash at distances varying from two feet to eight feet. Without flash exposure compensation, only one of these distances would give a correct exposure, but the N70, with its built-in smart flash, gave perfect exposures up to five feet, where they began to go dark. I concluded that 4.5 feet was the maximum distance, and eight times 4.5, or 36, was my guide number. To confirm this, I later tested fill up to eighteen feet at f2 and down to about two feet at f16. I get a majority of properly exposed fill-flash images with the N70 simply by checking to make sure that I'm always within the limits of my experimental guide number.

With the Canon Rebel, exposures aren't so simple. The extremely light camera is very appealing for recreational use, but it lacks a flash exposure compensation setting and has a fill guide number that tests out at 30. Images made closer than the distance computed with the guide number are consistently overexposed for natural-looking fill.

If successful fill-flash in the outdoors was merely a matter of choosing guide numbers, lots of people would be doing it with simple cameras. There are other complications. Two photographs on page 69 were made with and without fill-flash using a Canon Rebel on a climb of El Capitan in Yosemite. Without flash, the image is too dark. With flash at five feet at f5.6, the fill is excellent except for a strange round shadow on the rock at the left. The big 20–35mm zoom lens I was using interfered with the built-in flash's coverage area at close range with wide-angle settings.

There are three easy corrections for this problem. One is never to shoot wider than 28mm. The camera's manual recommends this limit as the coverage of the flash, but in practice the fill looks okay on this 20mm shot, even with a bit of fall-off at top and bottom. The second solution to the lens-shadow problem is to turn the camera 180 degrees so that the shadowed flash is not a factor against the natural light of the sky.

The alternative of using the 28mm setting and backing farther away from my subject was not an option on a tiny ledge 1000 feet up a sheer rock face.

A major problem with overexposed backgrounds occurs when a camera with a low flash synch speed and a weak flash is used in an auto-exposure mode. An aperture of f8 that works perfectly for fill at four feet will give a hideous two-stop or more overexposed background in bright daylight if the camera automatically limits shutter speeds to 1/90th when the flash is popped up. The Nikon N70 is better with a 1/125th synch speed. More sophisticated top-of-the-line Nikon and Canon SLRs have a far more versatile 1/250th synch speed, but lack a built-in flash.

In summary, any camera with a flash can give you perfect daylight fill if you know how to choose the situation. Depending on whether your flash unit is basic, dedicated, or smart, you will need to follow some or all of these procedures:

1. Compute your own experimental guide number and stay within its limits of shutter speed times aperture.

2. Don't let your camera choose a slow flash synch speed that will overexpose the natural light. (Many cameras have warning signals for this.)

3. Test wide-angle or large-diameter lenses for light fall-off and shadowing of close subjects.

4. When shooting verticals, turn the camera so that the flash is on the side of the lens that maximizes light on the subject and minimizes shadowing of wide or large lenses.

When all is said and done, it takes a focused mind as well as a focused camera to make consistently good fill-flash exposures with point-and-shoot equipment. The only other option is to always carry around that pro SLR with a 1/250th synch speed and separate flash that will allow you to shoot away at f8 or f11 in bright daylight. I'm still waiting for someone to come out with a perfect camera for my outdoor adventures. It should weigh less than a pound, zoom to 20mm with full flash coverage and no lens shadow, synch to 1/500th, and have programmable flash exposure compensation. In the meantime, I've taught myself how to make do.

Aerial Wisdom

"The obvious vibration lessens as you move the point of contact away from your hand. It virtually disappears when you lift your arm up. I've had shots at 1/1000th go soft when I've braced my camera hand."

Experienced outdoor photographers rarely shoot good aerials on their first attempts. I'm a case in point. My murky 1970 Yosemite aerials will never be published because I assumed that my cherished techniques for terra firma would easily translate to a moving world seen from above.

I recently watched a dedicated photographer with more lenses than fingers turn a memorable Himalayan flight into muddy Kodachromes, in which Nepal might as well have been New Jersey. His wife, who lacked his baggage of technical assumptions, used her point-and-shoot with grainy, but forgiving ISO 400 print film to take excellent record shots of their once-in-a-lifetime flight.

My wife had success with aerial photography for different reasons. A pilot for over a decade, Barbara had been doing Lighthawk volunteer flights to give influential people the powerful experience of directly seeing environmental problems. She shared the group's conviction that most photographs fail to convey the aerial environmental message.

Barbara didn't shoot from airplanes herself until I asked if she could photograph threatened rainforests on a mission to Costa Rica with other pilots. Since her land-based images had appeared in *National Geographic* articles, I didn't volunteer unsolicited advice. As she was packing, she said, "If I do shoot aerials myself, tell me what to do, but make it simple. I don't need the reasons."

She scrawled: "Velvia pushed one stop/fast fixed lenses/no autofocus or zooms/shoot wide open/wide angles sharper/polarizer." Weeks later, she proudly showed me twenty rolls of crystal-sharp, well-exposed aerials.

Even though I've just listed all you need to know, Barbara's experience is the exception. I've given the same advice to other photographers who generally ignore one or more items out of habit. They just love that 28–200mm AF zoom that precludes having to change lenses. They don't consider that it's three stops slower than my 35mm $f1.4$, far lower in contrast and resolution, and incapable of autofocus on moving aerial edges. Thus, experienced photographers seem to require the most deep background information.

I'm dictating these words while driving south from Moab, Utah, where I picked up some Chicken McNuggets and fries. The crunching sounds mixed with my words are only distracting to my assistant. Once they're transcribed onto paper, the words are as clear as the winter landscape out my window. But that's not how photography works.

The snow-covered red sandstone flashing past me is a photographer's paradise. I can easily use words to describe how the peaks of the La Sal Mountains hover over an ever-changing panorama of blushed slickrock etched in white. But to execute the critically sharp photograph of my choice, I have to stop when I see a special situation that turns me on, line up the foreground to lead my viewer's eye, and use a high aperture with a slow shutter speed to get full depth-of-field with my camera on a tripod. If I tried to hold up my camera and click away from my moving car, my best results would be blurry and imprecise.

Given only this bleak comparison, it would take a miracle to shoot a publishable aerial. The saving grace is that every form of photographic failure has

a flip side where the same effect can be creatively used in a different situation with a positive result. For example, the loss of shadow detail that makes one aerial photograph appear murky makes for a sharply defined outline with the proper light and subject matter. Dramatic shadows are maximized by shooting at an angle to the sun, and this also happens to be where a polarizer selectively removes scattered blue light from the thick atmosphere to greatly increase color saturation and contrast. Remember that polarizers used in line with the sun or in indirect light have no effect on color or contrast.

Dramatic aerials require either strong shadows or sharply defined differences in reflectance, like those found at the boundaries of biological edges such as coastlines, meadows, forests, or snow cover. Search these out, rather than the more softly lit foreground objects of the sort that create the most visual power in normal scenics.

The flip side of not having close foregrounds is no focusing. Everything stays at infinity. Yet improper equipment choices can make focusing problematic. An autofocus lens high in the sky is about as useful as a cellular telephone at the bottom of Carlsbad Caverns. AF systems were designed to lock onto the sharp edges of ground-level features. Aerial haze and reflections make them whir like a washing machine as they search the murk.

Because AF lenses set manually vibrate out of focus while shooting from a moving plane, I choose older manual lenses that stay locked on infinity. My Nikon 35mm $f1.4$ and 85mm $f1.4$ give me the highest possible shutter speeds to use with slow, sharp slide films. I try to shoot at over 1/1000th and consider 1/250th my slowest safe speed with my 35mm lens (1/500th for my 85mm). Using a custom gyro can lower minimum shutter speeds by two or three stops, but at a four-figure cost combined with a high gumption factor.

I've found the major cause of soft, unsharp aerials to be poor technique that connects the aircraft's inherent vibrations to the camera. For example, let's say you want to shoot a dark mountain lake in beautiful last light on ISO 100 film. You ask the pilot to slow down, get his permission to open the window, and brace your forearms on the sill as you aim your camera down to compose the perfect picture. When you get your slides back, they look great held up to the light, but blurry upon projection.

In another situation, you shoot eye-level mountain terrain at the same shutter speed. This time your arms didn't touch the aircraft as you shot and your images are perfectly sharp. You can judge a similar effect while driving down the freeway by putting your wrist against the top of the steering wheel and watching the tips of your fingers. The obvious vibration lessens as you move the point of contact away from your hand. It virtually disappears when you lift your arm up. I've had shots at 1/1000th go soft when I've braced my camera hand.

While averaging meters often over- or underexpose contrasty aerials, multi-segment metering systems will do the trick about 95 percent of the time in aperture-priority mode. Program modes that won't select maximum apertures in bright light are to be avoided.

The ideal film for aerials needs to be fine-grained, yet very high in contrast and color saturation. Our visual system allows us to see subtle differences in color from the air that aren't recorded on films that impart accurate colors of close subjects in ideal lighting. Aerials look just right on a film that appears almost harsh and garish for studio work. I use Fuji Velvia push-processed one stop to ISO 100 to gain contrast and extra warmth to cut the blue haze. When I need a faster aerial film, I push Kodak E100VS one stop to ISO 200.

Even with my extensive experience, aerials remain iffy enough that I follow the action photographer's motto: *If it looks good, shoot it; if it looks better, shoot it again.* I have yet to discover how not to use about ten times as much film as I do on the ground to get publishable results.

Going to Extremes

"Let's face it: Average-looking pictures are boring. Are there exceptions? Not really. The more subtle a successful nature photograph appears, the more conscious effort has usually gone into making it look that way."

Many years ago, a wise geographer told me his theory that the extreme becomes the norm. A veteran of decades of college field instruction, Doug Powell explained how human perception can polarize information about the natural world into extremes. If you ask locals how cold it gets in winter, they'll usually tell you the all-time, record low temperature. If you ask how deep the snow gets, they'll hold their hands over their heads to the height of the deepest snowfall ever, when they were three years old and three feet shorter.

Powell's Law is especially relevant to photography. We tend to search out extremes, even when our intention is to have them represent the normal in other people's minds. We choose the most perfect spot in a meadow, the meanest look on a captive wolf, the boldest angle on a mountain face, the most traditionally dressed person in a native culture, and the peak moment of a smile.

Let's face it: Average-looking pictures are boring. Are there exceptions? Not really. The more subtle a successful nature photograph appears, the more conscious effort has usually gone into making it look that way. Eliot Porter, the early master of large-format color nature photography, knew just how to compose and print his images to appeal to sensitive souls. He was an absolute stickler for detail from conception in his mind's eye to perfection in his hand-made dye transfers or color separations.

When he gave a presentation in his middle eighties for *National Geographic* photographers, I overheard a group of the top movers and shakers trying to figure out what all the fuss was about. They agreed that they hadn't seen a single image that an editor would pull for a select for a *National Geographic* story. Since hundreds of selects are pulled for stories with ten photos, the criticism was harsh, yet heartfelt.

What was overlooked was that Eliot Porter never went around the country giving slide shows. He had made an exception to share his work in a strange format with an esteemed group of his peers. His exquisitely detailed, large-format imagery that fascinates the eye when viewed up close had been copied onto 35mm dupe film to be projected onto a distant auditorium screen. Thus his stylistic extremes became virtually invisible, even to an unusually sophisticated photographic audience.

So it is with all successful photography. Subtleties are carefully orchestrated so that viewers remain unaware of how intentional they really are. Only when photographers try to copy a remarkable landscape image that they have seen do they perceive unique elements that were not, at first, apparent. This discovery rarely happens through the viewfinder; it descends like a dark cloud when the new image is compared to the one that first drew our eye.

How did we fool ourselves? We mentally compared an incomplete image stored in our memory with the finely detailed scene before us. As soon as a few characteristics appeared the same, our perception jumped to the conclusion: "That's it!"

The ability to recognize a pattern from limited bits of random information is what separates brains from computers. Every animal needs to make quick decisions based on limited information. An insect assumes that any point light source is the sun. A rocket

scientist assumes that a set of curved lines in a newspaper cartoon is the face of President Clinton. The public, through photography, assumes that Eskimos live in igloos, Hawaii is always sunny, and wild buffalo can be safely approached for point-and-shoot snapshots. Powell's Law. No wonder most people assume that nature photography is simply having the right equipment in the right place at the right time.

Successful photographers avoid becoming passive victims of fickle extremes and norms. They actively tune into them to provoke a predictable emotional response. Deceptively simple images can download cascading crystal kaleidoscopes of stored emotional personal experience. For example, Alfred Eisenstaedt's famous image of a sailor kissing a woman on the street would fall flat as a fresh image in today's marketplace. Its universal appeal was related to *the* extreme of its time: World War II. Ansel Adams' iconographic images reflect the prewar heightened reality of national parks as pristine playgrounds with no hint of human impact.

Extremes become norms in photographs because of yet another assumption of overall intentionality. Despite our somewhat contradictory penchant to overlook details, we assume that a human being is trying to tell us something within the framing of a photograph, whereas if we were to witness the real scene we would not jump to such an extreme conclusion. Most often, this assumption causes well-intentioned photographs to fail because of distracting, inadvertent content. This tendency to rush to judgment can also be consciously manipulated toward considerable rewards. The images published here were shot within minutes of each other and have produced tens of thousands of dollars of stock photography income for me, yet I have far more dramatic rainbow images that have never sold.

Yosemite, like World War II, is a shared public icon charged with far more complex emotions than in the early days when Ansel Adams sought out singular beauty. I have a rainbow image similar to the three shown here, but without human presence. It represents the pristine beauty of cliffs, waterfalls, and green vegetation, but I've had more success selling the one that has a spot of natural light on a lone figure in the wilds. It triggers the romantic notion of enjoying a day hike—an icon of a positive visitor experience.

The second image of a hiker descending with a heavy pack has been published scores of times to represent the rugged extreme of hiking the 211-mile John Muir Trail, though I have no idea if the person hiked the whole trail or just the last miles of it. The third image has had the greatest number of sales. Waiting for a moment when a large number of people were beneath the rainbow, I created an image often used to illustrate overcrowding in our national parks.

None of the assumed iconic meanings of these images reflect my experience at the time. The popular trail was neither overcrowded nor particularly wild, being close to the noisy floor of Yosemite Valley. Yet by consciously searching out several extremes of one situation, I was able to illustrate a variety of norms that were already embedded in the minds of my audience.

Commercial success, however, is not my ultimate goal in nature photography. True satisfaction comes from a multiple convergence of Powell's Law. Not only should an image illustrate an extreme chosen to echo one already firmly embedded in the public consciousness, but also it should mirror one more grounded in reality: the photographer's personal experience. All too much of today's published editorial photography is contrived to appear to be something it isn't. It serves the marketplace, but not the soul of the artists who make it. The rare images I've made where everything comes together mean far more to me than others that may have produced greater income because of perceived extremes that were not really my true experience.

Filing is Forever

"Today I can drop off one hundred rolls of slide film at The New Lab on the way home from San Francisco Airport and give a perfectly ordered in-depth slide show the following day, with all the editing for my stock files completed."

Every successful nature photographer finds a way to edit an ever-growing number of images and get them in the hands of clients or stock agencies. In today's fast-paced world of magazine, calendar, and advertising sales, the best 100,000 images on Earth that remain in their processing boxes might as well be toilet paper. Clients regularly demand to have specific images, with clear captions, sent to them overnight.

In the late sixties, I began selling my select 35mm slides out of metal storage boxes labeled by year and location. When I had an inquiry, I would madly scribble dozens of captions on the mounts of originals before sending them off with a prayer. Magazines often misread my sloppy handwriting and made grievous captioning errors. When I traveled, the friends I asked to send out requests in my absence lost many sales without the information filed only in my head. At home again, I would squander valuable time and money on long-distance calls to clients who wanted a caption for "that mountain with the pink clouds."

In 1973, the *National Geographic* jump-started my editing technique on my first assignment. The magazine had me ship all my raw film, numbered on the cassette to match a caption booklet with name, date, assignment, location, film, camera, and a description of each situation. One page might do for twenty rolls of Yosemite aerials, while three pages could be required for a single roll: frames one through five of one person, six through eight of a different situation, and so on. Before I arrived in Washington to work with the editors, my name, assignment, and roll number had been imprinted on each slide. We put together a slide show for the top editors in a day, and later used the caption book for key information about the images chosen for the story.

Even though a year passed before the story ran and my film was returned with rights to all but the published images, I found it easy to sit down with the numbered boxes from the shoot to select and caption sharp, well-composed frames in the order in which I first took them. I decided then and there to number my slides and keep a caption booklet for all future large shoots, whether personal or on assignments for publications. The amount of time saved over randomly opening boxes and trying to edit them out of order was far more than 50 percent. I saved even more time when I bought a Trac Slidetyper machine in the 1980s to stack-load up to fifty slides with identical six-line imprints. After devising more ways to minimize my own input into the process, I now spend less than 10 percent of the editing time per box that I spent when I first turned pro in 1972.

Today I can drop off one hundred rolls of slide film at The New Lab on the way home from San Francisco Airport and give a perfectly ordered in-depth slide show the following day, with all the editing for my stock files completed. Here's how it works:

When I pick up my film a few hours later, I order the boxes by number before editing on a light box, where I use a prototype device to spread out a dozen slides for comparison in less than a second. (Don't ask about buying one, because it's patented, but not in production. Photo companies say there aren't enough big shooters out there to make it a viable product.) I brush each publishable top select with a red marker that allows clear caption overprinting. Candidates for

my slide show or a special client get an extra green slash that tells my staff to return it to me after imprinting, rather than filing it. Images of generally publishable quality get no mark, while those that don't make the cut are boxed and stored or thrown away, depending on the subject.

All images that are to have the same caption are put into the same compartment of a divided box. I write it on a Post-it along with a file code number. If I have different subjects from the same location—sunset instead of sunrise, or lion instead of zebra—the Post-its for adjoining sections indicate only one of the six computer imprinted lines to be changed. My staff takes over from here (as can a part-time helper or a friend for busy people without regular employees). After the slides are imprinted, we place them in individual Kimac clear protection sleeves before slipping them into archival twenty-slide sheets and putting them into hanging files.

The crucial code numbers from my personal filing system are like library Dewey decimals, but for categories only, rather than single entities. The code C1-Y1-9A breaks down into C1 for California (C2 is arbitrarily assigned to Canada), Y1 for Yosemite, and 9A for summer scenics in Yosemite Valley (9 was all valley scenics until the file got too large and was further divided into 9A for summer and 9B for winter). Because of the nature of my work, I file by geographical location first, except for wildlife, which is filed by continent and species. Thus all Half Domes in summer are in the same file, and all coyotes are in a different file. My codes are not perfect, but they are far better for my diverse work than using someone else's system, especially present computer file management systems that by their very nature must satisfy a broad base of photographers. Each photographer is best off making a personal choice, and for some, that may be an off-the-shelf photographer's database.

My code names and numbers are stored in FileMaker Pro on a Macintosh to keep the list easily expandable. Individual numbers and caption info with keywords are not given to the 300,000 slides in the general file, because I'd rather spend the years of my life that the task would consume in the wilds instead of behind a desk. Stock agencies representing multiple photographers indeed must assign individual numbers to keep track of proper payments, but photographers in business for themselves can save time and money here. (I do keep a much smaller database for my relatively few sales of exclusive rights, such as "greeting cards for three years.")

Submissions of one or hundreds of images are tracked by xeroxing each slide sheet with a 300-watt lamp aimed through the slides from above while the top is left open on an old manual copy machine, to deliver a perfect little black-and-white record with the caption on the mount lit from underneath. Thus I can quickly figure out which slides have been returned or held without having to scan each image.

I only assign single numbers to a file of just over 1000 "AA Selects" kept out of general circulation. These top images that have appeared in books and calendars or otherwise captured my fancy are supplied in 70mm or 35mm duplicates to clients, except for very special circumstances, such as the production of a large fine-art poster. (Someone requesting a selection of top Yosemite work for a calendar would get more AA duplicates than originals from the general file, while someone looking for a picture of a foxtail pine would get most, if not all, originals.)

And that instant slide show? I get back my red-and-green marked, imprinted slides in those divided boxes with Post-its that reflect the chronological order of my edit as well as grouping of similar subjects. When I lay them out on the light box, I can select a tight sequence of the very best images ready to tray up in a few minutes. Or, if I want to project the show more than once or twice, I can shoot duplicate slides and file away those most valuable originals, fully captioned and ready to sell.

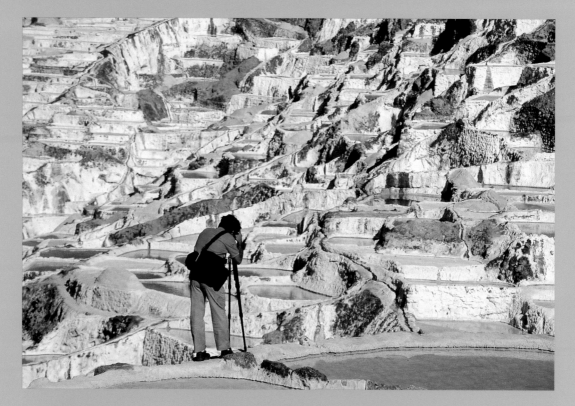

© 1994 GALEN ROWELL
SUNSET AT
PUNTA CHIVATO,

SEA OF CORTEZ,
BAJA, MEXICO M1–B1

Above: *Essay pages 84–85, 88–89, 135–137*
While I was shooting the pre-Inca Salt Pans of Maras in the Urubamba Valley of Peru, my wife Barbara caught me with my usual complement of equipment in a modular fanny pack that I designed (no longer available).

Left: *Essay pages 111–112*
Simple codes and captions maximize ease of editing, filing, and retrieval. "M1–B1" means "Mexico, Baja." The red mark means a top select placed in the front of the file. Green means an initial hold out for a special use—often, but not always, the prime select.

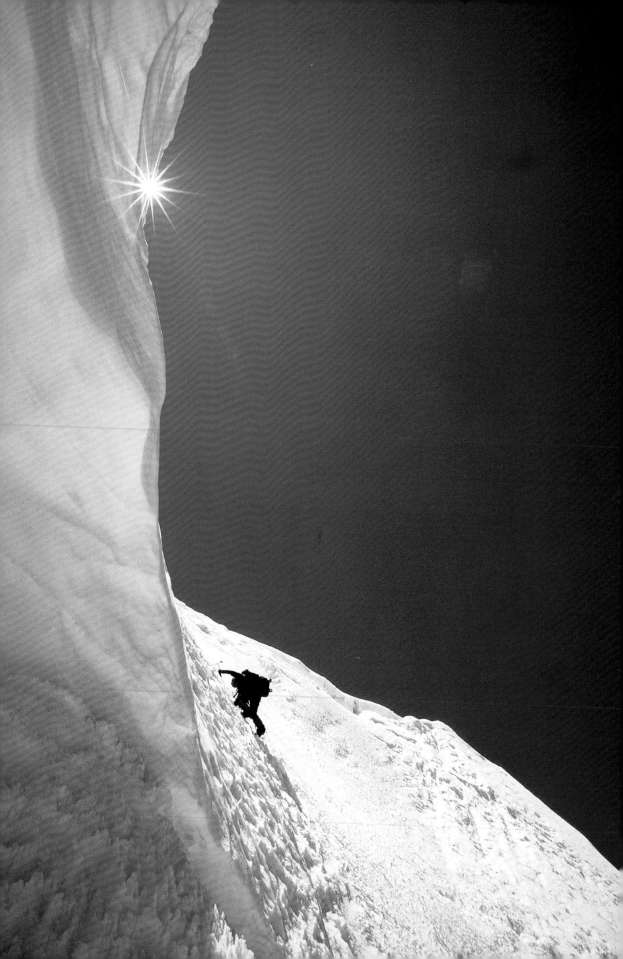

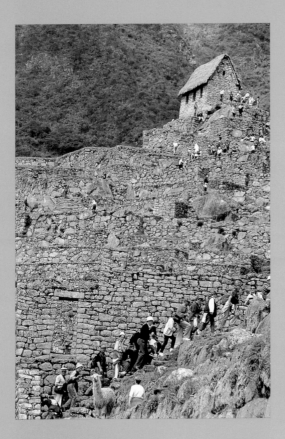

Left: *Essay pages 147–148* Climbing 22,205-foot Huascaràn, the world's highest tropical peak, has become ever more popular since the end of Sendero Luminoso terrorism in Peru.

Above, above right, and right: *Essay pages 135–137* Though Machu Picchu appears to be an untouched relic from a distance (page 5), many "ruins" are in the process of Disneyland-style reconstruction to lure more tourists to Peru. One is never sure which walls are truly ancient, which have been simulated by modern hands, and where the boundary between fantasy and reality lies.

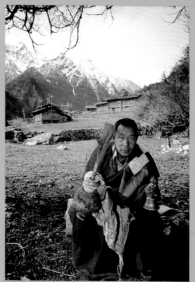

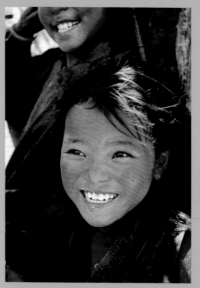

Above: *Essay pages 132–134*
The Kanchenjunga Glacier leads to the world's third highest peak of the same name in a pristine region where Nepal, Tibet, and Sikkim meet.

Far left: *Essay pages 98–102, 132–134*
A Tibetan refugee monk doing his prayers outdoors under a tree in the Kanchenjunga region is lit by fill flash over a manual exposure for the background.

Left: *Essay pages 98–102, 151–152*
The smile of an ethnic Tibetan girl leaning out a window in Mustang in northern Nepal lights up with fill flash.

Right: *Essay pages 132–134*
Many species of rhododendrons line the wild valley of the Ghunsa Khola in the Kanchenjunga region.

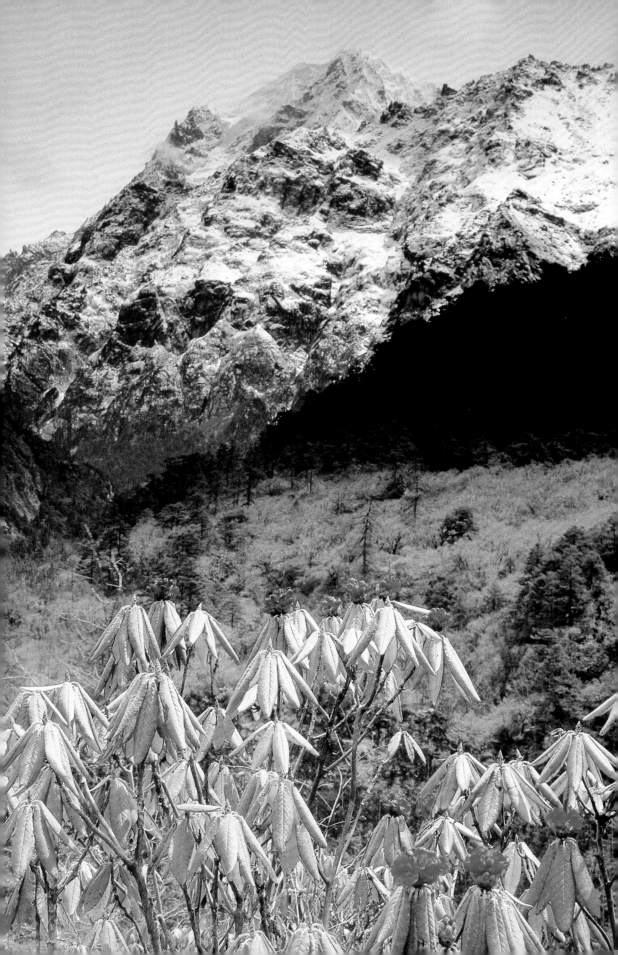

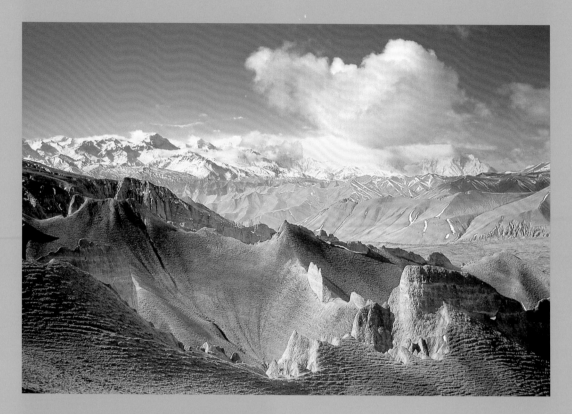

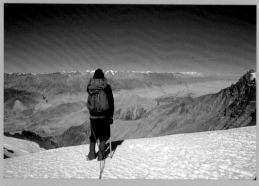

Left:

Essay pages 151–152
From the summit of a 20,600-foot peak in 1977, Kim Schmitz peers at the forbidden Kingdom of Mustang, part of Nepal, but closed to Westerners until 1992.

Above:

Essay pages 151–152
The same peak as at left is visible on the horizon in this view from Tramar on one of the first treks permitted into Mustang by the government of Nepal.

Right:

Essay pages 151–152
The walled city of Lo Manthang was the fabled capital of the once-independent Kingdom of Mustang.

Above:

Essay pages 151–152
The northern wall of the Himalaya looms over Mustang, politically a district of Nepal, but geographically and culturally Tibetan.

All (5): *Essay pages 138–144,
145–146, 186–188*
After reaching the North Pole (above)
on the Russian nuclear icebreaker
Yamal (top, center), we headed off
on a rescue mission to break out the
diesel icebreaker *Kapitan Khlebnikov*
(left and top, right), stuck in 20 feet
of pack ice while attempting the first
circumnavigation of Greenland.
Near the tip of Siberia (right), we
found a large walrus colony.

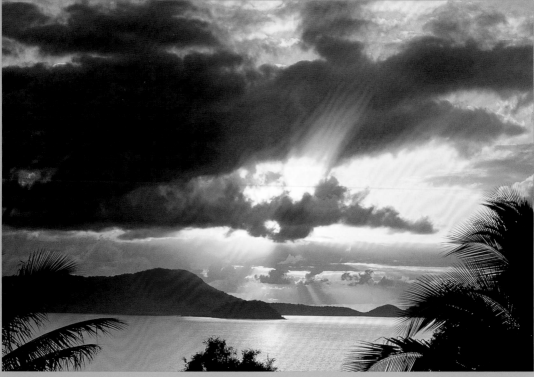

Above (3):
Essay pages 155–156
When not scuba diving, Dunk
Island beside Australia's Great
Barrier Reef is a great place
to watch sunsets and schools
of fish near the surface.

Right:
Essay pages 157–158
Colorful coral 60 feet below
the surface in the Fiji Islands
comes alive when lit by an
SB-104 flash on a Nikonos V
with a 20mm lens. The key to
wide-angle flash photography
underwater is even lighting
achieved by composing sub-
jects to be equidistant from
the light source.

Above (2): *Essay pages 98–102, 153–154*
A wombat (top)—Australia's marsupial panda—emerges from its den on the island of Tasmania, where a predatory Tasmanian devil (bottom) feeds on a carcass at night.

Right: *Essay pages 153–154* Tasmania's rainforests in splendid island isolation hold living relics of the break-up of Gondwanaland about 100 million years ago.

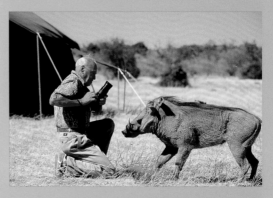

All (5):

Essay pages 149–150
During a Botswana safari (left) my wife Barbara made this haunting portrait (right) of a leopard peering out of dark forest. I captured a jackal following impalas at sunrise (above) with a 500mm lens plus a 1.4X teleconverter, as well as a lion chasing a pack of African wild dogs from a kill (top, left), and a wart hog confronting a photographer at less than his minimum focusing distance (top, right).

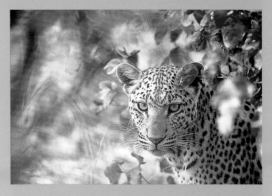

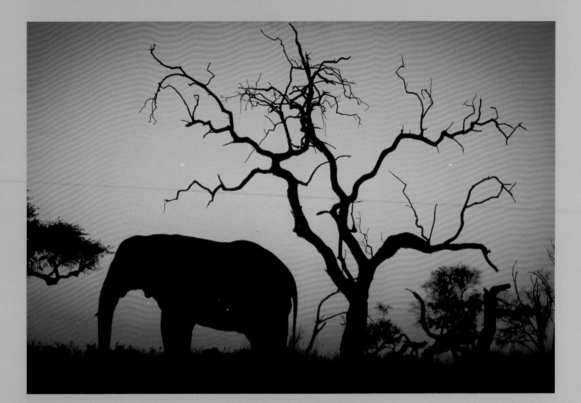

Above:
Essay pages 46–47, 149–150
An elephant silhouetted in
evening twilight stands beside
a watering hole in Botswana's
Chobe National Park.

PART III: JOURNEYS

Merging visions with realities

Of Persistence and Rainbows

"I knew that I was in for some of the most challenging outdoor photography of my life. I find it far easier to hang off a cliff with my camera in good weather than to stand in blowing rain and make sharp pictures of distant subjects."

I would never have gotten up at 4:30 on a stormy August morning in Glacier National Park if it wasn't for the photo workshop that I was leading. The forecast was for a weekend of steady rain.

As I stepped from my warm hotel room into the dark and rainy night, I wondered if I was really being rational. I'd given the fifteen members of my group two options: to meet for an official field session on Logan Pass at 8:00 A.M. or cross the pass in the dark to gamble on finding unusual light on the other side at dawn. I had lured my son, Tony, from California to join me for the three-day event—with glowing stories of wildlife beneath spectacular mountains and deep blue skies. Perhaps I was trying too hard to project an image of rugged resolve.

For the better part of an hour we drove through black rain toward Logan Pass. I rehearsed in my mind how I would say that I'd given it my best try. I had suggested to the group that the best chance of finding a clearing at dawn was on the east side of the pass, where summer storms from the west lose much of their precipitation. When we reached the pass, a dim gray glow was barely poking through steady rain. A mile down the other side, the faint glow turned pink in the distance somewhere over St. Mary Lake. I headed for a parking area where a short trail leads to Sunrise Point atop a high bluff overlooking the lake.

The rain had almost stopped as Tony and I stepped out beneath a section of rainbow rising over the lake. When I reached the top of the bluff, I turned around and saw the heavy rain cloud through which we had just passed bearing down on us from the west. I guessed that we had less than five minutes before it would hit us; five minutes in which the sun rose over the eastern horizon with a crimson aura through the clouds. I took a few abstract shots in beautiful light, but was frustrated by the lack of a strong silhouette or foreground subject to match with it.

As the direct sun hit the oncoming wet cloud, I turned to see that a complete rainbow had dropped over the lake. On the one hand, I felt blessed to be witnessing such a spectacle. On the other hand, I knew that I was in for some of the most challenging outdoor photography of my life. I find it far easier to hang off a cliff with my camera in good weather than to stand in blowing rain and make sharp pictures of distant subjects.

Even if I succeeded technically, the rainbow itself was highly problematic. In the splendid warm light, it was only about half its normal width with the green, blue, and violet hues of the full spectrum virtually missing. Since primary rainbows always maintain their 42-degree radius around the point opposite the sun (when the sun is shining, the point opposite the sun is the shadow of your head), a photograph wide enough to show the entire thin arc would not be a particularly strong image.

I sensed that the rainbow would stay around and become much stronger as the sun rose and the wet cloud passed over us, but could I capture it on film? The wind had picked up to about forty miles per hour and rain was beginning to blow sideways. I searched out a small overhang on the bluff that offered protection from the rain to work out of my camera bag. From the top flap I pulled out one of my most important

items for wilderness photography: a square foot of top-quality chamois cloth. With my camera on a tripod, I managed to shoot a hasty roll of different compositions and exposures before the brunt of the rain hit me broadside, quickly soaking me to the skin, even though I was wearing a ski parka.

Tony had taken off to shoot from a partly protected area in the trees. I could have quit photographing, knowing that I already had a great shot or two, but I could see that the rainbow was getting brighter than ever. I ducked behind the overhang, wiped my lens with the chamois, and held it there until I had my next composition almost framed. Then I pulled the cloth off for a second or two, clicked the shutter, quickly covered my lens, and wiped it dry again. Repeating this procedure, I was able to shoot two more rolls as the rainbow gained intensity and lowered down over the peaks in direct opposition to the rising sun. When I finally quit and returned to the car, I was surprised that a full hour had passed since sunrise. In the flow of the action, working entirely in the present, it had seemed like minutes.

We dried out over breakfast in a warm coffee shop, then headed back up the pass to meet the group in far less exciting light with occasional sections of rainbows appearing now and then. As it turned out, more than half of the other photographers had crossed the pass on their own before dawn and found rainbows at other locations.

After we had our film processed overnight in Kalispell, we had a group critique session that taught each of us an individual lesson. Those who had braved the elements and made fine photographs of rainbows with varying scenic backgrounds were rightfully proud. Those who slept in or didn't cross the pass into the sunlit rain learned something valuable about the role of dedication and persistence in making the most captivating outdoor photographs.

During that weekend, I saw the worst weather in ten years of Rocky Mountain workshops produce the best pictures ever. I know better than to try to predict such an event, even an hour beforehand. Because of what happened, I'll probably be getting up before dawn on more stormy mornings than ever, usually driving or hiking into weather that never breaks. I almost never write about those times, but when they happen, and they will, I won't consider them as failures. If I had to choose between actively pursuing light that never happens in a wild environment or waiting out the rain in a hotel room until the sky is clear, I'd choose the "bad" weather without hesitation. I've found over the years that the value of time spent in the wilds is cumulative, both with and without a camera.

Cultural Conservation and Ecotourism

"While ecotourism works in some places, it has a nasty habit of wiping out the very traditional cultures that travelers come to see. Instead of experiencing remote villages in harmony with the natural environment, ever more ecotourists end up face to face with each other."

A decade ago, I made a New Year's resolution not to write or photograph assignments that merely promoted outdoor destinations without furthering environmental awareness. *American Photo* incorrectly reported that Galen Rowell would no longer do a travel assignment. To the contrary, I've done many that have allowed me to express some of the strong opinions I hold about the effects of tourism on wild destinations. This story about the creation of a new nature preserve in Nepal reveals much of that philosophy, as well as ways in which I regularly get beyond the limitations of camera gear designed for urban shooters.

Let me begin by saying that being an environmentalist ain't what it used to be. In the good old days, all we had to do was advocate locking up lands to keep those other selfish folks from exploiting the birds and the bees, the rocks and the trees. Well-meaning visitors like us didn't count. Only when there got to be too many of us did the travel business coin that comforting moniker, ecotourism. Local people were supposed to be grateful to quit their ecologically insensitive lifestyles and open their doors to ecotourists for the rest of their lives, and we were all supposed to live happily ever after.

While ecotourism works in some places, it has a nasty habit of wiping out the very traditional cultures that travelers come to see. Instead of experiencing remote villages in harmony with the natural

environment, ever more ecotourists end up face to face with each other in modern lodgings created to cater to their needs.

The United States escaped the brunt of this culture clash by practicing genocide before creating national parks. The few aboriginal descendants of Yosemite, the Grand Canyon, and Yellowstone are now well compensated, but if you think of immigration as a recent problem, just ask a Native American.

Wild areas with native cultures began to suffer globally after our simplistic blueprint for national parks was exported overseas into the homelands of local people. A few decades ago, timeless villages that had existed with low impact were moved out of some new parks in Nepal to make way for ecotourists. Other local people allowed to remain in parks became second-class citizens in their homelands. As in America, national parks were ruled by the army until a new paramilitary core of uniformed personnel was established. The flat hats and wide lapels of our modern park rangers reflect the army uniforms worn when the National Park Service was founded during World War I.

When a Nepalese national park was created beneath Mount Everest in the seventies, cutting of fragile forests radically increased to build new structures for soldiers, wardens, and tourists, as well as for heating and cooking. New park plans didn't include old taboos against felling "sacred" forests around villages. An exodus of the best and the brightest Sherpas began as they lost local control and were lured into tourism work elsewhere.

In the mid-eighties, when a new national park was proposed for the Annapurna region, 30,000 native residents wanted no part of it. I was invited by the World Wildlife Fund (WWF) in 1987 to document

their radical solution. In cooperation with the government, an Annapurna Conservation Area was created, fully empowering the local people—for better or for worse—to make decisions about their environment, culture, and ecotourism. Education and incentives were provided by WWF and the government.

When Barbara and I made a story proposal to *National Geographic*, it was turned down with regret that the reserve would not have national park status. After we documented its unique creation for WWF, the magazine ran our story.

A decade later, WWF's Vice President of Asia Programs, Bruce Bunting, invited us back to Nepal to document "what could be the last reserve in the high Himalaya, the Kanchenjunga Conservation Area." Would we join a VIP trek for a final survey into this pristine, roadless region beneath the world's third highest peak? He mentioned the major role my earlier story had had in establishing Annapurna "as the model on which countries all over the world have designed reserves that address the needs of local people."

We said yes and joined a 1997 trek that included WWF's president, Kathryn Fuller, several council members, a *Wall Street Journal* editor, a Nepalese botanist, the Nepalese director-general of national parks, and Mingma Norbu Sherpa, an old friend born beneath Everest. He had attended his village's Hillary School, then studied in New Zealand and Canada for a master's degree in resource management. After returning to Nepal as chief warden of the Everest park, he stepped down to be the first director of the Annapurna Conservation Area. Mingma then became the WWF Nepal representative as well as the project manager for Kanchenjunga. He organized our trek, and so much more.

Day 8, Kambachen village. Only Mingma and I are up before dawn to photograph from the highest and most spectacular spot on our trekking route. As we shiver on a hill at 13,500 feet, waiting for sunrise to hit the sheer north face of Jannu, we discuss our respective bold plans born out of VIP time constraints. His seems the more risky venture.

Our ten-day trekking itinerary does not get us to any place where we can see the 28,206-foot peak of Kanchenjunga. To get us even this high—and to a banquet tomorrow with government officials and ambassadors—Mingma has chartered a huge Russian helicopter to whoosh us to Kathmandu from Ghunsa, nine miles down the valley. It will also bring ministers, other politicians, and TV crews for an on-location press conference. But the last few days of rising mists and roiling clouds would not have been flying weather. Just hours ago, it snowed.

My endeavor involves more predictable ground travel. I am wearing running shorts over polypro underwear with a featherweight Nikon FM-10 in a chest pouch, plus two lenses, three PowerBars, and one Gore-Tex shell. I hope to make Ghunsa for dinner after running nearly forty miles round-trip to Kanchenjunga Base Camp at 17,000 feet.

There's no way I could attempt such an ambitious outing at age fifty-seven with my heavy Nikon F5. It's packed to go back to Ghunsa by yak, along with my other gear. Back in the seventies (my thirties), I used to carry two identical Nikon bodies, but I've learned the wisdom of having very different bodies that fit the same lenses. The F5 may be the sturdiest, most advanced pro camera, but it is four times heavier with its eight batteries than the manual, thirteen-ounce FM-10 I bought for lightweight adventures and emergency back-up. A similar pairing for Canon owners would be an EOS–1N and a Rebel.

Jogging along the frosty trail, my FM-10 feels so light I forget it's there until a feisty yak blocks my path. I grab off a few close shots, divert around the beast,

and reach Base Camp in the sun at 11:00 A.M. as the clouds that have followed me rise and dissipate into the dry mountain air. An American expedition invites me in for yak steak salvaged from a pack animal that fell to its death off the trail I just ran. I spend another hour shooting two rolls with top Nikon lenses loaned to me by a climber before running back beside the Kanchenjunga Glacier to Ghunsa.

Mingma's bold plans unfold like clockwork. The next morning, a chopper drops through the only blue spot in the clouded sky to whisk us to the banquet after the press conference. A few weeks later, the government mandates the new conservation area. *National Geographic* decides to run an "Earth Almanac" piece with two of my photos—one F5 shot in a village, plus the yak in the snow taken with the FM-10. The photos that appear in this book also reflect those different cameras and working styles. For the Tibetan monk doing prayers in blotchy shadows, the F5 on a tripod gave me perfect ambient and fill-flash auto-exposures; for the Kanchenjunga Glacier on the run, the FM-10 produced tack-sharp, hand-held manual exposures.

The moral of this story is both environmental and photographic. Camera gear, like clothing, needs to be chosen for the occasion. Ultralight SLR bodies may lack bells, whistles, and durability, but they allow more creative options than switching to a point-and-shoot when your pro camera becomes a burden. By all means write your manufacturer if you can't find enough functional, lightweight options for your SLR camera system. When many photographers express a need, they begin to listen. That's how we ended up toting those three-pound bodies and three-pound $f2.8$ zoom lenses in the first place!

The Long Way to Machu Picchu

"Machu Picchu is changing forever. The walls that have stood well against the forces of nature are not enduring the influence of Disneyland and its ilk. Like the Spaniards in their ruthless pursuit of Inca gold, Peruvians are now sacrificing their heritage in a lust for foreign currency."

In 1990, my wife, Barbara, made an emergency landing at 12,500 feet in Peru after being cleared internationally to Bolivia. Her single-engine Cessna was fine, but the oxygen had failed on an identical plane flying over the Andes with her. Both craft set down on a perfect runway near Juliaca, where Barbara explained the situation to a distressed airport manager while I did the obvious thing: grab my camera and head into the fields toward Quechua Indians herding alpacas.

Minutes later, I was sternly called back. We had no permission to be there or to take off again. No private foreign plane had ever landed there, and they had no repair facility. We had dropped out of the sky into a region controlled by Sendero Luminoso guerillas. After an eerie night in an empty tourist hotel, we negotiated permission to depart for the Atacama Desert of Chile.

So ended my first visit to Peru. By 1994, the infamous decade of terrorism was over and Wilderness Travel asked me to lead an Inca Trail trek for photographers. I was hesitant until a guide who had just made an Inca Trail reconnaissance said that personal safety seemed to be on a par with trekking in Nepal, which I considered safer than staying home. Barbara and I agreed to lead ten photographers on a five-day trek to Machu Picchu, with gear carried by porters and camps set at the most photogenic spots. After two nights

135

in a hotel near the classic ruins, we would return to Cuzco by narrow-gauge railroad.

Machu Picchu is inaccessible by road. Most visitors arrive by train, while some trek the thirty-two-mile Inca Trail through cloud forest with no inhabited villages along a seemingly endless quilt of hand-carved granite blocks laid down in the fifteenth century. It was completely grown over when an American amateur archaeologist named Hiram Bingham found it in 1911. He had been searching for the lost city of Vilcabamba, the Incas' legendary last refuge from invading Spaniards, when peasants led him to the partially exposed ruins of Machu Picchu. Though the media touted Bingham as the discoverer, local Peruvians were quite aware of Machu Picchu's existence and an earlier explorer, Antonio Raimondi, had correctly mapped its location.

The true importance of Machu Picchu is due to the city *not* being what Bingham thought he found. Instead of a town built hastily in an unlikely, well-hidden location by Incas fleeing the Spanish invasion of the 1530s, Machu Picchu is the finest surviving example of the "Late Imperial Inca" style of architecture, as yet untainted by European influences. Bingham may not have truly discovered it, but he did reveal its existence to the developed world.

Much of the significance of the ruins is based on their improbably fine construction and endurance. The Inca stonework took decades to complete and shows a reverence for precision far beyond that of modern stone masons. Blocks weighing many tons with up to twelve sides fit together so perfectly without mortar that a knife blade would rarely fit between them.

While en route to the Inca Trail, we stayed in Cuzco's five-star Hotel Libertador, built within existing Inca walls because of strict laws for historical preservation. After another night in the Urubamba Valley, "The Sacred Valley of the Incas," we caught the train at Ollantaytambo, a close modern counterpart to a living Inca village. Many of our porters lived here and boarded with us for the brief twelve-mile ride to the start of South America's most famous trail.

The route began seemingly out of nowhere and went up a dry side canyon toward a 14,000-foot pass. Our camps were near ridge crests, where we could wander off to take fine landscapes at dawn and dusk, uninterrupted by meals or chores, while porters watched any gear we left behind. On our fourth and final trail night, Barbara and I were awakened by whispers outside our tent. I unzipped the door and saw two dark silhouettes within arm's reach. "Café con leche?" a voice asked.

Two of our porters were waking us before sunrise with mugs of coffee mixed with hot milk. Other photographers emerged from their tents as the eastern sky was turning crimson behind icy peaks. We were joined by a porter named Francisco wearing a Quechua poncho and eared woolen cap. When first light struck him on the crest of the ridge, the vivid reds in his ornately patterned fabrics came alive. As he played his Andean flute beneath the white pyramid of 20,000-foot Salcantay, I could imagine his Inca ancestors standing in the same spot.

A breakfast of hot cakes, fruit, and coffee was served just after the magic hour. As the crew broke camp, we began the final descent toward Machu Picchu. With each step away from arid Andean highlands into moist Amazonia, my powers of perception felt keener. Perhaps the Incas planned it this way, perching their sacred town behind green-clothed monoliths on the boundary between these two worlds.

Machu Picchu didn't show itself until the final mile at Intipunku, a notch floored by a walled plaza. My attention was diverted to white numbers painted on all the lower stones of Intipunku's walls, but I forgot about these un-Inca intrusions as I continued on to the classic overlook where the most splendid integration of landscape and architecture I had ever beheld was stretched out before me. The bold coherence between intentional design of stone city and natural splendor of rock walls rising out of jungle veritably defined the intangible rewards of adventure travel.

Every culture breeds pilgrims who voluntarily leave the comforts of their normal routines to experience hardships without hope of material gain. Their intentions and rewards are spiritual and personal—a heightened sense of joy and understanding of a chosen destination, perhaps nothing more. So it is for modern travelers who follow the path of the Incas over three mountain passes to reach a site of great spiritual and ceremonial significance. Yet Machu Picchu is changing forever. The walls that have stood well against the forces of nature are not enduring the influence of Disneyland and its ilk. Like the Spaniards in their ruthless pursuit of Inca gold, Peruvians are now sacrificing their heritage in a lust for foreign currency.

Early in the morning, I entered a closed area before government workers appeared to rebuild walls. I watched them use mud for mortar that was never there to fit together an assemblage of white-numbered stones that began at ground level. A supervisor's schematic of the rocks, numbered as they had been taken down, showed the jagged outline of a typical ruin, but the reconstructed wall before me terminated in a perfect turret of unnumbered rocks several feet higher than what Bingham had uncovered. Behind that turret was another rebuilt one, and another—

fabrications to complete what the original structure "might" have looked like.

When I asked the supervisor about the simulation, he gestured toward hundreds of people who had just arrived on the train and said "tourismo." His government, with its economy reeling from civil unrest, had ordered him to recreate a virtual Machu Picchu, mimicking the success of orderly American theme parks.

When I learned that our train would not depart until 3:00 P.M. on the third day, I decided to run the trail in reverse and hop aboard at the start. For seven magical hours without my camera, I retraced the thirty-two miles past far smaller, but unretouched ruins rising out of the jungle that took on new significance. Like photographs in a scrapbook, they were visions from the past that could be trusted. Machu Picchu, however worth seeing, now seems to me like a digital advertisement in which apparent reality is suspect.

The Nuke That Came In From The Cold

"The idea of boarding a Russian nuclear ice-breaker bound for the North Pole seemed about as likely as landing a couple of NASA 'journalist-in-space' grants to go moon-walking with our favorite cameras."

The idea of cruising to the North Pole on a surface ship never occurred to me until I saw a most unusual slide show. Polar bears, walrus, rare gulls, and a huge nuclear icebreaker danced on and off the screen as strong hands tried to still the projector. The lecture was taking place on a conventionally powered Russian icebreaker returning from Antarctica. As we crossed the wild seas of the Drake Passage in the heart of the Far South, the stunning images of the opposite polar realm were especially memorable.

My wife, Barbara, and I were expecting to be part of a "once-in-a-lifetime" journey on a Soviet icebreaker, but this cliché of the adventure-travel industry had come decisively true for an unexpected reason. Once we had reached Antarctica, our ship had anchored in a quiet bay. Vodka flowed while the Soviet flag came down and a hand-sewn Russian replacement was raised. A cast-iron hammer and sickle clanged onto the deck as a crewman broke it free from the superstructure. The crew did not seem happy.

While we tourists flitted about with strobes flashing to record the historic moment of the last Soviet flag coming down from a ship in a remote corner of the world, the distant promise of democracy did little to melt the ice in the hearts of the crew. They tried hard to be polite and to toast their future with us, while no longer knowing who owned their geophysical research vessel, let alone how, when, where, or if their next paycheck would arrive.

Here was an inkling into why Russian novels are long and American movies have bold, simple endings. We had about as much chance of understanding what the Russians were experiencing as penguins watching a video of *The Hunt for Red October*. We expected our crew to happily return to their arctic home port of Murmansk as soon as the brief shortage of iceworthy tourist vessels in the Antarctic ended. When democracy pulled their country out of its little economic slump, we would all live happily ever after in a free world without wars.

Earlier on the day of the slide show, the idea of boarding a Russian nuclear icebreaker bound for the North Pole seemed about as likely as landing a couple of NASA "journalist-in-space" grants to go moon-walking with our favorite cameras. Yet here in front of our eyes were wonderful slides of just such a journey made by Colin Monteath, a Kiwi photographer and adventurer who was the co-leader of our current trip. He had crewed his way to the North Pole as a lesser staff member and Zodiac jockey, not by luck, but by matching opportunity with overwhelming qualifications from seventeen previous seasons of Antarctic field work for both government and tourism.

The nuclear icebreaker had been leased on behalf of Quark Expeditions by his friend Mike McDowell, an Australian geophysicist-turned-travel-entrepreneur. With typically British understatement, the story sounded much like being offered an upgrade on a rental car. When McDowell went to Murmansk to book the ship we were now on, the recently privatized Murmansk Shipping Company asked if he might like to charter the world's most powerful nuclear icebreaker during the slow summer season. Why would he want to do that? The majority of the world's ports ban nuclear vessels and the whole of Antarctica is off-

limits by international treaty. The ship could, however, take tourists anywhere in the Soviet Arctic, including the North Pole. Monteath, McDowell, and a hundred passengers and staff participated in the first tourist cruise to the North Pole in 1991. Their journey took them across ten time zones of the Soviet Arctic with plenty of photo stops on islands, capes, and sea ice.

Monteath's slide show greatly exceeded my expectations, more clearly showing the diversity and photographic opportunity of the Arctic than a pool of select stock images I'd seen on a *National Geographic* editor's light box. The magazine had made a cattle call to agencies and arctic photographers to send their best images, made on dog sled, ski, kayak, snow machine, or airplane trips, to fill out an issue's polar coverage. Monteath's work had a more satisfying consistency of perspective from the deck of the ship well above the surface of the ice. The combination of images taken from the ship itself, from its ship-based helicopters, and from earthbound high ground gave me a sense of the Arctic Ocean I'd never gotten from books, magazines, or films. A photographer could make carefully executed tripod images on remote islands, carrying lots of special gear, with full knowledge that minutes later he would be comfortably back inside a private cabin on a warm ship.

The slide show inspired us to arrange a 1993 photo workshop tour on board the *Yamal*, a brand-new nuclear icebreaker launched in December 1992 that Quark booked for the North Pole. No one signed up. Despite a heartfelt letter to our mailing list as well as to clients of Geographic Expeditions, our chosen adventure travel agency, the $22,000 ticket was a considerable deterrent at a time when democracy wasn't pulling the United States out of its little economic slump, either.

After we had to cancel the photo tour, Geographic Expeditions helped us become on-board photography lecturers for all the ship's regular passengers without pay. We brought a series of slide lectures to be shown in the *Yamal*'s below-deck theater with seating for eighty and were delighted to have more time to ourselves to devote to photography.

Midsummer twenty-four-hour daylight at extremely high latitudes can be quite boring for photography, so we chose the latter of two 1993 departures that would go well into September. Above 80° latitude in July and early August, the sun never gets low enough to produce truly warm light, even though it stays relatively low all the time. We weren't willing to trade away magic hours of sunrise and sunset for mediocre light that lasts forever.

Our journey began with an Alaska Airlines charter to Provideniya on the Chukchi Peninsula at the eastern tip of Siberia, because our nuclear ship couldn't dock anywhere in Alaska. One nuclear event may ruin an individual's whole day, but if that individual happens to operate a port, just the idea of closing it down for the half-life of forever is enough to never consider an exception.

Before the trip, we asked plenty of nuclear questions about what we might be getting ourselves into. What was the radiation level on board? A physicist who had monitored the first voyage came up with levels below what an air traveler gets from background cosmic rays on a transcontinental flight. Were we supporting nuclear power by participating in such a cruise, or worse yet, increasing the odds of some future Chernobyl-style disaster at sea? Many such questions were unanswerable, but one convincing line of reasoning was that tourist dollars provide for safer and stricter maintenance of the reactors on the chartered

icebreakers that would be plying Russia's Northern Sea Route for the remainder of the year.

The nuclear waste issue is clearly unresolved, but fission, once initiated in the ship's reactor, doesn't stop with the turn of a key. Whether or not the ship is chartered, its fuel rods burn out every four years. I don't feel strongly enough about the dangers of nuclear power not to use it where it exists. I wouldn't keep my lights turned off while in France, for example. I have no pretense that all my actions in life are consistent. I regularly fly into jet airports I once opposed and I ski at areas I wish had been left as prime wilderness.

The era of heroic exploration of the Arctic is clearly over. Unlike a Nansen or Peary, modern explorers can no longer seek out a remote adventure without a helicopter or nuclear icebreaker buzzing in the back of their consciousness. Even if they never use such means of transport, the very knowledge that it exists and may be used for rescue if they get in trouble alters their primary experience. As passengers on a cruise ship basking in the shadow of previous human endeavor, we were quite unlike the true arctic explorers of old.

At Provideniya, we stood by while passengers from the first cruise were helicoptered to board the return leg of our charter flight. I recognized Tim Cahill, the great clown prince of outdoor journalism who infuses off-beat travels with his own special brand of self-deprecating humor. After a brief trip summary conspicuously devoid of whimsy, he deadpanned, "Good luck. We're leaving you a broken ship."

On the way back from the Pole, one of the *Yamal*'s steel propellers had sheared off at the base, giving the ship a seven-ton equivalent of a blow-out. After we boarded, we vibrated fifty miles into a remote bay, where the crew spent four days diving in ancient dry suits with huge levers and dynamite in hand to replace the broken blade.

Meanwhile, the ship's two helicopters took us to visit Chukchi Inuits with their reindeer herds on the mainland, as well as a protected walrus colony on Arakamchechen Island. Despite resident wildlife wardens, the colony had now diminished to 3,000 from 15,000 in 1991 because of severe poaching in the wake of Russia's economic hardships. The only permitted vantage point for the walrus colony was a roped-off ridgetop half a mile above their haul-out beach. The warden insisted that we spend only a couple of minutes so as not to disturb the animals. Realizing that this could be the best walrus opportunity of the trip, even though it seemed mediocre, I hedged every bet to make a tight, sharp image of animals freshly out of the sea with wet bodies that glowed pink instead of the normal brown of their dry fur.

I had brought along a new Nikon 300mm $f2.8$ AF-1 lens with matching 1.4X and 2X teleconverters. With the 2X in place for 600mm, my shutter speed dropped to 1/60th, far too slow for moving walrus in the narrow field of such a big lens. Mist was rising from the crashing waves in flat light. To rescue this seemingly hopeless situation, I pushed ISO 50 Fuji Velvia two stops to ISO 200 to gain speed, increase contrast, and use the accompanying warm shift to help cut the blue haze of flat light. With the lens simultaneously braced on a rock in front and my tripod in the rear, I was able to freeze a moment at 1/250th when all the walruses simultaneously lifted their heads in alarm.

We hadn't disturbed them. The wildly gesticulating Russian warden stood in front of us at the edge of the cliff to motion that we might disturb the animals if we stayed longer, hunkered down on our knees. As he approached, I kept one eye on the viewfinder and a hand on the new instant override feature of this special AF-1 lens. So long as I held light pressure on the shutter release in the AF/M mode, the autofocus instantly gave way to a twist of the focusing ring. Neither motion, long noses, nor low contrast could thwart perfect focus so long as my hand and eye were prepared to use the manual override for fine-tuning after I made initial contact with my subject with autofocus.

This ideal marriage of auto and manual focus is

made possible by a special motor in the lens itself. It answers all my previous doubts about using autofocus to track moving, unrepeatable events. Later in the trip, I was able to track white polar bears on ice, ivory gulls in clouds, and any number of other subjects that a standard autofocus might have searched and servoed into blurdom at the height of the action. My shots of moving polar bears from the moving ship proved remarkably sharper than I expected at shutter speeds of 1/500th and less, with a 600mm lens perched in the slot of a Kirk beanbag on the bow.

I also used Energizer lithium AA batteries with very positive results, so long as I was careful to choose the proper applications. When first released in the early nineties, they were not approved by many camera manufacturers because of a transient voltage increase for a split second at initial loading. Nikon, for example, would not honor warranty claims for electronic problems if lithiums were used, but after some years of experience without any problems, they approved them. On my 1993 trip I decided to give them a try, backed by Energizer's guarantee to replace any device damaged by their products.

My Nikon F4 with the small MB-20 four-AA battery pack used to go dead in extreme cold after as few as ten rolls. Using the new lithiums, the camera became even lighter and lasted for seventy-five rolls, including lots of outdoor shooting at the North Pole itself. Though this proved to be an exceptional gain in useful life where the batteries' cold response and high tolerance for short bursts of heavy loadings (such as motordrive and autofocus) created a compound effect, I regularly get at least three times the service out of lithium AAs in a camera body with batteries that weigh a third less than alkalines. I refrained from using lithiums in my Nikon N90 because it lacks a manual rewind lever and forces me to power-rewind cold film at a considerably faster speed than cold alkaline batteries deliver, increasing the potential for scratching. On the other hand, I've found the N90 to be an exceptional cold-weather camera that has yet to let me down at the North Pole, South Pole, or in northern Greenland. With normal alkalines in cold conditions that stiffen film and increase mechanical drag, the motor rewind naturally slows down to a rate very similar to doing it carefully by hand. In extreme cold, the remote DB-5 battery pack designed for the Nikon 8008 slips right in to give me reliable shooting down to −45°F. In room-temperature, constant-drain applications such as flashlights or Walkmans, however, lithiums have far less of an advantage over normal AAs.

My personal experience with Energizer lithium AA batteries underscores how professional use of equipment so often nullifies the penny-wise *Consumer Reports* mentality. I recall one of their surveys that urged readers not to pay a lot more money for a tripod just because it would be sturdier, since a cheaper one gives acceptably sharp photos with a normal lens. Thank you, *Consumer Reports,* for eliminating so much of my competition for selling tack-sharp 35mm images to wall calendars over the last two decades. Similar logic about lithium AAs goes something like this: Why pay two to three times as much for only about two or three times as many flashes or motor-driven rolls of film, when most batteries die a quiet death at home between birthdays and Christmas?

Besides not having to carry lots of extra flash batteries, or, worse yet, to change them in the middle of a fast-moving situation as top images pass you by, recycling times for lithiums stay fast until they are almost dead instead of slowing way down a third of the way through their life, as with ordinary or alkaline AAs. The increased reliability of my lithium-powered electronic cameras at low temperatures convinced me to leave backup mechanical cameras at home for the North Pole journey, something I never would have considered a few years ago.

My electronics performed flawlessly, with one strong caveat for using lithiums in strobes for long

bursts of flashes near full power. I was baffled at first when my lithium-powered flash suddenly shut off during a fast roll of outdoor fill shooting. I thought either the flash itself or the batteries had completely failed, but lithium AA batteries are designed with a thermal switch to prevent the flammable lithium from igniting. The switch returns to normal as soon as the battery cools off. My solution is either to plug in an accessory battery pack for high-load situations, or to switch to nicads before the going gets hot and heavy.

Our journey northward into the Arctic Ocean was ice-free until we reached Wrangel Island at about latitude 80° north. The island is called the Galápagos of the North, not for its weather, but for its unusual wildlife. Helicopters took us to a research station, where we delivered gifts of medical supplies and met scientists who had recently discovered the unfossilized teeth of a dwarf mammoth, 3,600 years young. The almost mythical ice-age creature had wandered the tundra while the Pharaohs ruled Egypt, thus defying the long-standing belief that mammoths were extinct well before the rise of human civilization. The "little" race of Wrangel mammoths weren't exactly dwarfs. Their shoulders would have reached the top of an NBA forward's head, if the Egyptians had thought to further human progress by inventing basketball instead of mucking about building pyramids. Wrangel, however, appears to have always been uninhabited until a Russian community was established after the turn of the century.

In 1975 the Russians decided that Wrangel's protected environment was ideal for transplanting musk oxen, which had been hunted to extinction in the rest of the Russian arctic. We located a herd by helicopter and landed on the glacier-carved highlands to photograph them. We didn't see any polar bears, although Wrangel has the Arctic Ocean's largest denning population. Our first and most thrilling sighting came when we reached Vilkitskiy Island in the New Siberian Islands. A white bear rushed through a herd of walrus on a beach as some of the passengers watched at close range from a Zodiac raft in the rough seas. I was stuck farther back on the main ship with my long lens after abortive attempts to launch a second raft in the big waves.

We tend to think of polar bears as land mammals, but the Russian and German name, "ice bear," far more aptly describes an animal that spends most of its life on sea ice or in the sea, upon which it depends for its sustenance. We saw several bears over a hundred miles from land. In the fifties, a U.S. nuclear submarine surfaced near the Pole in open water to the great surprise of a watching polar bear.

During a party on the ice beside the ship, combined with a stop for divers to check the tightness of the new propeller, an uninvited visitor appeared about 200 miles from the nearest land. A Russian with a large rifle who had been patrolling the ice saw a yellowish speck on the horizon and hastened us back on board. As the speck became an adult polar bear, curious about the nature of this 22,000-ton intruder into the realm he normally dominated, I focused with my 600mm and was ready for a full-frame image that never happened. Concerned about the welfare of the divers, the crew blasted the ship's loud horn. We got to see how fast a polar bear can sprint.

At the North Pole my cameras functioned well in relatively mild temperatures. Unlike Antarctica, where temperatures at the South Pole hovered around −45°F in spring at 9,200 feet in the middle of a continent, temperatures at the North Pole were only around freezing in the middle of the Arctic Ocean. Although I expected the North Pole to be surrounded by ice at least as solid as that in the trays in my refrigerator, there were open leads of sea water within sight of the Pole. When the sun came out after we arrived, the temperature climbed above freezing. A Russian officer who had been to the Pole on all six tourist voyages since 1991 said he was seeing the sun for the first time anywhere near the Pole and that temperatures were warmer than he had experienced before.

We celebrated by walking arm-in-arm around the world in a circle through all the time zones before seeking out individual pursuits. I went running around the ship in shorts and took a plunge into the hole broken through the ice at the stern. An immediate retreat to the sauna readied me for a barbecue party back on the ice. Meanwhile, the Russians had their own brand of frivolities. A crewman rode a motorscooter around the Pole, and two female crew members appeared in tight skirts and fur coats to pose on a raised ice floe like *Vogue* models.

I broke away from these festivities to try to make interpretive landscape photos at the Pole. I am certain I would not have done this if I hadn't visualized possible images in advance and written out a list of ideas well before we arrived. My favorite was a block of raised sea ice dangling with icicles. It would not have made a good straight photograph in its backlit situation, but balanced fill-flash at 1/250th allowed me to match a richly exposed dark sky with just enough fill on the foreground ice.

We "found" the North Pole by navigating with a read-out from a state-of-the-art GPS (Global Positioning System). Back in 1909, Commander Peary claimed to have reached the Pole on latitude readings derived wholly from solar observations. Our crew and staff were quite doubtful that Peary ever would have gotten to the immediate vicinity of the Pole by solar observations uncorrected by longitude information, even in ideal conditions. Although we had the best weather of all six tourist voyages to date, the sun was obscured by cloud cover for the great majority of our approach and retreat. Analysis of Peary's diaries, measurements, and public statements strongly suggest that Peary not only failed to reach the Pole, but was well aware of his failure.

One whimsical way of expressing our doubt was a "Peary Party" we held on the ice a hundred miles from the Pole. We photographed ourselves beside a "North Pole" sign stuck in sea ice that could have been anywhere. A passenger joked about adding a red circle with a slash through it.

As we returned from the North Pole toward Franz Josef Land, we received a distress call from another icebreaker. The diesel ship, *Kapitan Khlebnikov,* was stuck off the north coast of Greenland, while attempting the first circumnavigation of this largest of all the world's islands. The *Khlebnikov* had also been chartered by Quark Expeditions. On board were both Mike McDowell and trans-Arctic explorer Wally Herbert (the first person to actually reach the Pole by non-motorized means). Once-in-a-decade heavy ice conditions had trapped the ship twelve miles offshore of the world's largest national park in a totally uninhabited region.

The Danish, who control access to Greenland, at first forbade a nuclear ship to enter the broad economic zone off the coast. After a Canadian icebreaker failed to reach the stranded ship, we were given permission to break the *Khlebnikov* free and lead it out of the ice. As we came within fifty miles of the ship, Barbara and I went on a helicopter reconnaissance over far more solid ice pack than we had seen near the Pole. That night, our ship made seventeen runs of about a half-mile each at a pressure ridge of ice thirty feet thick. We finally broke through into mere ten-foot ice, where we plowed ahead at about eight knots toward our goal. Through the six-foot ice near the North Pole we had averaged about fourteen knots.

The history of polar exploration is replete with stories of ships trapped and broken up in the ice and crews that froze or starved to death over long periods of time while rescuers searched in vain. The idea of one tourist ship dropping in from the North Pole to rescue another must have Peary and Amundsen sitting up somewhere in the permafrost, but in this era of E-rides at Disneyland, the passengers on both our ships seemed surprisingly unfazed. After the party was over, the majority of our passengers were disappointed that we had missed seeing Franz Josef Land,

with its polar bears, rare ivory gulls, and historical sites of arctic exploration. Quark obliged by extending our journey.

By now the September nights were several hours long and the carpet of summer flowers on the tundra had been replaced by snow. We made an eerie helicopter landing at Cape Flora in near-darkness, wandering around an icy beach where the great Norwegian explorer and Nobel laureate, Fridtjof Nansen, happened upon a British arctic expedition in 1896 after a three-year attempt to drift his ship in the pack ice and walk the final miles to the Pole.

Two days of "bop-til-we-drop" travels through the islands of Franz Josef Land ended with a southerly heading into open, ice-free seas. Kittywakes, skuas, and occasional land birds that hitchhiked on the ship often flew right alongside our lenses as we cruised at twenty-two knots. Clouds and sun provided an ever-changing seascape with some rare outdoor optical effects, such as white rainbows and colored glories.

We disembarked in the formerly top-secret nuclear port at Murmansk, the world's largest city north of the Arctic Circle. From there we flew as a group via Saint Petersburg to Helsinki, where Barbara and I stopped over for a couple of extra days of gold-leafed Indian summer at a mere 60° north before boarding a nonstop flight over Greenland and the Canadian Arctic, thus completing our circumpolar round-the-world journey back to San Francisco.

The long-term goal of our Arctic/Antarctic photography is to communicate the meaning of the polar regions, and their inestimable global value as wild places, in books, articles, museum exhibits, and lectures. On our North Pole journey, a fellow passenger from Indianapolis mentioned that whenever she told people about heading for the North Pole, they would give her a blank stare, totally uncertain what that might mean and embarrassed to display their ignorance by asking if the Pole is on land or on the sea, if Santa Claus lives there, or if the polar bears eat the penguins.

Rescue on the Arctic Ocean

"We hoped to see polar bears, walrus, and rare ivory gulls, but without warning or notice to the passengers, we switched our heading toward hundreds of miles of open Arctic Ocean that had previously never been navigated."

On the night of September 1, 1993, my wife, Barbara, and I were returning from the geographic North Pole on the Russian nuclear icebreaker *Yamal*. As we were breaking through ten feet of sea ice at fifteen knots, what had already been the most unusual group tour of our lives took on an added twist.

That afternoon we had stopped on the ice one-hundred-odd miles from the Pole for a "Peary Party." Tea was served while passengers posed with a North Pole sign, much as Peary himself had done some distance from the Pole he almost certainly did not reach in 1909. In the evening I had lectured on photography in an eighty-seat theater in the two-foot-thick steel bow. The bangs and rows of breaking ice sounded like a war was going on outside. Just after the slide show, our crew received a radiogram from a ship in distress off the north coast of Greenland: "We need your urgent assistance to escort *Kapitan Khlebnikov* down part of the Lincoln Sea due to very heavy ice conditions in this area . . . Most important to give immediate assistance."

We were bound for Franz Josef Land in the Russian Arctic, where we hoped to see polar bears, walrus, and rare ivory gulls, but without warning or notice to the passengers, we switched our heading toward hundreds of miles of open Arctic Ocean that had previously never been navigated. As the ship neared Greenland two days later, the Russian crew was surprised by the formidable nature of the ice. How a non-nuclear vessel had gotten far enough to become stuck off the most northerly piece of land in the world was a mystery to us until we learned that the *Khlebnikov* had sailed around the north cape in relatively open seas. An arctic storm suddenly blew the pack ice southward against the coast, locking the ship not far from where Peary started his jaunt for the Pole.

Ironically, Barbara and I had once considered going on this same voyage of the *Khlebnikov* to attempt the first-ever circumnavigation of Greenland. Friends at a top adventure travel agency based in San Francisco urged us to book a group of photographers on what was billed as an historic journey. An Australian geophysicist-turned-travel-entrepreneur named Mike McDowell had chartered the ship for his company, Quark Expeditions. Having been on a highly successful Quark Antarctic trip on another Russian icebreaker, we had been genuinely interested.

We opted for a North Pole journey instead, because we had seen wonderfully diverse Arctic photography from the first tourist icebreaker to reach the Pole in 1991, and I was working on a book, traveling exhibit, and lecture series to compare the Poles and the polar regions.

On the morning we neared the *Khlebnikov* we were awakened by horrendous jolts and crashes. Our ship was backing up, using all its 75,000 horsepower for a half-mile run at a pressure ridge, and then shuddering to a stop. After seventeen rams, a ridge of ice fully thirty feet thick parted on either side of the ship. At the Pole and throughout the Russian Arctic, sea ice constantly drifts and is replaced every three years before it gets more than ten foot thick. A spiraling gyre off the coast of Greenland allows much thicker ice up to nine years old to develop.

As staff members, Barbara and I joined a helicopter reconnaissance of the *Khlebnikov*'s situation. The

accompanying photograph looks like a straightforward aerial, but required some technical tricks. I wanted the dark strip of the coast of Greenland to show along with detail in the boat and full sharpness. Since the light was very low and murky, the helicopter was shaking, and the sky was far brighter than either the boat or the ice, a straight exposure for the boat would lose detail in shore, sky, and texture of the ice. As we hovered nearby, my 24mm $f2.8$ lens gave me only 1/60th of a second with the ISO 50 Fuji Velvia I wanted to use. Shots from the helicopter would be unpublishably soft.

I decided to push Fuji Velvia to ISO 100 for greater speed and contrast, use a 35mm $f1.4$ lens, and set a two-stop hard-edged Singh-Ray graduated ND filter down to the horizon to hold detail in the sky and coast. My shutter speed jumped to 1/500th. Through an interpreter, I asked the pilot to hover farther away in a position where the horizon sat just above the ship's mast.

As our ship came abeam of the *Khlebnikov*, passengers on the opposing decks engaged in a camera war. I realized that one of these images of one ship from the other would capture the flavor of the two giant ships beside each other in churned-up blocks of blue sea ice. Looking out the porthole of my cabin, I saw a possible photo situation, but the *Khlebnikov* was so close that I could see only her bow through a 20mm lens. With a 16mm semi-fisheye, the horizon curved and the edges of the porthole took away from the power of the scene. Instead of giving up, I crawled out the window, hung off one of the exterior pipes of the ship with one hand, and lined the *Khlebnikov* up dead center so that it would not be affected by the lens's extreme edge distortion. The resulting image captured the essence of the *Khlebnikov* starting its engines to follow our path through the ice far better than ones made from other vantage points, including the air.

Although the *Khlebnikov* was unable to complete its circumnavigation, its hundred passengers were thankful to be escorted homeward by way of the Scandinavian Arctic. As both ships began moving again, we were invited aboard the *Khlebnikov* for a barbecue and returned several hours later by helicopter to the *Yamal*. After several additional episodes of the *Khlebnikov* getting stuck and being broken out again, we were back on course full-speed toward Franz Josef Land.

Even though our modern North Pole trip lacked the pain and personal effort of a self-propelled epic, it was as memorable and visual as any wild expedition I've undertaken. And we didn't even lose confidence in non-nuclear icebreakers. That same winter, we boarded the *Kapitan Khlebnikov* for the first-ever tourist cruise into the heart of Antarctica's Weddell Sea.

Charging Personal Batteries in Peru

"When we added up the cost of our successful expedition on the back of an envelope, we had spent a total of just $34 per person to climb 22,206-foot Huascarán in the Cordillera Blanca of Peru. Expeditions to Himalayan peaks often cost more than $10,000 per person."

I advise photographers to shoot away on their foreign travels, because film costs are minor compared to the rest of their budget. However, this is not always the case. My photography income far exceeded the cost of a recent expedition to the world's highest peak in the tropical latitudes. In the first week after I returned home, sales for a calendar more than covered all my film and processing costs, but it's the other side of the expense ledger that's more surprising.

When we added up the cost of our successful expedition on the back of an envelope, we had spent a total of just $34 per person to climb 22,206-foot Huascarán in the Cordillera Blanca of Peru. Expeditions to Himalayan peaks often cost more than $10,000 per person.

Our fantastically low expenditures were due to a number of unusual circumstances. My partners, Renzo Uccelli of Lima and Sevi Bohorquez of Spain, were already in Peru, as was I. My travel costs had been covered as the leader of two prior photo treks. No permit fees are required in the Cordillera Blanca, and the high peaks are reasonably close to roads in a country where food and services are inexpensive.

Even though purchasing and processing the fifteen rolls of film that I shot on the mountain cost six times as much as the climb itself, my photography remained in near-perfect balance with my pursuit of personal adventure. By taking only one camera with a 24mm lens, plus a telephoto zoom on the

upper mountain, I could freely move around without appreciably slowing down the progress of the climb. A tiny tripod enabled me to take calendar-sharp ƒ16 images at dawn and dusk, as well as self-portraits on the summit.

Through prior networking, I'd arranged to team up with Renzo and Sevi in the mountain city of Huaraz at the end of my treks. We needed to ascend Huascarán as efficiently as possible because I had only one spare week. We weren't trying to save money; we just got a lot for our $34. Instead of relying on public transport, we hired a private van to take us about fifty miles into the mountains. From the end of the road, two burros carried our eighty-pound packs up to the beginning of the steep climb at 13,000 feet. We also paid a local to share some of our load to the base of the glacier at 15,500 feet and watch a cache of extra food and camera gear for several days while we were on the upper mountain.

As we climbed higher, we met several descending teams who had failed to reach the summit. A snow bridge had collapsed over a major crevasse, exposing vertical ice cliffs. We then joined forces with an Italian, an Austrian, and a German, pooled our ice hardware, and climbed past the obstacle.

Our group opted to climb the slightly lower north summit, which has a more impressive view of the surrounding high peaks. On the last morning of the climb, low clouds were moving in from the east. Being well acclimatized from two months in the Andes, I unroped and reached the summit barely in time to photograph the magic of some of the most famous peaks in the Andes disappearing in the mist. The others arrived in a whiteout.

I've learned to operate my Nikon N90S quite well with gloves on in cold situations by dividing my snow and ice photography into two separate categories. If I am photographing climbers or open landscapes in full lighting, I simplify shooting by using autofocus and auto-exposure modes with a +.7 exposure compensa-tion to hold the snow reasonably white. For scenic photographs in the warm light of sunrise and sunset, however, I do not compensate exposure. I want to capture the rich, warm tonality of the sunlight on the snow, which is no different than warm light reflecting off sand or granite. I begin shooting right on my camera's meter reading and bracket on each side wherever possible. Quite often, the −.7 bracket has the best warm light saturation. For close-ups of my climbing companions, however, I take a reading off the back of my hand held against the sky and use manual exposure.

Temperatures had dropped to near 0°F when I got up at 3:00 in the morning at 20,000 feet for the final assault. From my polar experiences, I knew that the key to cold weather photography is keeping two things operating at all times: fingers and batteries. My solution to the finger problem is dropping a pair of *Grabber* chemical hand-warmer pads that last eight hours between my inner and outer sets of gloves. When I have to take my hands out of the outer gloves to change film or set small controls on a breezy pass before sunrise, I am able to quickly thrust them back into a pair of very warm mitts. My battery problems are solved by using *Energizer* lithium AAs in my N90S.

Could I have improved my coverage? Certainly. On assignment for a major magazine or ad agency, I would have brought along more equipment and paid assistants to help carry it. I could have brought back more saleable images of controlled situations, but at the high price of loss of spontaneity and active participation in the natural unfolding of a personal adventure. The batteries that keep my cameras working might as well die in the darkness of my camera bag if my personal batteries are not constantly recharged by the direct encounters with the natural world that first gave me the burning desire to interpret that experience in photographs.

Winter Safari in Botswana

"Nowhere else in Africa is there anything quite like the clear waters of the Okavango, which disappear into the vast sands of the Kalahari Desert and, like the rivers of the Great Basin of the American West, never reach the sea."

If mention of an African wildlife safari brings forth an image of a hot drive through dust and malarial mosquitoes to photograph animals habituated to encirclement by Land Rovers in an unfenced zoo, guess again. July in Botswana, next to South Africa, is much like January in Tucson—crisp nights merge seamlessly into bug-free, short-sleeve afternoons. Crowds are few and clouds are less common than leopards.

In 1982, Barbara and I set out to photograph the great herds of Africa before it was too late. We visited Tanzania and Kenya, and had a wonderful time, but weren't keen on returning after hearing stories of greatly increased poaching, crowds, and restrictions against cruising off the roads in the Masai Mara that had once allowed me to creatively compose the light and the landscape for shooting the great herds. We knew that our multiple sightings of rhinos unafraid of close approach had become epitaphs preserved only in our memory and photographs.

What convinced us to return to Africa and visit Botswana were the eloquent pictures of my friend and fellow photographer, Frans Lanting, and the anecdotes he shared with us over beers. His superb book, *Okavango: Africa's Last Eden*, graphically illustrates why his earlier seventy-page story on Botswana was, at the time, the longest natural-history article ever to run in *National Geographic*, despite plenty of coverage of the larger herds of East Africa. Frans explained that although the animals were not in big groupings, as they are in the legendary migrations on the Serengeti Plain, and they also tended to be more shy, the photographic possibilities in Botswana were more varied and exciting. Animals amidst ghost forests, giant termite hills, watering holes, and the world's largest freshwater delta—the Okavango—offer far more options for creative imagery. Nowhere else in Africa is there anything quite like the clear waters of the Okavango, which disappear into the vast sands of the Kalahari Desert and, like the rivers of the Great Basin of the American West, never reach the sea.

Botswana stands apart from *Time* magazine's characterization of Africa as "the basket case of the planet, the Third World of Third Worlds, a vast continent in free fall." Since diamonds were discovered in 1967, Botswana has had the fastest-growing economy, as well as one of the highest standards of living, in all Africa. English is the official language, spoken by the literate majority of the country's younger citizens. A far higher percentage of the land— 17 percent—is protected for wildlife than in America.

Botswana's best-known claim to fame over other African wildlife destinations is elephants: 70,000 of them, unculled, unafraid, and virtually unpoached for many years since troops began killing armed poachers on sight. Because firearms are totally banned in the national parks, any armed civilian is instantly recognized as outside the law. True to the experiences of many biologists who choose to study potentially dangerous animals without firearms, the incidence of attacks on either tourists or locals in Botswana is extremely low. Many top wildlife photographers, animal trainers, and zoologists say that animals sense a difference in a person who is armed, a difference that may be perceived as a threat and may increase the probability of an aggressive attack. Protection on Botswana photo safaris comes from being in or near

your vehicle or tent, except for remote camping and hiking outside the parks, where guides do bring along weapons.

Long lenses and faster films are a must for the best Botswana images. A Nikon 500mm f4 was used for the majority of the images printed here. Both the extremely rare scene of a lioness attacking wild dogs and the jackal following the impala were made with a 1.4X teleconverter for 720mm on Fuji Provia 100 pushed to ISO 200. Barbara captured a portrait of a leopard in deep shadow on a straight 500mm by bumping up her Fuji Velvia two stops to ISO 200 in mid-roll and having a custom lab "snip" the film to process part of it at ISO 200 and the rest at the normal ISO 50. The elephant in twilight required a one-second exposure on Kodak Lumiere. Only the too-close warthog was shot on straight ISO 50 Velvia.

Barbara and I visited Botswana as co-leaders of a Wilderness Travel photo trip operated by Capricorn Safaris, based in Maun. Our guides were extremely capable and patient with photographers. Meals served in tented camps in the bush would rate a ten on anyone's scale of wilderness cuisine. As much as we highly recommend these companies to first-timers, knowing what we do now, Barbara and I wouldn't hesitate to simply fly to Botswana, rent a 4WD vehicle, and head off into the parks to camp, spending a few nights at game lodges as we did in the past in East Africa.

The Kingdom of Mustang

"$10,000 in special fees to go to Mustang sounds like ecotourism at its best, but in practice it begs the question of whether any culture previously closed to the outside world can enter the twenty-first century gracefully."

The last forbidden Himalayan kingdom couldn't quite hold its doors closed into the twenty-first century. Sandwiched between Tibet and Nepal, Mustang lost much of its autonomy in 1951, when it became a special district of Nepal to avoid being subsumed into the Chinese takeover of Tibet. The area remained closed to foreign visitors until 1992 by mutual agreement between the kings of Nepal and Mustang, with a not-so-gentle nudge from the C.I.A. in the sixties and early seventies, when they used the kingdom as a staging area for Tibetan guerrilla resistance against the Chinese. But after Nepal's absolute monarchy caved in to democracy in the early nineties, Mustang was opened to tours by a special permit.

I first dreamed of visiting Mustang when I stood atop a 20,000-foot mountain on the edge of the kingdom in 1977. Red and white badlands that reminded me of the American Southwest dropped below the snows into the upper end of the deepest valley in the world, the Kali Gandaki Gorge, which begins in Mustang north of the Himalaya along an ancient course that predates the geologically recent uplift of the mountains. When India collided into Eurasia about forty million years ago, the Himalaya began to rise. The river cut through them like a hot knife through butter.

When Mustang finally opened, I arranged to lead a group of photographers on a trek, knowing full well that the traveler's dream of stepping off an airplane into the fourteenth century wouldn't happen. The local people knew far more about our world than we knew about theirs. Young men in Hard Rock Café tee shirts and L.A. Gear hightops greeted us at the first village. The people of Mustang are traders who traditionally head for warmer climes in the winter, sometimes boarding flights to Hong Kong, Bangkok, or Singapore.

The special photography trek that we arranged through Wilderness Travel began with a flight through the great Kali Gandaki Gorge. Only by peering out the tops of the porthole windows could we glimpse the summits of 26,000-foot Dhaulagiri and Annapurna on either side of us. All of us were looking forward to hitting the trail. Spending two weeks trekking one hundred miles around Mustang is in many ways less rigorous and more relaxing than ordinary travel through airports, hotels, and city streets.

Indeed, our trek was far easier than backpacking in a U.S. national park. Each morning, Sherpas woke us up before dawn with hot tea or coffee at our tent door. After shooting landscapes and cultural scenes during magic hour, we would return to find breakfast served and tents packed away. We had time to add heavy photographic accessories we didn't want to carry on the trail to our duffel bags before they were carried off by a caravan of Tibetan ponies.

Soon we would set off at a leisurely pace with a light daypack along trails worn into the bones of the earth by centuries of native footsteps. Before noon, we would round a corner to a hot picnic lunch prepared by a kitchen crew that had set out ahead of us. After a siesta and three or four more hours of walking, we would round the final corner into a new camp, where, like the old British Raj, we sat around drinking tea while our tents were erected.

Most of my favorite photographs were made with

very simple equipment on the trail. I rarely use my 55mm lens except for close-ups, but one day, as we were cresting a small pass, I saw a landscape that begged simple framing and even balance between foreground and background. There above me was Thorungtse, a 20,000-foot peak that I had climbed sixteen years earlier. I was standing below it in the very eroded badlands I had seen from its summit. The two photographs that appear on page 118 depict those opposing 1977 and 1993 views.

Our impact on the land and culture had been well anticipated. Of the $4,000 cost of our trek, $840 per person went into a required fund that was to directly benefit the people of Mustang. The money was earmarked for projects to preserve culture and environment that would be chosen with the guidance of the Annapurna Conservation Area Project. The ACAP had been formed in 1986 to administer a special kind of nature preserve that would create the environmental protection of a national park in the adjoining Annapurna region, without introducing a ruling class of rangers or soldiers that would denigrate local residents into second class citizens in their own homeland. By including them as part of the solution, the ACAP has become an international role model for Third World nature reserves with pre-existing human habitation.

The government had turned down the ACAP's request to postpone the opening of Mustang for two years to allow local people to make plans before permit money flowed. When we arrived, ACAP funds had yet to be distributed and the local people were frustrated. Children begged unmercifully. Adults secretly offered us centuries-old family heirlooms at greatly inflated prices, although a questionable ruling prohibits them from selling anything whatsoever to trekkers. One intention of this ruling was to keep locals from selling off their culture and tradition, as has happened elsewhere in Nepal. The result, however, is that most trekking groups move through Mustang in bubble-packed insulation from the local economy. Much of the money they spend (except the special fee) winds up in the coffers of overseas agents or trekking outfitters in Kathmandu. Although our trek was required to be basically self-sufficient, we catered to the local economy wherever possible by using Mustang ponies and pony packers and leasing campsites and local kitchens in villages.

Most adventure travel companies oppose opening Mustang to individual tourists, not only because these trekkers would bypass the golden goose of their group-tour monopoly, but also because in other parts of Nepal where individual trekkers have been allowed, inflation, depletion of forests and other resources, and rampant overconstruction have overwhelmed the very traditional lifestyle that visitors come to see.

The people of Mustang would love to have individual travelers stay at local inns and buy local products instead of camping in self-contained units outside the villages with little cultural exchange. Entrepreneurs are afraid to open any quality lodges until individual travelers are clearly permitted, but one reason the government gives for not allowing individuals is lack of facilities. When we discussed this situation with Wilderness Travel after our trip, we agreed about the desirability of a happy medium in which a few nights could be spent as paying guests in individual homes or local lodges.

The fact that our single trekking group paid over $10,000 in special fees to go to Mustang sounds like ecotourism at its best, but in practice it begs the question of whether any culture previously closed to the outside world can enter the twenty-first century gracefully. Both the ACAP and Wilderness Travel are doing as well as they can in a situation with no easy answers. If I was a zealot about zero impact, I would have had to either stay home, or, at the very least, never lured anyone else to Mustang by publishing my photographs.

The Tasmanian Connection

"Resident biologists and photographers call the island the jewel in the crown of Australia because its wild forests, coasts, mountains, and moorlands continue to hold the majority of the fauna and flora that have been rapidly disappearing from the mainland."

I used to laugh whenever I saw an ancient Volkswagen sputter through Berkeley bearing a "Reunite Gondwanaland!" bumper sticker. The idea of reassembling the southern supercontinent that began to break apart 120 million years ago seemed like a perfect parody of the improbable quests for social justice that have made my hometown famous. The broad free-speech demonstrations of the sixties have evolved into ever more singular quests, such as reunifying Bosnia, freeing Tibet, or trying to keep that VW bug running into the next millennium. Even the rebels who seized diplomats and held them hostage in Peru had their website based in Berkeley.

Since I returned from photographing Tasmania, the sight of that bumper sticker makes me sad. Comparing Tasmania's pristine qualities to the condition of other fragments of Gondwanaland has given me a new perspective. Resident biologists and photographers call the island the jewel in the crown of Australia because its wild forests, coasts, mountains, and moorlands continue to hold the majority of the fauna and flora that have been rapidly disappearing from the mainland. I now see that bumper message as an epitaph for fascinating wildlife unwittingly sacrificed in our accelerating quest for a global society. As we humans meddle with life forms that have evolved in isolation, the results are all too often catastrophic. I'm considering spicing up my Berkeley commute with a larger sticker on the back of my Suburban, saying: "Stop Reuniting Gondwanaland!"

The twenty-four English rabbits a homesick farmer set loose in Australia in 1859 spread seventy miles a year across the continent until the population reached 750 million in 1930. Tens of millions of native creatures starved to death. At least 8000 years earlier, ancestors of the aborigines had introduced dogs to mainland Australia, causing the slow and complete demise of the unique marsupial predator now known as the Tasmanian devil. The establishment of the dogs that became today's feral dingos also spelled doom for a much larger native marsupial predator, the thylacine, which became extinct in the wilds of mainland Australia about 3000 years ago. The boldly-striped creature with a hauntingly wolflike body survived on the island of Tasmania as the Tasmanian tiger.

Tasmanian Mammals—A Field Guide, by Tasmania's top wildlife photographer, David Watts, lists the thylacine with a full description and reports of sightings after the last documented animal died in 1936. Though classed as extinct, the thylacine remains officially protected under a 1970 law. Accounts of more recent sightings have led to years of unsuccessful efforts to photograph them with remote cameras set up in the Tasmanian wilds. I settled for taking a picture of a color hologram at a national park visitor's center created from old black-and-white thylacine photographs.

I was able to photograph Tasmanian devils in the wild, thanks to David Watts, who was kind enough to allow me to use the portable blind that he had erected in prime habitat in the Asbestos Range. After dusk, I attached my Nikon to his four strobes preaimed at a road-killed wallaby. Two hours later, a terrible sound erupted out of the darkness ten feet away. To my American ear, it resembled the noise that would emerge from a gunnysack into which an

alley cat, a pit bull, and a handful of pepper had been tossed.

As I turned up the rheostat on the red focusing light, I made out a muscular black predator skulking toward the carcass, and shot the image of the fierce creature with a bloodied snout that appears here. Though the devil appeared much more canine than many recognized members of that genus certified by the American Kennel Club, it is an unrelated marsupial that co-evolved to fill a similar predatory niche in the Australian environment.

The devil has such powerful jaws that it wholly devours kangaroos—bones, fur, and all—with loud cracking sounds. Yet the abundant kangaroos, wallabies, and wombats of the Asbestos Range have little fear of humans. I made the image of the wallaby mother with a "joey" in her pouch using a 24mm lens and fill-flash, though the portrait of the more tentative wombat did require a 500mm lens.

Tasmania is something of a biological Rosetta Stone. As one of the best-preserved fragments of Gondwanaland, it holds keys to understanding not only its own ancient condition, but also present relationships between fragments that explain why various types of southern wildlife survive only in certain places. We citizens of the north are spoiled by living in a unique zoogeographic realm that we take for granted. Our present Holarctic region is a gift of the ice ages, during which mammals such as deer, sheep, goats, wolves, foxes, bears, and humans came to circle the globe in the northern temperate latitudes. The rest of the world is not like this, and the lesson of the severed Tasmania connection is that many of the Earth's ecosystems must be preserved as separate, but equal.

Ancient Gondwanaland slowly split apart into the continents of Africa, Antarctica, Australia, and South America, as well as smaller bits that are now Madagascar, New Zealand, Tasmania, and southern India. Many travelers to Australia return with the misguided belief that all pouched marsupials, like kangaroos and koalas, live in the south, while placental mammals that nurse their young populate the north. Never mind that native marsupial opossums are found in two-thirds of the United States or that lions and zebras live in South Africa.

The breakup of Gondwanaland started before the age of mammals was fully underway. Africa and India spun off early to connect with lands where modern placental mammals later became dominant. Marsupials actually evolved in North America, but most died out by 25 million years ago in the presence of the ancestors of modern lions, tigers, bears, and wolves. Before this event, some marsupials took a permanent southern vacation onto a splitting fragment that broke up into South America, Antarctica, and Australia.

Marsupial predators ruled South America in isolation until only two million years ago, when a row of volcanoes bridged the gap to North America. After the dust settled, the Yankee invaders held far more new ground than the southern escapees. More than half of the present mammals of South America come from northern placental stock, while only the southern opossum survives in the north (plus a few placental migrants, such as the armadillo).

Antarctica moved too far south to support warm-blooded land animals, while Australia drifted into splendidly temperate isolation, where marsupials thrived until humans began introducing placental life forms—rabbits, rats, dogs, and themselves. Thus began the figurative reuniting of Gondwanaland toward ecological disaster, except in isolated areas such as Tasmania, which became an island off the southeast coast when seas rose at the end of the ice ages.

The severed connection of Tasmanian wildlife is echoed in the island's rocks, fossils, and rainforests, where more than a hundred endemic plants survive with minimal competition from exotics. Tasmania's amazing landscapes and botanical life deserve a story all their own.

Australian Reef Resort

"Australian tourism has a special knack for blending the nostalgia of laid-back times that are long gone in most of America with modern convenience. In big towns as well as small ones, we never received a room key without a relaxed personal chat."

If I won an all-expenses-paid trip to a typical beach resort, I probably wouldn't go. It's not that I don't care about the ocean. I've explored and photographed my share of wild coasts around the world, including five trips to the Galápagos Islands and visits to more than a dozen Caribbean islands. It's simply that my vision of paradise clashes with forced inactivity. Slowly roasting at the beach more closely matches my mental image of the opposite eternal realm.

So when Barbara and I discussed ending our travels in Australia with a week's visit to the Great Barrier Reef, I wanted to avoid being stuck on some desert island where our only alternatives to solar barbecue sessions would be eating or passing time in some air-conditioned, high-rise prison. We found what we were looking for on Dunk Island, three miles offshore from Crocodile Dundee country in north Queensland.

Yes, there is a long white beach with palms and turquoise waters, but without any Miami-style high-rises in sight. The low-profile resort tucked back into the tropical rainforest is surrounded by more options for outdoor photography than we could manage in our week. Although circled by coral reefs and beaches, the island itself is bedrock that tops out with a 1000-foot hill at the end of a nature trail. A longer loop trail traverses six miles around the island.

I used the trails every morning for exercise as well as for photographing the striking and approachable bird life. The island has no native land predators except snakes. One memorable evening, I walked around for hours with the resort's naturalist, James Rainger, who sensed just where to point his spotlight on perched birds, cane toads, and strange little rodents called Banfields that are one of Australia's few non-marsupial mammals.

We reached the Barrier Reef itself by a daily fifty-minute boat ride from the island. One look over the side at untouched coral in wilder colors than I'd seen anywhere else in the world, with large schools of fish all around, convinced me that I should bag my snorkeling gear and learn to scuba dive.

When I came up from my first dive, the instructor commented that I seemed more comfortable underwater than the others. "Why is that?" I asked. "Because you were always taking pictures instead of checking your equipment, like everyone else does the first time."

The point-and-shoot underwater camera that I had brought along produced great moody silhouettes, but none of the vivid colors of purple and yellow coral and iridescent fish that I had seen with my eyes. I kicked myself for not borrowing the Nikonos V with 15mm lens and TTL strobe that I had used with great success in the Galápagos. Though I definitely need to return with a better camera for underwater images as vivid as I've made snorkeling elsewhere, I was able to get good enough coverage for a short photo essay on Dunk Island to sell to magazines. Pictures taken with a regular camera from the upper deck of the boat, looking down at snorkelers amidst hundreds of fish, helped fill out the story.

After a number of days on Dunk Island, we decided to spend a night on the mainland to get magic-hour pictures of the island from four miles away, as well as to explore some of the legendary Australian

outback and visit the South Johnson Crocodile Farm, where huge problem crocs from the wild are held for captive breeding. The lush landscape reminded Barbara of how her native Hawaii looked when she was a child. Small villages and large sugar cane plantations, set below hillsides blanketed by virgin rainforest, made us both feel as if the clock had been turned back half a century. With foresight, some of the most scenic areas have already been set aside as national parks.

Australian tourism has a special knack for blending the nostalgia of laid-back times that are long gone in most of America with modern convenience. In big towns as well as small ones, we never received a room key without a relaxed personal chat with the desk clerk that often led us to great photo opportunities.

In general, the Aussies offer far more practical accommodations for active outdoor photographers than what we have in the States. Among my pet peeves in the American West are bed and breakfast inns that are no more than a creaky bed. I'm used to having breakfast and coffee always served after I'm long gone to get dawn photographs, but that was not a problem in Australia. Every hotel or motel room we stayed in had a mini-kitchen complete with virtually instant 240-volt teapot, tea and coffee, fresh milk, plus just enough plates and utensils to turn a take-out meal into a pleasant dining experience.

Australian travel costs are generally a bit higher than in the States, but with more variation. If you're on a budget, shopping around goes a long way. Near the Great Barrier Reef, you can spend $1500 a day at an exclusive island resort or $100 for a great four-star hotel on the mainland coast. When we return to the reef, as we surely will, we plan to split our time between the island and the mainland, only minutes apart by scheduled water taxi.

Prisoner in Paradise

"Black skies and blurry palm trees bending in the wind won't sell people on strolling the pristine beaches, scuba diving through schools of fish and vivid corals, reserving a private island for a day, hiking a rainforest trail, or photographing fantastic landscapes and sunsets."

I'm writing this essay in the middle of an assignment in the Fiji Islands that may not be a complete success. Barbara and I planned a leisurely week here at the Jean-Michel Cousteau Resort to shoot photographs of wild natural beauty amidst the understated elegance of the fine traditional accommodations. The owners want to use our photos to illustrate how they've created a world-class resort in a tropical paradise that they believe can be preserved for ecotourism with long-term environmental sustainability. Indeed, the resort appears to have changed the landscape less than the natural events of the last two days.

We're lying on the bed in our thatched-roof "bure," warm and comfortable in shorts and tee shirts, but we certainly don't feel relaxed. We're in the midst of Tropical Cyclone Gavin—what we call a hurricane up north. Black skies and blurry palm trees bending in the wind won't sell people on strolling the pristine beaches, scuba diving through schools of fish and vivid corals, reserving a private island for a day, hiking a rainforest trail, or photographing fantastic landscapes and sunsets.

Though I've been taking the obvious shots, I'm lying here thinking that I've been a bit too casual. I've walked by many great scenes with turquoise waters, coral sands, and lush vegetation, believing that I had several days left to go back and work situations that grabbed my eye. In the leisure of those moments, I violated my own cardinal rule of outdoor photography: *If it looks good, shoot it; if it looks better, shoot it again.*

On the other hand, we're lucky to have come to one of the rare resorts that understands the needs of photographers. The old Chinese water torture is preferable to waking up to a full moon about to set in a rosy pre-dawn sky, only to discover that the double-paned window in your eighth-floor room won't open more than 49mm, your smallest lens has a 52mm filter diameter, and the obstacles between you and a clear view—elevator, distant parking, power lines, condos, and gated community—negate any possibility of making a decent photograph. Room service generally starts fifteen minutes after you needed to leave your room to catch the sunrise, and dinner service generally stops fifteen minutes before you get back in from photographing the sunset.

Before dinner on our first evening here, I stepped out to photograph a fabulous sunset over Savusavu Bay. Total time from our bure to where I set my tripod on the beach was less than thirty seconds. It's less than a minute to the dive shop and the pier where the boat leaves for scuba diving. When I went scuba diving, I was sorry to have gone to the trouble to borrow a Nikonos with the latest TTL strobe, only to find that the dive shop had the same equipment for loan, plus its own E-6 lab to process slides. Thus, I was able to dive in close, shoot film, and critique my work before heading out to the most spectacular dive sites. Photographing the vivid colors of Fijian coral, untouched by careless divers, gave me the same sort of joy I find in a remote mountain meadow filled with wildflowers. Above water level, hikes into a rainforest and through a local Fijian village give us the feeling that we are part of the local scene, rather than inside a Club Med bubble-pack from another world.

Now, the first hurricane to hit Fiji in several years is central to our experience. I'm confined to shooting pictures that travel publications aren't going to use, such as huge brown waves in what's usually a turquoise mirror of a bay. My shot of Jeff the Chef, the resort's cook from Southern California, surfing the eight-foot waves off the flooded pier are, shall we say, unique. While we would prefer to have chosen a different week, we're glad we came and especially glad we chose to stay after advance warning of the hurricane. None of the guests have had problems in these twenty impeccably built structures, designed over eons by Fijians to best weather the big blows that come through every so often.

The eye of the storm has passed some miles to the side of us, but two guests who decided to leave early have not been so lucky. They just called here to tell their friends how they escaped to the main island by charter flight only to find that all scheduled flights to the U.S. were grounded. They checked into a Western-style hotel, which had flooded and lost all power. Meanwhile we're having great hurricane parties under the thirty-foot ceilings of the main lodge after quiet days of reading and writing in our bures. When the winds die down, I'm planning to take a run a few miles down the beach with a light camera to check out the native village, talk to the locals, and stretch my legs.

The resort was founded by Jacques Cousteau's son, Jean-Michel, Executive VP of the Cousteau Society for fifteen years as well as a recognized ocean environmentalist and diver in his own right. After his father's late-life remarriage to a mistress with a vengeance, Jean-Michel became disenfranchised from family enterprises. Sued by his senile father and caustic stepmother to take the Cousteau name off his resort, Jean-Michel asked just what name, other than his own, he should use.

A settlement agreed upon use of Jean-Michel Cousteau's full name on a property that represents his joint venture with the owners of Post Ranch Inn, the finest place to stay on the Big Sur Coast of central California. Reflecting this joint venture, some of the staff members come from Post Ranch, while the majority are native Fijians, who live up to their reputation as the world's most genuinely friendly people. It takes a while to realize that these are not just resort smiles, but the genuine expressions of a people unspoiled by contact with the modern world. In their own villages, the same open spirit, positive attitude, and presence for the moment is equally apparent.

As the storm came in, under overcast skies, I saw the perfect opportunity to shoot the interior of our bure at the moment when the soft morning light coming from outdoors matched the intensity of the indoor artificial lights. To avoid parallax distortion and yet take in the full bure, I used a 15mm rectilinear lens aimed absolutely level at the height of the lower ceiling beams.

Before the storm, the 86°F ocean temperature was ideal for learning underwater photography. It's a simple matter to get a roll processed after a dive or a snorkel, study the results, and go down again with a better understanding of the limitations of the medium. For example, the 20mm wide-angle lens I used allowed depth-of-field that far exceeded the capability of the flash to evenly light near and far subject matter. Choosing main subjects equidistant from the lens is critical for success unless a creative fall-off of light is desired. Aiming the camera up to get rays of sunlight behind subjects lit with flash is especially tricky, because the low synch speed of a Nikonos often requires an $f11$ or $f16$ aperture, which can limit fill light down to a foot.

Because I've processed some rolls, I know I've got fine coral shots with a full spectrum of vivid hues, both from snorkeling just off the beach and ten scuba dives on guided daily excursions. I'm also sure that I caught an incredible tropical sunset as the weather was moving in, plus some resort activity shots of sea kayaking, tennis, and poolside scuba instruction. What I'm missing are the kind of "signature" photographs I'd planned to make on the final days of the week, after I'd done the dives, walked the beaches, and saturated myself in awareness of the place. There could be worse things in life. We're already planning to come back!

Photograph: Page 161

Top of the World to You

"I had gotten a magazine assignment from *Life*. Knowing their penchant for the unusual, I preconceived creating the look of the top of the world, as seen on a globe, with a 16mm fish-eye lens."

Before joining a private expedition to the world's largest and least-explored national park, I checked the archives of major American magazines and drew a blank. I wanted to see existing photographs and glean information about Northeast Greenland National Park, half again as big as Texas, as well as to strategize how to pitch a photo story of my own.

Colorado geologists John Jancik and Ken Zerbst, who had invited me, had been trying for seventeen years to obtain the necessary permits and funding to climb virgin peaks in an unexplored range and traverse sea ice with open leads to a tiny island. They said that my extensive polar experience would come in handy in the field and that my name might help cut through red tape. And oh, yes, they hoped to get their story published in *National Geographic* or *Outside*.

The island is the northernmost point of land in the world, located in 1978 by a Danish survey following up on discrepancies of more than ten miles between satellite imagery and existing maps. I explained that major American magazines are rarely interested in original exploration for its own sake these days. Entertainment value comes first. Celebrities, mummies, or the more recently deceased are better ways to getting modern adventure stories published. If some of us died or suffered terribly from our stupid mistakes, then we or our heirs might land a book contract or major magazine sale during the week our story was hot.

I further explained that I'm constantly being asked how to sell an adventure story in advance and I

answer that I'm rarely able to do so myself these days. In this age of photographic and information overload, editors know that the more remote the adventure, the less likely that it will result in the kind of flashy, contrived imagery necessary to grab the short attention span of their similarly overloaded readership. A tragedy on oft-visited Everest makes cover stories and headlines, but a successful personal adventure in an unheard-of place is not general-interest news.

Nevertheless, I joined the roster and contacted *National Geographic* a year in advance. My proposal was declined. An editor I knew gave me inside information that it conflicted with a cultural Arctic story already in the works. Nunavut, a giant new Canadian territory larger than any province, was about to be created with rule by its Inuit majority. Greenland was judged too similar to that story for their diverse readership.

Out of the blue, Universal Press Syndicate asked me to write and shoot a feature on Nunavut for hundreds of newspapers. That put me in a bind. The etiquette of freelance journalism prohibits divulging inside knowledge of stories-in-progress to other publications. I tried to convince UPS to do Greenland, but they rightly felt that Nunavut was a more appropriate travel story for Sunday newspapers. When I told them that I was committed to Greenland—story or not—for the summer 1996 Arctic weather window, they allowed me to wait until 1997 and shoot their assignment just after the *National Geographic* article appeared.

I struck out more completely at *Outside*, where I am listed as a contributor on the masthead. The top editor failed to answer my calls and faxes. When we finally talked long after the expedition, he told me to take comfort in the fact that many of their best-known contributors never get a reply. The moral here is that

if you think you're being singled out by that editor who doesn't return your calls about a fantastic (but unsolicited) proposal, welcome to the turn of the twenty-first century.

At the turn of the last century, the legendary explorer Robert E. Peary arrived at the tip of Greenland by dogsled in 1900 and returned to tell the world he had discovered Cape Morris Jessup, the world's northernmost land. He named it after the president of the American Museum of Natural History, who had put up $50,000 toward his expedition.

Nine years later, Peary was celebrated as the first person to reach the North Pole. Today, both of these exploits are disputed, yet maps and reference books continue to credit him with the pole and to designate Cape Morris Jessup as the world's northernmost point of land. Our goals were the true northernmost point and the summits of unexplored mountains in the H. H. Benedict Range, named by Peary for another major contributor.

In 1921, the Danish explorer Lauge Koch traversed the northern shore of the Arctic Riviera, a long section of Greenland's northeast coast that has too little precipitation to breed glaciers. Contrary to the public conception of northern Greenland as a vast icecap second only to Antarctica in size, the snow-free summer tundra along the coast blooms with wildflowers each July. Koch spotted an obvious island that he suspected could be farther north than the Cape and named it Kaffeklubben—Coffee Club Island—for his informal group of geologists.

A 1978 Danish survey landed a helicopter on Kaffeklubben and determined it was north of the Cape. Just as they were celebrating, someone pointed to a tiny dark spot nearly a mile farther north. They flew out to a gravel bar about twenty-five feet wide by fifty feet long and named it Oodaaq, after the faithful Greenland Eskimo who accompanied Peary toward the North Pole.

Our expedition began in a Twin Otter with a 1,200-mile flight that seemed to reverse geological time. From the green fields of Iceland we receded into the Pleistocene as icebergs dotted shipless seas, pack ice closed in against rocky shores, and an apparition appeared 10,000 feet above on the horizon: the great Greenland Icecap. It slowly vanished before we landed in North Pearyland.

A few days later we headed out for Oodaaq Island and failed because of deep slush and open leads. The next time we made it in a thirteen-hour marathon, wearing snowshoes to keep from plunging through cracks in the ice.

When we reached Oodaaq, my feet were soaked and numb, despite double boots, gaiters, and two pairs of socks with plastic garbage bags over them, duct-taped to my thighs. Even so, I laughed heartily as I watched math professor Bob Palais try to balance on the single rock breaking the surface. This was our island? Our great goal? But here it was in just the right place at 83° 40' north, 1360 meters off Kaffeklubben. Pack ice driven upward near shore had given off meltwater that created a false sea level, obscuring all but the island's highest point.

In the final months before departure, I had gotten a magazine assignment from *Life*. Knowing their penchant for the unusual, I preconceived creating the look of the top of the world, as seen on a globe, with a 16mm fish-eye lens. To solve the exposure problem of Bob smiling in stormy shadows surrounded by white ice, I manually set my flash for 70mm coverage to project a beam only onto Bob that would not overlight the closer water.

I was not surprised that *Life* ran the image that appears here as the major spread in a six-page story that did not include any of our first ascents, ski descents down unexplored glaciers, or encounters with wildlife, including the herd of musk oxen that spent the day eating wildflowers in our base camp. My personal favorite image of the trip is a dead musk ox almost wholly receded into a barren area of soft tundra. The slowly vanishing creature, returning nutrients to the earth that gave birth to the luxuriant blooms surrounding it, is highly symbolic of the Arctic cycle of life.

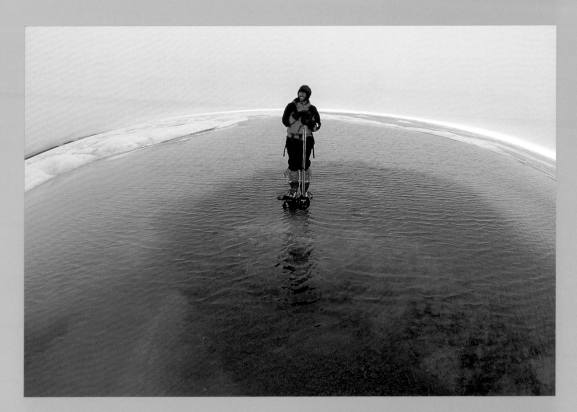

Above: *Essay pages 98–102, 159–160, 186–188*
The Earth's northernmost point of land—the tip of Greenland's Oodaq Island barely rises above water during a freak melt of trapped pack ice. A 16mm fish-eye lens was used to create a top-of-the-globe look, along with an on-camera fill-flash tunneled to 70mm to light up the smile of my partner, Bob Palais.

Right: *Essay pages 159–160, 186–188*
The Arctic cycle of life clearly comes across in this scene of a musk ox sinking into soft tundra, returning nutrients to the ground that allow flowers to bloom—flowers that live musk oxen graze for survival.

Left and far right: *Essay pages 186–188, 226–227*
Among the visual comparisons from opposite poles in my book, *Poles Apart*, is a pairing of creatures that are not fish leaping out of the sea. The Arctic bowhead whale evolved from a land mammal and the emperor penguin from a flying bird into this 60-pound living torpedo erupting from under the sea onto a high ice edge with a belly full of food for its chick.

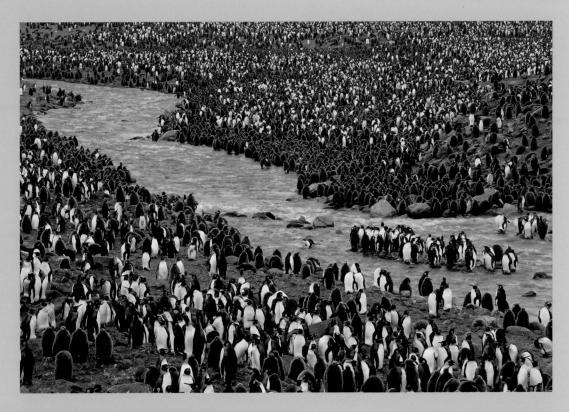

Above and left, top:

Essay pages 186–188

A graphic pairing of North and South polar subjects shows the John River flowing through misty boreal forest in Alaska's Brooks Range beside another river flowing through a virtual forest of king penguins on South Georgia Island.

Left and far right:

Essay pages 186–188
Another *Poles Apart* pairing shows trees growing north of the Arctic Circle in Alaska's Brook's Range (left), while the continent of Antarctica (right) has none at all. The ice-free Dry Valleys are littered with strange rocks called "ventifacts" carved by wind-driven particles over millions of years.

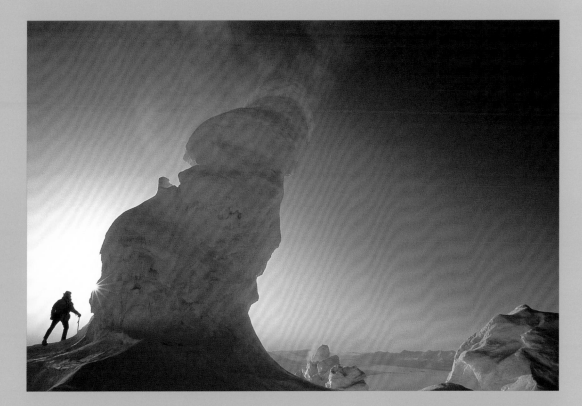

Above and left, top:

Essay pages 186–188
Because the North Pole sits in the middle of the frozen Arctic Ocean (left, top), while the South Pole is at 9,300 feet in the middle of a continent, polar adventures can be very different. The figure (above) is beside a frozen steam vent atop 12,447-foot Mt. Erebus, the world's most southerly active volcano. The dog team (left, top) is at sea level in midwinter on pack ice north of Alaska.

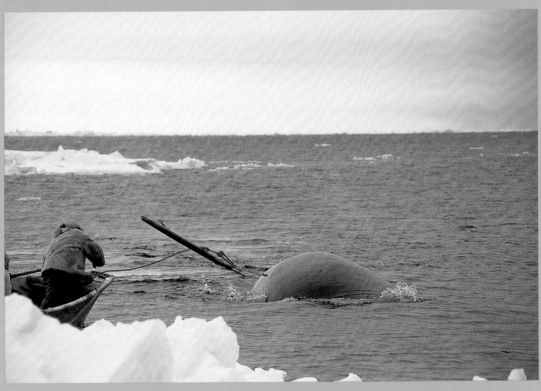

Left: *Essay pages 186–188, 226–227* An Inupiat Eskimo woman of Barrow, Alaska, wears a traditional parka—a garment first invented by her ancestors, who populated the Circumpolar North in search of sea mammals over 10,000 years ago.

Above: *Essay pages 186–188, 226–227* A harpoon frozen in midair at ¹/₁₀₀₀th of a second between an Eskimo arm and a whale's back concludes a legal subsistence hunt from a sealskin *umiak* off the north coast of Alaska.

Top, center and right: *Essay pages 184–185, 186–188* In Nunavut, created in 1999 as a new territory in Arctic Canada larger than any existing province, the native Inuit have regained political and social control of their ancestral lands.

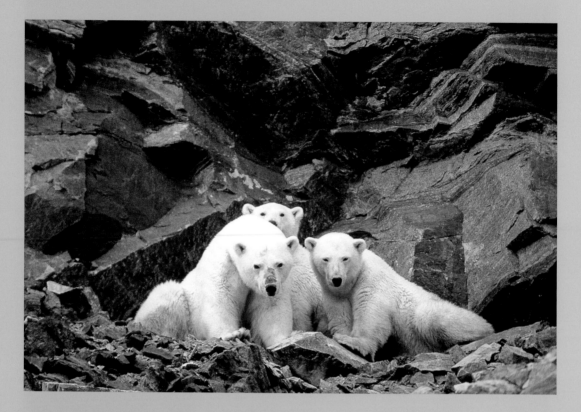

Above and left:

Essay pages 184–185
A cornered polar bear mother and cubs glower from a rocky alcove (above) after failing to climb a cliff (left) at the head of a narrow *cul de sac* to escape approach by small boat beneath the sea walls of Nunavut's Bylot Island. I leaped ashore to make these photos, covered by an Inuit with a shotgun.

Above:

Essay pages 182–183, 186–188
A clan of 28 Dall rams chose to spend a blustery fall day with me after I joined them on a high terrace out of the wind in Denali National Park. My best photos came after I sat down and let them slowly approach me on their own terms. I used a 2-stop graduated neutral-density filter to hold the sky and open up the foreground.

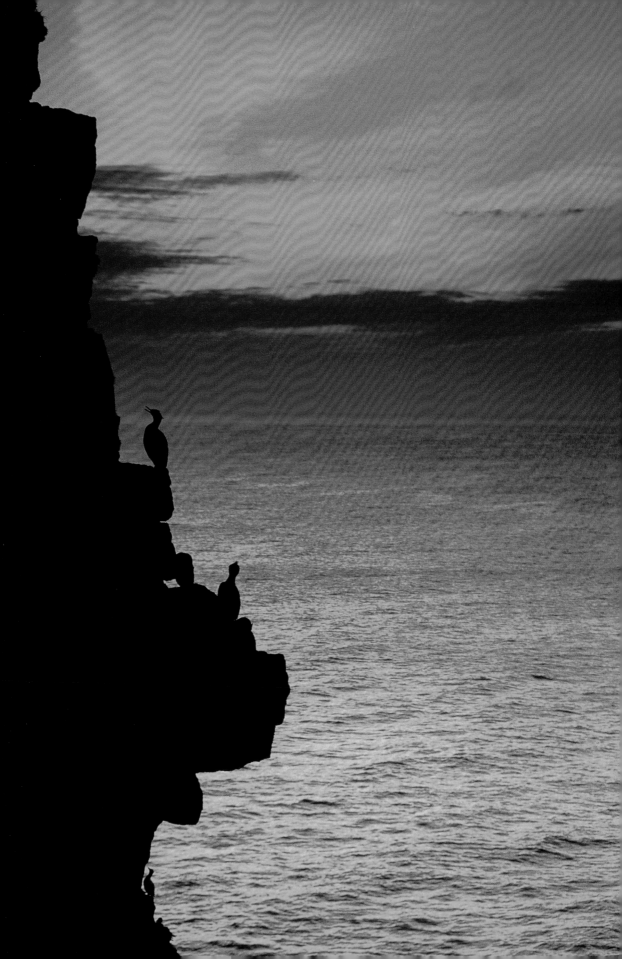

Left: *Essay pages 180–181, 186–188*
The Pribilof Islands hold the world's greatest concentration of mammals and seabirds. Here, thick-billed murres greet a rare clear dawn over the Bering Sea from their sea-cliff roost.

Above: *Essay pages 180–181, 186–188*
An arctic fox, unaware of my presence just above, stalks a murre on a narrow ledge a hundred feet above the Bering Sea in the Pribilof Islands.

Right: *Essay pages 180–181, 186–188*
A tufted puffin takes flight from a sea-cliff perch over-hanging the Bering Sea.

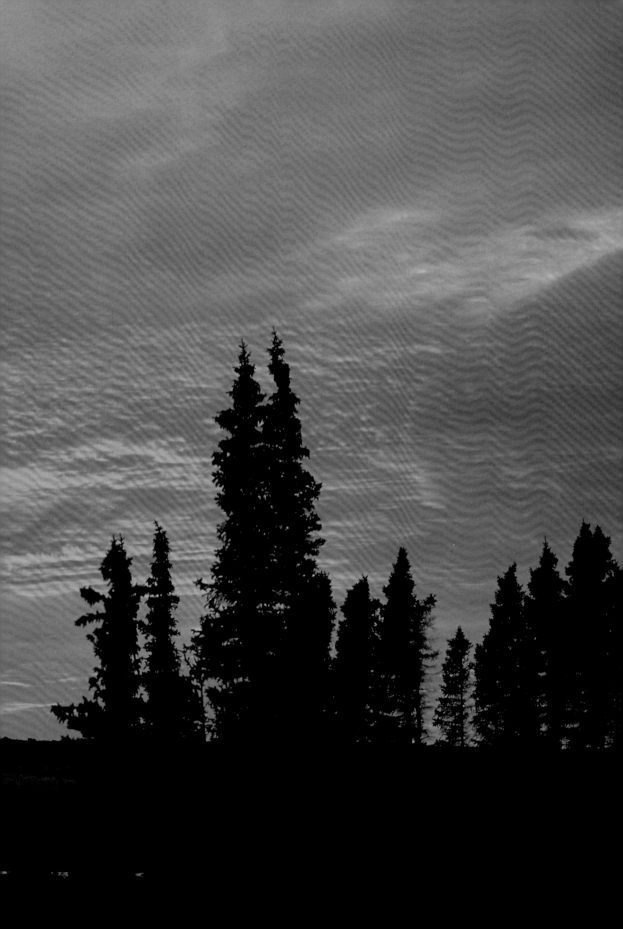

Above and right:
Essay pages 177–179
In the Barrenlands of Arctic Canada where boreal forest ends and tundra begins, tiny lichen sprouting amidst bearberry and crowberry (above) mimics the form of caribou antlers (right)—still attached to the skull of a wolf kill near a den.

Preceding pages:
Essay pages 177–179
On a late summer evening in the Barrenlands, the ghostly silhouette of a caribou moves across open ground beneath a crimson sky at the headwaters of the Thelon River.

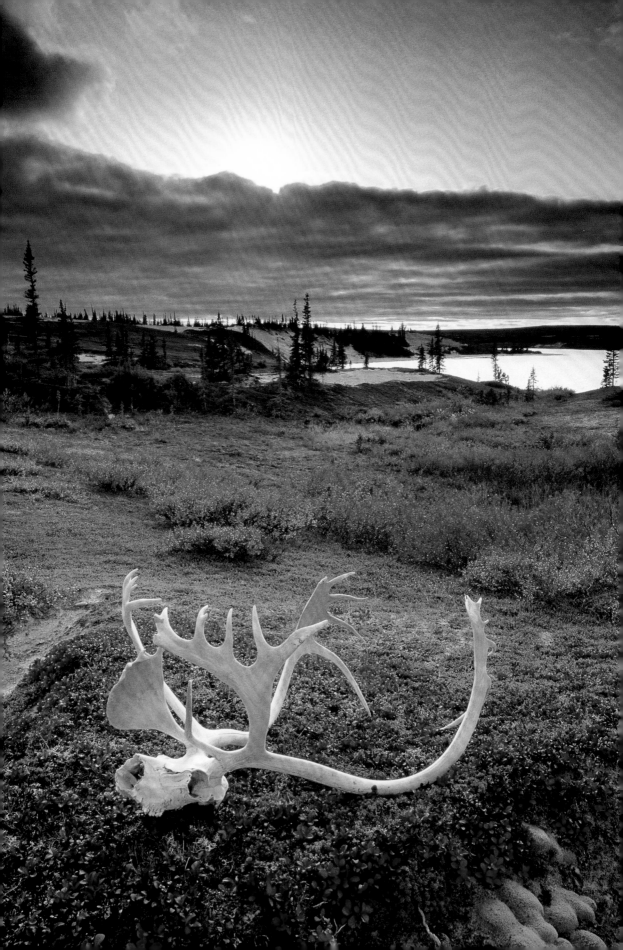

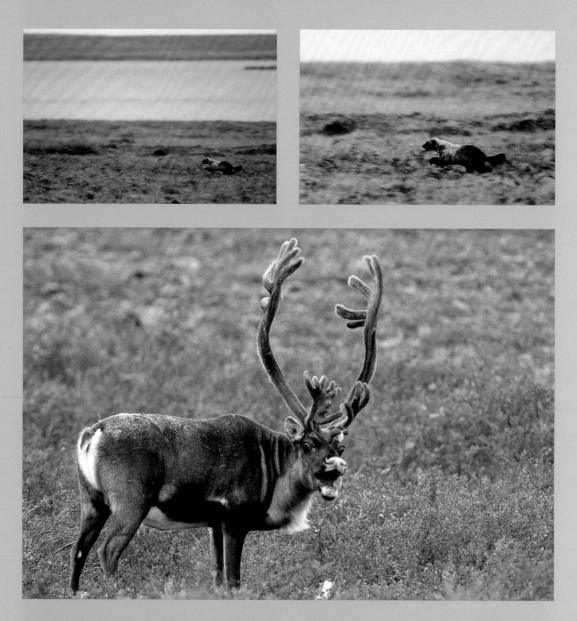

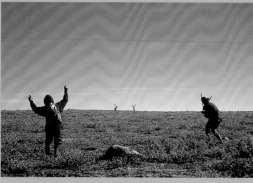

Left and above:
Essay pages 177–179
On the open tundra near the headwaters of the Thelon River in the Barrenlands of the Canadian Arctic, our guide taught us to "dance with the caribou" (left) to create a caribou-like silhouette during downwind stalks. Sometimes the caribou never knew, but at other times they expressed surprise (above) at close range as they realized that we were not their kin.

Top, left and right: *Essay pages 177–179, 230–231*
A rare photo of a wolverine charging across the Barren-lands in daylight was salvaged by scanning the original (left) and doing digital cropping, edge sharpening, and contrast moves (right) without altering the form of what had been before the lens.

Dances with Caribou

"A wolverine, one of the most elusive and rarely seen of Arctic animals, was approaching us in broad daylight as if we weren't human. It suddenly veered, turned in the opposite direction, and ran past us a second time at full speed."

When I agreed to assist a group of photographers in the remote Barrenlands of Arctic Canada, I took the names in the travel brochure to be marketing hype. "Dance with the Caribou," led by a character named "Tundra Tom," seemed to be no more than a clever twist on the name of the movie, *Dances with Wolves*. To my surprise, the dance proved real.

My departure from Great Slave Lake bore a striking resemblance to the opening scenes of *Never Cry Wolf*, another fanciful film based on Farley Mowat's legendary bestseller about his season surveying wildlife in the Barrenlands. As he did in the movie, I walked into the deafening propwash of a 1940s DeHaviland Beaver, inched along one of its floats, and hopped into the copilot's seat. Moments later, we roared off over a landscape that instantly dispelled the popular notion of the Arctic as an abode of cold and emptiness. In contrast to the movie's depiction of frozen lakes in summer, scenes beneath the wing fit Mowat's eloquent descriptions of summer plains "thronged with life and brilliant with the colors of countless plants in bloom" and of lakes "whose very blue depths are flanked by summer flowers and sweeping green meadows."

"Tundra" Tom Faess, a big, jovial man in his forties who had grown up in the Canadian North, was the pilot and owner of Great Canadian Ecoventures. He winced when I told him that my initial attraction to the Barrenlands, some thirty years before, had come from reading Mowat's books. "Up here we call him Hardly Knowit. You don't know what you can believe."

I was vaguely aware that Canada's best-selling nature writer had come under heavy critical fire in his home country of late, but the flak failed to reach most of his readers in the States. Mowat has publicly admitted that his books, though sold as non-fiction, are full of factual errors and purposeful elaborations. In 1996 he smugly told an investigative journalist, "I never let the facts get in the way of the truth. . . . I didn't have all the information so I elaborated on it." His descriptions of walking right up and touching wild caribou have created unreal expectations for several generations of Arctic photographers.

Continental North America's largest tract of roadless wilderness extends from Yellowknife to Hudson Bay. Mowat's wolf book and movie suggest that a bush pilot could simply drop you there amidst a caribou migration. Mowat may or may not have actually witnessed what he describes as "the most tremendous living spectacle that our continent knows."

Tundra Tom made it clear that in late summer we had no chance of seeing a true migration. We would see the mixing of animals in prime pelage across a broad area leading up to their mating period and fall migration. In twenty-two Arctic seasons of extensive flying and ground explorations, he had only witnessed two actual migrations. Even the Indians who once depended on the caribou for food, clothing, footgear, and shelter described them as arriving "like ghosts, like the wind, coming from nowhere, filling up the land, then disappearing." Though many photographs of actual migrations exist and have been widely published, one top nature photographer recently resorted to digitally cloning caribou into a scene to make it appear like a migration.

Though the small groups of caribou that graze open tundra near the northernmost trees in late

177

summer usually bolt at first sight of a wolf or a human, Tundra Tom has discovered a most unusual technique for approaching and photographing them. The first time I saw this stocky, middle-aged man bend over, raise his hands high alongside his head, and begin waltzing slowly across the tundra with a volunteer in tow, I could hardly hold back my laughter. The caribou, however, were nonplused by the sight of a crude silhouette of a four-legged creature with a rack of horns slowly walking out of the forest. I expected them to sense the ruse and run off at any moment, but instead they lowered their heads and returned to grazing. Indeed, Tundra Tom has literally learned to dance with the caribou.

Over the next two weeks I had many chances to hone my own technique and approach dozens of groups of caribou close enough for telephoto portraits. Sometimes they actually approached me. Calves were especially prone to leave their mothers and walk up to check out the new guy on the range, but even they sensed something odd when they got within a hundred feet—plenty close for my 500mm lens.

Since caribou horns have complex and unpredictable shapes, I carried my camera and big lens on my shoulder with tripod attached and legs turned upward to look like horns. So long as I didn't let the caribou smell me or hear human sounds, my open stalks generally worked. Tom also taught me how to calm a suspicious animal by softly blowing through closed lips to imitate a common caribou sound. This would often tip the scales to allow an even closer approach.

While it might seem that successfully impersonating a caribou would require much more than this obvious ruse, studies of animal perception indicate that we have far better visual pattern recognition than other large mammals. Though they may have higher sensitivity to motion and higher acuity for discerning distant objects, they lack the computing power in their brains to assemble a meaningful perception of an unfamiliar subject. This explains why an obvious, but newly placed trash barrel may cause a horse to shy or a grizzly to charge. It also suggests why caribou calves,

who have fewer stored visual images than adults, seem most likely to approach dancing, middle-aged men.

The great majority of animals we stalked and photographed may never have seen a human being before, may never see one again, and came away with nothing to match to more normal human encounters in the future. I considered my stalks to be most successful, not when I had made the closest photographs, but when the decision to retreat was mine alone and the animals seemed unaffected by my presence.

Once, however, a downwind stalk across open ground with a party of four seemed to be failing for no apparent reason. The healthy group of caribou acted skittish and began trotting away as soon as we showed ourselves. Was someone wearing a highly reflective color or too much white? Had the wind shifted so that they caught our scent? Did someone make a noise? Or did the arthritic gait of two men in their seventies trying to move in synch with each other give our act away?

While I was contemplating these possibilities, an animal built like a small bear came charging across the open tundra toward us. A wolverine, one of the most elusive and rarely seen of Arctic animals, was approaching us in broad daylight as if we weren't human. It suddenly veered, turned in the opposite direction, and ran past us a second time at full speed. The fleeing caribou must have sensed the wolverine, which, in turn, had mistaken us for easy pickings—downright sickly-looking lame stragglers, ripe for the slaughter. I managed to pan a couple of successful frames of the wolverine with my 500mm lens and disappointingly slow film. My camera body with ISO 200 film was tucked away in my bag, while I had ISO 50 Velvia in the body I had mounted on the lens, hoping to get sharp, static caribou portraits.

Later, when a herd of nineteen musk oxen neared our tented camp, I decided to try the dance on them with an Italian photographer as my hindquarters. They looked up with disdain and went back to grazing as we set up our cameras on a knoll within one hundred feet and photographed for the better part of an hour.

Early one morning I climbed to the top of the

highest esker with the well-known wolf biologist, David Mech. As he described where he thought wolves might go after leaving a nearby den some weeks before, I began scanning with an attachment on my 500mm lens that turns it into a 50-power spotting scope. Within the first minute I discovered three white Arctic wolves on the tundra at a great distance, totally unaware of us as they rested in the shadow of a rock in a patch of willows. To my greater surprise, first one, then two, and finally a third caribou entered my narrow field of view. As they unknowingly approached within forty feet of the wolves, a pup came out and cocked its head. Nothing happened until the adult wolf stood up. In an instant, the caribou blasted out of the scene like grenades from a launcher, leaving only trails of dust. The wolves, perhaps well fed from an earlier kill, simply laid down without giving chase.

As September arrived, so did vivid fall colors and nightly northern lights that kept us up well past midnight. I tried using fill-flash on the spruce trees and human figures, as well as catching reflections of the lights in still ponds. Within a few days, I made some of my best Arctic landscape photographs in over twenty expeditions to the Far North. Normal subjects came alive in morning mists and beneath wildly colored Barrenland skies big enough to see the sun set through a caribou's legs.

Not everyone who signed up for "Dance with the Caribou" through Great Canadian Ecoventures (800-667-9453) was as satisfied as I was. A few who had not taken the time to read the trip literature arrived with false expectations of being dropped into the middle of a migration with no walking, no stalking, and more comfortable amenities. On the other hand, a group of retired CEOs, who were avid photographers, congratulated Tundra Tom on the overall quality of the camp, the food, the guiding, and the photo situations. Having traveled widely for photos, they were quite familiar with the limitations of having to fly in all supplies to a tented camp by bush plane in unpredictable weather.

I summed up my appraisal with a journal entry saying that Tundra Tom doesn't promise more than he can deliver, but does deliver more than he promises. I'd had no expectation of encountering a wolverine or seeing the northern lights reflecting in a lake as a wolf howl pierced the night. I discovered for myself how much more lasting my memories were of stalking totally wild animals through thoughtful interactions, compared to "drive-by shootings" of habituated animals from my car window in national parks. Most surprising of all, I found out that learning to dance with the caribou in the Arctic had a profound effect on the way I now experience wildlife back home.

For three decades I've been running trails in the Berkeley Hills above San Francisco Bay, where I often encounter mule deer that always sprint off when I get closer than about 200 feet. I've sometimes made good photographs by carefully stalking to a closer distance, but in the open, these local deer have always fled at my approach.

The week after I arrived home, I was running up a steep fire trail at dawn when I spotted a doe and fawn up ahead. It seemed natural to raise my arms, slow down, and dance on up the trail. To my surprise I came alongside them, just six feet away. Only as they caught a glimpse of my two-legged profile, and perhaps a whiff of my scent, did they step off the trail and give me that deer-in-the-headlights startled stare.

A week later, running alone at midday, I spotted more deer. Making sure no hikers were around to see my crazy antics, I waltzed across a grassy plain with my arms outstretched. A fawn left its mother's side and approached me. The doe kept on grazing, failing to recognize me as human. I had no regrets about not having a camera with me. The experience, like that of the wolves, the wolverine, and all those caribou I stalked, felt complete and imprinted in my memory with far more significance than film could ever record.

I returned the following year during the same time in early September, wandering the Barrenlands with wild animals amidst fall colors, short nights, northern lights, vivid sunrises and sunsets, and almost no bugs. What I still can't figure out is why the real story wasn't good enough for Farley Mowat. Such a genuinely remarkable place needs no embellishment.

Willful Detention

"Where the climate and access are ideal, as in the Galápagos Islands and the Serengeti Plain, photo tourism especially flourishes. Visitation radically drops off where photographers actually have to enter uncomfortable environments for extended periods of time."

I can't begin to apply any of the usual platitudes of travel writing to the Pribilof Islands, nor can I explain why I feel so satisfied to have visited such an uncomfortable, abnormal, expensive place. The answer is deeply rooted in my obsession for photography—my personal quest to extract beauty from even the most unforgiving surroundings. If you share it, you, too, may be destined for the Pribilofs.

Most of you read these words in the comfort of some sort of artificial subtropical microclimate that replicates the evolutionary cradle of humanity. It's become the norm in every developed nation. On the other hand, the kiss of death for modern journalism is normalcy. Even the simplest story gets a spin. Tabloids feed off the secret satisfaction that normal people feel when reading about the common tribulations of the famous or the rare afflictions of the lesser-known.

Magazines and books about outdoor photography, however, focus on the more lofty, yet equally strange, aberrations of deviant humans who transport their bodies into habitats to which they are not adapted. These odd beings go to great effort, expense, and physical discomfort to wallow through malarial swamps, dive under the sea, or scramble onto icy heights to bring back images that illustrate their separateness from normal society. They actually choose vacations wading through penguin poop, while their kin lounge around on coral sands at a fraction of the cost. Many of these deviates lust for close encounters with bears throughout America's last frontiers, the very thing their ancestors tried to avoid at all costs.

Yet the extremes that published nature photographs appear to depict rarely represent the actual human experience. The majority of extreme images are made from or near mobile subtropical environments. Drive-by shootings around Yellowstone or Churchill account for the majority of bear imagery. Comfy cruises bring photographers face to face with penguins.

Where the climate and access are ideal, as in the Galápagos Islands and the Serengeti Plain, photo tourism especially flourishes. Visitation radically drops off where photographers actually have to enter uncomfortable environments for extended periods of time. The world's greatest concentration of wildlife is in just such a place—the netherland called the Mother of Storms by Arctic sailors, between the Gulf of Alaska and the Bering Sea.

Fifty times fewer photographers visit the Pribilof Islands than go to the Galápagos. Hundreds of miles apart from the Aleutian chain, they remained uninhabited until the eighteenth century, even though Aleut Indians had reached them by sea kayak and found millions of northern fur seals, hundreds of thousands of sea otters and Stellar sea lions, and over a million nesting seabirds of tremendous diversity. Rather than live in such a wet, windy, cold, and treeless place, the Aleuts rowed back hundreds of miles across open ocean.

The Pribilofs' lack of trees is due to a huge dip in a line drawn by climatologists to define Arctic conditions. The 50°F summer isotherm drops below the Pribilofs at latitude 57° north (just a few hundred miles north of London), while it arcs well above the true Arctic Circle in Alaska, Siberia, and Scandinavia, favoring forests and native people. With

just three clear days a month, morning summer temperatures in the thirties, and frequent gale-force winds that average seventeen miles per hour year-round, the Pribilofs are a virtual blueprint for hypothermia.

In 1786, Russians searching for the breeding grounds of the fur seal "discovered" the Pribilofs. With heaven hidden by eternal clouds and the czar far away, they enslaved Aleuts from more hospitable islands to harvest Pribilof furs for them. Over 2.5 million seals were killed during the first thirty years. The Aleuts, too, began dying off from white man's diseases and a climate unfit for survival. Their agony did not end with Russia's 1867 sale of Alaska. As virtual slaves of the U. S. Fish and Wildlife Service, the Aleuts were kept on the islands to harvest furs until after World War II. But that's another story.

The same Alaska Native Claims Settlement Act of 1971 that ended one of the least-known and most sordid chapters of our government's mismanagement also opened the door for nature photographers. Extensive lands and dollars were signed over to the disenfranchised natives. An Aleut village corporation was set up that began to operate "St. Paul Island Tours" (800-544-2248).

Today's Pribilof visitor must have special access to alternative transport and lodgings or buy a tour that includes a Reeve Aleutian Airways turboprop flight from Anchorage, 800 miles out into the Bering Sea. Since the Aleuts control the islands (except for seal colony management by the feds), luggage is conveniently checked all the way into the lobby of St. Paul's only hotel. Amenities in this ancient fur traders' lodge without private bathrooms or a tight roof have noticeably improved since a member of my 1979 photo safari announced, "They ought to put a penal colony here." The stark old dining room is now a warm sitting room with books and videos. Meals are served in the galley of a fish processing company. The all-you-can-eat medley of prime rib, steaks, jumbo shrimp, salmon, halibut, and mashed potatoes more than matches the high caloric burn rate of photographing in the wind and cold.

Daily guided bus trips to bird cliffs and seal colonies are optional after the first day's orientation. Last August, Barbara and I took off on our own in a rented Suburban after getting a necessary permit from the local National Marine Fisheries office to enter the seal blinds. The benefits of not standing atop a cliff with fifteen other photographers trying to photograph flighty puffins perched just below the edge may sound obvious, but it is the unexpected that makes venturing out on one's own most worthwhile.

One rainy day I was the only one out at the Zapadni bird cliffs, seated on a small ledge in the lee of the wind. After using my 500mm lens for puffin and murre portraits, I switched to an 80–200mm f 2.8 and the new Fuji MS100/1000 film for puffins in flight. Soon I had seemingly merged into the cliff with the birds ignoring me. But they all came to attention when something dark moved along a long ledge just below me on the cliff that overhung the sea. I got one perfect frame of an Arctic fox stalking a murre before the sound of my shutter sent the animal scurrying out of sight.

Only the birds within reach of the fox flew off, but a massive departure a few minutes later surprised me. Even the pair of crested auklets anchored in a nearby rock crevice disappeared. Then I heard voices. A tour group of dedicated birders peered over the edge, saw nothing of special interest, and walked on. That evening at dinner, one of them remarked how he had yet to see a crested auklet.

My assignment in the Pribilofs was for *Living Planet*, a World Wildlife Fund book that documents the Global 200, a group of ecoregions carefully selected to represent areas that hold critical links of biodiversity. I needed images that gave a sense of the Bering Sea region, rather than just tight wildlife portraits. After four days of rain, my opportunity came on the fifth day in three months to dawn clear. Before sunrise I was miles out beside a bird cliff, ready to capture its teeming profile against the expansive sky and sea. By the end of the day, I had shot twenty-eight of a total of sixty rolls. The next morning, our return flight almost didn't make it in. After three missed approaches, it finally landed in the rain on the gravel airstrip barely within the legal minimum overhead visibility of eighty feet.

A State of Mind

"What's disturbing is that ever fewer Denali visitors are having the kind of wild experience that is so fresh in my mind. Their strongest memories are not of close encounters with wildlife, but of frustrations over the inequitable management of park visitation."

First-timers love Denali National Park. Old-timers like myself hold indelible memories of far richer experiences. In the not-so-distant past, the ninety-mile dirt road through the park was a guaranteed roadside attraction. Driving your own vehicle through a diorama of North American large mammals with no hassles was America's answer to the Serengeti. Today, that same road is well on its way toward becoming just another over-managed civilized intrusion into receding wildness. In this sense, Denali continues to be the icon of American wilderness.

At the turns of the last three centuries our forefathers took for granted a wilder wildness than outdoor photographers find themselves in at the turn of the twenty-first. When you reach your destination today, you haven't arrived yet, for true wildness is not so much rooted in a place or a photograph as in the state of mind of an ever-less-common experience.

September 21, 1998. Three cars, two shuttle buses, and two ranger vehicles are stopped on the paved road near the Savage River watching two caribou more than five football fields out in the willows. I can't help but recall a dozen caribou in the grass beside the same road in 1974, when it was unpaved and empty except for our family station wagon. Back then, we located animals by seeing them rather than by coming across a cluster of vehicles and looking where other people were looking. One August day, my ten-year-old daughter spotted a lynx

in broad daylight, only to later spot wolves, a wolverine, and grizzlies.

In September 1998, a half-day of driving does not result in any wildlife sighting close enough to take my camera out of its bag. I'm able to drive myself because I've arrived after the summer season when park road permits awarded by lottery are no longer required. Only the first thirty miles of the ninety-mile road are open, and after a few round-trips, I head out of the park while making mental plans to go elsewhere. Before completely giving up, I decide to follow a ritual that field zoologists have taught me: sit down and glass the landscape to see if it's really empty. At a turnout I set up my 500-mm lens with an attachment to create a 50-power scope. Minutes later, a couple from Los Angeles in an Avis car stop and ask, "What do you see? We haven't spotted an animal all day."

"Take a look through my scope at what's on that hill," I reply. The man gets out, peers through the lens focused about two miles away, and beckons to his wife. A group of twenty-four white Dall rams are browsing fall foliage before the first snows. Though the couple are not photographers, they are clearly captivated by wild living things and they decide to stay in the park a while longer.

As they take turns peering through the lens, I put on a dark jacket and ready a small pack to stalk the animals. Forty minutes later and 1500 feet above the valley, I begin shooting portraits from fifty feet with my 500-mm lens. As the animals accept me, I move back without appearing to have had any effect on them. Changing to my 80–200mm $f2.8$ zoom, I move in slowly and spend two more hours in the midst of the herd by their choice as much as mine. As I sit beneath a rock out of the biting fall wind, the animals approach me as close as six feet on their way toward new foliage.

During these hours, dozens of vehicles cruise the road far below, but not one person ventures more than a car length away. I wonder if their visitor experience is as empty and unfulfilled as mine was before I spotted the sheep. For me, Denali's wildness has been transformed through personal effort and a little luck.

Returning before sunrise, when it is too dark for wildlife photography but optimal for catching the distant eyes of animals in my high beams, I spot a bull moose camouflaged in tall willows and spruce. I turn my vehicle sideways and watch it in the headlights. A few miles farther into the park, I see what appears from a distance to be a stray dog. Up close, the lanky frame and seven-minute-mile lope clearly identify a magnificent adult wolf. For long minutes I follow in tandem, until the wolf suddenly drops off the edge of the road and arcs lazy S-turns through the willows like an Olympic skier.

Even though I never have a chance to use the Nikon F5 equipped with infrared autofocus and flash that is readied for action on the front seat, the wolf sighting makes my day. The animal seems too skittish to pull alongside, and I feel no need to verify my experience on film for anyone else. Having a tiny four-legged blur that I could point to and say, "There's the wolf!" never enters my mind. Yet in a more personal way, the sight of the wolf does validate my experience. My photographs of the Dall rams seem enriched because they represent an experience that includes other close animal sightings.

Those who judge photographs only on technical merits may discount the notion that my later experience could have any effect whatsoever on my earlier photography. After all, the images of the Dall sheep were unchanged and made before. Case closed. But that's not all there is to nature photography. We respond to an image on a flat piece of paper only when it triggers something from our life experience. To identify a wolf we need to hold something of wolfness in our mind, even if it is an image from a children's book.

If the couple from Los Angeles visit my gallery next year, are they more or less likely to buy a print of the group of Dall rams after having seen them on their own visit to Denali? Perception is inextricably tied to experience in the real world, as well as to what we see in the secondary imagery of photography.

What's disturbing is that ever fewer Denali visitors are having the kind of wild experience that is so fresh in my mind. Their strongest memories are not of close encounters with wildlife, but of frustrations over the inequitable management of park visitation. While travel brochures promise the wild Denali experience of old, I have yet to read a recent article by any veteran Alaskan travel writer that extols the wild experience without mentioning serious problems. I timed my visit to hit the brief post-season, late-September window when vehicles are allowed to drive thirty miles without restrictions.

An Alaskan newspaper recently published an editorial about "winning" the annual lottery for a coveted permit to drive the park road for one day in August. The staff writer and 399 other people drove the ninety-mile, mostly dirt, dead-end road, but both backcountry camping and overnight camping in roadside campgrounds deep in the park were prohibited. Why? Because 400 more "winners" would be coming the following day. Traffic might become congested if some vehicles spent the night. The columnist joined a mad and dusty evening dash to drive out of the park.

I doubt that few, if any, of the 1600 people who won the lottery for the four days of personal road travel had as satisfying a visit as mine, when the peak-season restrictions were lifted a few weeks later. Had I not consciously forced myself to stop and scope the landscape before leaving the park, I, too, might have returned home to write mainly about Denali's road and ranger hassles. Instead, the experience emphasizes once again that the wildness I seek to represent in photographs and hold in heartfelt memories is less a place than a state of mind.

Northward to Nunavut

"Contrary to the myth that polar bears have no fear, this mother clearly wanted to flee. Her rage spoke legions about Nunavut's growing conflict between ecotourism, sport hunting, and subsistence hunting involving the same wild creatures."

On April 1, 1999, Canada created a new territory much larger than any existing province. In the netherworld of Canada's northeast, where the continent splatters into islands before dropping off the edge of the earth into the Arctic Ocean, the Inuit regained control of their ancestral lands and modern uses of them, such as tourism. The radical splitting off of a vast region to be controlled by its Inuit majority was the result of decades of protests over human rights issues and land claims.

Nunavut means "our land" in the Inuktitut language. As one Inuit leader explains, "We live off the land, while white people live off money. That's why we worry about our land and they about their money." Yet the new territory's 22,000 Inuit drove a hard bargain for a settlement of 1.148 billion Canadian dollars and extensive mineral rights, plus outright ownership of 136,000 square miles.

Knowing the sad history of other native communities, the Inuit are not letting rivers of tourist dollars run freely southward. To photograph around the northern tip of Baffin Island, I worked through Nunavut Tourism, an organization of operators (www.nunatour.nt.ca), who set me up with Tahoonik Sahoonik Outfitters in the subsistence village of Pond Inlet.

When my son, Tony, and I arrived by scheduled flight, our jaws dropped when we were taken to our next form of transport—an open boat no longer than my Suburban, which isn't very seaworthy. We helped our 61-year-old guide, Ham Kadloo, and our deckhand, his seven-year-old great-grandson, Hosia, load 125 gallons of fuel plus a week's food and camping gear aboard. With little room left, we stayed surprisingly comfortable on near-freezing seas in one-piece inflatable survival suits. Hosia proved to be amazingly mature, helping on board and playing quietly around our campsites without need for discipline. His focused attention seemed inbred by the unforgiving environment.

At 10:00 one evening, I coaxed Ham to cross twenty open miles of Eclipse Sound to Bylot Island. Beyond a wild Arctic Yosemite of a fjord, a tiny yellow spotlight appeared over a peak. The scene was so otherworldly that it took us long moments to recognize the tip of the moon rising sideways into the twilight. For two hours it moved across the horizon, never higher than its own diameter above snowy peaks in a kaleidoscope of changing sky colors. I felt as if I was on another planet, but I couldn't make the necessary half-second exposures from our moving boat.

Tony spotted something breaking the glassy surface "like the Loch Ness monster," and mythical creatures began rising up all around us. Groups of two, three, and four narwhals were surfacing at a distance. Tony and I had come to the tip of Baffin because of reports of thousands of these strange, single-tusked whales being forced south by an unseasonal August freeze. Though we never got close enough to get a good photo in the twilight, as soon as we landed I set up my 500mm lens with a 2X converter to shoot the setting moon. The twilight was too dark for a matching landscape exposure, but when I got my film back, one frame of the huge orange orb had a green flare on the edge. I'd caught an extremely rare green flash

on the moon instead of the sun. All the conditions that favor its solar counterpart were present.

For five days, we had a great time searching the seas, camping on beaches, and exploring trackless tundra. Once, as we trolled the base of Bylot's sheer cliffs, I spotted a polar bear with twin cubs sprinting into a cul-de-sac with vertical walls. I'd seen polar bears on ice, on flat land, and swimming in the sea, but never one climbing rock. The mother would scramble well up onto the sheer wall, only to fall back, roar with rage, and try again. Finally, she led her two large cubs back toward us into an alcove, where she hovered right above us and glowered down.

A typical tour guide would have said, "Time to move on. That's all, folks." Ham covered Tony and I with his shotgun while we jumped off the bow in heavy swells onto a wave-swept rock with our tripods and telephotos. In between pounding heartbeats, we squeezed off rare photographs.

Contrary to the myth that polar bears have no fear, this mother clearly wanted to flee. Her rage spoke legions about Nunavut's growing conflict between ecotourism, sport hunting, and subsistence hunting involving the same wild creatures. Wildlife viewing always suffers in areas where animals are regularly hunted. The Inuit hold broad traditional hunting rights (though visiting hunters can only hunt bears by nonmotorized means). To a mother bear all humans smell the same.

Like ourselves, Ham's ancestors were lured to the Canadian High Arctic by the profusion of marine mammals, including polar bears. For tourists, seeing large creatures is exciting, but for traditional Inuit traveling across the Bering Strait thousands of years ago, these animals were the very embodiment of life and survival. To start out the long winter night of Arctic darkness without enough stored meat meant slow death by starvation. Whales—bowhead, beluga, narwhal—made the difference for survival in the most extreme inhabited environment on Earth.

Modern Inuit have a continued economic, social, and artistic dependence on Arctic large mammals. Their paintings and soapstone carvings convey the abstract shapes of creatures that have long been the focus of their lives and more recently captured the fancy of temperate cultures.

The Inuit weren't consulted in the nineteenth century when the huge Hudson's Bay Company sold off its assumed holdings to the government, nor did they ever sign a treaty giving up ancestral lands they had inhabited for thousands of years before Europeans "discovered" them. After the Greenland Inuit gained home rule from the Danish in 1979 and the Alaskan Inuit settled their native claims in 1980, the Canadian Inuit stepped up pressure to create a territory to be ruled by the majority. Before a national commission in 1993, many Inuit testified that the government had forced them to relocate farther north to further sovereignty over uninhabited regions.

Despite some contested statements of government abuse, the Inuit made it all too clear that they had been treated as second-class citizens on lands that morally and legally deserved to be their own. As their devastating assertions of hardship and starvation echoed around the world, parliament rushed to validate their long-disputed land claims.

Though Nunavut has been there all along, its new political identity begs comparison to an Alaska that can no longer truthfully promote itself as "The Last Frontier." Nunavut is larger with ten times fewer people, far more polar bears, and just twelve miles of roads outside its few scattered towns.

Thus Nunavut is unlikely to become just another one of those overmature ecotourism destinations where travelers face each other in suspiciously comfortable lodgings owned by absentee landlords, surrounded by seemingly traditional people who worship the dollar. With GPS and satellite phones, however, life on any frontier ain't what it used to be. Nunavut's jet-serviced, English-language, easy-sleeping North American time zones may allow you to see a lot in a week, but don't fall into the trap of living by the clock. If you come in summer with expectations of great photography, sleep by day with eye blinders and ear plugs. Stay up all night to see spectacular Arctic light shows and far more wildlife.

Photographs: Pages 6, 120–121, 161–167, 169–171, 208, 241–243, 254–256

Poles Apart

"Direct photographic comparisons make the similarities and differences come alive in ways not always apparent, even to those who have actually visited both polar realms. Only then can we take the next step to begin to appreciate their interconnectedness with each other and the rest of the world."

My failure to become enchanted with the polar regions until middle age is directly related to the failure of most polar photographs to hold my attention. Images in books of explorers holding up flags at points said to be the poles did little for me because they lacked visual context. On the other hand, I was captivated by a newspaper photograph of Tenzing Norgay standing on the summit of Mount Everest for the first time in 1953, when I was twelve. The steep-angled snow beneath Tenzing's feet ended abruptly with no more upness. The photograph evoked a strong sense of place atop a singular and cold natural feature.

Two years earlier I had stood on such a snowy spot on top of a mere 10,000-foot mountain in the High Sierra of my home state of California. Below me was not an endless expanse of snow and ice, as in polar photographs, but a hauntingly familiar landscape with lakes, forests, and a distant meadow where I was camped for two weeks with my parents on a Sierra Club annual outing.

Each summer I hiked back into the High Sierra with my family into a world ever more simplified by each increment of altitude. I loved the sight of clean alpine meadows dotted with flowers and boulders well above timberline, but I failed to make the connection that I was indeed standing in the Arctic life zone of my planet in these meadows and on the summits of Sierra peaks, regardless of the California summer beneath my feet.

It was no coincidence that the byword of early Sierra Club outings was, "Life begins at ten thousand feet." The life zone at this altitude in the Sierra just below timberline is called "Hudsonian" by biologists because its climate and vegetation closely match the region beside Hudson Bay near the northern treeline. The next higher life zone, where I stood upon that snowy summit in summer, is called "Arctic/Alpine" because a similar climate is to be found both at high latitudes in the Arctic and at high altitudes in the Alps.

Even after several summers of hikes into the snowy Sierra, books of polar exploration continued to leave me cold, so to speak. My eyes would search in vain across bleak white landscapes printed on white pages for a hint of the familiar to render an impression of something more than a great white blank. I was left with the distinct feeling that the polar regions were as irrelevant as they were mysterious. Besides, why should I be concerned with polar explorers who always seemed to be struggling, suffering, dying, negating each other's claims, and publishing photographs that gave me little sense of place? Climbers seemed not only to be having more fun, but also to be reaching summits that captivated me both in person and in photographs. Books on mountains whetted my young appetite and set me on the path of my last four decades to climb, explore, understand, and interpret mountains of the world.

I feel compelled to relate these strong anti-polar emotions of my youth because it occurred to me, both in the bottom of a steaming ice cave on an Antarctic volcano and while whaling with Eskimos in seal-skin boats on the Arctic Ocean, that if I failed to return someone might search my library and personal files for the earliest record of the polar passion that led inexorably toward my end. They would believe they

had found it in a rare first edition of a nineteenth-century book on Arctic exploration graced with a 1952 inscription, "For Galen on his graduation from Hillside School as an Arctic explorer." I was eleven years old at the time.

Further searching might reveal an enigma. Only a smattering of other polar works found their way into my library until almost four decades later, when I undertook most of my twenty-odd journeys into high latitudes. Like a rare fossil, the old book sits apart from the known record, begging answers to questions not asked before its discovery. It is the account of an expedition led by a man who died searching for Sir John Franklin, who had died searching for the Northwest Passage.

A decade ago I would have shrugged off the inscribed book as an anomaly somewhat off the track of my life. I lay no claim whatsoever to a lifelong fascination with the Arctic and the Antarctic, and yet in a larger sense the old book had much to do with the shaping of my own 1995 work, *Poles Apart: Parallel Visions of the Arctic and Antarctic*. I found the old book's text so heavy and convoluted that I had to resort to entries about the explorer in my father's encyclopedia to try to make sense of what was being described. I remember vowing that I would never do a book like that, knowing with the certitude of youth that active involvement with books was somewhere in my destiny and that polar exploration was not.

The story of how I acquired the old book begins with my father, a professor of philosophy, reading me jungle, mountain, and polar adventure stories from the time I was three. Before my seventh Christmas, he admonished friends and relatives not to give me children's books, suggesting far too prematurely that my reading comprehension was approaching his own.

The heavy packages under the tree that year contained no toys. Among the new additions to my library was an advanced reference book on medieval mythology that I couldn't fathom. The weighty Arctic exploration book my neighbors gave me four years later may have been chosen at least as much for its incomprehensibility as for its subject.

Though I could read most all the words of the big adult books I was given, I was often unable to assemble them into patterns that held a larger meaning for me because their context was entirely too foreign. I now recognize this as similar to the perception of single polar photographs as empty or, at best, mysterious because of our inability to mentally reassemble unfamiliar visual symbols into anything close to the original scene.

In the 1990s, when I began visiting the polar regions with thoughts of doing a book that would compare them, I was both captivated by what I saw and worried as I thought back to how my early lack of interest had stemmed from the same secondary visual input of photographs that I was about to create.

What shocked me most about the polar regions on my first travels was neither the cold nor the remoteness, but a bewildering confrontation with my own lack of understanding. Looking at picture books and reading epic tales of exploration hadn't adequately prepared me for the loss of basic rhythms—as universal as the sunrise—that my body and mind have always taken for granted. Traveling to the extreme polar latitudes creates a far more powerful disorientation than the jet lag that disrupts the biological clock of those who travel rapidly to distant longitudes.

The polar regions defy simple definition. They do not follow the Arctic and Antarctic Circles any

more than America's highway system follows grid lines of latitude and longitude. The very qualities that set them "poles apart" from the rest of the world fail to translate into the sort of singularly distinct boundaries that define oceans or nations.

"What does Arctic mean?" Only some geographers and cartographers point to the circles on their maps with certitude and answer, "The region beyond the Arctic Circle." Botanists just as assuredly respond, "Life zones beyond treeline." Marine biologists say, "The southern limit of the winter pack ice," with a few extra twists that follow the juncture of water masses. Climatologists and land biologists strongly suggest "areas north of the 50°F summer isotherm," an invisible boundary of average temperature. Earth scientists prefer "the southern limit of the continuous permafrost" with the same conviction that social scientists generally include "all of Finland, Sweden, Norway, Iceland, Greenland, Labrador, northern Quebec, the Northwest Territories, the Yukon, Alaska above the Panhandle, and the Russian North."

We tend to see the polar regions, like the faces of a foreign race, as having a similar look. Without clear comparisons, their differences are likely to escape us. For example, the North Pole sits in the middle of an ocean surrounded by land, while the South Pole is at 9300 feet in the middle of a continent surrounded by ocean. Antarctica is not only the coldest, but also the driest, highest, and windiest of all the continents.

The first step toward understanding the polar regions is to develop a sense of place about the Arctic and the Antarctic that makes them as separate in our minds as Austria and Australia. Direct photographic comparisons make the similarities and differences come alive in ways not always apparent, even to those who have actually visited both polar realms. Only then can we take the next step to begin to appreciate their interconnectedness with each other and the rest of the world. Understanding and appreciation grow out of active mental involvement and questioning rather than passive ingestion of facts. My hope is that this understanding will lead readers yet another step toward feeling a sense of responsibility for the future condition of these most pristine parts of the Earth, at the very time when they have become most vulnerable to change from without.

A conscious goal of my polar photography has been to create images that move beyond the limitations of instant comprehension toward a greater relevance. I decided to try direct North/South comparisons early on, but received lukewarm feedback from friends to sketchy slide shows of my work in progress. I continued imagining direct comparisons of images, both while working in the field and after the fact. Reading about polar phenomena helped me visualize new pairings of the 40,000 images I had taken. I would wake up in the night and scrawl a note about putting a breaching whale beside a penguin erupting from the sea, for example.

I saw the Arctic and the Antarctic as metaphors, not only for wildness itself, but also for the myriad significant things about Earth's wild places that cannot be expressed in words or images. My reward came, not so much in the limited sales of the book by a university press, but in the recognition of its value by the cognoscenti. The *Atlantic Monthly* called the photo pairings "sometimes surprising, sometimes amazing, and always informative." The great conservationist David Brower wrote in the *Los Angeles Times*, "I boldly allege that no one but Rowell has reached so many difficult places, assigned so magical a role to his camera, and put so much of it so well into words."

Demystifying a Diffraction Fringe

"At its best, nature photography transcends mere visual information in the same way that poetry transcends the meaning of words to communicate not just what's out there, but how it feels spiritually and emotionally."

Outdoor optical effects keep nature photography interesting. Exceptional phenomena—rainbows, glories, and diffraction effects—are what first come to mind, but more common effects—haze, shadows, and blue midday light—can be the most challenging to render into an appealing photograph. Some fine-art critics judge exquisite photographs of rare phenomena as simply "cheap shots" of effects packaged and delivered by nature. In their world, a perfect rainbow connecting to an earthbound subject or a diffraction fringe painted around a figure indeed appears contrived, but in photography a rare moment is perceived to represent what a fellow human being witnessed. For example, Eddie Adams' 1968 image of the roadside execution of a Viet Cong almost instantly changed the face of the war after it was seen on TV and front pages around the world. No artist's conception of the same event could have had such power.

A vocal minority of the fine-art world would like photographers to show nature as average, never exceptional. In an *Art Issues* editorial, Rebecca Solnit wrote, "Yosemite Valley, in its most usual condition, is a green or brown landscape with indifferent air quality." She went on to describe Galen Rowell as one of those wretched photographers "who use colored lenses to depict a souped-up, hot rod-bright world." Poor Rebecca must never have gotten up early enough to see alpenglow at dawn or to see the natural features crystallize during the clearing of a storm when the atmospheric perspective taught in art schools vanishes

in the absence of haze. One of my best-selling photographs of Yosemite was made without the bias of any filter or highly saturated film almost thirty years ago. I have yet to replicate the clear, rich colors of Yosemite alpenglow touching 1970 Kodachrome at the end of a ten-day storm. Put simply, exceptional outdoor optical effects make exceptional photographs.

I found even more clear air one recent summer in the High Sierra on the summit of 13,080-foot Mount Darwin shortly after dawn. The sky had near-perfect clarity after a windstorm. I tested the potential for a diffraction fringe with my "little finger" rule. If I can block the sun entirely with the tip of my baby finger at arm's length and see blue sky all around its outline, conditions are ripe for a diffraction fringe to bend the sun's rays around a backlit subject at a proper distance.

Peter Croft and I had reached the summit of Mount Darwin after starting out by headlamp to first climb neighboring Mount Mendel. We were attempting the first-ever traverse of the crest of the Evolution Range. After doing all seven peaks along the Sierra crest, I returned to camp at 3:00 P.M. with bleeding fingers worn through all layers of skin. Peter continued over the tops of several more peaks, reaching camp at 7:00 P.M.

Without prior preparation, I never would have spotted the fantastic light or made the photograph that appears on page 201. Having scouted the scene on the previous afternoon, I convinced Peter, who was itching to move on, to stand on the summit pinnacle for a minute holding his ice ax. I scrambled to fit myself within his shadow on the side of a cliff sixty feet away—the magic distance.

The day before, I had climbed Mount Darwin by a different route and noticed the potential for a

189

diffraction fringe around a climber on the summit about an hour after sunrise. When the sun is closer to the horizon, the air is always too disturbed for a good diffraction fringe. That's why the sunlight turns reddish as blue rays are scattered away. Only when the sun shines through air devoid of moisture, smog, and dust—all those things normally present at sea level—can enough direct rays bend around an object to cause a strong fringe.

Finding a low enough position in your subject's shadow sixty feet away at midday is almost impossible. Steep, open landscapes an hour or two after dawn have the best odds. The gradual bending of light rays cannot be clearly seen much closer than sixty feet; from farther away the width of the sun destroys the shadow and the effect. The ideal geometry is so rare on mountain summits that I've only found it twice during forty years of climbing in the High Sierra.

The way I saw Peter—through my lens stopped down so as not to be blinded by the sun—is almost exactly what I see in the photograph: a beauty that I discovered for myself in the natural world. Virtually all scenic photographs include outdoor optical effects: sunrises, sunsets, shadows, reflections, godbeams, rainbows, glories, and seemingly ordinary blue skies and white clouds. Understanding what causes these phenomena allows a photographer to maximize their appearance on film. Even without any knowledge of the physics of light, a photographer quickly discovers that the true beauty of a Yosemite does not record on film in that hazy average light touted as true reality by an art critic.

Despite postmodern stagnation in the art world, civilization reached its present level through the efforts of men and women who searched out order from chaos to unfold hidden beauty in both the arts and the sciences. The pursuit of beauty is just as present in the elegance of Einstein's theory as in the "terrible lucidity" that came to Van Gogh as he painted. The nature photographer's task is to record the same sort of inner vision that empowered a Van Gogh—as an image of light and form on film that succeeds in communicating such a vision to others. At its best, nature photography transcends mere visual information in the same way that poetry transcends the meaning of words to communicate not just what's out there, but how it feels spiritually and emotionally.

The public seems to believe that photographers only record what they are seeing in front of them. The search for outdoor optical effects belies the common misconception that anyone who happened to be there could take pretty much the same picture. Neither Peter Croft nor I would have seen a diffraction fringe on Mount Darwin without creative forethought.

Outdoor optical effects can be truly personal. Two people standing beside each other see two different rainbows, reflected back from different raindrops. The spectre of the Brocken, in which a shadow surrounded by a glory is projected into mist, is also an individual experience where each person is seeing only their own shadow. Indeed, shadows become ever so individual when they spoil front-lit photographs of close subjects in low-angled light.

Shadows are also the key to understanding how to photograph the diffraction fringe. Place your camera inside the shadow of your subject's head at the proper distance in rare point-source sunlight. That's the easy part. The hard part is being prepared for the open-ended potential of the right natural situation, and that's what leads me to lug my camera along on every adventure.

A Lucky Day

"I sensed that conditions were ripe, but I had no way of knowing I was about to witness the most spectacular light show of twenty-seven trips to the Himalaya."

Though luck is defined as "the seemingly chance happening of events which affect one," the creative scientist Louis Pasteur said something far more relevant to creative outdoor photography: "Chance favors the prepared mind." Those "lucky" people who make great scientific discoveries, great amounts of money, or great photographs don't just happen to be in the right place at the right time. They're there before the time is right with a headful of intimate knowledge of their field.

Most photographers are in denial about the role of luck, afraid to let anyone speculate that their best work might be based on it. The word is conspicuously absent from the indexes of manuals and the agendas of workshops, yet without it, photography would lose much of its joy and all of its spontaneity. Denial of luck is usually a misguided effort to have one's art taken as seriously as the planned creative acts of painters and sculptors, who can't simply glance over their shoulders while one work is nearing completion, see something new, and produce yet another totally different work in 1/125th of a second.

I've never minded having my photographs appear as if I just happened to be in the right place by chance. People relate to them as if they would have seen the same thing had they been there, but such is rarely the case. To see a "seemingly chance happening of events," and compose it with the visual harmony that makes for something more than a record shot, requires anticipating luck before it happens.

In 1998, I scrambled to the top of Gokyo Ri, a Himalayan peaklet just under 18,000 feet, only to find thirty other trekkers occupying natural box seats among the rocks to watch the full moon rise over Mount Everest. All of them had cameras. None of them were very lucky.

A thick blanket of cloud rose from the valley floor to obscure Mount Everest just as I crested the summit ridge on my third scramble to the top in two days. The mist had risen the same way the previous evening to obscure all the high peaks in the last minutes of fine light. This time, however, high winds from the south held the cloud bank blocking the view of Everest at bay just in front of Gokyo Ri's summit. To the sides and overhead, the clouds thinned into wisps that vanished into an indigo sky. From behind, low-angled beams of sunlight shined directly into the mist.

Having studied the physics of outdoor optical effects for years, the possibility of finding multiple effects happening simultaneously in a grand natural setting had long been on my mind. I sensed that conditions were ripe, but I had no way of knowing I was about to witness the most spectacular light show of twenty-seven trips to the Himalaya. As I ran around, photographing more haloes, glories, coronas, and godbeams than I had ever seen in a single hour, the trekkers seemed to be focused on the impending moonrise and whether to descend because Everest was in cloud.

The only other person chasing the light was my trekking partner, Ervin Skalamera, a photographer from Italy who shared my enthusiasm for searching out natural optical phenomena. As I stood atop a pinnacle jutting out from the ridge to photograph the spectre of the Brocken in blowing mist, Ervin yelled for me to come see vivid colors in god beams coming

through prayer flags. We had found spectacular phenomena at the same moment in opposite directions. My spectre was a shadowy figure within a colored glory around the anti-solar point, while his unearthly beams of light were coming from the sun itself in the opposite direction. Bands of color in the beams were caused by their intersection with the corona, a colored arc that only forms in certain-sized droplets of mist.

I positioned myself beneath the upward-slanting beams and centered the white aureole marking the heart of the corona so that its rich reds, greens, and yellows appeared in the rays seemingly emanating from the flags themselves. Then I ran back to my pinnacle just in time to photograph the spectre in rapidly thinning mist with a motor drive. I shot bursts at 3.5 frames per second during momentary clearings, but only one frame caught the full spectre in thick mist with Mount Everest poking through thinner mist above.

The spectre of the Brocken is named after a peak in the Hartz Mountains of Germany, from where it was frequently seen and considered to be a religious apparition in the Middle Ages. I understood why as I watched my shadow pulsate in three dimensions, changing apparent size in the blowing veil. Passive aircraft spectres are frequently seen around the shadow of a craft flying high over a cloud bank, but seeing your personal spectre from a mountain is as different as standing at 29,000 feet on Everest and flying at that altitude in a jet.

Though I've never been to Everest's summit, I did spend two months on its flanks as climbing leader of an expedition attempting a new route without oxygen, without Sherpas, and without a single image in fine light worthy of an exhibit print. I found out the hard way that the perspective from very high mountains is not conducive to dramatic images of lower peaks profiled against unusual light shows in the sky.

Gokyo Ri is in a more distant valley than Kala Pattar, the classic viewpoint above Everest Base Camp, where most single-mountain Everest portraits have been taken. I much prefer the fuller Gokyo panorama, where after many of the trekkers had left, the clouds suddenly lowered to reveal the moonrise over alpenglow on three of the five highest peaks in the world—Everest, Lhotse, and Makalu. Moments after sunset, the remaining trekkers left, but Ervin and I stayed on until the blue earth shadow rose into pink twilight behind the great peaks. Though we knew we'd be descending in the dark, there was nowhere else on Earth that we wanted to be as we kept on photographing until the light show faded into twilight.

Above and right:

Essay pages 191–192
Alpenglow flushes Mount Everest near the end of the grandest light show of all my 27 Himalayan journeys. As the full moon rose (above), last light touched the tips of three of the world's highest peaks: Everest, Lhotse, and Makalu. Minutes earlier (right), golden light bathed Everest's north and southwest faces.

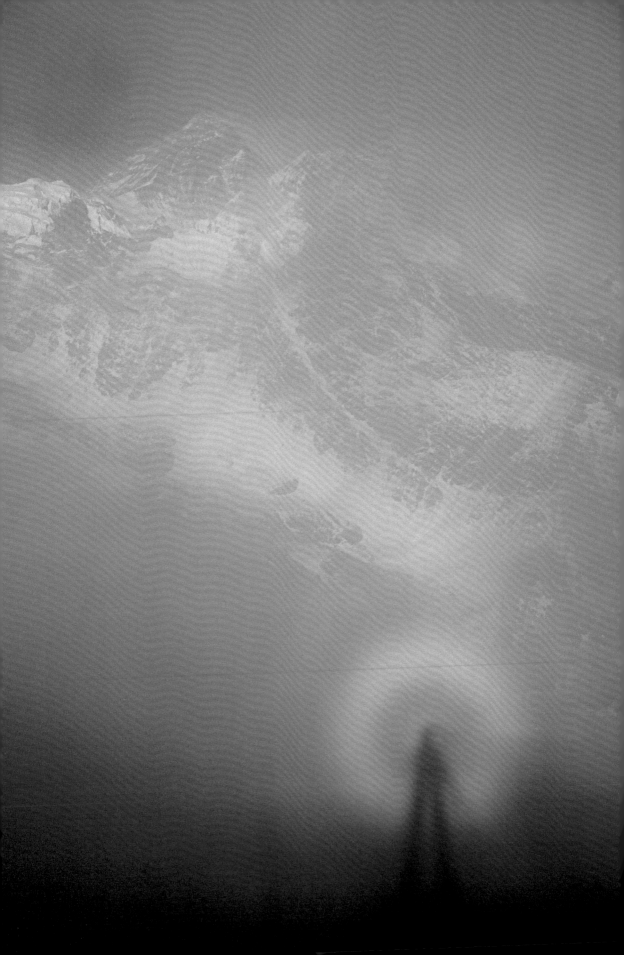

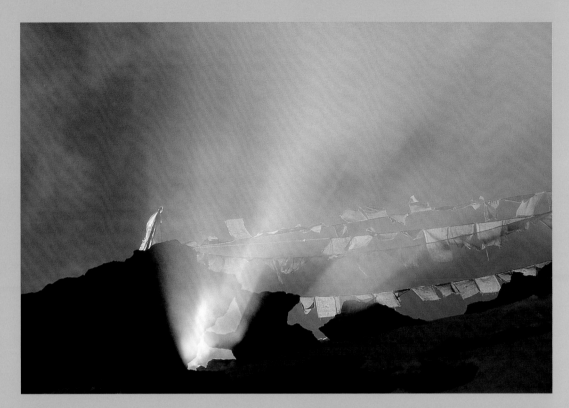

Left: *Essay pages 46–47, 61–62, 94–95, 189–190, 191–192*
My grandest Himalayan light show (page 193) began when a cloud descended over my 18,000-foot stance atop Gokyo Ri and I figured out where to be to see a momentary display of the spectre of the Brocken with Mt. Everest visible through the mist.

Above: *Essay pages 191–192*
God beams, technically called crepuscular rays, overlap with the concentric colors of a solar corona as they pass through blowing mists and prayer flags atop Gokyo Ri.

Right: *Essay pages 191–192*
The light show ended with the blue curtain of the earth shadow rising into pink twilight behind Cholatse, the last peak in the Khumbu to be climbed in 1982. I had been one of the summit team.

Above and above, top:
Essay pages 221–222
Are these two scenes taken
by different photographers
during the same sunset on
Machapuchare in Nepal
coincidental, or has one
knocked off the other's
creative concept? The top
photo is by my wife, Barbara,
while the lower one is mine.
The answer is in the essay.

Right: *Essay pages 232–234*
My photograph of a jaunty
Tibetan boy wearing a
Chinese soldier's hat in a
region of guerrilla resistance
was chosen for the cover of
the February 1982 *National
Geographic,* but dropped
after the issue was at the
printer when the Chinese
Embassy objected. The hasty
replacement was digitally

altered to move the Egyptian
pyramids and make room
for the magazine's logo,
an infamous decision later
regretted.

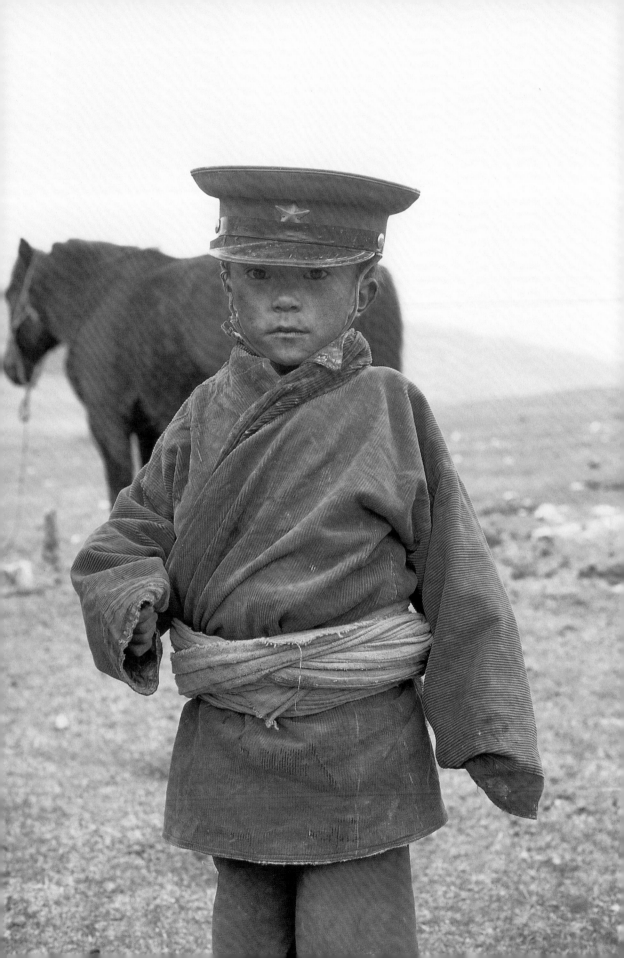

All (4): *Essay pages 98–102, 212–215*

While climbing and photographing the first free ascent of the Direct Northwest Face of Half Dome, I used fill-flash for all the images on this page. To emphasize the wild natural architecture of the 400-foot granite chimney at left, I used a 16mm lens. During the seven weeks it took for Todd Skinner to work out the difficult sequences (above, center), Nancy Feagin got so bored that she taped a crossword puzzle to the cliff while belaying the rope. She led some difficult sections herself, but left before the climb was completed by Todd, Steve Bechtel, and Chris Oates (right).

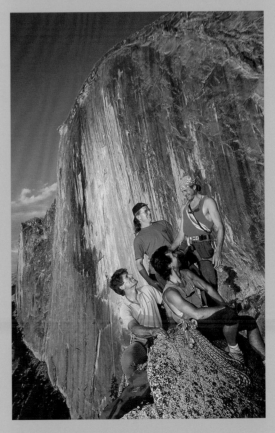

Left:
Essay pages 36–37, 210–211
In an early published photograph made in 1968 with an Instamatic 500 on Kodachrome, Warren Harding lounges in a hammock on the south face of Half Dome.

Right: Essay pages 36–37, 61–62, 189–190
An unearthly fringe of diffracted sunlight, seen clearly through my viewfinder, surrounds Peter Croft atop Mount Darwin in the High Sierra of California. I had scouted the site the previous day and knew the conditions were optimal for this effect.

Left, center and bottom:
Essay pages 216–217
Audubon chose two of my photos shot on the same assignment for the same month's cover: the bottom one for subscribers and the top for newsstands. They gave me parameters to shoot for an image that would work both as a wrap-around horizontal and a vertical cropped from the left.

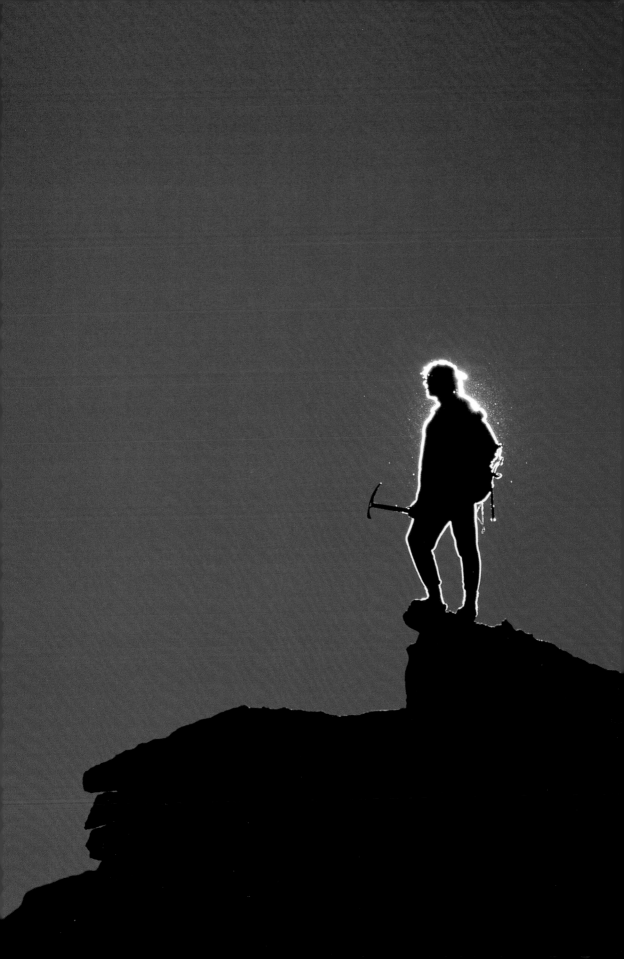

Above:

Essay pages 276–279
Morning light strikes the
Berkeley Hills behind my
home, one of 200 wild
areas within 40 miles of San
Francisco that are larger in
total than Yosemite National
Park and the subject of my
book, *Bay Area Wild*.

Right:

Essay pages 276–279
Intersecting green hills
beside Morgan Territory Road
beneath Mount Diablo are
among the Bay Area's vast,
but shrinking, greenbelts.

Preceding pages:

Essay pages 276–279
A ribbon of fog clings to
Bolinas Ridge at dawn, high
over the Pacific Ocean in
Mount Tamalpais State Park.

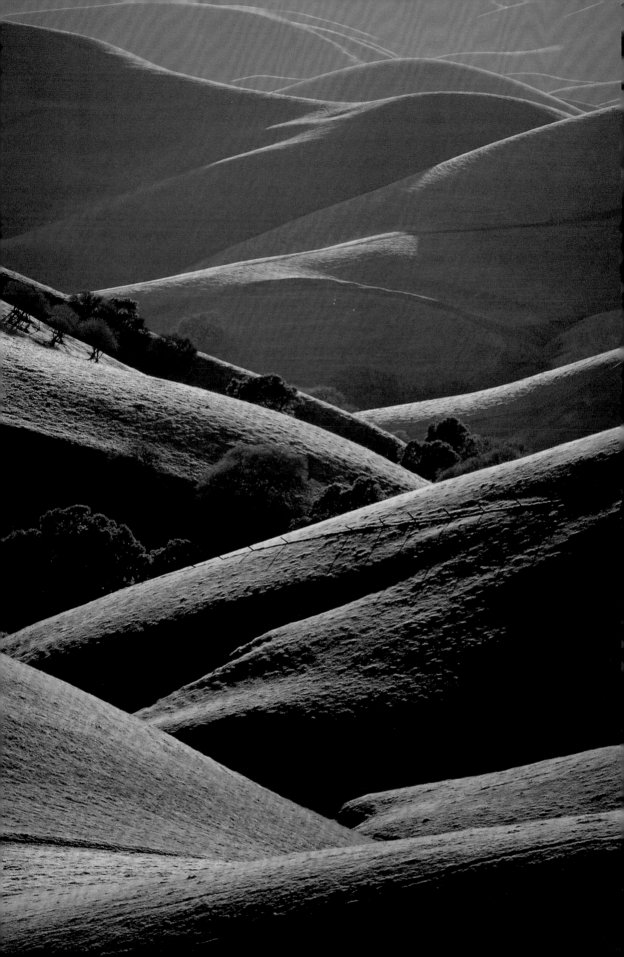

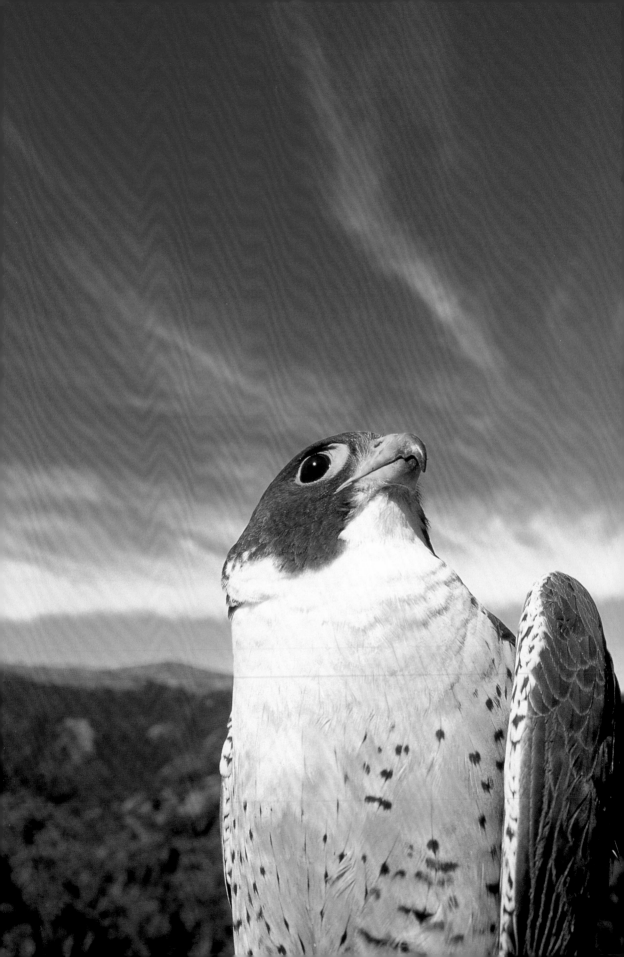

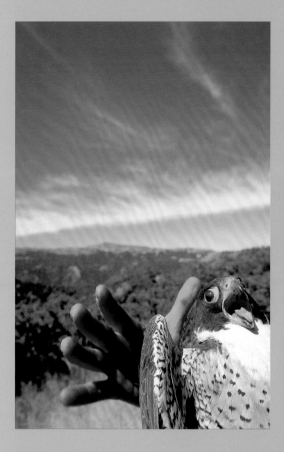

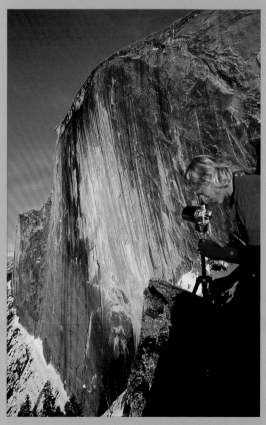

Left: *Essay pages 98–102, 235–237, 276–279*
This breeding adult peregrine falcon captured for a blood and band check in the Sunol Regional Wilderness turned out to be the same bird I had helped release as a chick into a nest five years earlier on Mount Diablo, while working on a *National Geographic* story.

Above, center: *Essay pages 98–102, 235–237, 276–279*
Moments after the photo at left was made with the falcon held in a researcher's hand, the bird sunk in its claws and broke loose. Neither falcon nor human were worse for wear.

Above, right: *Essay pages 98–102, 235–237*
At an eyrie on a Big Sur sea cliff, fill flash lights biologist Brian Latta holding out fragments of peregrine eggs from a nest that failed due to thinning from DDT contamination.

Right: *Essay pages 48–50, 235–237*
A researcher peers through a telescope at a peregrine perched on a Half Dome ledge. The essay on pages 48–50 explains why, in last light, we see the extra-warm tones recorded by film on natural rock as beautiful, but sense them as wrong on human faces.

Above:

Essay pages 186–188, 238–240, 257–259
A second-year polar bear cub rests against his mother in evening light on Cape Churchill beside Hudson Bay. Out in the field with researchers who had tranquilized both animals, I used a normal lens on a tripod at ƒ16 for full depth of field and detail from 4 feet. The 250-pound cub charged a researcher just after I made this photograph. It turned out not to have been adequately tranquilized.

PART IV: REALIZATIONS

Communicating your worldview through photography

An Early Published Photograph

"The fact that no major publication would print my well-executed photo of Warren Harding hanging on Half Dome, a newsworthy event in which I was directly involved, led me to my local camera store, where in December 1968 I purchased a Nikon FTn with two lenses."

Four years before I became a professional photographer, I made the photograph of Warren Harding that appears on page 200. We were about to spend our fifth night hanging on the unclimbed south face of Half Dome in 1968, and I had no idea that a blizzard would pin us down in the same spot for three days and two nights, ending in the first big-wall rescue in the history of Yosemite National Park. I shot the image on Kodachrome 64 with my trusty Instamatic 500, equipped with a fine Schneider lens. Within a week of my return I wrote an article about our close call and rescue and submitted it to both *Life* and *Look*, who rejected the piece with praise for the text, combined with similar advice that they never publish photographs smaller than 35mm format.

For years, I had favored the featherweight Instamatic 500 because it caused almost no interference with my primary adventures. I used the images for slide shows presented to clubs and university outdoor programs that paid me up to the princely sum of $100, thus helping me finance future adventures and photography. The fact that no major publication would print my well-executed photo of Warren Harding hanging on Half Dome, a newsworthy event in which I was directly involved, led me to my local camera store, where in December 1968 I purchased a Nikon FTn with two lenses.

In those days, most outdoor magazines did not print color. The photo of Warren on Half Dome was

finally published in 1969 as a black-and-white conversion accompanying the full text of my Half Dome adventure in a specialty magazine called *Summit*. Three years later it was a key part of the package that helped me land my first book contract for *The Vertical World of Yosemite* just before I decided to become a full-time photographer and writer.

Significantly, only this one frame of our final bivouac before the storm turned out worth publishing. Others made during the storm were either blurred in low light through the slow lens or seriously underexposed after the meter drowned and stopped working. I'm not sure that a state-of-the-art pro SLR camera of today would have fared better in those conditions, which were as bad as I've experienced anywhere on Earth for photography. We had started climbing in the warm Indian summer of early November, taking five days to reach what we named "the potholes," several dark spots 1200 feet up the face that resembled shadowy caves through binoculars. When we reached the largest pothole on a sunny afternoon, we found it to be merely a depression of dark rotten rock, perhaps five feet deep with no level place to stand, much less sleep. Instead of a floor, it had a ramp inclined at over fifty degrees. I anchored with several pitons and hauled up the bags, and we set up Warren's latest invention, two enclosed hammocks that would hang from a single point of suspension each, christened "bat tents." The description that follows is from an article I wrote soon after the climb in 1968.

"Waking at midnight, I heard a new sound outside. It was the running of water and dripping of raindrops upon our hammocks. Several hours later, I realized my down footsack and jacket were soaking up water. The 'waterproof' hammocks had been tested hanging free from a tree in the city, but not leaning against a rock wall running with water. The tightly woven fabric let water soak in, but would not let it out. Pools formed at the bottom of the hammocks. We had to puncture holes to let the water out.

"By dawn we were both soaked to the skin. Snow covered all the mountains in the high country. The rain became sleet and then turned into snow. We had seen a practical demonstration of the forces that form the potholes. Ours was a focal point for the drainage from the upper face. We were in a small waterfall. There was no chance of climbing in the cold, wet conditions. The weather became worse and worse. The snow fell thicker and thicker. Incredibly, it stuck to the almost vertical face and we were soon plastered. All day we shook with cold and looked for a blue spot somewhere in the sky. It never came. We passed a second night in the storm. A sleepless, cold, wet ordeal. Fourteen hours of November darkness. When the light finally came, everything was white. Small powder snow avalanches began to batter us about in our pothole. We were shaking almost uncontrollably and our fingers and toes were numb. Every article of our clothing was soaked and I was sure I could not last one more day and night. It was our eighth day and our second in the storm."

Just before nightfall, a helicopter landed on top and Royal Robbins rappelled down to us, fixing a rope for us to ascend. On top we were greeted by friends and treated to hot soup and dinner. We spent that night warm and dry in a tent on the summit before the helicopter returned in the morning to take us back to the Yosemite Valley floor.

Half Dome and History's Lessons

*"***Several European adventure magazines bought our true story, while their American counterparts seem content to have rushed to judgment with the dirt, no photos, and without checking facts—hardly surprising to media watchers these days.***"*

In early June 1993, exactly thirty years after my last attempt on the Direct Northwest Face of Half Dome, I began climbing up the cliff with two camera bodies, five lenses ranging from 20mm to 400mm, a smart flash, and a small tripod in a pack I hauled up behind me. I was both a member of the climbing team and a working photographer, with an agreement from *Life* magazine that they would pay nothing unless the climb was a success.

In the intervening years, I had climbed other routes on all of Half Dome's faces, but never "The Direct" because of what had happened to me on it in 1963. Back then, a top climber and mountain photographer, Ed Cooper, invited me to join him to attempt a new direct route up Half Dome's northwest face. The previous year, I had made an early ascent of what was then the only route on the face, closer to the left edge. I felt honored to be asked on a major new climb at the tender age of twenty-two, but I explained that I had a final at the University of California in Berkeley a week after Ed wanted to start. "That's okay," he told me. "We're going to spend a few days fixing ropes up blank areas on the lower face. We'll come down for your final and go back on the wall to finish it when you return."

Ed taught me how to use his 35mm SLR. He had cut a deal with *The Saturday Evening Post* to sell our story for several thousand dollars—a king's ransom to a sixties climber—contingent upon completing the first ascent and bringing back publishable photographs.

As we began climbing, the part of the lower face that most interested me defied my attempts at photography. We were the first humans to reach the Crescent Arch, a giant crack a few hundred feet above the ground that slowly widened until we could squeeze inside. Higher, it became a chimney that we could bridge with our backs and feet. Instead of disappearing into the dark depths like other chimneys, this crack ended abruptly after just eight feet against a smooth wall parallel to the main cliff. After hammering wide pitons for safety into cracks that completely separated the back wall from the outer rock upon which we were climbing, I wrote an eerie entry in my diary: "Here is the Half Dome face of the future, fully cleaved and waiting patiently, be it one or one hundred thousand years until it gleams for a geological moment in the noonday sun."

The top of the curving arch merged into blank vertical granite. Above, we saw no natural cracks in which to place pitons, so I hand-drilled a row of ¼-inch expansion bolts spaced a few feet apart to attach ladder-like slings for direct aid. I never imagined that climbing would advance so far in thirty years that I would be photographing people trying to free-climb this section protected by a safety rope clipped to my old bolts.

After my final exam, we returned to find Royal Robbins, the most accomplished rock climber of the times, climbing well above our high point with Dick McCracken. They stayed on the climb and made the first ascent in five continuous days, using the bolts I had placed for direct aid.

Afterwards, Robbins justified his rude appropriation of our route as setting a better standard for future Yosemite climbers. His single, ground-up effort was done in better style without the umbilical cord

of the ropes we fixed on the lower face. Yet he, too, had seiged other new Yosemite wall climbs of his own with fixed ropes until just two years before. Only after he became more bold and experienced did he begin promulgating that all climbers had a moral duty to follow his new ethic.

I was somewhat demoralized by the outcome and began doing more climbing in remote wilderness areas, rather than in the competitive arena of Yosemite Valley. Meanwhile, Ed Cooper vanished. A few weeks after the climb, he sent me a disheartened note from Manhattan, saying that he had given up climbing for good and taken a desk job. Notably, he didn't say he was giving up outdoor photography. Although he kept his promise about hard climbing, he soon couldn't hack the big city and returned West to become one of the most published large-format color landscape photographers of the sixties and seventies. He influenced my future in 1969 by looking at some of my best 35mm Kodachromes made with my new Nikon FTn and telling me, "You could make a living at this."

Thirty years to the month after our aborted climb, I eagerly accepted an invitation from Todd Skinner and Paul Piana to attempt the first free-climb of "The Direct" using ropes for safety only. I set aside all of June to join them. At fifty-two, I wouldn't be free-climbing the hardest sections, but I could lead more moderate climbing and take photographs of the best big-wall free-climbers in the world pushing their limits to new highs.

This time I was able to capture the nature of climbing inside the Crescent Arch by using an ultra-wide 16mm lens (page 198) and waiting until the evening sun shone almost straight into the crack. When we reached my old bolts, neither Todd nor Paul were able to free-climb the few feet out of the arch. They tried again and again, day after day, moving to one side and then the other with a safety rope from above for practice. Weeks later, when Paul had to leave to be with his teenage son in Wyoming, they

still hadn't mastered the first moves out of the arch.

Paul opted not to extend his stay because he liked faster-paced climbing with continuous forward motion through a cliff's natural defenses. Todd, on the other hand, became ever more obsessed with free-climbing his way out of the arch and beyond. He headed up the mostly crackless 300-foot wall above the arch by mastering a complex series of moves up tiny knobs and crystals that were often no bigger than door dings. Some were so small that he couldn't find them again without first ticking them with white chalk that would wash off in the next rain.

Dangling from a fixed rope right beside him, I watched in awe through my 20mm lens as he carefully previsualized and climbed sequences beyond the upper limit of his ability in practice (page 199). He explained how he holds a totally positive attitude and keeps on pushing until he feels "a spiritual lessening of gravity when something kicks in from the ozone. You feel like you're faking it for a few moves, but you don't fall."

Todd came down the fixed ropes to sleep at the base, gulp bionic growth hormone, work out special muscles for special moves, and use my cellular phone to plan his future. He soon enlisted a top female climber, Nancy Feagin, to join us and arranged to buy a cell phone of his own for Half Dome.

Like Paul, I balked at the slow pace of the ascent and began taking off a few days at a time to do other assignments. Todd would call me when he had rehearsed a critical section, rested up to regain his strength, and was ready to lead a whole 165-foot rope length, or *pitch*, of the 2,000-foot climb. I would run the eight-mile trail, join the team for a day or two, and photograph Todd falling yet again on the first part out of the arch or succeeding on other, almost equally hard sections hundreds of feet above. Nancy also led several hard pitches, but more often she would be Todd's "belay-slave," holding the safety rope from below for him for hours at a time. She took to taping

crossword puzzles to the cliff (page 199) to relieve her boredom.

Once I photographed Todd climbing flawlessly up the second pitch above the arch past all the extreme moves (rated 5.13c on a scale of difficulty that only went as far as the more logical decimal range of 5.1 to 5.9 when the face was first climbed in 1957). Then he slipped on easier climbing in the last ten feet before reaching the bolt he had previously placed at the end of the pitch. That didn't count for him. To consider the climb a "free" ascent, he had to do a whole rope length at a time without falling or supporting his weight on the rope or an anchor in the rock. When he said that he needed two days' rest before his fingers and hands were recovered enough to try this pitch again, I headed down to run the Tuolumne River for an *Audubon* magazine assignment.

Todd traces his drive for success to the down-home cowboy philosophy he learned from his Pinedale, Wyoming, kindergarten teacher, Mr. Cookie, who had been a local rodeo star until a bull named Gravedigger bucked him off and broke his back. He became a cook, and when that didn't work out, he moved on down the cowtown ladder to teach kindergarten. Mr. Cookie taught his class that to be a good cowboy, which every kid in Pinedale wanted to be, you needed to follow these basic rules of cowboy logic: "If you want something very badly, take it. If someone says something you don't like, hit 'em. And always remember that there ain't never been a horse that couldn't be rode."

In 1988, Todd and Paul spent forty-eight days doing a free-climb up the Salathe Wall of El Capitan that wasn't repeated for almost a decade. Rumors abounded among local climbers that the two ex-cowboys had secretly used direct aids, but as Todd says, "We were so paranoid about being watched through spotting scopes every inch of the way that we were scared to go to the bathroom."

The climbing on Half Dome was enough harder than that on El Cap to prevent Todd from being able to free-climb each pitch in sequence from the ground up. To push big-wall free-climbing difficulty higher than ever before in history, he used the entire arsenal of "sport climbing," including top-roping with tension from above to work out sequences in advance and pre-placing anchors in the rock for protection, sometimes with carabiners left in place to clip the rope. Success in this arena is more of a judgment call, as in Olympic ice skating, than a clear "step for mankind" onto the moon or an untrodden summit.

When Nancy had to leave in mid-July, Todd recruited two of America's top competitive sport climbers who proved unable to free-climb the hardest sections he'd already done. Todd's self-confidence was solidly reinforced, and he finally mastered the extreme pitch out of the arch as well as the higher pitch where I'd seen him fall near the end. His new partners, however, left in a tiff after Todd refused their demand for $1500 each to finish the route, money they imagined would come out of the profits of my photography. When I returned, two of my belongings were missing from camp: a conspicuously patched sleeping pad and a water bottle faintly marked with the letter "P" to demark its special night use in my tent. Todd recalls last seeing it being filled with drinking water just before they hiked out.

From the base of the cliff, Cellular Todd soon recruited yet another two climbers, Steve Bechtel from Wyoming and Chris Oates from Toronto. More pitches were free-climbed, but others remained that were extremely difficult. Before I headed off on a three-day assignment to the Grand Tetons, Todd and I set Tuesday, August 2 as the date we would all go on the wall to spend several days and nights making a final bid to complete the climb after the lower 1,000 feet was fixed with rope.

Déjà vu.

When I returned to the base of the face of Half Dome on the evening of August 1, Todd, Steve, and Chris had just completed the entire climb. Todd said he came to feel so ready and centered that he didn't want to risk waiting the extra days. The batteries were low on his cellular phone, so he hadn't called to tell me.

The outcome seemed to fit that famous line,

"Those who fail to heed the lessons of history are doomed to repeat them." My heart sank as I believed I had lost both the experience of the final climb and the story for *Life* magazine, based on a similar contingency as Ed Cooper's in the distant past. In this case, however, my efforts proved more fruitful. *Life* understood that I had indeed shot the hardest free-climbing, even without covering the ascent of the upper face or the summit. They rightfully considered Todd's success to be far more important than my complete participation. The editors decided to publish a broader photo essay in the July 1994 issue based on Todd's "grand slam" of the first free ascents of the four greatest mountain walls in North America. Over the past four years, I had also photographed Todd and Paul free-climbing Wyoming's Mount Hooker and the Northwest Territories' Proboscis. Bill Hatcher had taken great photos of Todd and Paul's 1988 El Cap climb.

By the time our story ran, a specialty climbing magazine had used the covetous account of one of the two sport climbers who failed and quit in an editorial account that appeared to discredit Todd, suggesting that he didn't really make all the moves free. In other words, that what should be one of the greatest climbs in Yosemite history shouldn't count.

As with all his other free-climbs of big walls, Todd fully acknowledged that he had relied on sport climbing techniques with lots of preparation via direct aid before free-climbing all the moves. The most specific criticism was that he pre-placed a long sling on the final bolt on one pitch, grabbed it, and thus didn't do the last moves free. I had watched him reroute a better finish to that pitch off to the side and tie on the sling to avoid placing extra bolts at the end of his new-found variation, just a few feet away. He indeed completed all the free moves on his new variation and began the next pitch from where he grabbed the sling, not up and right where the bolts were fixed. Ironically, if he had placed extra bolts where the sling reached, no one could have questioned the validity of his free-climbing.

So it is in today's climbing world. In the old days, we clearly knew our own success or failure by whether we had stood on the top. For Todd, the jury of history is still out.

I stopped climbing for eight months after the ascent, not by conscious intention but out of disgust. I had hoped that climbers and the public alike would see my photos, read the text, and be inspired by the positive nature of extending the limits of the possible on the world's greatest natural cliffs by applying the extreme skills developed through sport climbing. Because of my exclusive agreement with *Life*, I couldn't even write the truth about the climb for another magazine until after they published it.

After I began to climb again, several European adventure magazines bought our true story, while their American counterparts seem content to have rushed to judgment with the dirt, no photos, and without checking facts—hardly surprising to media watchers these days. It's becoming ever more usual for Americans to discover the truth about events in our country only when they are translated back to us from foreign sources.

With hindsight, the climb was a painful learning experience about the pitfalls of doing either climbing or photography without equal commitment from all concerned. On the positive side, Todd's supreme confidence to exceed limits others set for themselves is infectious. He did what he thought he needed to do when I wasn't there at the time he felt ready to do it.

A few years later, Todd and Paul's personal story finally came out in a lavishly illustrated Sierra Club Book, *Big Walls: Breakthroughs on the Free-climbing Frontier*, using many of my unpublished photos and an upbeat, informative text, written by Paul. Todd went on to write his own cover story for *National Geographic* about his later free-climb of the Trango Tower in the Karakoram Himalaya, and we remain good friends.

Cover Shot

"Candid photographs of people at close range are always difficult because their expressions tend to become unnatural. The attitudes of attention and concentration toward work or family that we hope to capture on film usually vanish the moment we lift that camera to our eye."

Cover photos aren't just great pictures; they're pictures that have to communicate in a highly restrictive format. One photographer I know had a see-through insert with the *Time* cover logo made to slip over his camera's focusing screen to better compose images that might pull the brass ring. Other photographers who often get their shots used on covers shoot their best vertical scenes in tight compositions for inside use and then reshoot a looser composition with extra open space to accommodate type.

While on assignment for *Audubon* magazine some years ago, I was asked to keep an eye out for cover possibilities. Peter Howe, the director of photography, explained to me that the magazine's wraparound 11-by-17-inch horizontal cover images require a composition that most photographers don't deliver. The images have to read both as a normal vertical cover with a logo on just the right half of a horizontal frame and as a full horizontal when the cover is spread out.

While in the field, I dutifully conceived compositions that would fulfill this visually complex mission. Most of the two sheets of cover candidates that I submitted from the assignment were carefully framed and shot with a tripod at apertures chosen to give maximum depth-of-field and sharpness. Virtually all of them were landscapes without people, since I was told this should be the major focus for my accompanying photo essay on California's Tuolumne River to celebrate the twenty-fifth anniversary of the Wild and Scenic Rivers

Act. When I suggested photos of river rafting, hiking, or climbing, I was told that these were of a much lower priority.

Photographers rarely have much say about which of their images are used or how they are used after an assignment is shot. I've learned not to get too attached to preconceived notions about a layout, even when I review and approve one days before it goes to the printer. Too often, the "final" copy fails to materialize in print. The increasing ease and speed of digital scanning of both photographs and layout make the final product ever more changeable at the last minute. Perhaps the most famous digitally altered magazine cover ever published came about as a hasty replacement for a Tibetan portrait of mine that had the Chinese embassy in a snit. After the magazine was already at the printer, the *National Geographic* digitally moved the pyramids of Egypt in an image the photographer had clearly not composed with a cover in mind.

I was pleasantly surprised to see the rivers issue of *Audubon* hot off the presses with one of my cover choices, just as I had visualized it. There was my image of Waterwheel Falls, carefully executed on a tripod with conscious forethought for a dual composition reading as a full horizontal and a vertical cover. A few days later another copy of *Audubon* arrived with the same internal contents, but a different cover. Instead of the waterfall scene, or any of the thirty other cover possibilities I had sent, the shot was taken from a whitewater raft with a Nikon Action-touch point-and-shoot waterproof camera that has fully automatic settings, including nonadjustable DX film speed settings. I knew all these facts because the rafting shot was also mine. I had been pleasantly surprised about how sharp, well composed, and candid it had turned out, but I never thought of it as a cover.

Candid photographs of people at close range are always difficult because their expressions tend to become unnatural. The attitudes of attention and concentration toward work or family that we hope to capture on film usually vanish the moment we lift that camera to our eye. Many of my best pictures of companions on adventures have come when they are too involved with the situation to be concerned about the presence of the camera. I purposely chose the beginning of a Class Four rapid to lift the Action-touch to my eye and use its small flash to fill facial shadows at close range. The first frames were adequate, but there was a slightly self-conscious look on the boatman's face. Then came the one frame that stood out above all the others. As I composed a photo including a background with the river and the other rafts behind us, my boatman had bent over low, thinking I wanted him out of my frame. While he gazed past me to judge his course, I purposely included him in the lower right-hand corner of the frame and caught his look of total concentration.

I liked the shot very much, but hadn't selected it as a cover candidate because I was viewing it in an entirely different way. Its composition had been forced on me by circumstance, rather than created by artistic intention. It simply didn't register that here was an image which fulfilled the wrap-around cover mandate as well as my other prime candidates.

Had the first magazine I saw been a preproduction sample scrapped for a later replacement? On the contrary, magazines with both covers were being distributed simultaneously. The wild waterfall went to subscribers with no price bar code and a November–December 1993 date. The more exciting rafting shot went on the newsstands with a December-only date to give it an edge in sales.

Getting two covers in the same month for the same magazine is a case of two cups half full. One image validates the careful forethought that goes into the majority of my successful landscape photographs. The other image validates my wild-card approach, often using lots of film with a low success ratio to shoot unusual juxtapositions of people and their surroundings from moving cars, boats, trains, and planes. When such an image works, it livens up a set of technically superior but static images that lack a feeling of spontaneity.

One of the reasons that I wholly limit myself to 35mm photography is the joy of knowing that anytime I go anywhere with a camera, whether it be my top-of-the-line pro body with fifteen lenses and smart flash or a simple point-and-shoot, I might take the best photograph of my life. If, however, I trapped myself into believing that the success of my style would only come through in the grainless technical perfection of a cumbersome larger format or the heady fine art of a preconceptualized composition, then I would lose much of the magic that drew me to photography in the first place. That's why, after nearly thirty years as a pro, I still do my best work for the joy of it, whether or not I'm getting paid.

Antarctic Art and Anarchy

"It's important for photographers to admit that their images never catch it all. For me, Antarctica is a metaphor for the myriad of significant things about the Earth's wild places that can't be expressed in words or images."

Anarchy was the furthest thing from our minds when Barbara and I were invited to attend a Boulder, Colorado, gathering of recipients of National Science Foundation (NSF) Artists and Writers grants for visits to Antarctica. An amazing nineteen out of the thirty-five grantees since 1959 showed up. Those who didn't attend were either no longer alive, somewhere abroad, or still working "on the ice."

Guy Guthridge, director of public information for the NSF Division of Polar Programs, told us that he hoped we would express visions that would help guide the future of the United States in Antarctica. This was more explicit than the goal stated in the invitation of presenting "perspectives that can enrich future human involvement with Antarctica," yet we were not to address the subject as if we were responding to an NSF request. There was none.

The idea of expressing our feelings seemed appealing enough, but we were quite bewildered how this was to be accomplished. The meeting was soon turned over to a skilled facilitator to help us "discover" the concise messages hidden within us. Shared ideas were scrawled into sound bites that were posted on the walls. Soon they were organized under broad headings such as environmental protection, the role of the NSF and the U.S. government, and the relationship between art and science. I was pleasantly surprised that by far the largest category was "our roles and responsibilities as artists/writers."

My previous experience with group discussions of the inner motives of successful photographers or writers has been a knee-jerk regurgitation of our First Amendment right to express ourselves any way we darn please. In fact, this God-given right of art and the media has never reigned supreme. We pursue our crafts in the shadow of the economic imperative that compels us to consent to the whims of the editors, curators, and ad agencies who butter our bread and pick up our film and processing tabs. Their covert selection processes, hidden from the public eye, censor free expression as effectively as dictatorships. Those who complain too much simply disappear from the loop.

Early on, the great nature writer, Barry Lopez, shared his feelings with us about the current American obsession with self. "We are living in a time of desperate spiritual hunger," he mused as he explained how Americans have come to devote their energies to issues of personal autonomy rather than social responsibility, both as individuals and as a nation.

Our group seemed to agree that the rare Antarctic experience afforded us by NSF should not be used to foster art forms that emphasize obsessions of self over honest interpretations of place. Over lunch, I was surprised to hear an informal debate about the Antarctic photography of one of the deceased NSF grantees, Eliot Porter, who produced a major book thirty years ago that portrayed the continent without human presence. Even then, the U.S. base at McMurdo had an awful Rock Springs, Wyoming-temporary-boomtown look that foretold future problems. One artist suggested that because the book implied a documentation of Antarctica, a Porter photograph or two of the esthetically shocking base might have averted the continued pollution of the nearby bay and landscape that ended in a highly expensive clean-up and

international loss of face for the U.S. and NSF after media confrontations with Greenpeace.

NSF controls U.S. activity in Antarctica as virtually a closed system. Without NSF support, a military posting, or a prohibitively expensive private expedition, public access to the main continent of Antarctica is extremely limited. Most Antarctic tourist cruises never penetrate the Antarctic Circle, visiting only the Antarctic Peninsula, as far from the South Pole as California is from Alaska. At NSF–run U.S. facilities on the continent, uninvited guests are unwelcome. Adventurers who request assistance must either pay the full cost of immediate evacuation from the continent or continue on their way without help.

The artists and writers program that Guy Guthridge oversees has helped shape the public's vision of a place with virtually no public accessibility. We provide the counterbalance to those rigid scientific and governmental publications about Antarctica that favor facts without emotional interpretation. Working within this paradigm has created a special responsibility for each of us to use our personal art to communicate truths we have realized. Unlike artists who work in places already overexposed to the public eye, with little sense of obligation to go beyond calling attention to their own creative acts, we share the philosophy expressed by the astronaut Rusty Schweickart, who said of his visit to the even more remote environment of space, "It comes through to you so powerfully that you're the sensing element for humanity."

Late in the first day of our meeting, a civil insurrection began. One by one, artists and writers stood up to denounce the idea of being channeled into producing a joint document by committee. Some refused to write a word or draw a sketch during the week-end, citing their desire to hone their art on their own terms until ready—if ever—to unveil it before the public eye. When we agreed we couldn't duplicate that process in a meeting, both the facilitator and Guthridge stepped down, acknowledging that successful artists and writers are indeed anarchists who march to their own drums. The meeting was ours, but what next?

We couldn't agree on a message to send the White House or any other single common agenda. Just as things seemed hopeless, a simple idea surfaced. Since our presentation needed to preserve the individuality of each of our art forms, what if we each were set free to create a single 18-by-24-inch framed item for a joint portfolio? The result would be an original exhibit with extra portfolios, plus the opportunity for eventual publication. Writers would write, artists paint, and a writer/photographer like myself could devote half of the space to an image and half to text.

Here's what I came up with to go with the photograph reproduced on pages 254–255:

"The moment I stepped off the plane, I felt a strong sense of perceptual disorientation. Virtually all first-timers feel it and chalk it up to the mystery of the place. The landscape seemed profoundly different from the image that movies and still photographs had created in my mind. I knew then that my work, too, would be deficient in the kind of familiar symbolism that allows us to clearly recognize a face, a sign, or a tree.

"In a limited sense, I agree with the insensitive presidential remark: 'If you've seen one redwood tree, you've seen them all.' Having seen one ancient giant enables you to properly scale a mental image from patterns in a photograph that

represent a whole forest, but no photograph will lessen the awe of really seeing that first big tree.

"Normal life doesn't prepare us to see Antarctic photographs. Because relevant visual constructs of size, color, and form are missing, we create twisted renditions of real Antarctic scenes as well as photographs. Gone, for example, is the atmospheric perspective that normally evokes distance. As a Los Angeles scientist quipped, 'I don't trust air I can't reach out and touch.'

"This photograph depicts neither sunrise nor sunset as we know it. Night has fallen on the frozen sea while long hours of alpenglow bathe Mount Erebus during its first week of 24-hour daylight. The world's most southerly active volcano rises 12,447 feet above the tide-fractured sea ice, higher than Mount Everest above its base camp.

"It's important for photographers to admit that their images never catch it all. For me, Antarctica is a metaphor for the myriad of significant things about the Earth's wild places that can't be expressed in words or images. We need to understand this in a modern world bent upon becoming a theme park of artificial visual inputs."

Beyond Coincidence

"Appropriating a creative concept for profit is treading on far more dangerous ground. Courts have awarded large sums for these kinds of infringements, both with and without formal copyrights."

I rarely came across outdoor photographers in the field thirty years ago. Today, people with cameras are often right where I want to be. If I choose another spot, I'm ever more likely to see someone set up in my tripod holes when I leave.

This never concerned me much until recently. Photographers are as drawn to previously used terrain as a dog about to lift its leg. Originality is the exception; imitation is the norm. I've always thought I knew the difference—and, more important, *practiced* that difference. Many top pros directly communicate their style and favorite locations in workshops. It's satisfying when students "get it," and up to a point, imitation is the most sincere form of flattery. If things go too far, however, photographers need to know when to blow the whistle.

Both with and without attorneys, I've collected healthy fees for unauthorized use of my photos in artwork on tee shirts, government signs, fine-art paintings, and even jigsaw puzzles. In each case a reasonable person could spot a telltale "fingerprint" of details beyond coincidence, such as the patterns of shadows or the positions of figures.

Nearly two decades ago, my assistant on a commercial shoot photographed a scene with a model that I had conceived and orchestrated. It surfaced as his business card and a limited edition print. I decided to choose my battles, sigh, and let it become his loss. He hasn't been part of the ongoing fertile exchange I've kept up with dozens of other photographers who haven't stepped on my creative toes, yet in a broader sense, we remain friends. Such is not the case in a number of recent feuds between nature photographers over "first rights" to landscape images. The typical claim is that a singular personal vision has been copied for profit by the photo equivalent of an art forger. Dollars and reputations are put on the line.

When photographers who feel ripped off ask my advice about whether to make a private fuss, go public, or hire a lawyer, I have no easy answer. Repeating a photograph in the same location at the same time of day is not by itself a legal infringement. Appropriating a creative concept for profit is treading on far more dangerous ground. Courts have awarded large sums for these kinds of infringements, both with and without formal copyrights.

To win a legal judgment—or to avoid the wrath that rightfully reflects back on false accusers—you'd better be sure that a reasonable person *knowing all the facts* would conclude that the image in question is clearly derivative. Could it have been made without first seeing and copying important aspects of your work?

A reasonable person, shown just the two sunsets on Machapuchare in Nepal by different photographers on page 196, might well think that one is a knock-off. Indeed, one photographer believed her concept was being ruthlessly appropriated. Had the two not known each other so well, a lifelong feud could have begun.

In this case, husband and wife resolved their conflict. Barbara had seen me busily taking photographs of Himalayan peaks over tents in a meadow just before sunset. She decided to do something different and look for a simple foreground to juxtapose against one spectacular peak. The forest looked too "busy," so she dropped over a bluff to single out the profile of one tree. When I ran down beside her and began taking

221

photographs, she got upset. She was absolutely certain I was stealing her idea and her location. After all, she'd gotten there first, hadn't she? I kept on shooting, and at the time, she wouldn't let me try to explain.

Hours earlier, I had cased out two situations to shoot near camp at sunset. I would do the tented meadow first while light was more fully on the peaks. Then I planned to drop over the bluff to where I had stomped out a tripod platform behind a tree.

After I shot the tent scene, I ran to the edge of the bluff and let out a laugh of surprise (which didn't help things) when I saw Barbara already shooting "my" tree a few feet away from my chosen stance. I was amused how similar thoughts and visual clues had led us to almost the same spot, but I never thought about "first rights." I expected our photographs to be somewhat different, despite emphasizing the common shapes of the right sides of tree and mountain. Barbara composed more tightly with a Cokin graduated gray filter she knew would give the sky a magenta cast. I put the crown of the tree higher in the frame with more sky, expecting my prototype "Galen Rowell"-series Singh-Ray ND grad to hold it true blue, which it did. Though we each prefer our own vision, our pictures (both widely published since 1987) are close enough that we might not have noticed at first had our boxes been accidentally switched by the lab.

An analogous situation explains a feud between two photographers selling fine-art prints of the same Southwest scene at dawn. Number One says Number Two asked directions and permission to make a picture that would not be sold in their home town, several states away. Bad blood flowed after Number Two came up with a very similar print for sale.

Number Two says he saw the scene on postcards in the Southwest years before Number One's image. He went there, but didn't get a great shot on his first try. Much later, he saw his fellow local photographer's image and called him about current logistics of getting to the remote site. Out of courtesy, he said that if he came up with anything too similar, he wouldn't sell it in their home area. He doesn't see his vertical composition as derivative of Number One's

fine horizontal in almost identical light, yet people who compare only these two photographs and are unaware of similar published images view it as a clear rip-off. Since then, literally hundreds of images of the same formation in the same dawn light by other photographers have appeared in travel magazines, as photo contest winners, and as fine-art prints.

A derivative image with a more substantial "fingerprint" appeared in a stock photography sales book in which I had paid about $2000 to print a page including one of my own original versions. My image was an outtake from a commercial assignment where I used hired models roped together on a cliff to illustrate my chosen theme of mutual trust. The exclusive time limit in my contract with my client had just expired, but I held back from using a visually stronger photograph similar to my client's selects in favor of a more subtle image of the two climbers standing together on a ledge.

When the stock book arrived with another image of the same two climbers wearing similar red outfits on a nearby cliff below the same snowy peak, in a situation much closer to my client's image, reproduced far larger than mine, I was, shall we say, unhappy. The ad was done by my assistant on that shoot, who later asked the same models to go back to the same location to shoot the same concept with minor variations. If his photo appears in a magazine, I'll shrug it off, but if it sells as a far more profitable national ad, I'll ask for at least half the fee for breach of copyright and intellectual property.

As outdoor photography has become more competitive, I've sadly recognized the need to ask assistants to sign non-competition agreements. I wouldn't think of thrusting one of these forms on someone in an informal shooting situation, but someday soon I'll probably be handed one when I least expect it.

In summary, choose your battles where the stakes are high, the facts are known, and the appropriation goes beyond mere location, which even the richest photographer rarely owns. Otherwise you'll lose even when you win on paper, because you will have wasted some of the priceless energy that powers true creativity.

Captivating Cat Shots

"The traditional assumption that the basic form of what we see in a nature photograph represents an event in the natural world is not inborn, but culturally established by the general reliability of published editorial photography over the last 160 years."

For me, there is no question which of these images is the better bobcat photograph. My son, Tony, took the image on page 74 on his twenty-third attempt in the hills of Marin County, California, months after spotting one during a mountain-bike ride. When he first showed me a distant image of a wild bobcat in tall grass from an earlier outing, I was excited by what the photograph represented, but not by its quality. It possessed the basic integrity that we take for granted in editorial nature photography—a record of a visual event that a human really saw in the wilds and captured on film—unless we read a disclosure to the contrary.

Based on this assumption of wildness, we might not choose his image of an immature bobcat taken with a handheld 400mm lens over my image of an adult male taken at close range on a tall tripod with balanced fill-flash. However, I cannot in good conscience present my image for comparison or editorial use without disclosing that it depicts a captive animal. The cat belongs to Wildlife Associates, a non-profit group that brings animals to schools to show children their environmental heritage. I took the photograph in a suburban field near San Francisco on a commercial assignment. I was demonstrating the capabilities of a new camera for a manufacturer's video that clearly depicted the captive situation.

I have serious misgivings about placing my bobcat photograph with any stock agency that makes a practice of selling captive wildlife images without

disclosures. I believe that nature photographers and their agents have a moral obligation to identify captive or controlled animals in captions and strongly suggest to buyers that this information be printed with all journalistic uses. I pulled all my images from Tony Stone, a major agency that was not only failing to do this, but also making a regular practice of supplying images with digitally added animals and sunsets to editorial customers. Needless to say, sales of my truly wild images with this agency had been poor, but for me the last straw came when another photographer related that the agency told him point-blank they didn't care if any of his images were wild or not. Since then, Tony Stone has been bought by Getty Communications and has decided to identify altered images, after a major fiasco selling an image of a polar bear in Antarctica (where they don't occur) for a *National Geographic* full-page ad.

This and other incidents have proven that book and magazine readers *do* care. Despite the chorus from workaday nature photographers that they must shoot captive portraits to compete in the marketplace, the magazines we most trust place a high value on truly wild images and go to great effort to reveal the truth about the captive shots they sometimes use to fill out coverage, especially of rarely seen creatures. For example, 1940s articles on cougars in *National Geographic* and *Natural History* clearly disclose that they are captive animals. Some years before, the struggling American edition of the fine German magazine, *Geo*, closed its doors after negative publicity over purporting to have the first photos of wild pandas. In actuality, the photos were taken of captive pandas in an enclosure and misrepresented to the magazine by the photographer.

Disclosure of a staged nature photograph is not a moral imperative for illustrative uses that do not imply direct journalistic representation of wild situations. These include field guide illustrations, decorative posters, and most advertisements. The ethics of still photography, like those of television, have plenty of room for created fantasy but firm guidelines for journalistic representations. Two major networks were brought to their knees in recent years by assertions of staging news coverage. In the one, a battle in Afghanistan was reportedly re-created after the fact. In the other, a gas tank on a rigged vehicle was shown apparently blowing up solely from a collision. In both cases, the imagery had enough validity to have been used with proper disclosure (and decreased visual impact) to illustrate what a person at one of the real scenes *might* have seen. Similarly, captive and digitally created wildlife photos show the public what *might* have been seen in the wilds.

The ethical litmus test is whether the meaning of an editorial photograph significantly changes when the facts of its creation are revealed. An excellent rule of thumb for all use of controlled situations and image manipulations in photos that purport to represent the natural world is for both photographers and editors never to do anything they would not feel comfortable having disclosed in a caption or by later investigation. For example, I do not feel comfortable creating photographs of wildlife at game farms. Others do. For the video demonstration of wild animal photography that I was working on during the same week that Tony took his first publishable slide of a wild bobcat, I purposely avoided "game farm" operations that cage healthy animals to make money from photographers, and instead chose an educational facility that uses mostly injured or orphaned animals.

Tony was filled with pride, and unaware of what I had just been shooting for the video, when he came to my office to show me a slightly blurred, full-frame profile of a bobcat on the run. He was well aware, however, that as of the previous week I had no close-ups of wild bobcats in my stock files (although he had been with me in Alaska in 1974 as a five-year-old when I made a rare close-up of a wild lynx). After I congratulated him on a great action shot of a wild

creature, he asked if I thought a magazine like *Outdoor Photographer* would publish it. I said probably not. Without an explanation, I put my photograph of the captive cat on the light box.

Tony looked crestfallen. He asked if I had been out with Michael again, referring to a friend who had won a major contest with a tight shot of a wild bobcat called in to the sound of a dying rabbit. Tony knew I had been in the field with Michael several times without calling in a cat.

"Yes," I replied, watching Tony's disappointment as he checked out an image that appeared to better all his efforts. The instant I explained that Michael had only been with me as my assistant when I photographed a captive bobcat, his own wild image reigned supreme again. As we talked, he saw a new Sierra Club Calendar on my desk with a too-perfect bobcat on the cover and asked, "Is that captive, too?"

"I believe so," I answered, checking the vague "northwestern Montana" caption. He was getting the message loud and clear that most of the visual power held by photographs of nature is mostly a cultural response based on trust, personal knowledge, and basic assumptions about the wild reality those images represent. His experience of instant disillusionment with a photograph of a seemingly wild animal revealed to be captive is ever more common these days. The cat is out of the bag, so to speak. Readers cannot regain faith in the power of truly wild photographs as easily as Tony did with his bobcat image because they weren't there to validate the situation by direct observation. His photograph has absolute eyewitness credibility in his own mind, yet it might look captive to readers who saw it in one of those publications that does not disclose captive situations.

On an Antarctic natural-history cruise, I watched a wealthy amateur photographer entertain passengers by calling out the funky first names of dangerous-appearing predators in picture books by well-known photographers that she borrowed from the ship's library. She had paid large sums to the same game farms to work with the same animals. Only a small percentage of the shocked passengers had any inkling that such practices were commonplace. Word spread quickly, and passengers began openly making a game out of questioning wildlife photographs in other books. Several of my books were aboard, and I breathed a sigh of relief that I had insisted on proper disclosure of the few captive animals. Sometimes I lose, as in the 1999 World Wildlife Fund book, *Living Planet*, where my shot of an endangered Florida panther at an Everglades wildlife rehabilitation facility is not disclosed, despite two strong notes to the book's caption writer.

I see what happened aboard that Antarctic cruise as a microcosm of greater public scrutiny to come. Misrepresented nature photography is bringing that scrutiny upon itself, as well as upon genuine wild situations that seem too good to be true.

The traditional assumption that the basic form of what we see in a nature photograph represents an event in the natural world is not inborn, but culturally established by the general reliability of published editorial photography over the last 160 years. While there have always been a few abuses, just as there are always a few counterfeit $100 bills around, our basic trust about what an image printed on paper represents is now open to question as never before. It is up to us photographers to police ourselves and make sure that our work is created and published with moral integrity before others step in and do it for us.

The Real Thing

"With absolutely no warning, the sea erupted in front of me. Out of a yawning black hole just thirty feet from where I was standing on a raised ice floe, a bowhead filled the sky with a full breach."

"I gave up photography," an adventure travel guide told me, "after I forgot my camera as I was rushing my clients into a Zodiac. A pod of killer whales began surfacing all around our raft. While everyone else was looking through a camera or futzing with photo equipment, I witnessed a once-in-a-lifetime event that I can still see clear as day.

"I realized then and there that life isn't about looking at the world in pictures. I don't understand people laying out big bucks to glimpse wild scenes in person that anyone can tune into on the Discovery Channel, then getting so involved with taking pictures that they lose out on seeing the real events. At least you've got a valid reason. They pay you to take pictures."

I assured the guide that most of my wildlife work resulted from my own personal passion quite apart from being handed great assignments on a platter. Since then, I have a better answer: a once-in-a-lifetime whale sighting without a photograph that leads me to a different conclusion.

Only my active pursuit of photographs led me to camp on the frozen sea ice of the Arctic Ocean with Eskimo subsistence whalers. I searched out the experience on my own to complete a personal book and visualized two key images: an endangered bowhead whale fully breaching, and an Eskimo throwing a harpoon into a whale from a sealskin boat. To come close to matching this idealized imagery, I would need either extraordinary luck or to become an active participant in the world before me, a creative process

quite distinct from the arranged-experience mode of adventure tourism. Bob Gilka, longtime *National Geographic* director of photography, cited this difference when he told me in the early seventies that he avoided assignments for commercial group travel.

During the first few days in the Arctic, I shot little and spent long hours at an observation point on the ice edge. After a few whales passed and occasionally breached a mile out into the lead, I set up a 1420mm telephoto by stacking 2X and 1.4X teleconverters behind a 500mm lens. If a whale came closer, I planned to remove both teleconverters. I also had a second body ready with an 80–200mm zoom to catch the Eskimos launching their nearby sealskin *umiak*.

Once, as a typical group of bowheads passed by in the middle of the lead at quite a distance, I caught the Eskimos launching their *umiak* with my zoom and switched to the big lens for a telescopic image of a whale's back and the *umiak* in the same frame. Though the Eskimos never came close enough to throw the harpoon, I felt quite satisfied with a "record shot" that I knew wouldn't be entirely sharp with multiple teleconverters. To date, only one of the forty Eskimo whaling crews had been successful.

After those whales seemed to disappear, I stayed alert as the crew paddled their *umiak* closer to the action on the opposite side of the lead. Minutes later, with absolutely no warning, the sea erupted in front of me. Out of a yawning black hole just thirty feet from where I was standing on a raised ice floe, a bowhead filled the sky with a full breach. My big lens was about as useful as a torpedo in a trout stream. Even my smaller telephoto would only have caught a blurred section of the animal. I watched in awe as the whale seemed to hang in the air before crashing into the sea with a wave that forced me to jump back as it washed over where

I had just been standing at the edge of the ice floe.

My immediate sense of disappointment not to have gotten a picture gave way to the realization of what I had just witnessed. The inner glow of having seen one of the most powerful natural spectacles of my life began to erase my sense of loss, even though a person with a wide-angle point-and-shoot might have easily gotten one.

My pursuit of photography hadn't failed me after all. I never would have witnessed such an event without my passion to make photographs. And in a larger sense, I remain beholden to outdoor photography for leading me to most of the great visual events of my life.

In a similar vein, the power of the otherwise unremarkable bestseller, *The Bridges of Madison County,* derives not from the images shot by its *National Geographic* lead character, but from what he had witnessed with his own eyes and assimilated into his worldview as a result of being a traveling photographer. When compared to the more conventional sensory experience of an intelligent woman living out her life in middle America, a dramatic vehicle is set up with strong emotional tensions. If the character had been a *Sports Illustrated* or *Vogue* photographer, I doubt the book would have been a bestseller. We sense a profound difference between modern moments photographed at arranged events or inside private studios and the enduring, immutable quality of uncontrived events personally witnessed in the natural world or within a native culture, *whether they are captured on film or only in one's memory.* As a neuropsychiatrist photography friend puts it, "Is a Kodachrome really better than a Neurochrome?"

Where I clearly agree with the Zodiac guide is that most vacationers who passively seek visual records of what first catches their eyes often miss out on things readily perceived by people without cameras. I've often lost track of the times and scores that are the essence of a spectator's experience when I've photographed sporting events, such as the Olympics, yet I rarely become so oblivious in the wilds, where I'm actively anticipating events that I otherwise might not be witnessing. In an ideal world it would be great to actively observe natural events without distractions (such as cameras), but for me, the compromise is well worth it.

In other words, outdoor photography is more than a season ticket to natural events, because I'm an active player rather than a spectator. My best photographs result from choices I make during pursuit of imagery I'm not yet seeing. When something different happens than what I have imagined, serendipity may deliver unexpected and wonderful imagery, whether or not I am able to record it on film. Thus when I look at my slightly fuzzy 1420mm telephoto of a distant bowhead breaching, it triggers a clear mental image of that far closer breach. Indeed, the image that I took turned out to be such a rare one that the U.S. Fish and Wildlife Service purchased it to use as their single photograph of the endangered bowhead. My other top image of the harpoon frozen in mid-air brings forth not only a direct mental overprint of a key moment I successfully captured, but also a cascade of memories of the Eskimo festivities later, occasioned by the landing of the second whale of the season.

To be self-directed is to be self-aware. When we are in the driver's seat, we take personal control over the direction our vehicle travels, but also are far more likely to retain a clear memory of what we see. Consider two people in a rental car driving to a meeting. Both see the same scenes, yet the driver is usually more aware. If the passenger had to return the car alone, even though the same scenery had passed before his eyes he would have a far greater chance of getting lost, having to ask directions, or consulting a map than the driver would.

So it is with photography. The odds of finding the way toward fine pictures are far higher if you have been in the driver's seat well before a photo opportunity appears. My advice to packaged-adventure guides and clients is to consider if you are willing to make photography an intimate part of your experience. If so, bring along those cameras and lenses. If not, leave them behind or take a simple point-and-shoot for a few record snapshots to trigger some Neurochromes that will evoke fond memories. You'll also be ready to catch that once-in-a-lifetime breach without loss of the sort of primary visual experience that helps define our lives.

Sunrises and Simulations

"I revere the great natural scenes that have passed before my eyes as the core experiences that center my being, whether or not I have a chance to photograph them. I sense them as vastly superior to any form of artificial visual input that seeks to imitate them."

During a foggy early morning run in the Berkeley Hills behind my home, my partner stopped in his tracks. We were topping out of the mist at the very moment of sunrise as crimson godbeams began appearing out of nowhere and vanishing before our eyes. Although I wished I had a camera, I knew that I would always hold this vivid natural event in memory, regardless of whether I made a photograph to validate my experience.

As we set off again, we talked about never having seen anything quite like it, although we'd been doing the same weekly run for years. Then my non-photographer partner added, "It's incredible how the sunrise never looks the same. Seeing all these dawns is like being in a giant theater watching an ever-changing panorama."

His comparison took me by surprise, because I wouldn't think of describing my experiences in nature by comparing them to artificial simulations. I revere the great natural scenes that have passed before my eyes as the core experiences that center my being, whether or not I have a chance to photograph them. I sense them as vastly superior to any form of artificial visual input that seeks to imitate them, including photographs, computer simulations, movies, and stage productions.

At best, I want my photographs to reflect what was really there before my eyes at an unusual moment. Original sensory experience comes first in our lives.

Despite all the photography of national parks, we feel the need to "see" for ourselves. Despite the finest efforts of the world's greatest still and cine photographers, no secondary documentation of a war or an environmental problem ever matches the power of direct observation in real time.

These thoughts passed through my mind as my body began rapidly moving uphill again. That relationship of a moving, active, living body with an embedded intelligence—the conscious life force that we all share—is what separates us from the increasingly smart machines that we produce to assist us in our relentless pursuit of wealth and happiness.

Nature photography, among other things, validates that all-important personal experience. To see a nature photograph after the fact is to simultaneously become cognizant of its subject matter and the experience of another human being witnessing a natural event. To succeed, every photograph must tell a story that we accept in the long tradition of the tales our ancestors told around campfires. We only believe a story if we believe in the human being telling it. This is why I feel so deceived if I later learn that a nature image I've contemplated with awe doesn't reflect what the photographer actually saw.

One of the most common arguments for digital compositing of nature photographs without disclosure is that manipulating photographs is as old as photography itself. A recent feature in a Seattle newspaper quotes a photographer as saying, "Did Ansel Adams deceive people when he darkened the sky in 'Moonlight over Hernandez?' He didn't say, 'I darkened the sky'."

I see this implied comparison to modern digital illustrations as ludicrous. The sky was there in front of Ansel's lens. His tonal interpretation following the

blueprint of what he was actually seeing isn't in the same league as assembling an image on a computer and calling it a photograph. That he chose to represent the deep blue evening sky as nearly black on his gray scale in no way lessens the value of one of his prints. If it were ever discovered that the full moon didn't rise on that evening in 1941 and was later added in the darkroom, the value of the print would fall faster than the stock market in 1929. And as with the nearly worthless stock certificates of that era, the paper and what was on it would not have changed at all. Perceptions are all-important.

I have long sensed an inherent contradiction in my own career. I want to have the finest primary experiences for myself, but I also make my living feeding the voracious marketplace for artificial visual input. I can't honestly justify this course without coming to terms with my own elitism. I admittedly search out and thrive on primary experiences that most others cannot have. I'm all too aware of the need for balance in my life, of the need to seek out meaningful direct visions and hold them dear for their own sake, regardless of whether I can photograph them.

I'm even more aware of the dreadful trap that lies at the end of the road for those elitists who pursue perfection in secondary imagery without understanding the critical value of primary experience. On the way home from that sunrise my friend compared to a theatrical light show, I imagined a hypothetical scenario in the not-too-distant future.

A top scientist has focused his life's work on virtual reality simulations. His goal is to produce, in real time, moving imagery of such high quality that it becomes indistinguishable from primary visual experience. He devises a tiny implant to trigger neural synapses on the retina that closely match those which we receive from the objective world. Visual information from a vast, global database can be selected, mixed, and downloaded by satellite. The subject has no awareness of an intermediate entity, such as a pho-

tograph, a screen, or a head-mounted display. All visual input is modulated by the implant, and as the scientist begins to master the final problem of subduing other sensory perceptions that might conflict with the veracity of the artificial visual image, he finds himself occasionally slipping, for a moment or two, into a state where he loses certitude over whether the world he is seeing is real.

At first, he is in ecstasy. This state represents his ultimate personal success, a life's goal achieved after a long pursuit along a pathway that appears to coincide with scientific truth. But the episodes of certitude soon become long enough to be frightening. His very perfection of means no longer allows him to know which world he is observing. His need to know his own "truth" borders on desperation. The more he subjects himself to his own experiment, the more he questions the validity of his own life experience, which is no more or less than memories of events ever more tainted by synthetic constructions, devised by his own hand, that he cannot detect.

His observations begin and end with the pressing question: Is it real? In the process of making this external judgment, he loses a major element of what it means to be human: the ability to respond emotionally to scenes that appear before our eyes.

The moral of this story is that there is a price to be paid down the line for passing off imagery that can't be distinguished from primary experience. Whether the effect is directly on us, as in the case of the fictional scientist, or on our audience, as in the case of outdoor photographers, the human process of emotional response and appreciation begins to shut down when we stop to ask "Is it real?"

Digital Decisions

"To say that somewhere in there remains a real vision of nature is as bogus as trying to convince someone that a counterfeit $1000 bill, created by adding zeros to a ten-spot, is really okay because the original bill does represent a certain value held in trust."

After I took a public stand against altering the contents of nature photography without disclosure, photographers began walking up to lecture me on my censoring of artistic freedom and anachronistic rejection of digital technology. While I firmly believe that adding subject matter which was not in front of the camera deceives the public trust in photography, I am amazed how many people assume that I am against all digitizing of photographs. They act surprised to hear that I have allowed my images to be digitized for many years.

Corbis, the world's largest commercial photo archive, owned by Bill Gates, has 16,900 digital scans of my images on a non-exclusive basis. We have agreed that minor alterations may be made for quality reproduction, but that without my permission, no changes may be made to the basic form of what was before my lens. I would easily give that permission to have one of my running grizzly bears dropped in behind a sport utility vehicle in a lucrative car ad that no one believes anyway. I would never allow such a content change in an editorial image that represents the natural world in the viewer's mind.

I'm not sure when the first of my photographs was digitized. It was probably sometime in the seventies, during the printing of one of my books in Japan. My slides were scanned for color separations at a multimillion-dollar digital workstation that had less capability than the desktop equipment now in my office. By the late eighties, editors at several small American magazines were doing their own digital prepress in Adobe Photoshop on desktop computers. Outdoor magazines rode the crest of this new wave, using digital techniques to lighten, brighten, sharpen, and retouch mediocre slides shot in compromising conditions in the field. Great slides that appeared perfect on the light box were also digitally tweaked a bit.

Over the course of thousands of stock photo sales to magazine and book publishers, I can't recall anyone asking permission to sharpen edges, clone out dirt and scratches, or increase color saturation within reasonable limits to make my work look as good as possible on the printed page. Digital is the major difference between the clean reproductions in magazines of the nineties and the murky ones of the not-so-distant past.

I've switched to digital scans for my highest-quality photographic prints because they're clearly superior to optical enlargements. Digital corrections for edge sharpness, color, film flaws, and minor scratches are incorporated into finished photographic prints that more accurately represent what I saw at the scene. Nature photography is less of a science than an interpretive art that combines the way our film responds to light with the way our eyes interpret both the finished photograph and the original scene.

When we alter an image to create a color or form that wasn't there on the original film or in the eye of the beholder, we are using the belief system inherent in 160 years of photography to create a false impression that this unusual image represents something film recorded in the natural world. To say that somewhere in there remains a real vision of nature is as bogus as trying to convince someone that a counterfeit $1000 bill, created by adding zeros to a ten-spot, is really okay because the original bill does represent a certain value held in trust in the national

coffers. In both cases, the operative word is greed.

How far am I willing to enhance an image to show what I really saw more clearly? The two renditions of a wolverine in the wild on page 176 are examples for comparison. The differences may not reproduce exactly the way I see them on my light box, where the corrected one has much better clarity without communicating any false information. One reproduction is from a straight duplicate transparency. The other has been outputted from a digital scan of the same transparency. The leading edges of the moving animal have been sharpened, the eye socket lightened, and the color of the tundra enhanced to more closely resemble what I saw. I would normally not enhance color, but panning through a 500mm lens in cloudy weather caused the image to lose overall color and contrast, as well as blurring the outline of the animal.

Seeing a wild wolverine this close may have been a once-in-a-lifetime sighting for me. I had only a few seconds to respond (see page 176) while I was with several other photographers stalking a herd of caribou on the open tundra. We had been creating silhouettes with our bodies that looked roughly like caribou, so roughly that a wolverine mistook us for very sickly caribou that were easy prey. Only after it charged in the open did it see its mistake and reverse its direction. No one else managed to get off a shot.

Since the great majority of published wolverine photos are of captive animals, this image of a running animal in the wild seemed well worth rescuing, both for editorial sales and my own slide shows. I asked Robyn Color of San Francisco (415-777-0580) if they could make a dupe transparency with digital alterations which would help viewers see the wolverine better without any awareness of manipulation. It was important only to more accurately control the content of the image that the film had recorded, and not to add any form that wasn't before the lens. They outputted several choices on their state-of-the-art LightJet 2080 digital film recorder, but after I approved the trans-

parency published here, I secretly wondered if perhaps I had gone a bit too far, to the point where the digital work might be obvious to someone more experienced than myself. When I critically examined the already enlarged 4-by-5-inch image with a 10x loupe, I could see a bit of ghosting around the sharpened edges of the animal, an artifact of the digital process.

I had the corrected transparency out on my light box one day when an outdoor pro known for his strong opinions dropped by. He took a good look at it and said, "This is a rare image all right, but I think that it's an ideal candidate for some digital work. You ought to try it someday." The transparency had passed muster.

Ethics always move more slowly than technology. The people who brought us organ transplants and gene splicing don't have all the answers yet, either. Professional photographic organizations such as ASMP and NPPA have set hard and fast rules for editorial publication about not altering content without disclosure, but where that line is crossed remains murky indeed. Each photographer needs to make a personal choice that he or she feels comfortable with. In the end, the future power of photography rests upon the execution of two separate moral imperatives. Photographers should only alter photographs for editorial use to the extent that they would feel comfortable fully revealing in a caption that described exactly how the image was made. Publishers should only print altered photographs or alter them themselves to the extent that their readers would not feel deceived if full disclosure of their methods was revealed. Since the power of editorial nature photography is so dependent upon the viewer's belief that it directly represents something actually seen, alterations need to be kept well below the threshold of controversy where they are not disclosed. Beyond a not-so-certain point, altered photographs need to be described as digital illustrations. I feel comfortable revealing the full story behind the wolverine image, and sense no need to disclose what has been done for editorial sales.

Censored in America

"The difference goes deeper than what is euphemistically described as a European penchant for gritty stories. Despite the First Amendment, America has anything but a free press. Despite the ever greater power of the media in America, truth and freedom seem less apparent."

Aspiring photographers constantly ask for the inside story of how to get published, as if a blueprint of my footsteps should lead them there. Some think I can shoot what I want and get it published in *National Geographic* or *Life* on the power of my name. The cold reality is that I had more stories published in America as a little-known photographer in the seventies, when the use of photography in major magazines was more spontaneous, less competitive, and less contrived than it is today.

Today's outlets for stock photography have dramatically increased, while serious photo essays in major magazines have declined. Competing media and declining advertising dollars are the most often-cited causes, but they fail to explain why I'm far from the only outdoor photographer who has been selling an increasing percentage of magazine stories abroad. At first I believed that my agents were simply doing a great job. Then I began to notice a strong difference between work chosen for American versus foreign publication. Investigative story packages of text and photos that were rejected by major magazines at home were soon gobbled up in Europe.

The difference goes deeper than what is euphemistically described as a European penchant for gritty stories. Despite the First Amendment, America has anything but a free press. Despite the ever greater power of the media in America, truth and freedom seem less apparent. Special interest groups, including, but not limited to, the big corporations that own most mainstream publications, exert direct and indirect pressure over the images and words that appear. Simply put, the flip side of political correctness is censorship.

To be able to regularly photograph or write from the heart for an American magazine is a rare privilege these days. I am grateful that *Outdoor Photographer* has generally allowed me to freely express my opinions, which explains why I could write on this subject for them, as well as why readers often tell me that what they read between these covers has an especially genuine feel. Most monthly columns in the magazine are written by working photographers, rather than staff writers. *Sports Illustrated* isn't written by the athletes and *Vogue* isn't written by the models. After writing something for every major photography magazine in the past, I've written a column for every issue of *Outdoor Photographer* for fifteen years because I feel directly in line with the primary special interest group: outdoor photographers who influence what is written not only for them, but by them.

Seasoned pros learn to anticipate publication problems that may arise when the agenda of a special interest group conflicts with that of photographers, writers, or readers, but we all have our share of failures. Perhaps I should have realized that my photograph of alpenglow in Antarctica (pages 254–255), with a thousand words about how it was made and what I learned in the process, didn't fit a travel magazine's request for an exotic image. I wove cold-weather photo tips and differences in polar light into a narrative about photographing in Antarctica under a National Science Foundation Artist's and Writer's grant. Months after I had been paid, a proof was

faxed for my immediate approval. For use in a magazine funded by tourism advertising, it had been radically rewritten to cast me as a tourist, and NSF had not been mentioned. Catch 22: NSF does not encourage tourism to their research stations and specifically requests mention in articles by grantees. Rather than compromise, I withdrew the story and returned the payment.

In 1995 I wrote and photographed a long feature on the status of peregrine falcons in California for a major American wildlife magazine. I had proposed it as a follow-up to my 1991 peregrine article for *National Geographic,* and timed it to coincide with a five-year national survey of the endangered birds. I hoped for an upbeat story, but funding cuts stopped field monitoring in its tracks after opponents of the Endangered Species Act (ESA) gained power in the 1994 elections. The Department of the Interior soon announced "a notice of intent to propose delisting" the American peregrine falcon as federally endangered across the nation. My text documented ongoing re-productive failure in California birds caused by DDT and the complexity of assessing the population stability of the state's estimated 125 nesting pairs. More than 800 captive-bred birds had been introduced over sixteen years, and the annual levels of nest pro-ductivity set by the federal recovery plan had yet to be achieved and monitored.

My text was edited to greatly minimize the prob-lems. Phrases that I never wrote were added, such as: "This bodes well for the Endangered Species Act at a critical time in its history," when I had actually writ-ten that the Act itself was in trouble if its recovery goals were not being properly monitored and assessed.

I was willing to compromise some, but not to negate carefully researched facts. The story was summarily canceled with a revealing oral explanation. The organization that publishes the magazine was lobbying hard in Washington for reauthorization of the ESA. They needed a peregrine success story to convince Congress that the ESA was working.

Why not just compromise, stay quiet, and fur-ther my career? Because I tried it for years and it felt very wrong. My life's goal is not to publish as much as possible, but to make a difference. My greatest reader response has come, not from a *National Geographic* or *Sports Illustrated* article that reached tens of millions, but from a cover story for *Greenpeace* that expressed regret for having compromised the hard truths of Tibet's environmental destruction for nine long years, so as to be able to get my work in print and go back to Tibet. *Greenpeace* could publish the essence of what I had documented over five trips to Tibet because the Chinese government had no hold over them. Other organizations had researchers, representatives, writ-ers, and photographers working in Tibet or China.

When I first returned from the Tibetan Plateau in 1981, the group of scientists with whom I had traveled talked at a press conference, outlining a litany of unethical Chinese practices causing extreme environmental degradation. The Associated Press asked to publish our story as an exclusive, but it never appeared. An AP staffer later confided that a decision was made not to jeopardize the Beijing bureau by run-ning "unnecessarily negative China material."

Covert censorship also set the stage for the famous incident of *National Geographic* digitally moving the pyramids. Shortly after I had been congratulated for having my photograph of a Tibetan boy wearing a Chinese soldier's hat (page 197) chosen for the Feb-ruary 1982 cover, I was informed that the Chinese embassy had been shown the layout, objected to the

image as suggestive of Tibetan demands for independence, and threatened to restrict future journalism. An image from a story on Egypt was manipulated to fit the cover. The positive result of word leaking out was that the editors resolved not to alter content again without disclosure.

This brief revelation that our American media—the most powerful on Earth—is anything but a free press would not be complete without mention of its effect on the freedom of a human being, rather than mere images and text. Ngawang Choephel, a Fulbright Scholar and legal resident of the United States, disappeared in his native Tibet in 1995 while photographing the cultural and oral traditions of Tibetan music. Though he was seen in a Tibetan prison in October 1995, the Chinese government would not acknowledge his detainment, and as of the turn of the millennium, has not released him. His plight has been conspicuously absent in photography and travel magazines.

The extensive video record Choephel left behind shows that he was solely engaged in cultural documentation for his studies in ethnomusicology at Middlebury College in Vermont. Although Congress has declared Tibet an occupied nation with a right to independence, Choephel's case has not been splashed across our major media, as it would have been if he were a native of Arkansas, going to Harvard, who was held by the Chinese.

Though many individuals have written their representatives in Washington and asked them to look into the situation, Choephel's plight continues to tug on the heartstrings and outrage the souls of many of us who visit and photograph exotic places. Freedoms erode unless we defend them and speak out for them. If my collection of material censored in America grows much larger, I'm thinking of assembling it into a revealing book. I've learned that getting published, like other life goals, begins with a positive and personal visualization of how to get there from here.

The Peregrine Paradox

"There is a public misconception that a 'saved' species removed from the list is no longer in need of special treatment. The fallacy is similar to believing that a person just released from an intensive care ward counts as a healthy member of the work force."

On a clear spring morning in 1995, I stepped off the edge of a crumbling sea cliff with joyful expectation. As a mountain climber beginning a roped rappel, I was elated to be sharing the vertical realm I have come to cherish with a superlative creature variously described as the fiercest, fastest, most efficient, and best-designed of all birds. As a photographer, I hoped to symbolize the cautious optimism I felt about the future of California's coastal peregrine falcons with an image of wild-hatched chicks in a Big Sur eyrie, where all breeding had failed since shortly after World War II, when DDT-induced eggshell thinning began causing massive reproduction problems in peregrine falcons, bald eagles, and brown pelicans.

I had visited this eyrie five years before to help replace dead eggs with live chicks for a sixteen-year California captive-breeding program that was scheduled to end in 1992, whether or not the birds were fully reproducing on their own. After my story appeared in the April 1991 *National Geographic,* I planned to return and cover a 1995 five-year, continent-wide peregrine survey. After opponents of the Endangered Species Act (ESA) gained power in Congress in 1994, funding cuts stopped most field monitoring in its tracks.

Rappelling below me on a separate rope was Brian Latta, a falcon biologist for the Santa Cruz Predatory Bird Research Group. Here on a wild section of the Big Sur coast, we had found four perfect eggs a few

weeks earlier. Adult peregrines had repeatedly dived on us, avoiding contact at the last possible moment with a rush of air that swept across our faces. Now the cliff was so quiet that I didn't trust my perception of being in the same place. A wave of sadness overcame me as I reached the bookshelf-width ledge.

"It seems so different when it's lifeless," I said to Latta. "Is this really the spot?"

Latta held out sticky fragments like the dregs from a popcorn bowl and replied, "These are definitely fresh."

My photograph of those shell fragments in his outstretched palm delivers the opposite message from what Secretary of the Interior Bruce Babbitt proclaimed to the media that month: "Once a tragic symbol of what was wrong with our environment, the peregrine is now a symbol of hope."

Babbitt announced a "notice of intent to propose delisting" the American peregrine falcon as federally endangered, while large numbers of eggs were still known to be breaking along the Pacific Coast, the East Coast, and throughout the Northwest. The birds were rapidly multiplying in interior states around his Arizona home, making for convincingly high national population estimates. Even California statistics appear to support the myth of national recovery. From only two breeding pairs found during a shocking statewide survey in 1970, the population increased to over 125 pairs in 1994. Beneath the surface, peregrine numbers represent a disturbing enigma rather than an unqualified success.

The California peregrine population now clearly exceeds the 120 nesting pairs suggested by the federal recovery plan, yet no distinction is made between birds born in the wild and those introduced from captive breeding. Mortality and productivity rates of

introduced peregrines cannot be presumed to be equal to those of birds born in the wild. Brian Walton, coordinator of the Santa Cruz Predatory Bird Group since its inception in 1975, estimates that 90 percent of California's nesting coastal peregrines are release birds from his sixteen-year captive-breeding program, which has introduced 800 peregrines into the skies. After captive breeding ended in 1992, only a few biologists continued to monitor the population's ability to sustain itself without supplemental introductions.

The federal recovery plan for California suggests that productivity of 1.5 young per year, per nest be achieved for five years before downlisting or delisting the species. Because this level had yet to be reached or monitored, wholly delisting the species without following established procedures boded ill for the future ability of the ESA to firmly mandate courses of action.

Though the ESA provides the vital framework to help save species in trouble, there is a public misconception that a "saved" species removed from the list is no longer in need of special treatment. The fallacy is similar to believing that a person just released from an intensive care ward counts as a healthy member of the work force. The current political climate creates extreme pressure to certify successes by fully delisting species because of sheer numbers rather than healthy populations.

Although biologists agree that if you tried to get peregrines federally listed all over again now, they'd never qualify, the number of introduced birds complicates a highly politicized issue. The temporarily inflated California population may not be self-sustaining, according to a computer model developed at the University of California by biologists Douglas Bell and Timothy Whootton. Based on necessarily simplified modeling assumptions, the peregrine "could become extinct in California in a century without further population augmentation or immigration from other subpopulations."

As late as 1968, the peregrine was described by ornithologists as "the world's most successful flying bird" because of its unexcelled flight characteristics and unusually stable, near-global population on every continent except Antarctica. Unlike most endangered species, it suffered an abrupt population crash rather than a gradual slide toward oblivion. Dr. Tom Cade, the biologist who pioneered captive breeding efforts, calls the peregrine "a unique biological monitor of the quality of the world's environments" that tells us, by dying before our eyes, that our Earth is being poisoned.

Like ourselves, peregrines live at the top of their food chain. Fat-soluble toxins bioaccumulate at ever greater levels as they are absorbed by small organisms, which are eaten by fish and other species consumed by birds on the wing that are the peregrine's prey. In the late sixties, research pointed to DDT as the major factor in eggshell thinning. The pesticide was banned in the U.S. in 1972, and the peregrine was declared internationally endangered in 1973. By the end of the decade, the birds were on the increase, yet all along the Pacific Coast they showed high levels of contamination from not only DDT, but also PCBs and dioxins. Eggshell integrity was not improving and embryo mortality was actually on the rise.

Peregrines prey on many species that migrate each winter to Latin America, where DDT is still being used. Many basic questions about DDT sources remain unanswered. Are they more U. S.-based or international? Current or residual? Do they move up the food chain more through migratory prey birds or residents?

California's intense agriculture consumes about 40 percent of the nation's pesticides, including some with proven effects on birds. Between 1947 and 1971, the Montrose Chemical Company dumped residue from sloppy manufacturing that averaged 600 pounds of raw DDT a day into the ocean off Los Angeles. Parts of the ocean floor still have over 300 parts per million—the world's greatest known DDT

hot spot. Biologists consider this to be the major source of toxins for peregrines breeding along the central and southern California coast.

Interior California peregrines are doing somewhat better, with average contamination above the egg-failure threshold. Shortly after my 1995 rappel into the failed Big Sur nest, I joined Brian Latta in Sunol Regional Wilderness east of San Francisco Bay to trap a breeding peregrine and take a blood sample. He borrowed my cell phone to call in the bird's band number and found it matched a captive-bred chick I had photographed in 1990 on Mount Diablo, thirty miles to the north, as it was being "cross-fostered" into a prairie falcon nest.

Thrilled to have another chance to honestly symbolize my cautious optimism about the species' future, I asked Latta to hold the bird up for a portrait with his hand as low as possible, so as not to show. As I shot several frames of the fiercely proud bird with a motor-driven Nikon F4, Latta said he didn't want to hold it any lower because it might . . .

At that instant, the bird dug its talons into Latta's hand and broke free while I held down my finger to capture an unplanned symbol of the hand of Man behind the agony of a species. The bird dropped onto a short tether, unharmed. Latta wiped his bloodied hand, held the bird up again to release it back into the wild, and relaxed his grip. The bird blasted away like some living heat-seeking missile.

Polar to the People

"I wanted my photos to capture that positive reaching out of one species for another, rather than an image that could be twisted by an editor's clever turn of phrase into an icon of savage nature."

As we watched a polar bear head straight for a sled dog, Jim exclaimed, "It's going to happen right in front of us!" The bear looked calm, almost serene, as the dog leapt in the air and jerked against its chain just fifty feet from the open window of our rental van. The huge male could have dispatched the smaller animal with a casual swat, but he didn't.

Through my viewfinder I saw a very different scene than the life-and-death encounter I had imagined from a few published photographs with sensationalized captions about fierce bears, courageous dogs, and the skill of the photographer to capture a rare moment. For the next eight rolls, the scenario unfolded exactly as our biologist friend, Jim Halfpenny, had described it over dinner the night we arrived in Churchill, Manitoba.

The bear had only come to play with the dog, not to harm it or steal its food. "You can tell when the bears are out with Brian Ladoon's dogs," Jim had told us, "because you see the locals' trucks all around with big lenses sticking out the windows. It's about the only place where they can predictably see bears these days without having to pay hundreds of bucks to ride a Tundra Buggy filled with tourists into the controlled area out by the cape. All the bears that come into town or visit the dump get darted by Manitoba Natural Resources officers and stuck into the 'Polar Bear Jail.' In November when the ice forms on Hudson Bay, they're turned loose and they naturally head out to hunt for seals. The system works pretty well. It's saved a lot of bears from being killed or relocated.

"There's a lot of misinformation around. A local told me that seven of Brian's dogs have been killed by bears this year, but his records show only four in fifteen years. I examined one last year that wasn't eaten and had no marks on it other than a broken neck. It just played too hard."

We watched in total fascination as the great bear rubbed noses with the dog, tugged on it gently, and rolled it over on the snow. The dog nipped back playfully. Both animals clearly made conscious efforts not to harm each other. I wanted my photos to capture that positive reaching out of one species for another, rather than an image that could be twisted by an editor's clever turn of phrase into an icon of savage nature.

Jim had teamed up with my wife, Barbara, and I after leading a week-long polar bear tour around Churchill. He was shooting a video on animal tracking while we were shooting 35mm slides. We all wanted better coverage than was possible from high up on a fat-tired Tundra Buggy filled with tourists, who are always shaking the vehicle by rushing to the windows just when you need it still to get a sharp telephoto and always wanting to move on when nothing happens for sixty seconds or so. Jim knew from experience that big group tours are something like those "greatest hits" albums where the song ends just when you really begin to appreciate what's going on.

We had already observed a full day-in-the-life of a mother polar bear with two young cubs from a smaller and lower tundra photo vehicle driven by local entrepreneur Donnie Wolkoski. Today we were confined to the roads in a rented van. After lunch in town and a successful stalk for full-frame images of an Arctic fox beside its den, we decided to see if the

bears and sled dogs were still playing. As we crested a rise on the snowy dirt road to the remote site, we saw 4WD trucks from the Royal Canadian Mounted Police and Manitoba Natural Resources parked near our favorite bear. A shot rang out, the bear ran off and collapsed, and we joined a group of locals who followed the officers to where the animal lay spread out in the snow, disarmed by the tranquilizer but not unconscious. His great head lifted and his eyes followed us as officers winched him into the bed of a pickup truck filled with debris. He was on his way to the polar bear jail, the officer said, because they had been instructed to take bears hanging around Brian's dogs that might be attracted by artificial food sources, such as the dog's food, the dogs themselves, or meat dropped to distract the bears during feeding time.

The polar bear jail is a holding facility for sixteen bears in solitary confinement, plus four family groups. The idea behind it is to provide a neutral or negative experience around approaching human food sources such as the town or its dump, where far fewer bears now show up. However, the officers began going well beyond their original mandate of managing bears around populated areas in the interest of public safety.

In a sudden escalation of predator control miles away from town, three bears were darted near the dogs on the evening we were there. The action began after a bear crawled up onto an officer's truck. Its filthy bed, littered with trash, had the scent of seal bait used for mechanical bear traps. That bear was put to death, while the other two (including the one in my photographs) were held in the jail.

In late 1993 and 1994, the issue became highly controversial in the town of Churchill, where over a hundred locals signed a petition asking the provincial government to stop the game officers from pursuing bears outside the control zone. Taken to its absurd, yet logical, extreme, public safety could be wholly maximized by getting rid of all the bears.

The majority of the residents feel that the world's largest concentration of polar bears should remain a wild population, rather than become a game park where every bear has been darted with ubiquitous ear tags that destroy the sense of wildness, in both photographs and direct observation, as surely as trash along a wilderness trail.

Tour operators with coveted tundra vehicle permits benefit in the short term when bears approachable by car are removed from the population, leaving only those far out on the tundra for public viewing. What's at stake is not only the powerful, unstructured feeling of viewing great bears in their natural surroundings, but also the very nature of the gentle interaction between species that I have witnessed between bears and dogs, and, more important, between bears and humans most of the time. Even though polar bears have a reputation for pursuing any human being on foot to the death, Churchill anecdotes of bears avoiding human conflict far outnumber tales of grim encounters.

No one has stood out in the snow night after night after darting bears to see if they have become more aggressive toward the source of their troubles, but Steve Miller's helicopter does exactly this. The Churchill pilot, who has been called the "most experienced immobilization pilot in the world," understandably did not want to be quoted taking sides in this article, but his aircraft speaks for itself. On multiple occasions, bears have approached his parked helicopter at night and battered it. One even got inside and tore up the upholstery. The bears that do this

have been darted up to nine times from the helicopter before apparently taking out their frustration on the perceived source of their trouble.

Polar bears are not endangered. In the near future, there will undoubtedly be lots of polar bears to photograph from tundra vehicles near Churchill, but the larger question is, what kind of experience will our children or our children's children have? "There is a need," the great naturalist Loren Eiseley has written, "for a gentler man than those who won for us against the ice . . . and the bear."

We photographers share a major portion of the blame for the Churchill situation and for control measures elsewhere on black and grizzly bears. Much of the increase in darting and tagging bears is based on the larger number of bear/human interactions due, in great part, to close human approaches for photographs. Of course a mother with two small cubs will charge a harmless woman with two small children who intrudes too close with an Instamatic. Viewed objectively, it might make better sense to dart the woman instead of the bear.

One outspoken bear biologist told me with a grin that every time he darts a bear he imagines himself darting a photographer. I replied that every time I see an ear tag on a bear that will show up in a photograph, I imagine putting one on a biologist. In my heart, however, I know that we need to take the lead in cleaning up our species' act so that humans and wild bears can share the same planet for generations to come.

Above: *Essay pages 186–188, 238–240, 257–259* A polar bear mother guards her cubs from marauding males on the edge of Hudson Bay in a blizzard, captured with a 500mm ƒ4 Nikon lens, 1.4X converter, and Fuji Velvia pushed to ISO 100.

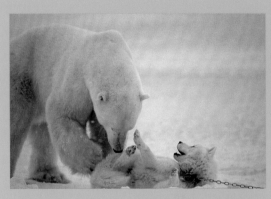

All (4): *Essay pages 186–188, 238–240, 257–259* When I watched a polar bear approach a sled dog, I thought it was all over for the dog, but the two animals began to play (top, left and right) for the better part of an hour with the bear showing amazing restraint, much like an adult dog playing with a puppy. They totally ignored observers until a game warden showed up in a truck that smelled of seal bait for bear traps. The bear put its feet up on the bed and was shot with a dart rifle (bottom, left and right), before being hauled off to "Polar Bear Jail."

Above: *Essay pages 186–188, 238–240, 257–259* Though my wife Barbara's photo of a polar bear seemingly behind bars has been used by editors to depict the "Polar Bear Jail" of Churchill, Manitoba, it was actually the people who were behind bars in a special vehicle set up for photographing wild bears.

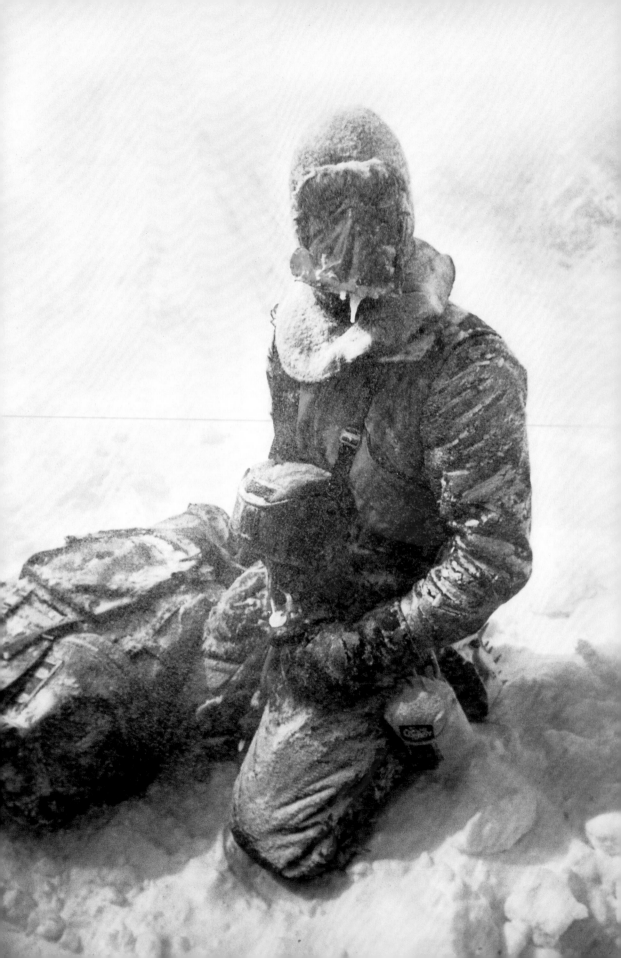

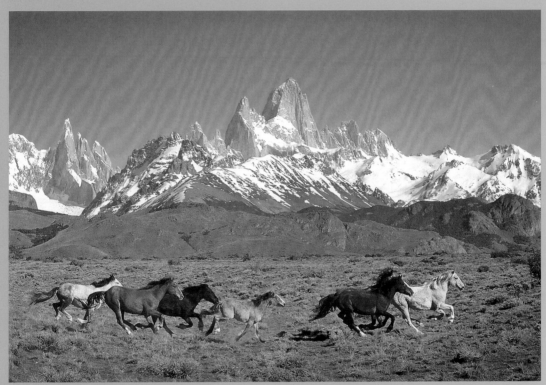

Left:

Essay pages 36–37, 94–95
Photographing in a blizzard high on Mount Everest, as John Roskelley caught me doing in 1983, is a far cry from digital image management in my California gallery in 1999 (as shown at top, right).

Above:

Essay pages 269–275
This reproduction of wild horses running below the Fitz Roy Range in Patagonia was made off a digital duplicate 70mm transparency from a LightJet 2080 film recorder using a 96-megabyte file from a Heidelberg TANGO drum scan.

Top, center:

Essay pages 269–275
This reproduction of the same image of wild horses as below was made from a traditional 70mm duplicate transparency.

Top, right:

Essay pages 269–275
Both the 8 x 10-inch test proof of tule elk at Point Reyes (title pages 2–3) and the 50-inch mural were printed from a 96-megabyte TANGO drum scan that delivers the same color and contrast regardless of size, due to digital exposure of photographic paper by a scanning laser, instead of light spreading ever more widely from an optical enlarger.

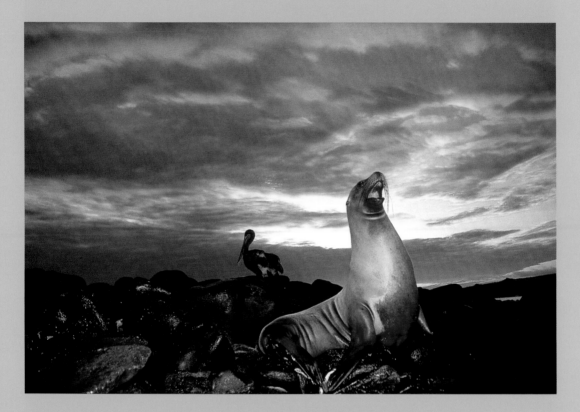

Above: *Essay pages 98–102, 260–262* A Galápagos sea lion greets the dawn lit by fill flash matched to the sky color by means of a warming gel.

Right: *Essay pages 98–102, 260–262* A Galápagos giant tortoise appears nonplused by a photographer using fill flash to render one of his kin against shadowed foliage.

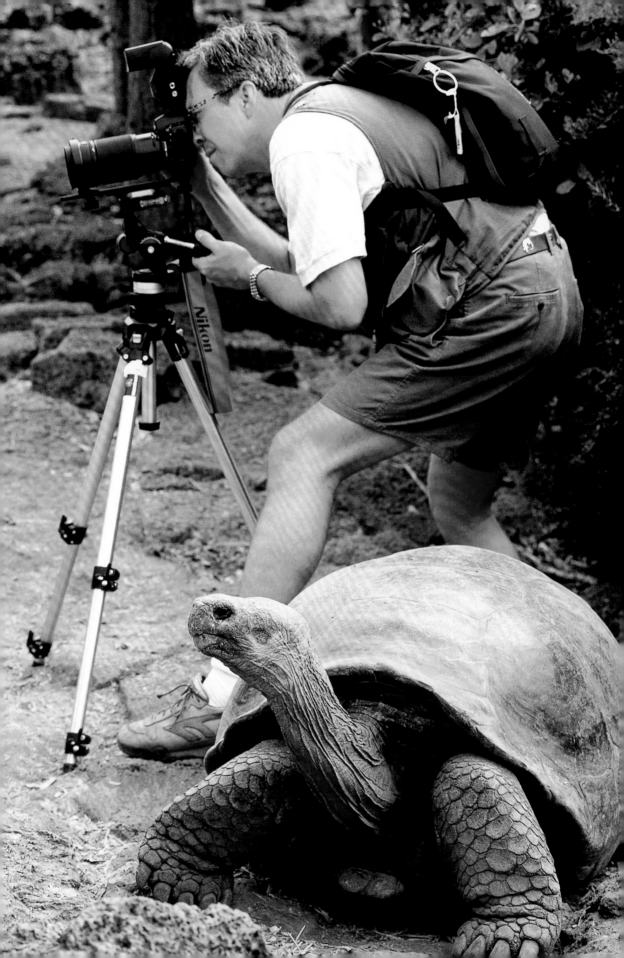

Above: *Essay pages 263–265*
As I made this photograph of
sunrise over the Zambezi River
in Zimbabwe, I was startled by
a rustle in the bushes behind
me. I turned, half expecting my
eyes to meet those of a lion.
Instead, they peered into eyes
strangely like my own. A troop
of baboons (right) had also
been watching the sunrise.

Following pages:
Essay pages 276–279
On a hunch on a cold, foggy
evening, I drove from a
Palo Alto meeting to the San
Mateo Coast, where I caught
the sun sinking behind giant
winter storm waves with an
80–200mm ƒ2.8 zoom lens
and a 3-stop graduated
neutral-density filter.

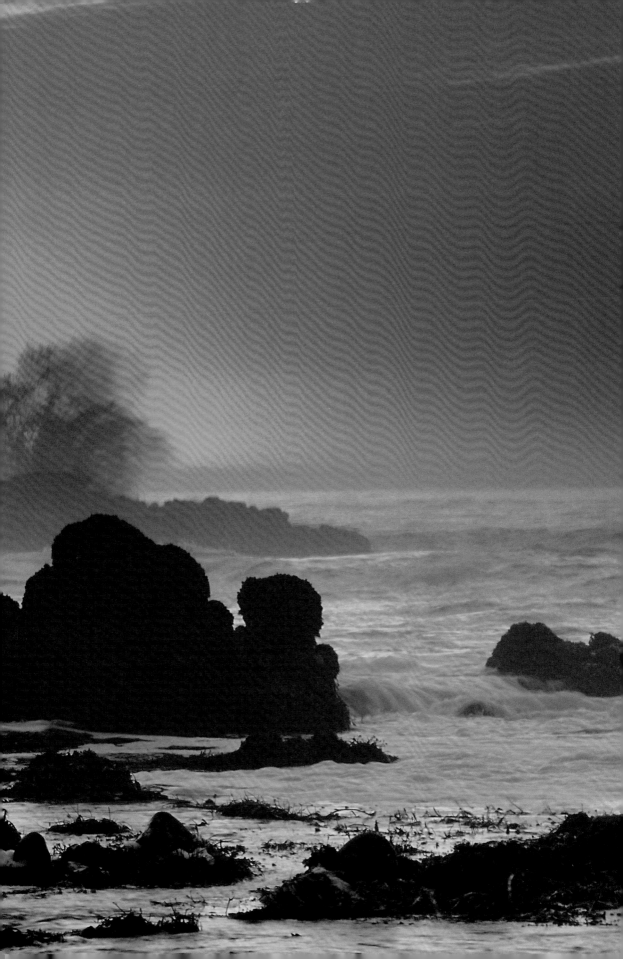

Above: *Essay pages 31–33, 41–43, 46–47, 263–265*
Alone before dawn in Montana's Glacier Park, I rejoiced as vivid alpenglow lit up a fluted cloud. After exhausting normal landscape options, I set my self-timer, ran into the frame, and hung from the limb of a dead tree until the shutter clicked.

Above:

Essay pages 29–30, 31–33, 38–40, 41–43, 61–62
I created the image of a figure against a rising full moon in the Ansel Adams Wilderness in my mind's eye before I asked my partner to stand in a snowy gap. I then set up several hundred yards away on slanting rock slabs where I could line up the scene as if through a gunsight with a 400mm lens plus 1.4X teleconverter.

Following pages:

Essay pages 186–188, 218–220, 232–234
This is neither sunset nor sunrise on Mount Erebus in Antarctica. Though night has fallen on the sea ice of McMurdo Sound, the upper peak is catching the first 24-hour daylight in mid-October. Alpenglow lasts for hours a day, but vanishes within the week as the sun angle rises.

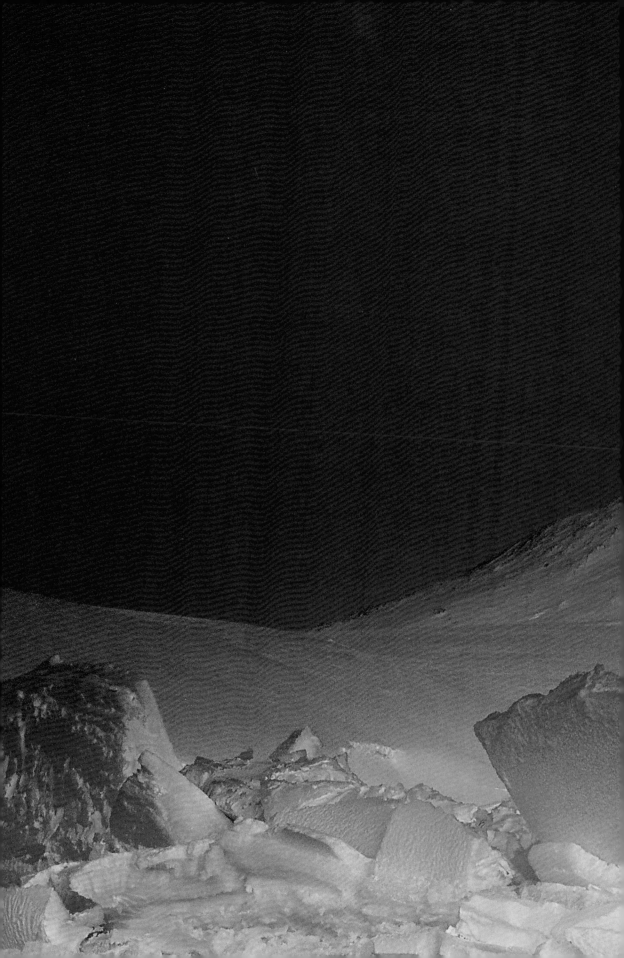

Above:

Essay pages 186–188
Northern lights glow over
a winter dogsled camp in
the Brooks Range of Alaska,
captured in a 2-minute
exposure at ƒ1.4 on ISO
100 Ektachrome push-
processed to ISO 200. The
"Arctic Oven" tent is lit by
a woodstove and a lantern.

Not a Random Bear Attack

"Though I wrote about the pitfalls of wardens violating their mandate to only manage bears for public safety, I never envisioned an event as drastic as what happened the very next season."

In October 1996, a polar bear ran amok through a remote sled-dog camp eleven miles outside Churchill. Six dogs were killed, two eaten, and twelve more wounded. If this grisly item was seen on the yellowed page of an 1896 frontier newspaper instead of the slick page of a modern publication, readers would assume it was just another random incident in the taming of the North. A man who chains down fifty sled dogs in polar bear territory should expect a bit of trouble now and then.

In this case, the actions of game wardens directly precipitated the attack on the prize Canadian Eskimo dogs that Brian Ladoon was breeding for a living. Ladoon had taken full responsibility for managing his dogs in the wilds for almost a quarter of a century before wardens knowingly thwarted his novel strategy and proven track record of saving the lives of countless bears and dogs.

During the fall, up to twenty wild polar bears a week pass through Ladoon's camp before heading out in winter to hunt seals on the pack ice. Instead of shooting bears to keep them from his dogs, Ladoon gradually allowed natural play behavior between healthy bears and his dogs to unfold, only occasionally ushering rare bad actors out of camp to the tune of a shotgun crack. Dominant bears accustomed to his dogs usually chased away potentially aggressive renegade bears before they had a chance to get near the camp.

Within a year before the attack, I had written about my own positive encounter with the bears and Ladoon's dogs (page 242). I described the joy of photographing a bear rubbing noses with a sled dog, tugging on it gently, and rolling it over on the snow, as well as the shock of seeing a game warden shoot it and two other bears with a tranquilizer rifle right before my eyes. Even though the bears' aggression toward dogs and humans was clearly inhibited, one bear was euthanized and the other two were put in "Polar Bear Jail," a facility for keeping problem bears until the ice forms on Hudson Bay.

Also photographing that event were my wife Barbara, biologist Dr. James Halfpenny, and German photographer Norbert Rosing, who later sold a delightful image of a bear playing with a dog to *National Geographic*. I shot eight rolls of images that captured the essence of that benign reaching out of one species for another, but turned down national magazine offers for single images of the joyful play to try to get the complete story published as a warning of mismanagement of Canada's wild polar bears and problems in the future caused by human interference. I'd previously done parallel stories on mismanagement of black bears in Yosemite and grizzly bears in Alaska. I listened carefully when Brian Ladoon expressed his profound fear about an attack by a rogue bear, perhaps an aging bear or an adolescent male, after the wardens removed several more dominant bears friendly to his dogs. Though I wrote about the pitfalls of wardens violating their mandate to only manage bears for public safety, I never envisioned an event as drastic as what happened the very next season.

The overture of the tragedy began with recording artist Sylvia Tyson's musical group arriving in Churchill to perform, driving to Ladoon's camp to see bears, and getting their 2WD minivan stuck in deep snow. The driver got out to shovel and a curious

polar bear approached. When the driver rushed back inside, the benign bear went to sleep thirty feet away. An unamused game warden eventually "rescued" the celebrities with his 4WD truck and informed Ladoon that he had unnecessarily put famous visitors at risk. No fees had been charged, and the road beside the sled-dog camp was in open, wild terrain.

Soon, twelve men and a helicopter appeared. They darted five large bears and airlifted them away. Ladoon clearly anticipated that his camp was now "open to every meandering bear that comes through" and kept a daytime vigil in near-zero temperatures and steady 30 mph winds. The carnage began in total darkness one evening while Ladoon was in town. A bear ignored meat set out as a deterrent on the perimeter of the camp, raged into camp, began attacking dogs, and ate one.

When Ladoon came upon five dead and eleven wounded dogs the next morning, his first priority was not hunting down the rogue bear. "I had my hands full trying to save injured dogs. I was managing a little battlefield with dead and wounded all around." A warden came, but failed to tranquilize the offending bear because of a problem with his dart rifle. Darkness fell again. Two more dogs were attacked and another one eaten. The next day, Ladoon found and shot an adult male polar bear he describes as being "about half functional, possibly rabid." Manitoba Natural Resources officers declined to test the remains.

When I asked Ladoon why he didn't want his dog facility within the public-safety bear control zone closer to Churchill, he answered that humans pose far more problems for his dogs than bears do. He chose the wild area far out of Churchill to have a natural site with clean, fresh water and to avoid unwanted intrusions by, and injuries to, people who might taunt the big dogs. He said game officers should "respect that I've been dealing with bears without problems for over twenty years, long before they made their public safety rules." Reports about bears being habituated to his dogs are false, he says, because as soon as the pack ice forms each November, the bears around his camp head out on Hudson Bay to hunt seals with all the other wild bears.

Ladoon was not trying to compete in the hot polar bear tourism marketplace and he did not advertise. The three or four thousand dollars he took in each year in voluntary donations from the few photographers who arrived at his camp barely paid to fill his dogs' mouths. Though his land permit allowed him to conduct tourism activities, he mainly wanted to breed and run some of the last of about 300 remaining purebred Canadian Eskimo dogs. His dogs have modeled for a Canadian stamp and a forthcoming coin, as well as appearing in magazines around the world.

Before the incident, only four of his dogs had died from bear interactions in twenty-three seasons. None had ever been attacked and eaten. Ladoon believes all four prior incidents were accidental—a broken neck from too-hard play and a running bear catching a chain between a breeding pair, for example. Though he was not on site when the recent attack began, he says he closely monitors his dogs and always tries to be there to assist: "If there's something seriously wrong, they don't just die out there. They die in my arms."

What I found conspicuously missing from both this scenario and my own personal encounters around Churchill was consistent government policy for the long-term survival of both bears and humans. The fatal attraction of wild polar bears as cash cows fed the short-term greed of some tourism operators and government officials. Ladoon's dog camp was the only place in the area where a tourist or photographer could still predictably see bears without paying a high tariff. Operators with coveted tundra vehicle permits stood to gain when bears approachable by car near Ladoon's camp were jailed or relocated, as they charged hundreds of dollars for rides into the controlled area beyond the dog camp. Wardens openly threatened to have Ladoon's permit to keep his dogs on the land revoked.

Manitoba Natural Resources wardens claimed that Brian Ladoon had no supporters, well after I'd sent three strong letters of support over several years and received copies of scores of others written by concerned photographers to the Minister of Natural Resources in Winnipeg. At first I received no replies, so I upped the ante of the letter-writing campaign by urging concerned readers of my column in *Outdoor Photographer* to share their own outrage and relate personal experiences that were problematic. Some months later, a Canadian national magazine published several of my photos of the bears interacting with the dogs, along with a news item that the province of Manitoba was changing their bear-management policies for the better. Off the record, an editor told me that the Department of Natural Resources insisted that their decision had nothing whatsoever to do with my photographs or the hundreds of letters they'd received from Americans.

A later decision was made to let Brian Ladoon keep his dog camp, with some minor restrictions. Finally, polar bear ecotourism was being managed as a sustainable resource. While bear/human interactions around the town of Churchill need to be curtailed in the interest of public safety, wild bears in more remote places need to be left alone to preserve the essence of what photographers from around the world come to see in the wilder environs surrounding Churchill. As Canadian zoologist Ian Stirling has said, "The wild polar bear is the Arctic incarnate . . . not just a symbol but the very embodiment of life in the Arctic."

Goodbye Galápagos

"I might have returned home in 1996 to write a glowing travel piece about how the Galápagos was at peace again. The natural splendor of the islands appeared undiminished, but what happened on a calm Sunday morning in Porta Ayora set me on the course of this investigative story."

During the last decade, a secret Peruvian cartel hatched a radical plot to destroy Ecuador's economic future. The scheme, involving ecotourism, economic terrorism, and the Galápagos Islands, was conjured up after troops failed to settle a long-standing border dispute.

A savvy clique of educated Peruvians saw the handwriting on the wall: Declining oil reserves and fisheries in both countries would soon fall behind the growing ecotourism market as sources of foreign exchange. They searched for a simple way to collapse the future Ecuadorian market, and struck Inca gold with a plan guaranteed to maximize Peru's share of the foreign currency bonanza.

Why, the members of the clique asked themselves, do so many upscale foreign ecotourists choose the Andes of Ecuador over Peru, which has higher, more spectacular peaks surrounded by legendary Inca ruins? Two answers surfaced: personal security and the Galápagos Islands. Americans view Ecuador as politically stable and Peru as unstable. Tourists who come to see and photograph the fabled wildlife of the Galápagos in peace and serenity often visit the Ecuadorian highlands on the same journey. Destroy that island experience, and the nation's future economic and political stability would begin to unravel.

I scrawled this fanciful conspiracy theory in my 1996 Galápagos diary months before Peruvian terrorists took diplomats hostage and Ecuadorians ousted their president. The Peruvian cartel is sheer whimsy, but the basic scenario reflected my ominous feeling that the government of Ecuador was doing the same thing to its own country by encouraging the systematic destruction of its natural and cultural heritage in the Galápagos Islands. The primeval lure of a place with rarefied life forces that gave Charles Darwin his powerful vision of the nature of global evolutionary processes, where so many modern photographers go to translate that vision onto film, was being sacrificed for short-term economic and political gain.

My intention was not to discourage Galápagos tourism. To the contrary, I advised photographers with a burning desire to see the islands to go sooner rather than later. I'd been five times in nine years on local boats chartered by Wilderness Travel of Berkeley, California (510-548-0420), and on my last visit the islands seemed as safe and visually compelling as ever. In fact, most visitors return blissfully unaware of any problems after living on a boat for a week amidst islands teeming with birds, reptiles, and marine mammals wholly unafraid of human approach. The growing plight beneath the surface was as invisible as a malignant tumor in a playful child.

In December 1996, the United Nations took the first step toward revoking the Galápagos Islands' World Heritage Site designation by placing them on its "Sites in Danger" list. In February 1997, the interim president of Ecuador conspicuously left proponents of environmental abuses in place as Galápagos officials, after announcing national removal of past political appointees. These officials saw themselves as defenders of social justice, fighting for the innate rights of the 14,000 Ecuadorian residents of these once-uninhabited islands to make a basic living off the surrounding lands and seas. The problem is that 95 percent of the land area is Galápagos National

Park, while the waters are in the Galápagos Marine Reserve.

Media coverage began in 1995, when masked fisherman brandishing machetes stormed the Charles Darwin Research Station and park headquarters on Santa Cruz Island. Researchers, staff, and breeding giant tortoises were effectively held hostage. Locals were upset that the first "experimental" sea cucumber season had ended. The limit was 550,000, but over 10 million of these $12-per-pound delicacies (served in Japan, but notably not in Ecuador) were delivered to large offshore processing ships before the government finally closed the season.

In the absence of strong local or national intervention, illegal fishermen camped on beaches inside the national park and the director of the Darwin Station received death threats. Those who spoke up against overfishing in the capitol city of Quito were branded "ecoterrorists intent on soiling the international image of Ecuador" by the Undersecretary of Fisheries.

Immigrants have flocked to the Galápagos as the great fisheries of Peru and Ecuador decline toward economic extinction. The same upwelling of nutrient-rich cold waters from Antarctic currents accounts for both a photogenic profusion of life above the surface in the Galápagos and what used to be the world's most productive fishery below the surface along the mainland coast. Peru failed to heed repeated United Nations warnings of gross overfishing and shifting currents before their yield collapsed 90 percent during the seventies.

The volcanic islands of the Galápagos begin 15,000 feet below sea level where cold currents are forced to well up into equatorial waters, creating an ideal breeding ground for marine life. The birds, reptiles, and marine mammals of the islands flourish in unique and splendid isolation because of the profuse numbers of fish and other creatures of the sea.

Darwin recognized that less well-situated desert islands could not have supported the thirteen different species of finches, frigate birds, boobies, albatross, sea lions, fur seals, land iguanas, marine iguanas, and giant tortoises weighing 600 pounds. In 1959, on the centennial of the publication of Darwin's theory, Galápagos protection began as an international success story. The Ecuadorian government worked with private organizations to set aside all uncolonized lands as national park under some of the world's strictest controls. Tiny villages on the 2 percent of remaining lands didn't pose much of a problem until they began to grow as the mainland fishing industry collapsed.

Park visitors must be accompanied by trained and licensed naturalist guides. The great majority of guides are dedicated environmentalists, but some who objected to the 1995 revolt were threatened not only by fishermen, but also by rogue local guides who were true believers in their people's rights to fish without restrictions. One guide was seriously beaten with broken bones, while another left the islands after being threatened with bodily harm for writing a critical article.

Were it not for a personal incident, I might have returned home in 1996 to write a glowing travel piece about how the Galápagos was at peace again. The natural splendor of the islands appeared undiminished, but what happened on a calm Sunday morning in Porta Ayora set me on the course of this investigative story. Barbara and I were walking across the public square with friends from previous visits. As we watched children skip out of church into the arms of waiting parents, one man, bare to the waist, kissed his small daughter and put her on the back of his bicycle.

I smiled and lifted my camera. The man leapt off his bicycle, flexed his muscles, and threatened me with four-letter words. I doubt he saw me shoot off one frame before I put my camera down. He turned out to be the same guide who had beaten up a fellow guide over the sea cucumber issue. Why he had not been held accountable was evident when I learned of a videotape showing thousands of fresh sea cucumbers drying on the local rooftop of a top Galápagos official's home, well after the season had closed.

National politicians were operating on the principle that the Galápagos would continue to be a golden goose of ecotourism longer than they would be in office. That was certainly true of Fabian Alarcon, President of the Republic of Ecuador during my visit. He was removed from office, not for his disastrous environmental policies, but for cutting awful CDs of his own singing while in office and otherwise leading the public to seriously question his sanity. Yet government officials who continued to say that fishing out the Galápagos would be no big deal seemed equally crazy to me. They claimed that only 50,000 of the 500,000 annual visitors to Ecuador go there. According to one estimate, this affluent 10 percent of Europeans, Asians, and North Americans drawn to the Galápagos account for 80 percent of tourism's foreign currency, as they normally travel through Quito and visit other parts of the country. The majority of remaining tourists are from Latin American countries and are on limited budgets or came for, as they say, purposes left unchecked on their travel documents.

Only after Galápagos park authorities seized three boats conducting industrial-level tuna and shark fishing for export, and seized evidence of Japanese aphrodisiac trade in dried sea-lion penises, did the national government finally take action to limit fishing on and around the islands. Whether there will be sufficient enforcement to ensure the long-term survival of the Galápagos ecosystem much as Charles Darwin saw it 160 years ago is another matter. Limiting extraction of natural resources is the key. Despite minor impact, ecotourists living on self-contained boats, who walk up to photograph unconcerned nesting birds on island trails, are having far less effect on the islands than local people and pirate vessels bent on making a living from the seas.

African Sunrises And Eco-Porn

"The only way I've managed to stay concerned and active and enthusiastic in life is by recognizing before I embarked on a career in photography that, for better or for worse, I'm an elitist. I do get to do things other people don't experience."

On a cool morning run beside the Zambezi River near Victoria Falls, I stopped in a clearing to photograph the sunrise. A rustle in the bushes startled me. Even though I was near a bustling tourist center, hippos, crocs, and lions were around.

Instead, my eyes met others strangely like my own. Twenty baboons were right behind me. Being possessed of that universal certitude of my species that gives nearly everything intentionality, I concluded that they had stopped to watch me. Wrong. They had been there first, and only when I moved did they bother to look at me. They, too, were watching the sunrise.

I had sought out the same unobstructed view that this troop seemed to be enjoying (although my judgment may, again, have been affected by intentionality). I tried to photograph them calmly watching the sunrise, but it wasn't working. I had either a great sunrise or a baboon in great light, but not both.

If I sell either of these scenes as stock photos, the odds of their re-creating my experience of a monkey watching a sunrise are not as great as the odds of their being used to promote Pontiacs or Prozac. The same human certitude that first led me to falsely conclude that the baboons had stopped to watch me adds a dimension to my published photographs that I can't control (except to some degree when I write about them in my own works). I thoroughly enjoy the process of seeking out the most powerful images of the natural world I can find, and if people imagine something that

wasn't there for me, I've always thought: *So be it; it's not my responsibility, so long as my intentions were honest.*

Soon after I returned from Africa, I again thought I was alone just before dawn in Glacier Park when vivid alpenglow struck a fluted cloud. I rejoiced over the richest sky colors I'd seen since the eruption of Mount Pinatubo in 1991 created a stratospheric layer that blocked typically vivid sunrises and sunsets for several years. After I shot two full rolls of landscapes, I set my self-timer numerous times as I ran wildly into the frame, climbed a silhouetted dead tree, and hung from a limb until the shutter clicked.

Only then did I notice a stone-faced elderly couple without cameras watching me. They must have thought I was crazy. It suddenly occurred to me that my failure with the monkey sunrise might have been what led me into the tree. I quit just before a shadow passed over us as the sun rose into the dark cloud. While we were walking the same path back to our cars, I turned and said, "Wasn't that a fantastic sunrise?"

The man thought a moment and replied, "I think it would have been nicer if that big cloud hadn't been there."

Our perspectives were more different than I had imagined. While I was passionately thrilled by a positive scene that I knew I had recorded with my camera, they were displeased by the big shadow that had just blocked their morning sun.

I returned home to a letter from Daniel Dancer, a concerned environmental photographer who had contributed many more pictures than I had to a big new Sierra Club book called *Clearcut: The Tragedy of Industrial Forestry*. Most of mine didn't make the first cut by our mutual friend, Doug Tompkins, who said I had a nasty habit of making devastating scenes look

too good by focusing on flowers among the stumps or attractive lines in the landscape. Dancer's photographs cut heartstrings like a surgeon's knife with bold, unmitigated detail. Our wealthy friend Doug, who underwrote a book that otherwise would never have made it into stores in direct sales competition with gift books of beautiful nature pictures, relates how one of Dancer's aerials of a fresh clearcut beside old-growth forest so grabbed his visiting mother that she said, "This cannot be; it just cannot be right," and on the spot became emotionally involved with the cause.

Dancer asked if I had given the notion of "pornecology" consideration. "What is the massive proliferation of nature images doing to our consciousness? Is it making us more environmentally aware, or is it fostering a Pollyannaish view of the world? . . . We consume images at a frightening rate and as a society have become increasingly content with images of nature rather than the real thing. Do we really need more outdoor photographers taking yet more pictures of grizzlies, wildflowers, half domes, and the like? If their pursuit of such is not firmly grounded in a strong and *active* environmental ethic, then I believe such work (likely the bulk of the images taken) may be deemed pornecology."

Dancer continued, "It is a curious aspect of civilization that we love to display that which we have conquered, or are conquering. . . . Witness the images of nature used to sell and promote earth-destroying corporations. . . . Indigenous people in many parts of the world (before they became used to camera-toting travelers) were suspicious of photography, and thought it stole something of the subject's essence. They may have been onto something. . . . I don't think we can justify photographs of nature any longer, as providing a record of what we are losing. We have countless millions of images in libraries, galleries and personal collections which do that."

Dancer also quoted a questionable statistic that over 40 percent of serious toxic chemical pollution comes from the photographic process, concluding that the environmental costs of over-imaging the world are staggering. I was already aware that over 50 billion photos are taken each year and over one hundred million disposable cameras are sold. To bolster his cause, Dancer enclosed an article from the radical environmental journal, *Wild Earth,* titled: "Eco-porn and the Manipulation of Desire."

The author begins by recounting being in the wilderness at sunrise with a photographer who "trapped a sacred moment like a rabbit in a snare" using a 4-by-5-inch view camera. For the author without a camera, it had been a moment he "struggled for, rose before dawn for, thawed an ice-filled coffee pot for," yet the photographer's "fragment of this brilliant dawn could be re-experienced by someone warm and comfortable in an easy chair, leafing through a magazine or a calendar." Like pornography, "a physical persona of unsurpassed beauty has been grotesquely trivialized by being removed from essence and context." He is convinced not only that "landscape photographers resort to the methodology of creating a pornographic image," but also that "the intention of most landscape photographers is to appeal to, even seduce, the beholder with an image removed from its physical context, amplified into a commodity by technique . . . to evoke a subjective response for commercial gain, to sell calendars and magazine subscriptions or to connive contributions."

The article made me think deeply about the purpose and end use of my own photography, but it also left me cold. All of my life I've resisted being told that everything I love to do somehow causes harm to something or somebody. I shouldn't rock climb because it's too risky; shouldn't travel overseas so much because it's too emotionally hard on loved ones left behind and wastes precious fossil fuel; shouldn't publish pretty pictures of travel because too many people will be lured into the wilds; shouldn't run long distances without my camera because I'll hurt my knees; shouldn't

speak out so much in my monthly magazine column because I'll get nasty letters.

Oscar Wilde wrote at the turn of the twentieth century, "Each man kills the things he loves." Some years ago, Dewitt Jones and I predicted that park rangers at the turn of the twenty-first century would be telling visitors, "Don't *touch* the park!"

The only way I've managed to stay concerned *and* active and enthusiastic in life is by recognizing before I embarked on a career in photography that, for better or for worse, I'm an elitist. I do get to do things other people don't experience. Most of the time, I do them for my own reasons. If I responded to everyone's concerns, I'd be forced into passive inaction in that easy chair, leafing through magazines with pictures of parts of the Earth I wasn't seeing with my own eyes.

Some of my photo companions have been ex-hunters who discovered they liked stalking animals with a camera as much as with a rifle. If given an ultimatum to ease up on their wildlife photography and become concerned deep ecologists spreading the word through carefully selected images, they might well go back to shooting the last of those animals I like to photograph. Life isn't fair.

Dancer's mandate to "re-evaluate the relationship between photography and nature" is highly commendable, but it won't have a great effect even if outdoor photographers listen and take a billion less nature photos next year. We'd still have 49 billion pictures of families and other personal ego gratifications, plus another 150 boxcar loads of unrecycled throwaway cameras. Even if a handful of nature photographers eventually lead the way to a new understanding for the concerned few, the problem of how to get meaningful but unattractive images in print in a way that communicates to the masses makes a manned Mars mission seem simplistic. The Internet is becoming part of the problem, not the solution. It contributes to the global glut of imagery far faster than a thousand Dancers could restrict visual commerce among the enlightened few (whose images I would rather see!)

The last sentence of the "Eco-porn" article is by far the most revealing: "I find hope that I may not always resent sharing a hard-won and spectacular dawn with someone casually leafing through a magazine or glancing at a calendar." I recognize a fellow elitist here, but one who is not yet comfortable with the idea that other human beings—or baboons—even when they witness the same scenes with their own eyes instead of through the secondary medium of photography, may have an entirely different perception of a moment we would like to think of as our own. Eco-porn is a concept worthy of consideration, but it shouldn't stop a photographer guided by personal passion from capturing honest moments of heightened perceptions, whether they be the enduring ugliness of a clearcut or the fleeting beauty of alpenglow under a cloud.

Eco-Porn Revisited

"I noticed a big difference between how people express themselves during ongoing interactive exchanges of ideas when others are virtually listening and responding, compared to the contents of the neatly wrapped verbal bombs they are more likely to lob into someone's backyard by going postal."

"How dare this Eco-Jerk try to tell anyone that he has any more right to a sunrise than a photographer?" Bill Basom of Dazura, California, asked in response to my request for readers' opinions on "eco-porn" in one of my monthly *Outdoor Photographer* columns. The hundreds of letters I received were almost unanimously against the idea that photographers of conscience should restrict the pursuit and sale of glorified images of raw nature, which a writer in *Wild Earth* magazine had compared to "grotesquely trivialized" images of the naked body that "seduce the beholder with an image removed from its physical context."

Many letters were the sort of ballistic tirades I would expect from members of the NRA if I'd done a story quoting folks who said they should voluntarily stop shooting. Daniel Dancer, who urges photography of ecological problems rather than natural beauty, was targeted as "one of those one-issue fanatics" because he deemed outdoor photography to be "pornecology," if it is "not firmly grounded in a strong and active environmental ethic." This led Helen Kent of New York to suggest that Dancer's own "narrowly documentary, time/issue-bound" work might lack the long-term relevance of the images of beauty he so disdains.

"I can't believe you are giving credence to such a silly, headline-grabbing topic," wrote Alan Klughammer of Duncan, B.C., Canada. Gary Lebo of San Antonio, Texas, said, "I am one of those that has recently leaned

more toward the camera and less toward the rifle. Then I see this. Is there no escape? . . . Sure photography can be misused. Shouldn't we ban all cars, all medical research, all forms of fossil fuel transportation?" Irene Davenhauer of Green Valley, Arizona, adds, "I would not care to hang ugly pictures on my wall; the world is full of ugliness; only beautiful pictures get hung."

Another perspective comes from Max Leggett of Toronto: "I can't walk without a cane. Who is your friend that he will deny me the pleasure of a photographed sunset that I would otherwise not be able to experience? Does he seriously believe such sanctimonious twaddle? . . . I certainly don't need the vacuous opinions of Eco-Nazis." Ed Orth of Birmingham, Alabama, wrote, "The outdoors is my holy place where renewal runs deep. Is sharing that enthusiasm with others through my work 'eco-porn?' What an absurdity! How ludicrous. How sad." Aspiring adventure photographer Randal Queen of Spring Branch, Texas, poignantly concluded, "I guess he [Dancer] has learned how not to destroy the Earth, just our dreams."

Dancer was not surprised: "Asking photographers to rethink the essence of nature photography is a bit like asking politicians to rethink our definition of progress. It's not a message you get thanked for." Many readers who aimed their wrath at him wrongly assumed he wrote the more strident *Wild Earth* article that disdained the sharing of a hard-won sunrise with a photographer who "trapped a sacred moment like a rabbit in a snare" to be re-experienced in magazines and calendars by people in easy chairs. I decided to discuss the subject in print only after dozens of people had asked my opinion, including a few editors in positions to affect future uses of nature photography. Like abortion, the highly-charged issue won't go away by murdering the messengers.

Dancer also re-emphasized his central point as more of a voluntary mandate: "Taking images of a natural place or animal should involve a giving to that place or animal. It must be a mutual relationship, the taking balanced with the giving—that which we offer of ourselves to the future benefit of the aspects of nature we photograph."

I have long practiced this as an open-minded ideal, but have not always been able to adhere to it, especially on short visits to areas to which I may never return. I have given back far more than I have taken from Tibet and Yosemite, yet I am unwilling to turn down an assignment to create pretty pictures of helicopter hiking in Canada because someone else believes it crosses an imaginary environmental cost/benefit line they have drawn up in advance. Many trips I did twenty years ago for purely selfish reasons, to climb or photograph, are now the basis for a more powerful emotional response to current problems in those places.

A pound of downloaded e-mail had a very different tone than ordinary letters. Less than half wholly denied Daniel Dancer's concerns. I noticed a big difference between how people express themselves during ongoing interactive exchanges of ideas when others are virtually listening and responding, compared to the contents of the neatly wrapped verbal bombs they are more likely to lob into someone's backyard by going postal. The more reflective writers usually sprinkled dabs of personal experience into their on-line philosophies, but sent letters by mail that tended to be either intensely vitriolic or sentimental personal accounts sprinkled with bits of philosophy. For example, Jim Chadwick of Hercules, California, opened up his heart in a letter: "My family never gave me any encouragement, and it never occurred to anyone at my house that being a photographer was

anything to do with one's life. . . . If a person only does what's surely safe and correct and clean, there won't be nearly as much good work done in the world. The bear *does* shit in the woods." Ellen Rudolph of Williamsburg, Virginia, reflected the tendency of on-line comments to keep discourse open: "The notion of 'pornecology' as Daniel Dancer uses it is an invaluable one in my opinion, if for no other reason than it causes us to re-evaluate what we think we know about the world."

Here are some select on-line one-liners that hint at the breadth of opinions: "Humans have inflicted massive damage on nature, and yet remain in denial about it; in that sense we can legitimately ask if some nature photos are part of the denial." "I chose to forget Galen's article. . . . Life has enough grief." "The reality of a clear-cut will mean something different to everyone; to some, it may mean a loss of habitat for a spotted owl or to others it may mean a house to raise their family." "I take exception to the insinuation that if my photography is not based on an 'active environmental ethic' that somehow that diminishes my images to pornography." "You can't make a living doing this unless your photos are marketable. . . . I believe that the ratio of 'pretty' to 'ugly' pictures we see in print is precisely because of these marketing reasons." "Should *Outdoor Photographer* concern itself with images that most of its readers don't care to see?" "Beauty so drives the publishing industry that, like Daniel Dancer says, the funding must come from other, less obvious places for the imagery which attempts to tell the whole truth about our ecological reality." "With the massive proliferation of point-and-shoots and the tons of snapshooters it becomes apparent in their own experiences that stunningly beautiful images are not the norm." "I don't need a picture of a raped landscape staring me in the face after I've spent 2½ days debugging a particularly difficult application." "Dancer's position is an extreme one; I disagree only with his taking his arguments

too far, not with the arguments themselves." "To suggest that we all stop photographing the sunsets and waterfalls and go out and shoot strip mines is ludicrous." "A camera may be the most powerful mind-changing tool on the planet."

In a letter from Missoula, Montana, Michael Wolf summed it up for the majority of my readers: "If I were to go to the wilderness to take photos to make money, period, I could see exploitation staring back at me. I go to enjoy the experience, the beauty, solitude and to get away from the rat race which humans have created for ourselves to live in."

Regardless of the state of the Earth, most of us continue to seek truth through beauty in our own way. Even Robinson Jeffers, my favorite environmental poet, best known for his savage imagery of such things as severed hands, concluded late in life: "Beauty is the sole business of poetry. . . . It is the human mind's translation of the transhuman." For me, this is precisely what nature photography is about.

World's Finest Prints

"Though we have created a mental template in our minds about how analog photographic prints represent the natural world, digital enlargements can negate many of the introduced shortcomings that we take for granted."

In the late sixties, a few years before committing to the life of a freelancer, I felt honored to join an inner circle of published writers and photographers who met every week at a waterfront bar in San Francisco. I listened for insights that might guide me down a similar rosy pathway to success, but mainly heard gripes about publishers, editors, and the evils of new technology.

When I made the mistake of showing off my new Nikon FTn with the lame excuse that I didn't dare leave it in my car, two pony-tailed graybeards (a bit younger than I am now) turned to their drinks and proclaimed the impending doom of automated photography. After agreeing that all great art must come from simple tools guided by hand and eye, and that every camera setting is potentially creative, they concluded that real men shouldn't be caught dead using through-the-lens meters, much less shooting color and not processing it themselves.

My translation was that the more time you spent diddling with that extra meter or fiddling in your darkroom, the more your somber black-and-whites might be worth when you were dead. I was more concerned with spending as much time as possible in the wilds doing the things that gave my life meaning. The experience came first. Where technology could aid my ability to share my passions through images and words, I readily embraced it, but where it might interfere, I opted for simplicity.

I wasn't cut out to be a studio photographer doing indoor set-ups of subjects dictated by my clients.

My best pictures resulted from a passionate, participatory involvement with the natural scene before my lens. None were purely based on technical expertise or automated equipment. Here, I found myself on common ground with the graybeards, who suggested that even though I had the latest Nikon, whenever anyone asked what camera I used, I should blithely reply: "Asking a photographer what model of camera he uses is like asking a writer what model of typewriter he uses."

That formerly popular repartee, once known to every pro, hasn't been heard since new technology deposed the typewriter and political correctness banished the masculine pronoun as general descriptor. To say, "what model of computer he or she uses" just doesn't have the same meaning or ring. Besides, today's real men and women no longer brag about avoiding technology as they reach for their cell phones or surf the web. They take for granted that word processing makes for faster and more consistent writing, and that automated features make for faster and more consistent photographs. Despite worship of traditional ways by a few, most of today's successful writers and photographers are highly computerized.

Fine-art photographic prints are one of the last bastions of resistance. Black-and-whites by dead guys with darkrooms are indeed the ultimate limited edition. That they command the highest prices has more to do with scarcity than image quality. In the minds of most fine-art collectors, mere mention of the use of Adobe Photoshop to create an exhibit print of a natural scene would be tantamount to blasphemy. It would register as art forgery somewhat less creative than a classic Botticelli imitation—more in the realm of a Chevrolet Blazer veritably walking on water atop an ocean wave.

The use of Photoshop to fine-tune the most accurate and truthful photographic prints in history is hard for many traditionalists to accept. Not so long ago, all digital renditions of nature were predictably awful.

Today, the gamut extends skyward to include every fine poster, book, and magazine reproduction, as well as digitally enlarged true photographic prints that exceed analog enlargements by every measure of sharpness, tonality, color rendition, and aesthetic appeal.

We have grown so accustomed to the disparities of analog optical enlargements that we accept them without question. Of course big prints will never look as sharp as our original transparencies; edges are softened by optical diffusion. Of course colors and contrast will fall off with increasing size; video on a big screen always looks flat compared to on a smaller monitor. Of course prints made at different times with different paper and chemistry will never look quite the same. What do you expect, a miracle?

My miraculous conversion literally happened overnight. Federal Express delivered 50-inch prints outputted from my digital files that held all the saturation of my original 35mm transparencies, with even better tonal separation and the sharpness of medium format. Though color prints used to be written off as not archival enough to be collectible, independent testing shows these prints on Fuji Crystal Archive paper to have a display life of up to seventy-one years before noticeable fade, compared to Kodak's best of sixteen to twenty years. Their stability also exceeds that of Ilfochrome materials, which have the added complication of color dyes less closely matched to those of either Fuji or Kodak transparencies.

Though seeing was believing, it took a bit more time to become convinced that state-of-the-art color profiling could guarantee future perfect prints with my precise aesthetic choices out of any properly calibrated output device, from my first $299 Epson inkjet proofing printer, to my present $22,000 Fujix Pictrography printer that makes photographs exposed by color laser up to 12 by 18 inches, to the $250,000 Cymbolic Sciences LightJet 5000 digital enlarger that also uses color lasers to expose my top-of-the-line exhibit prints. In the future, these same digital files

will reproduce my carefully selected values for direct computer-to-plate book printing, replacing the judgment call of a Hong Kong scanner operator working against a deadline.

Though we have created a mental template in our minds about how analog photographic prints represent the natural world, digital enlargements can negate many of the introduced shortcomings that we take for granted. Color and contrast fall off as they are spread ever thinner in traditional enlargements, but the same digital information for rich color and contrast can be fed to the output lasers that scan photographic paper grain by grain for either a 5-inch print or a 50-inch print. Film grain can be selectively defocused into obscurity in continuous-toned skies, while all the inherent edge sharpness of the main subject can be retained through unsharp masking.

As our Mountain Light Gallery began to hang its first full show of digitally enlarged prints in 1998, all was not wine and roses. I felt sixties déjà vu as an earnest gentleman began asking with a tone of alarm, "You mean every print will look exactly the same?" "They come out of a computerized machine?" "You don't print them?" "Do you use Photoshop?" "Are they manipulated?"

I explained how I had spent hundreds of hours over the period of a year making the creative decisions for just forty-five prints. I compared the way my creative decisions for an original transparency are completed before the film is processed with the way those for a digital print are completed before the file is sent for output. If he was concerned about over-manipulation, we would be glad to show him the original transparency of any print he was considering purchasing. I considered absolute repeatability to be a gift from heaven, empowering me to deliver to my customers prints that always hold my chosen artistic and interpretive choices.

I further described my belief that nature photographers have a sacred trust to print no more or less than what was actually before their lenses, unless the image is disclosed as digitally altered or presented as digital art. This doesn't mean that prints need to show introduced artifacts that weren't before the lens, such as scratches, emulsion flaws, enlarged grain, or inaccurate color shifts. Ethical use of Photoshop can eliminate or reduce these introduced flaws. I spend from two to twenty hours per image making creative decisions before scanning and during later image management, with a highly experienced imaging consultant, who then spends hours more prepping each image for flaws and profiling it for the LightJet 5000. The results are more accurate renditions of what I've witnessed and recorded on film than any traditional analog enlargements I've ever seen.

The two opening receptions for our Veridical Visions show of seventy Crystal Archive LightJet photographs at our Mountain Light Gallery drew more than 500 people. Half of the photographs were by Bill Atkinson, and many people came to see the work of this digital-guru-turned-nature-photographer who had introduced me to his process and mentored me for a year. Almost everyone expressed amazement at the aesthetic and technical quality of the prints, but a few Silicon Valley invitees took delight in pressing their faces against the five 50-inch murals made from 35mm slides to search out slightly brighter borders beside sharpened edges or normal film grain within subjects apart from continuous-tone areas where more obvious grain had been selectively defocused. Notably, I never overheard comments about whether they liked the photographs or not.

When I asked Bill about this confusion of medium and message, he shrugged and said that searching for grain in a digital print to validate it as photography is like listening for tape hiss in a CD to validate it as music. The noise is apart from the artistic signal, and to listen for it is not to hear the music. Similarly, some photographers delight in putting

down others' work by recognizing and pointing out techniques they themselves use, as if they can defuse the emotional power of the visual message by explaining away how it was created. For me, the opposite is more often true. The more I know about the medium of any creative endeavor, the more I am impressed by the message of those who do it well.

Bill Atkinson is a prime example. A long-time amateur photographer, Bill retired early from the computer industry to devote all of his time to creating the finest digitally enlarged photographic prints. The only one to appear twice in his high-school class portrait, he anticipated how the shutter of the panoramic camera would scan the bleachers, then ran from one end to the other during the exposure. Graduate work in neuroscience gave him a deep understanding of human perception before he turned to computer science to create a simulated tour through the human brain in the days before personal computers. Steve Jobs hired him as one of Apple's first thirty employees to head the elite team that designed the revolutionary Macintosh operating system to have a highly visual and interactive user interface. Bill invented the Mac's pull-down windows, wrote much of its software, and designed the first mouse used on a commercially available computer.

Later, when Bill began turning all his considerable talents and the technology he knew so intimately to creating photographic prints, he found plenty of imaging hardware on the market, but a paucity of suitable software. From the start, Bill realized that until the adjustments he made on his computer monitor would closely match what he got in finished prints, he would be shooting in the dark. He wouldn't be able to consistently make prints that expressively conveyed his intentions or technically matched the color and tones of his transparencies.

After developing action scripts to guide him through a consistent series of options for each image, Bill created "soft proofs" which could adjust the full-gamut scan that would normally be displayed to have the same color and contrast constraints as his chosen final output device. For example, his monitor could show a nonreproducible saturated yellow to match the full scan, a clean but slightly less intense yellow to match the inks of his non-archival Iris printer, or a more orange and less saturated yellow to match the dyes in Fuji Crystal Archive photographic paper. If you only view a full-gamut scan on your monitor, you're setting yourself up to be disappointed by prints that have a different dye set and hold less shadow detail.

Bill uses an expensive spectrophotometer to obtain numbers representing precise tonality and color from his monitor and his output devices to plug into an Apple ColorSync digital profile. He makes test proofs on his Fujix Pictrography 4000, which uses a true photographic process to transfer dyes onto continuous-tone prints up to 12 by 18 inches. The file he sends out for LightJet 5000 prints includes an Apple ColorSync digital profile to match one created for the machine in a similar way at the other end. He not only gets photographic prints to match his monitor, but also publishes greeting cards that look amazingly close to those fine prints by taking his gadgetry to his local printer and using Apple ColorSync to profile their proofing device to help them match traditional inks on press. Someday soon, he'll be profiling direct computer-to-plate printing, but as of this writing the results available in the United States are still well below the level of fine traditional printing.

Knowing the hyper-revolution of the digital kingdom, Bill modestly places his techniques about two or three years ahead of the pack. Translation: Much of what he does today will become standard practice by top labs and individual photographers within three years. Today, the great majority of labs and individuals doing digital photographic prints do not use Apple ColorSync profiles to guarantee consistent color and tonality from device to device. They may be able to make decent prints in-house by trial and error, as in

a traditional darkroom, but not perfect prints on the first try from someone else's digital file. Bill believes that many of those who choose to stay away from ColorSync profiling may not be in business in three years' time, unless something better comes along. By then it should be standard fare for quality labs to have scanners, monitors, proofing devices, and high-resolution laser enlargers create images from the same file that look startlingly the same.

To anyone who has tried and failed to make his own perfectly synched digital prints, or to have an unsynched lab do it, Bill's advanced techniques are indeed a miracle. When I first saw them in the fall of 1997, I wasn't sure that I was ready to commit the necessary time and money to make it happen for myself. Bill invited me to bring a few of my favorite originals, including those most difficult to print, to his home high over Silicon Valley. He escorted me into a basement imaging room powered by a Macintosh workstation that seemed to have enough memory to store the Library of Congress. It took us all day to clean and dismount a dozen of my slides, mount them on the drum of his Heidelberg TANGO scanner, adjust prescans with LinoColor software viewed on a calibrated Radius PressView monitor, scan them at 96 megabytes, clean up and sharpen them in Adobe Photoshop, and print them out on either his 20-by-30-inch Iris ink-jet printer or his Fujix Pictography printer. We still weren't ready to send any image for a final print on a LightJet 5000 digital enlarger, because it was clear that with the investment of more time and a hard proof or two, I could make a final digital file that held more accurate color and tonality than I had ever imagined possible.

As I drove home, the thought occurred to me to say thanks but no thanks. To heck with the finest prints, I want to be out there in the wilderness with my sleeping bag and camera instead of in a basement in the dark looking at a computer screen. I was wowed by the process, but it wasn't the life I envisioned when I became a nature photographer. I didn't have the time, the money, the inclination, or the expertise to do what Bill was doing, so who was I fooling?

But I had set another date with Bill, and when I returned we made Fujix Pictography proofs that surpassed the best photographic prints I'd ever seen. I also needed five 50-inch color murals for a San Francisco show that was opening soon. Bill sent digital files with appropriate sizing and profiling to EverColor Fine Art, which used the trademarked name Luminage for what were then the only LightJet 5000 prints with Apple ColorSync profiling. Three days later, Federal Express delivered those huge prints that knocked my socks off.

Bill kindly proposed that I could scan more images with him for a while and spend about $12,000 on hardware and software to do my own image management somewhat more slowly at a fiftieth of his investment. After we bought the equipment, and Bill saw that I didn't have the time to master the full learning curve, he suggested hiring an experienced digital imaging consultant to work hands-on with my creative oversight, which we did.

Beginning with some of my most critical transparencies that were damaged by age and handling, we ended up with LightJet prints that were far better than the best analog prints I had made even when the slides were new. These files can be outputted as low-end ink-jet prints, high-end photographs, fine-art Iris prints on watercolor paper, transparencies again, or separations for printing books and posters. Today, EverColor no longer has the only Apple ColorSynced LightJet 5000 digital enlarger. Both Bill and I now send our prepared files to Calypso of Santa Clara (800-794-2755) to output identical Crystal Archive prints without the Luminage name. I begin with TANGO scans made either as a personal favor by Bill Atkinson or by Bob Cornelis of Color Folio (888-212-7060).

Casual gallery viewers usually don't care about the process by which prints have been made. Their

gut emotional response comes first. Only then do they consider the price, the process, or the archival stability. They may not be aware of how much of their emotional reaction to a fine original print depends on the excellence of the medium until they see a less satisfactory inexpensive print or poster reproduction.

A variation on this theme happened to me when I first had a chance to stand alone and contemplate the full gallery of Bill's and my own images, printed by exactly the same process. The technical aspect vanished as the fidelity of the reproductions made the essential differences in our styles emerge for all to see. With the printing process identical, the artistry, rather than simply the craftsmanship, stood out in bold relief.

Though Bill's work and my own appear clearly different in style, our intentions and ethics are much the same. I use exclusively 35mm film to select and interpret evanescent moments when natural light and forms come together into an image that may never repeat itself. Bill mainly uses medium or large format to create images that deliver experiences of more enduring entities—impeccably detailed visions that make people feel as if they've stepped inside a flower or into a quiet forest. Yet at the most basic creative level, we are both attempting to internalize what is before us into a vision that communicates our human intention as much as it describes the flowers, rocks, trees, and water before our lens.

For us, the chosen values of the final print are as important as the chosen subject in a way that merges them into a new way of seeing the world. Photography is not art until it goes beyond mere representation to communicate emotionally and spiritually. A photograph in a textbook operates as a surrogate object, a somewhat deficient substitute for looking at a real moon, a real flower, or a real person. In its highest form, nature photography as art uses imagery to directly communicate emotional response from one mind to another far more quickly, more

powerfully, and more completely than the written word. The images become something more than they appear to depict, rather than being inferior copies of nature.

My writing was published before my photography, and though I have become better known for my images, I continue to express my feelings about the natural world in both mediums. With a similar bent, one of the century's truly great nature writers, Barry Lopez, began a budding career as a landscape photographer, but gave it up because the reproductions of the time couldn't match his intentions. His 1998 book, *About This Life*, eloquently describes the final straw: "In the summer of 1976 my mother was dying of cancer. To ease her burden and to brighten the sterile room where she lay dying, I made a set of large Cibachrome prints from some of my 35mm Kodachrome images."

He describes them and goes on to say, "It was the only set of prints I would ever make. As good as they were, the change in color balance and the loss of transparency and contrast when compared with the originals, the reduction in sharpness, created a deep doubting about ever wanting to do such a thing again. I hung the images in a few shows, then put them away. . . . I realized that just as the distance between what I saw and what I was able to record was huge, so was that between what I recorded and what people saw."

Digital enlarging allows me to create prints that come closer to what I saw without embellishing an image with something that wasn't really there—by accident or intention. I want to draw honest attention to what really drew my eye—key moments in the natural world that are most special for me.

All perception operates by comparison. No photograph moves us unless it triggers the memory of a pattern or form that we have seen before. If an image is made up entirely of original, unfamiliar subject matter, we simply do not comprehend it and so pass it by. On the other hand, if an image is so entirely comprehensible at first glance that it lacks all

sense of mystery, we often find it boring. The power of photography to captivate our senses, to teach us something new, to hold a sense of mystery that intrigues us, is contained in the way its balance of the familiar and unfamiliar forces us to extrapolate beyond what we already know.

Crystal Archive Lightjet photographs not only offer the ultimate fidelity in color, sharpness, tonal range, and archival stability currently available on any photographic paper, but also further the process of personal discovery for both artist and viewer by minimizing distracting inadequacies. I'm continually amazed at the large, fine prints that literally appear to have been taken with medium format instead of 35mm that I get from either last week's shoot on Fuji Velvia or my thirty-year-old Kodachromes.

For me, shooting 35mm has never looked so good. What Bill has demonstrated is that digital imaging can complement nature and editorial photography rather than compete with it. When the day comes that a small digital camera can do a better job of recording the emotional experience of the natural world than my Nikon, I'll be ready. The medium may not be the message, but it sure can make a big difference.

Photographs: Pages 2–3, 9, 73–75, 78, 202–207, 250–251

Nature Close to Home

"Barbara excitedly announced over the intercom: 'This is incredible. It's all unbroken forest down there. I'm seeing more continuous forest right here in the Bay Area than in all my flights over the national parks of Costa Rica.'"

I'm somewhat embarrassed to admit that I lived in the San Francisco Bay Area for more than fifty years before I recognized the true photographic potential of wild places near my home. The extraordinary amount of protected land around San Francisco is neither contiguous nor defined by a single name, yet it includes more than 200 parks, preserves, and other protected areas within forty miles of the city. Together, they exceed Yosemite National Park in size, biodiversity, and visitation. They became the subject of my 1997 book, *Bay Area Wild*.

Although some newspaper reviews related how my wife, Barbara, had a great idea one day and then we followed it up, it's never that simple. Many factors had begun to change the ways in which we viewed natural areas nearer to home before serendipity struck. Not by coincidence, Barbara saw both the big, singular picture of the concept and more individual ones of the many existing photographs of mine that fit that concept.

My first inkling that I might someday do a book about wild places close to home came after teaching our local Mountain Light workshops. They forced me into searching out the best field locations for students to photograph at the optimum times of the day and year. Having done this, I began surprising myself with local photographs that rivaled my best work from previous decades of shooting on every continent. Instead of getting isolated results from chance situations, I found myself preplanning images in my mind's eye, as I'd do on *National Geographic* assignments in exotic places.

Being a native son of Berkeley who had made thousands of visits to run or hike wild trails in local parks and preserves, I was astonished to discover how little I really knew about the Bay Area's wild places. Like a commuter, I had tended to travel the same routes over and over again. I was in good company, however. As I talked with veteran users of local wild lands, it became clear that virtually all of us knew a few places well, but rarely ventured beyond our favorite local haunts. We were more likely to have spent weeks in the wilds of Nepal than in preserves on the opposite shores of the Bay.

We simply hadn't given equal effort to planning visits to places we thought we could see anytime. Furthermore, most of our brief journeys to more distant parts of the Bay Area hadn't been self-initiated; rather, they were prompted by the presence of out-of-town visitors. This pattern confirmed my experiences as an assignment photographer, where I had often found that my own brief jaunts into a new region's wildlands exceeded the lifetime local excursions of residents. That's worth keeping in mind as you photograph in your own home area.

I decided to approach even the most mundane of my Bay Area journeys as if I was traveling abroad. Instead of choosing the fastest way to get from one point to another, I kept trail maps and natural history guidebooks in my car and, whenever possible, planned road trips to include visits to new wild places.

For example, on a drive to a business appointment in Palo Alto, I gave myself more time than usual to buck the rush-hour traffic and arrived a full half-hour early. Instead of reading the morning paper over coffee in a restaurant or studying the wallpaper in my

client's waiting room, I drove two minutes off the freeway to walk through the Palo Alto Baylands Nature Preserve—2000 acres of wetlands. I carried just the right equipment to capture the shorebirds and the landscape.

In one sense, Barbara's vision for the book did come out of thin air. She had done years of volunteer flights for Lighthawk, an environmental group dedicated to giving media, land managers, and political decision-makers aerial overviews of threatened natural areas. At first, she requested exotic locations and flew to save a river in Alaska and a tropical rainforest in Latin America.

Barbara came up with the idea for the book after she veered from her usual urban departure route on a more frivolous mission to pick up our golden retriever from friends. She had just returned from an environmental flight in Costa Rica, and we decided to fly, rather than drive several hours up the twisty roads of the North Coast. What she saw also inspired her to begin flights to save Bay Area open spaces.

The day was exceptionally clear after a storm. That, combined with the lush greenery of spring, provided some of the most ideal conditions for aerial photography I had ever seen. The glistening ring of cities around San Francisco Bay resembled little clusters of diamonds surrounded by huge emeralds of open space. The verdant facets of Mount Tamalpais rising above Marin County were so compelling that Barbara diverted from her normal route to circle the peak.

After we made a low pass over the north side with the window opened for photography, Barbara excitedly announced over the intercom: "This is incredible. It's all unbroken forest down there. I'm seeing more continuous forest right here in the Bay Area than in all my flights over the national parks of

Costa Rica." She went on to explain how forest preserves in Costa Rica were not only discontinuous, but also poorly enforced, with lots of native squatters and slash-and-burn agriculture visible from the air.

When we returned home, I checked some figures, which confirmed Barbara's aerial impressions. Whereas a significant 11 percent of Costa Rica is under national park designation, 27 percent of Marin County's land area is directly administered by the National Park Service. When other public-access natural preserves are added in, Marin's portion of protected land jumps to a whopping 44 percent.

The sense of wholeness and unity of Bay Area wildlands that we gained from the air that day reminds me of the first lunar astronauts' surprise to see a whole, living Earth after a lifetime of looking at globes segmented into brightly colored political designations. Though they didn't expect to see a planet with national borders, the reality of their direct observation was overpowering.

Recalling our infinitely lower pass over Marin County, I wondered how the visual integrity that had so impressed me could be translated to the printed page, where disparate pieces of the whole are unlikely to strike readers as memorably as would images of a whole Earth or even a Yosemite Valley. Despite the wealth of scenes in the Bay Area, I thought the uniquely sculpted landscapes people have grown accustomed to seeing on posters and book covers would be hard to come by here. Also, the more I considered it, the more impossible a task it seemed to bring together all the essential aspects of the wild Bay Area in one book. The photography would need to go well beyond aerial views and common scenes visible from roads and trails.

Just to document the elusive wildlife could take ten years. Truthful and evocative photographs of Bay

Area creatures in their natural settings aren't easily made, and I'm not willing to print images of animals from other locations with vague captions, to present captive animals as wild, or to pass off digital illustrations of animals dropped into empty landscapes as photographic documentation of natural history.

But the more I learned about local environmental issues, the more urgent the production of *Bay Area Wild* became. I sensed that my initial optimism about the greater Bay Area's unusually large amount of protected land needed to be tempered with concern over issues such as the threat of imminent development of areas of open space nineteen times the size of San Francisco.

I solved the problem of documenting Bay Area wildlife with integrity by inviting Michael Sewell to share the photographic coverage of a book that would be packaged (edited and produced) by our own Mountain Light Press, with printing and distribution done by Sierra Club Books. Michael, also a Berkeley native, had already spent ten years roaming wild parts of the Bay Area and photographing wildlife in some most unusual ways. I was especially impressed by the way he had captured a full-frame image of a wild bobcat at Point Reyes, a photograph that had won a state wildlife contest.

The bobcat hadn't stepped into a meadow in front of a camera in broad daylight by chance. Michael had mastered the Native American art of wildlife calling. He had imitated the sound of a rabbit in distress while sitting absolutely still in camouflage clothing, with skunk scent dabbed on nearby brush to mask his own scent.

Several times during the making of the book, I donned similar battlefield attire and joined Michael in the field as he called in bobcats, foxes, and coyotes, whose haunting expressions indicated their uncertainty about our true genus and species.

Michael had also spent four years maintaining remote cameras placed along wildlife paths, to be triggered by the tripping of an infrared beam. His thousands of slides from these endeavors include images of stray dogs and feral pigs, and a wealth of powerful, candid moments in the lives of wild creatures.

We agreed that we would both shoot new work for the book for two more years, with no firm dividing line between wildlife and landscape photography. In other words, we'd both continue to photograph whatever we believed was relevant. We were reasonably sure the majority of wildlife images would end up being Michael's and the majority of landscapes and close-ups mine.

To keep the visual voltage as high as possible, we decided from the outset to wholly avoid a guidebook approach. We had no intention of producing a visual inventory of every park, preserve, life zone, mammal, bird, reptile, insect, rare plant, and currently threatened piece of open space within our chosen area.

Though we agreed that some species and locales were "musts" to include, we also wanted to leave room for spontaneous, inspired imagery, whether a cloud or a clapper rail. The two of us painstakingly whittled down a selection of more than 20,000 images of the wild Bay Area to a group of 400; our graphic designer, Jennifer Barry, would choose 172 images for the final layout.

If I have a nagging doubt about the result, it's that we may have succeeded too well in producing a seamless vision of wildness. Casual page-turners may conclude that more than enough Bay Area land has already been preserved, unless they read the text, which is based on my fascination with the relationship between preserved areas and those who have gone out of their way to save them. Interviews that explore the motivations and accomplishments of key individuals reveal many ongoing battles yet to be won, as well as great successes. A map shows greenbelts at risk that will greatly affect future congestion and quality of life if they're allowed to be developed.

I can't deny an unfathomable longing to have seen the Bay Area in pristine times when the Ohlone Indians lived beside vast herds of antelope, deer, and elk. Biologists speculate that more grizzlies may have caught more salmon here than anywhere else on the continent. Nor can I deny how that longing clashes with who I am: a citizen of the modern world, trapped in my allotted era by more than the calendar of history.

As I daydream about what it would have been like to live in the Bay Area of the past, the notion becomes less romantic if I consider spending my whole life in that era. According to estimates of Ohlone life expectancy, I'd now have been dead for nearly twenty years. Were I an Ohlone Indian of old, would the same magic I feel on spotting a wild bobcat in the spring grass be there?

If I really craved living in that era, shouldn't I be living in some distant backwater of the Bay Area on the wildest piece of property I can find? One reason I don't is that I already dread the grueling drive to San Francisco International Airport, which enables me to explore and document distant and exotic places. I'm not willing to give up these travels or to have my airport commute become unbearably long. In fact, I'm convinced that my unabashed appreciation of Bay Area wildness is based on my direct experience of such highly touted places as Alaska, Hawaii, the Galápagos Islands, the polar regions, and Tibet. Only after having photographed all seven continents and both poles do I know with certitude how favorably my home wildlands compare.

LIST OF ILLUSTRATIONS

281

ACKNOWLEDGMENTS

Fourteen years ago, Steve Werner asked me to write a monthly column for his new magazine, *Outdoor Photographer*. I was interested but not overjoyed. A previous stint writing a photography column for a national magazine had turned into such an editorial tug-of-war that I would rush to the newsstand each month to see what was written under my name. Complex issues were reduced to breezy platitudes. I had resolved to devote my future writings about photography to the more personally controlled and enduring medium of books.

Steve encouraged me to choose my own subjects, write from the heart, and expect few editorial changes. He might suggest a subject now and then, but it would be my choice whether to pursue his idea. If a particular column got too far out of line, I would have the chance to approve any changes or do them myself. And, I could keep all rights to publish my columns in book form.

With a sense of freedom and a book in mind, I wrote the first sixty essays for *Outdoor Photographer* up to 1993 and published them in slightly different form in *Galen Rowell's Vision: The Art of Adventure Photography*. Though almost exclusively my words and images, that book was the result of a team effort, created and designed by our own Mountain Light Press with editorial direction by my wife Barbara and myself. Our mandate was to make a new kind of photography book that would be affordable and accessible rather than expensive and too clumsy to fall asleep reading in bed.

Jenny Barry, who has also worked on many of my other titles, conceived an innovative design to give both the text and the photos of *Galen Rowell's Vision*

their due without the one seriously compromising the message of the other. That book was a great success and went into multiple printings.

The book you are now reading follows a similar concept and design for sixty-six more recent essays first published in *Outdoor Photographer* between 1993 and 1999. Before W. W. Norton came on board to publish it in Fall 2000 with John Barstow as project editor, Kristin Skinner of Mountain Light had organized and edited these writings into a single narrative arranged into a sequence of initial goals, discussions of equipment and logistics, journeys, and realizations. John Barstow and the staff of W. W. Norton performed final editing and review before Jenny Barry once again did the design and layout in the format of the previous title, assisted by Kristen Wurz.

The photographs have been printed from enlarged 70mm duplicate transparencies made from 35mm slides or, in a few cases, from digital files—a case of practicing what I preach about photographers not needing to release their best originals to publishers for months or years in order to end up with a quality book. The majority of images have been reproduced from traditional optical duplicates done by The New Lab of San Francisco, but a few of the larger photographs have been reproduced from our digital master files used for fine-art prints.

Additional photographs of me at work in the field were taken by my wife, Barbara Cushman Rowell (page 113), John Roskelley (page 244) and Gary Crabbe (page 245). Four of Barbara's nature photos also appear on pages 72, 73, 127 and 243. Three wildlife photos by my son, Tony Rowell, appear on page 74. The 1924 black-and-white on page 65 was made and hand-tinted by my late aunt, Marion Avery. The photograph of Earthrise on page 65 was taken by William Anders under the auspices of NASA.

Special thanks are due the many publications, manufacturers, and travel companies which supported the projects described in these pages, including *Audubon, Life, National Geographic,* Universal Press Syndicate, Fuji, Kodak, Marmot, The North Face, Nikon, Patagonia, Photoflex, Powerfood, Singh-Ray, Geographic Expeditions, Great Canadian Ecoventures, National Science Foundation, Nunavut Tourism, Quark Expeditions, Rocky Mountain School of Photography, Wilderness Travel, World Wildlife Fund USA, and Yosemite Fund.

I would also like to thank all who shared in the travels and stories described in these pages, with special mention to John Ackerly, Conrad Anker, Lee Aulman, Thomas Brower III, David Brower, Bruce Bunting, Peter Croft, Tim Cully, "Tundra Tom" Faess, Guy Guthridge, Nancy Feagin, Jim Halfpenny, Warren Harding, Jim Jackson, Cheri Kemp-Kinnear, Ham Kadloo, Frans Lanting, Brian Latta, Brian Maxwell, Colin Monteath, Mingma Norbu, Bob Palais, Paul Piana, Al Read, Ray Rodney, John Roskelley, Barbara Cushman Rowell, Tony Rowell, Jim Sano, Kim Schmitz, Michael Sewell, Ervin and Elena Skalamera, Todd Skinner, Chris Vandiver, Brian Walton, and Steve Zimic.

Exhibit prints or stock uses of images in this book may be procured through Mountain Light Photography of Emeryville, CA (510-601-9000; www.mountainlight.com). Spring and fall three-day photo workshops can be arranged through the same office. Subscription information about *Outdoor Photographer* can be obtained by calling 800-283-4410.

INDEX

BOOKS BY GALEN ROWELL

The Vertical World of Yosemite (anthology), 1974

In the Throne Room of the Mountain Gods, 1977

High and Wild: A Mountaineer's World, 1979

Many People Come, Looking, Looking, 1980

Alaska: Images of the Country (text by John McPhee), 1981

Mountains of the Middle Kingdom, 1983

Mountain Light: In Search of the Dynamic Landscape, 1986

The Art of Adventure, 1989

The Yosemite (text by John Muir), 1989

My Tibet (text by the Dalai Lama), 1990

Galen Rowell's Vision: The Art of Adventure Photography, 1993

Poles Apart: Parallel Visions of the Arctic and Antarctic, 1995

Bay Area Wild (with Michael Sewell), 1997

Coastal California (text by John Doerper), 1998

Living Planet: Preserving Edens of the Earth
(with Frans Lanting and David Doubilet), 1999

North America the Beautiful, 2001

California the Beautiful, 2002